SEEING
OURSELVES

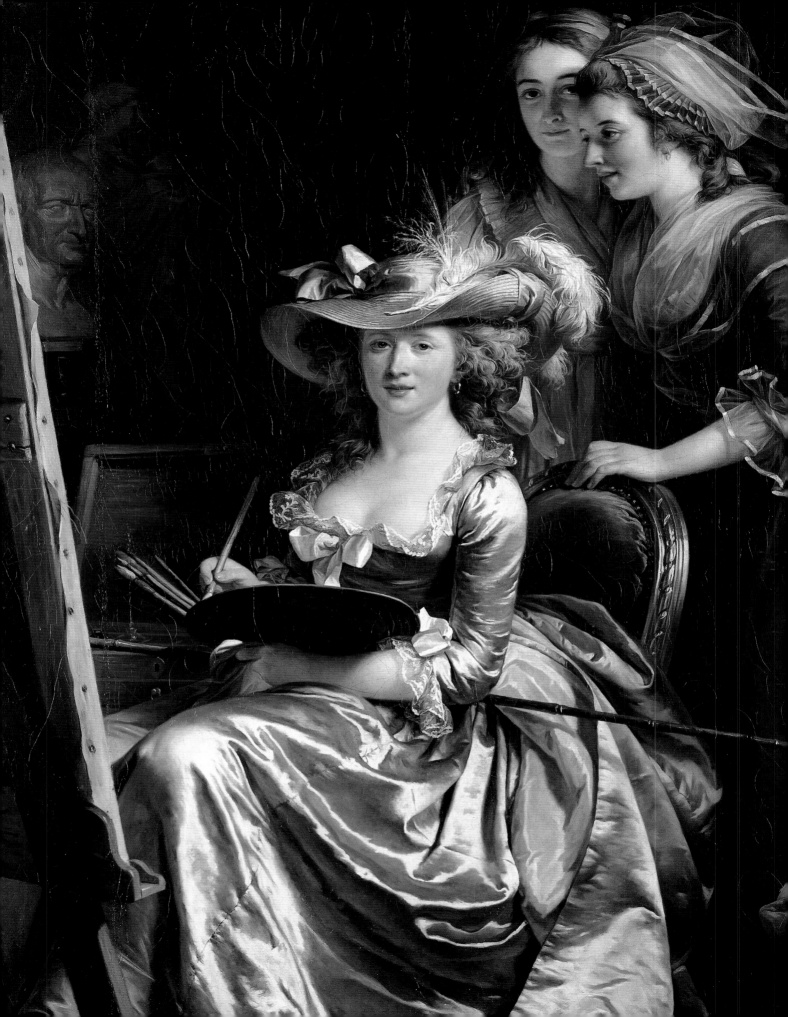

SEEING OURSELVES

Women's Self-Portraits

Frances Borzello

Harry N. Abrams, Inc., Publishers

ADÉLAÏDE LABILLE-GUIARD, *Self-Portrait with Two Pupils, Mlle Marie Gabrielle Capet and Mlle Carreaux de Rosemond* (detail), 1785 (p. 2).

Library of Congress Cataloging-in-Publication Data

Borzello, Frances.
 Seeing ourselves : women's self-portraits / by Frances Borzello.
 p. cm.
 Includes bibliographical references and index.
 ISBN 0–8109–4188–0 (cloth)
 1. Women artists—Psychology. 2. Self-perception in women.
 3. Women artists—Portraits. I. Title.
 N71.B673 1998
 704'.042—dc21 97–41441

First published in Great Britain in 1998 by Thames and Hudson Ltd., London

Published in the United States of America in 1998 by Harry N. Abrams, Incorporated, New York

Printed and bound in Singapore

 Harry N. Abrams, Inc.
100 Fifth Avenue
New York, N.Y. 10011
www.abramsbooks.com

CONTENTS

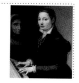
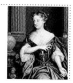
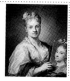
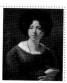

PREFACE

Every word of this book is underpinned by the historians who have written about women and art in the past three decades. The feminist art historians changed art history. To take just one example: in 1971 Linda Nochlin asked why there had been no great women artists and offered the research-based answer that it was because they had been barred from art academies until the nineteenth century. In one essay filled with irrefutable facts, she reduced emotional opinions about female creativity to dinner-party chatter. The feminist art historians gave me the confidence to see female self-portraiture as a valid subject of research, and so my first thank you goes to them.

With the exception of 'Face to Face' an exhibition at the Walker Art Gallery in Liverpool in 1994, and a few exhibitions of photographic self-portraits, self-portraiture has attracted little serious attention, and female self-portraiture even less. I found references to one or two small shows of contemporary works – too small, unfortunately, to have merited catalogues. Women artists of the past have fared better, and I want to offer special thanks to the select group of scholars who have written articles about specific female self-portraits: they are named in the relevant notes. Apart from these specialist articles and rare exhibitions, women artists had to wait for the attention they deserved until 1991 with the Tokyo Metropolitan Museum of Photography's exhibition, 'Exploring the Unknown Self: Self Portraits of Contemporary Women', and until 1996 for a theoretical discussion in Marsha Meskimmon's 'The Art of Reflection: Women Artists' Self-Portraiture in the Twentieth Century'.

I would like to express my gratitude to Elspeth Hector and her staff at the National Gallery library, London, and to Meg Duff and her staff at the Tate Gallery, London, for allowing me to dig through books and journals undisturbed. The staff at the London Library were invariably helpful, particularly the librarian who handed me on to solid ground after an attack of vertigo brought on by the grid floors of the book stacks. There would have been no book at all without my son's friend Alan Li, who one memorable day rushed round to retrieve the text out of the black hole of the computer screen. In ways that would surprise them, Ann Cook, Jane Manuel and Eileen Pembridge helped me through a personally unsettled year. And thanks to Moss, who was painting my house while I was writing to deadline, and who turned a myth on its head by making me cups of tea.

My aim was to present women artists' self-portraits as a genre in its own right, and my approach was to show that women artists' position in the art world and the ideas of their day were causally related to the self-portraits they produced. The various themes and tendencies which emerged owed little to biological promptings

CINDY SHERMAN, *Untitled # 122*, 1983 (opposite). By using herself as the model in all her images, the artist draws attention to the roles available to women, not just in everyday life but also presented to women through the media. This image of 1940s film-star sulkiness, symbolized by the clenched fists, could never be inhabited by a man.

and everything to being a female artist in a male art world. A by-product of the research and classification is that it has begun to seem possible to think in terms of a history of female self-portraiture.

Because I set out to classify women artists' self-portraits, not to illustrate every well-known woman artist who ever lived, the selection of images may seem quirky. For example, I have included a work by Louisa Paris, an English amateur watercolourist of the mid-nineteenth century, not because she is an unsung genius but because she produced an early female example of the 'absent' self-portrait, her presence signified by her palette and sketching stool lying on the hillside.

Every image illustrated in the book is there because it makes a point. Inevitably, following this principle meant that I had to let go of some of my own particular favourites, like the strong self-image of 1938 by Freda Robertshaw , the only standing nude self-portrait by an Australian woman artist before the 1970s (Private Collection); the tiny woodcut self-portrait Dora Carrington designed for her bookplates; Lotte Laserstein at work in 1925 with a brush in one hand and a huge cat in the other (Leicestershire Museums); and the self-confident seductiveness of Zinaida Serebryakova's nude *Bather (Self-Portrait)* of 1911 in the Russian Museum, St Petersburg. My only consolation is that I am alerting readers to a huge and fascinating area of art that has been ignored for far too long.

London
September 1997

SOFONISBA ANGUISSOLA, *Self-Portrait*, 1554 (opposite). The artist's signature in the book ensures that the viewer knows that this is the artist's own work and not a portrait of her by another hand.

ARTEMISIA GENTILESCHI, *Self-Portrait as 'La Pittura'*, c. 1630–37 (overleaf). The artist as the personification of Painting. Gentileschi achieved a brilliant and exclusively female extension of the self-portrait repertoire by combining her own features with the allegorical image of Painting in the throes of creation.

ROSALBA CARRIERA, *Self-Portrait*, after 1746 (p. 11). An image of old age, perhaps the one recorded as *Self-Portrait as the Muse of Tragedy*. The laurels of victory are contradicted by the haunting expression of old age, not seen again until the twentieth century.

ELISABETH VIGÉE-LEBRUN, *Portrait of the Artist with Her Daughter*, 1785 (p. 12). This apparently artless presentation of herself with her daughter is based on a reworking of the *Madonna della Sedia* by Raphael. It was a typical strategy of this artist to hide her cleverness beneath her charm.

SABINE LEPSIUS, *Self-Portrait*, 1885 (p. 13). By the end of the nineteenth century women artists are no longer looking out at the viewer from their self-portraits to charm or impress; they are examining themselves with introspective concentration.

LOUISE HAHN, *Self-Portrait*, c. 1910 (p. 14). Female self-portraits with an outdoor setting are rare before the twentieth century. Hahn painted landscapes and this may explain her choice, but it also seems to express the fact that women's lives were becoming less confined.

FRIDA KAHLO, *Self-Portrait with Monkeys*, 1943 (p. 15). The twentieth century brought psychosexual awareness and permission to express it in art. Monkeys were part of Kahlo's private mythology, representing the children she never had, sexuality and her affinity with the animal world.

PAULA REGO, *The Artist in Her Studio*, (detail) 1993 (p. 16). Much of late twentieth-century art, when not specifically autobiographical, has become oblique self-portraiture – it flickers with references to the artist's identity and experience. Here the painter portrayed is not the artist herself, yet the references and the people in the painting (including her grandchildren) are powerfully connected to her – it could be thought of as a surrogate self-portrait.

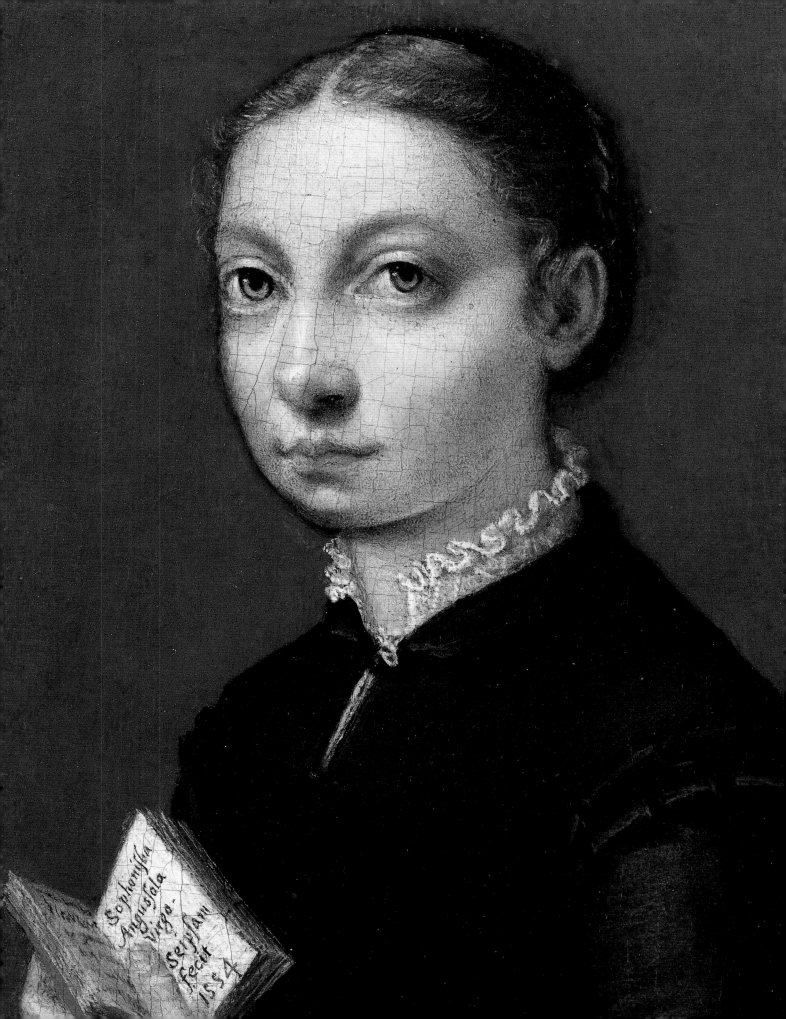

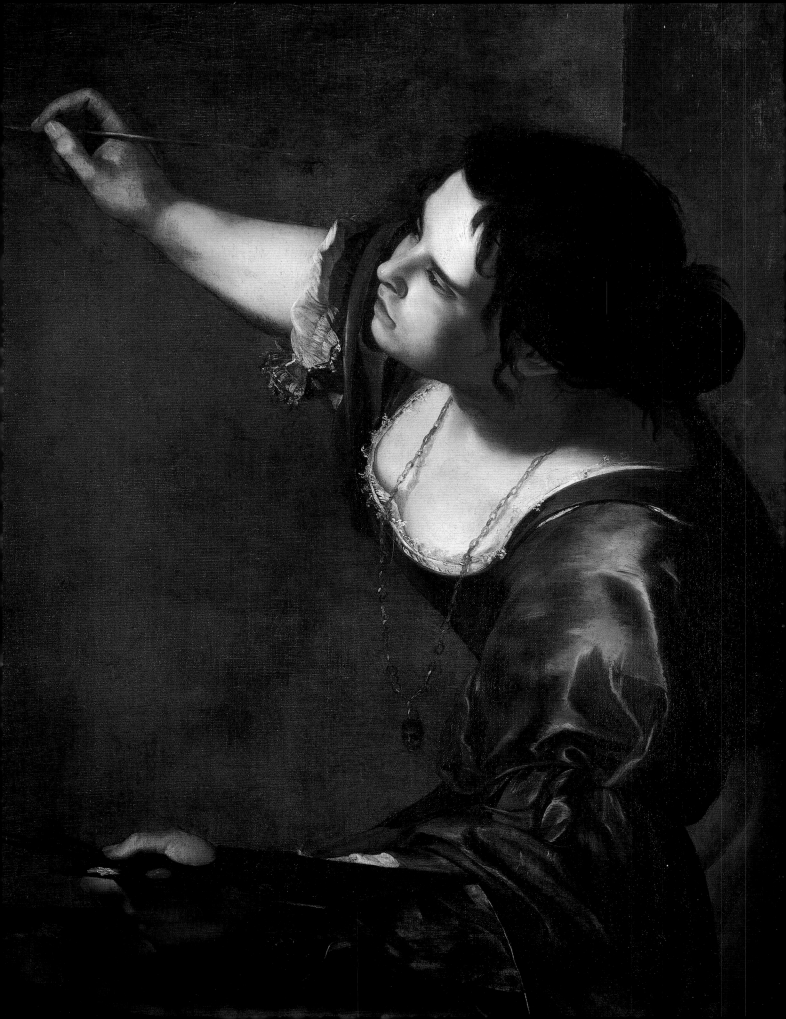

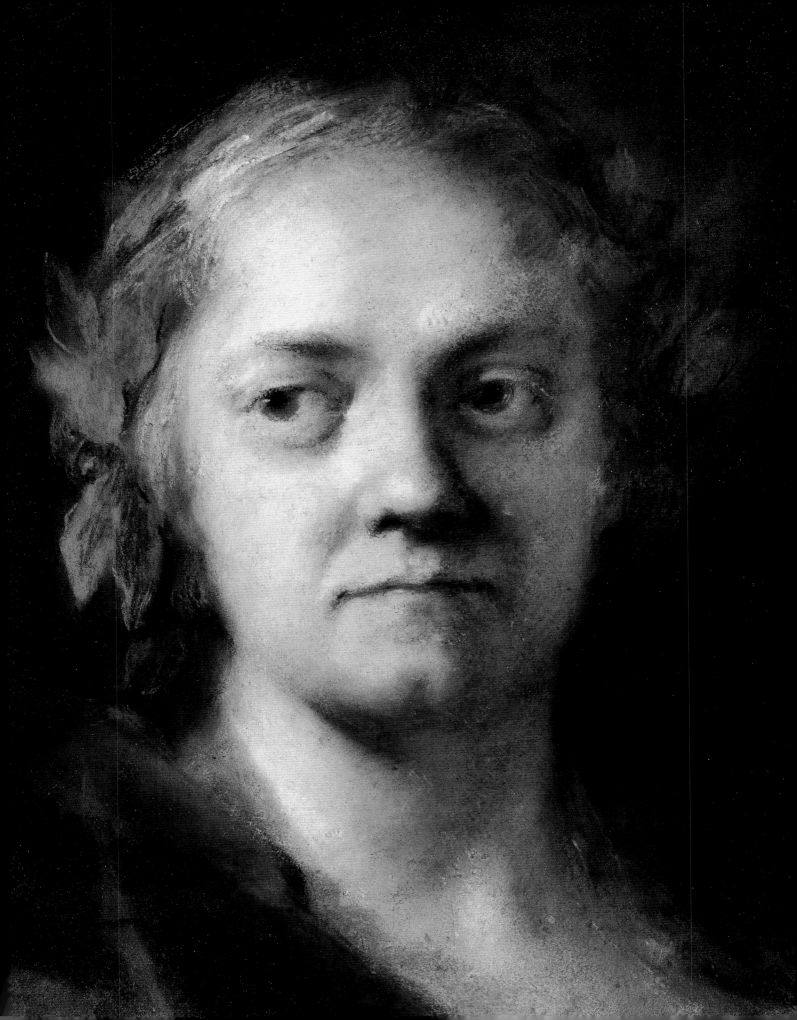

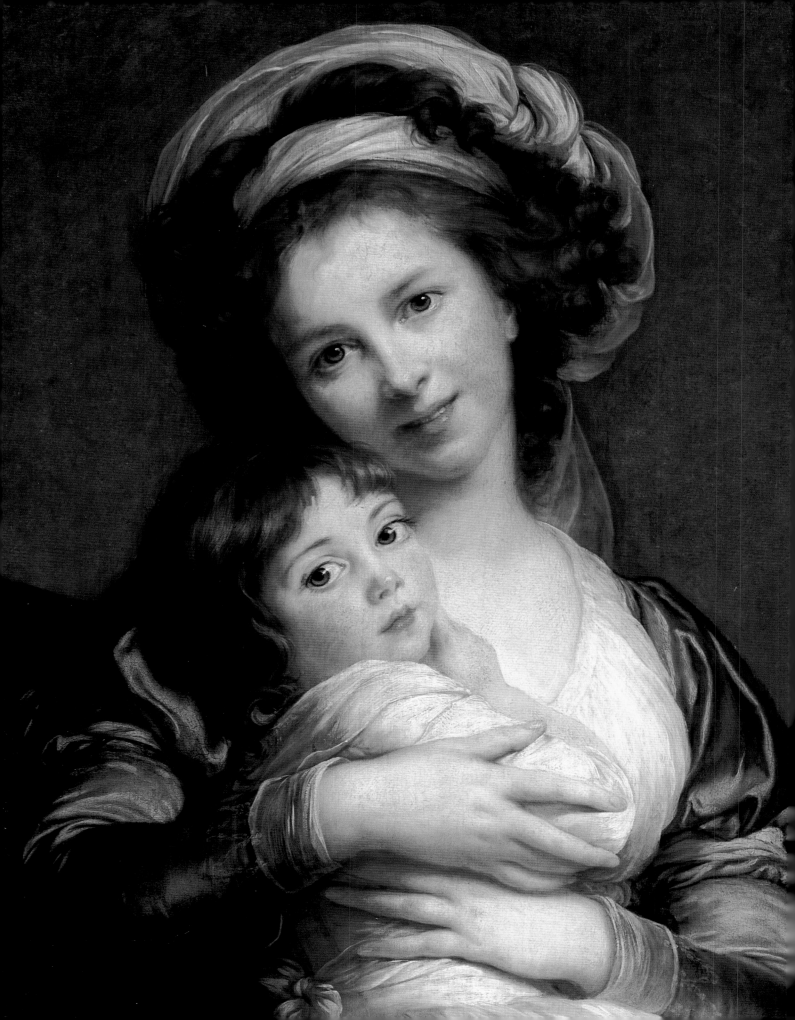

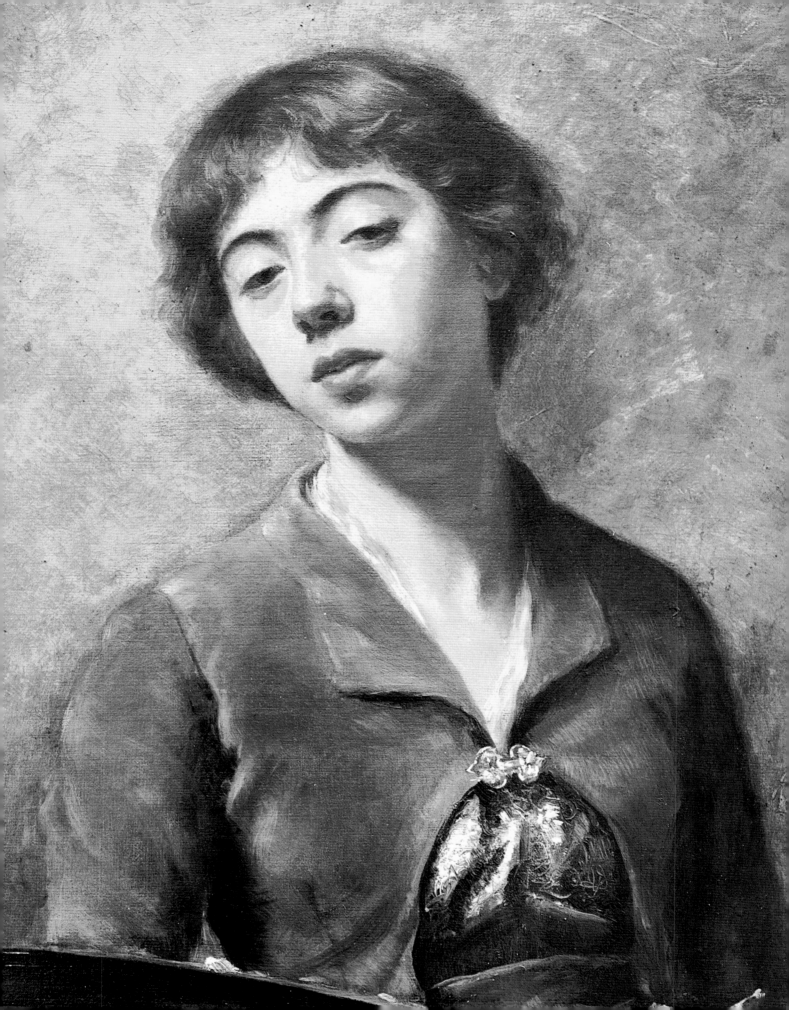

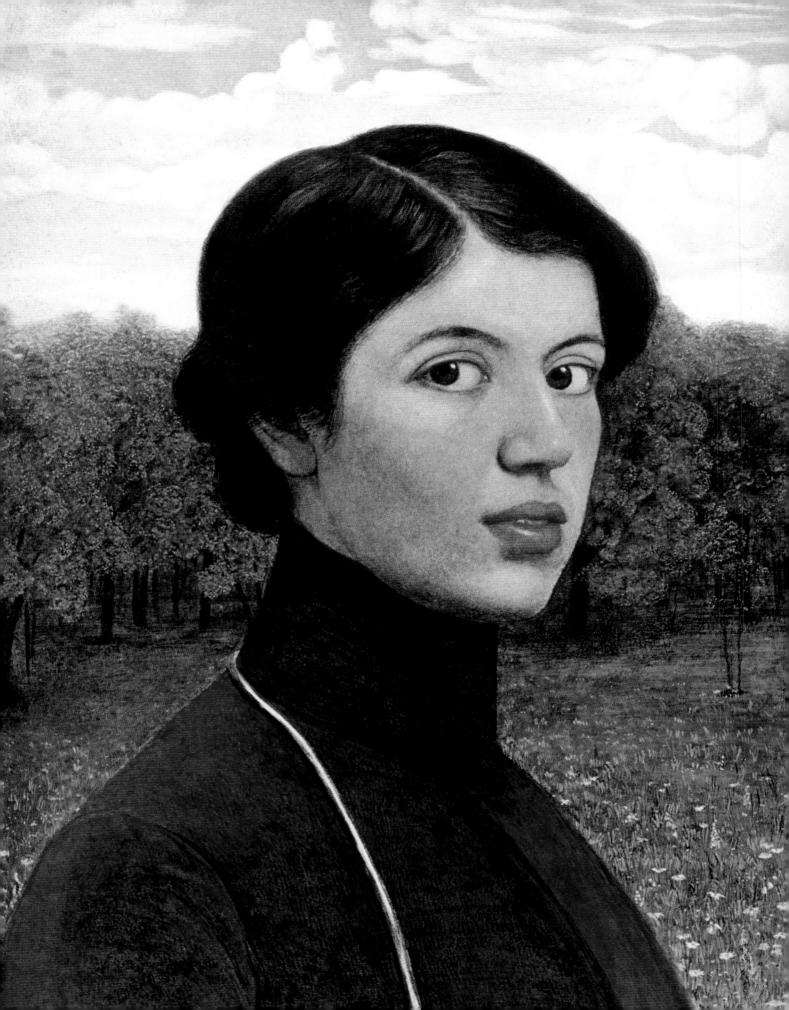

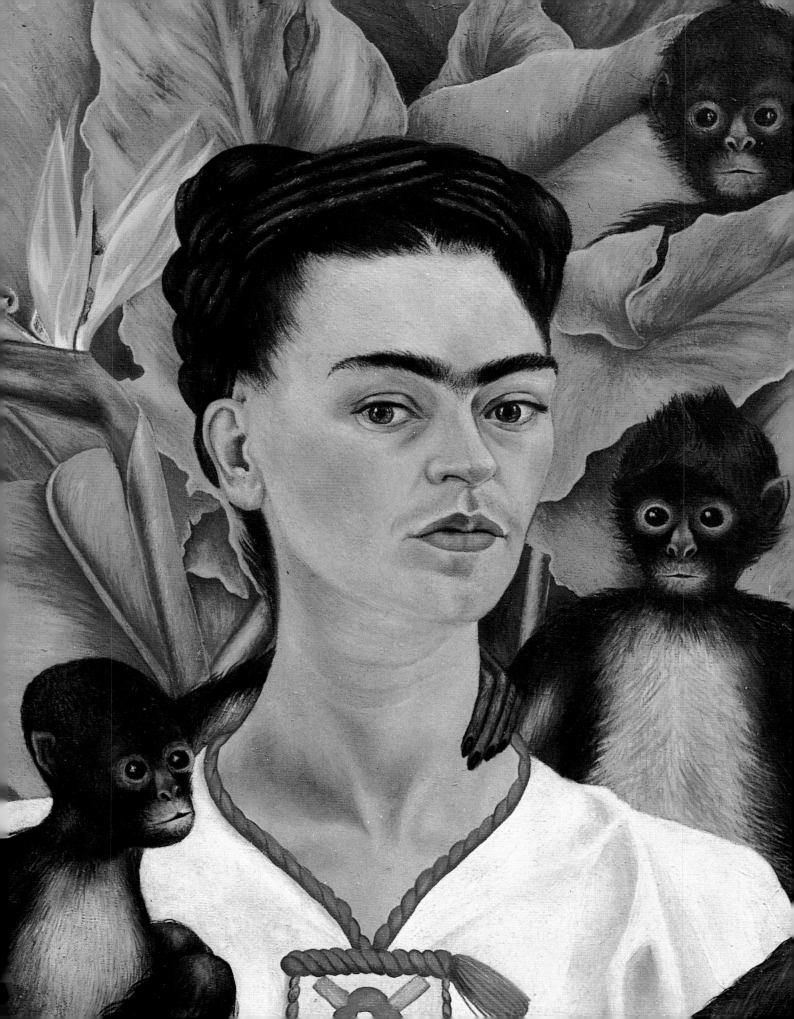

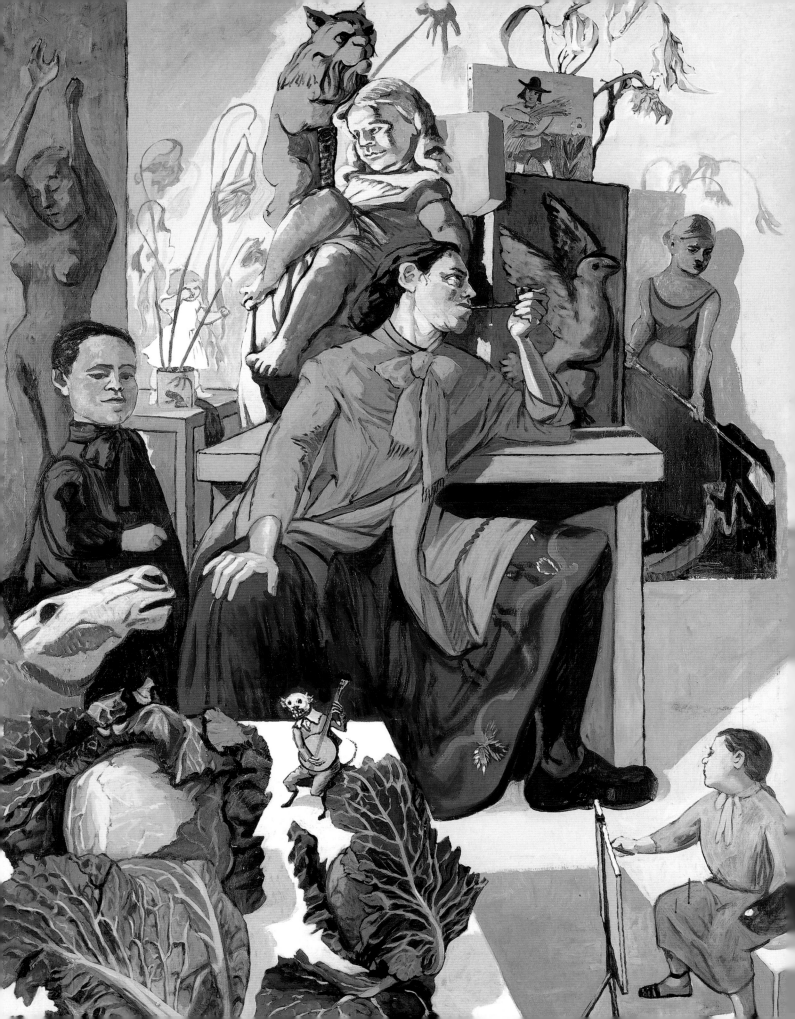

INTRODUCTION THE PRESENTATION OF SELF

Self-portraits by women artists had been catching my eye for years. I had filled a drawer with them – reproductions of works by Western artists from the medieval period up to the present. It was not that I thought they were all wonderful, though many of them were. It was rather that, since women artists were never the norm, there was something intriguing about even the simplest self-portrait at an easel which aroused my curiosity and demanded consideration.

Self-portraits are not innocent reflections of what artists see when they look in the mirror. They are part of the language painters use to make a point, from the simple 'this is what I look like' to the more complicated 'this is what I believe in'.

Artists paint self-portraits for several reasons – to show their skills, like the eighteenth-century Spaniard Meléndez proudly displaying his mastery of life drawing; to boast of their status, like Joshua Reynolds painting himself in his robes as Doctor of Philosophy after he had been honoured by Oxford University in 1773; to emulate past masters, like Rembrandt in 1640 basing his pose on a portrait by Titian which had passed through the Amsterdam art market the

LUIS MELÉNDEZ, *Self-Portrait with Académie*, 1746. A proud display of life-drawing skills.

previous year; to give reign to the wit not required by customary subject matter, as Murillo, famous for religious scenes, does in his surrealistic self-portrait for his family with one hand protruding from the frame within the frame; to publicize one's artistic beliefs, like Baccio Bandinelli holding a drawing of Hercules to show his respect for classical sculpture (p. 42). Gradually I began to notice differences between self-portraits by women and self-portraits by men. Why did so many women artists present themselves in so subdued a manner? In the National Gallery in London there is a self-portrait by Salvator Rosa in which he stands dramatically against the sky, wrapped in a dark cloak and holding a board whose Latin transcription recommends silence over loquacity. It is an operatic self-presentation, not unexpected from a poet and a painter of witches and stormy landscapes. But there was nothing so dramatic from the hands of women.

And why did women so rarely boast of their abilities? Why, when three decades of research into women artists have shown them to be as ambitious as the men, is there no female equivalent of the self-portrait of Meléndez showing the spectator his study of the male nude, his credentials for attempting the grandest subjects from the Bible, classical mythology and history ancient and modern?

Not all the differences were negative. There were a number of self-portraits which stressed the artists' maternal aspect, and a group which showed the painters as musicians. Some seemed to have no male equivalent at all, like Artemisia Gentileschi's depiction of herself as the personification of painting (p. 10). In this powerful and original image, she had invented a self-portrait type which no man could possibly inhabit.

Many of the differences appeared to be related to time. Maternal images tended to cluster together at the end of the eighteenth century; musical images were strong in the sixteenth. A huge change came with the twentieth century when artists began dealing with matters like pregnancy and sexuality which before had only been mentioned in writing (Elisabeth Vigée-Lebrun recalled painting through her labour pains in the eighteenth century),[1] or kept under wraps (Rosa Bonheur did not want her taste for dressing in masculine clothes recorded in paintings or photographs in the nineteenth). And as if to confuse my desire to classify, some themes seemed to escape the grip of history, like the Dutch artist Charley Toorop's comparison of her elderly self with the winter tree outside her window in the 1950s and the Italian Rosalba Carriera's portrait of her fifty-five-year-old self as Winter in the 1730s.

I began to feel increasingly surprised. Surprise that there were so many self-portraits. Surprise at their variety. Surprise at their originality as well as their timidity. The self-portraits stared back at me, challenging me to accept the evidence of my eyes, that women's self-portraits are different from those produced by men, and more interesting than the traditional female history of deprived training and lukewarm support might suggest.

I came to the conclusion that no self-portrait by a woman could be taken for granted. Whether it was 'good' or 'bad' or 'powerful' seemed of less interest than the fact that a female face signals a radical departure from the norm and is

BARTOLOMÉ ESTEBAN MURILLO, *Self-Portrait*, *c.* 1670–73. Pencil and paper advertise his profession, the protrusion of his hand from the mirror advertises his wit.

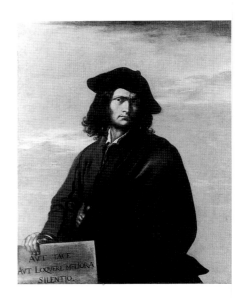

SALVATOR ROSA, *Self-Portrait*, *c.* 1640–45, also known as the *Self-Portrait as Silence*. The age-old linking of women with loquacity (Rosa used his mistress as the model for Speech) meant that no woman could use this self-portrait format.

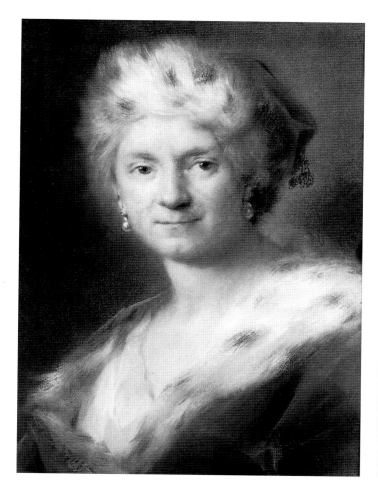

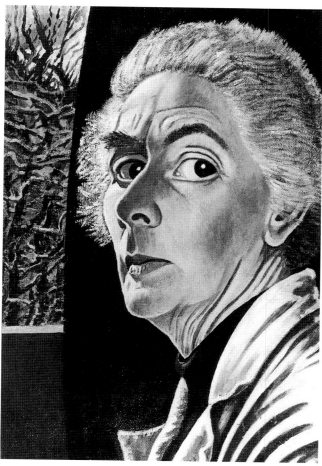

therefore enough to stop the image being read in the same way as a male self-portrait. I decided that with even the most conventional self-representations, the constructive approach, the one that would encourage them to release their secrets, was to consider why they looked as they did.

I tried to make sense of what I was seeing by treating the self-portraits as painted versions of autobiography, a way for the artist to present a story about herself for public consumption. Autobiography may be based on fact, but the author's need to tell a credible and sympathetic tale makes the end product as artful as a novel. And if it is art, there are rules for the artist and audience to understand. The viewer of a self-portrait reads the vocabulary of pose, gesture, facial expression and accessories and checks it against the ideas of its era.

As with written autobiography, certain things can only be said at certain times. Fashions in artistic style, in artistic conventions, and in the ideas from the outside world that find their way into art play an important part in encouraging certain kinds of self-portrait. It is as fruitless to expect the outspokenness of today's self-portraits in the art of the women of the past as it would be to expect Jane Austen to discuss the love-making of Elizabeth Bennet and Mr Darcy.

ROSALBA CARRIERA, *Self-Portrait as Winter*, 1731 (above left). The ermine suggests snow as well as the white hair of age.

CHARLEY TOOROP, *Self-Portrait*, 1955 (above right). Two centuries later, winter branches are a simile for age.

With autobiography in mind, I started to put my drawer of pictures into some kind of order. I took these intriguing images seriously and I asked them: why have you chosen to look the way you do in your self-portraits?

THE CONFLICT

The earliest representations of women painting their self-portraits appear as illustrations to Boccaccio's *Concerning Famous Women*, written between 1355 and 1359. The classical historian, Pliny the Elder, reported that Iaia of Kyzikos 'who remained single all her life' painted 'a portrait of herself, executed with the aid of a mirror.'[2] Boccaccio used Pliny as one of the sources for *Concerning Famous Women*, singling out this artist (by now named Marcia) for painting her likeness 'with the aid of a mirror, preserving the colours and features and expression of the face so completely that none of her contemporaries doubted that it was just like her.'[3] In an image from a manuscript translation of Boccaccio's book from Italian into French of about 1402, Marcia holds a mirror in her left hand and paints her portrait with her right. Two years later, in a manuscript presented to the Duke of Berry, she sits in a chair made out of a barrel, painting her portrait from her reflection in a convex mirror placed next to the panel on which she works.

Though self-portraits by women artists may seem as rare as a four-leaved clover, they are not, in fact, that uncommon. Look for them and they come into focus, a huge gallery of women painters wielding their brushes, clutching their palettes and scrutinizing their features. A medieval manuscript illustrator called Claricia draws herself as the tail of the letter Q. In the eighteenth century,

Miniature showing Marcia, 1404, (below), from a French translation of Boccaccio's *Concerning Famous Women*. She looks into a circular mirror to the left of her panel.

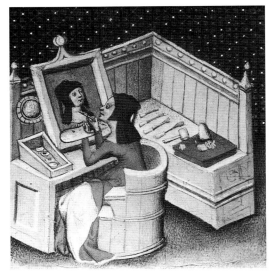

Miniature showing Marcia, *c.* 1402, (left), from a French translation of Boccaccio's *Concerning Famous Women*. An early image of a woman artist painting her own portrait from a hand-held mirror.

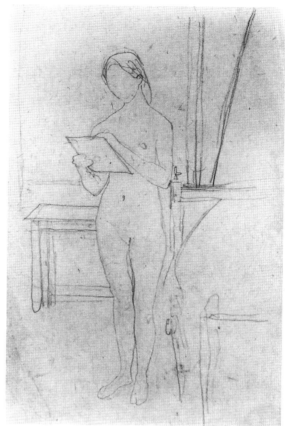

Adélaïde Labille-Guiard paints herself with two pupils looking admiringly over her shoulder as she works (p. 2). At the start of this century, a naked Gwen John draws herself in pencil. For centuries women artists have portrayed themselves with originality, charm and magnificence, and they continue to do so today.

One reason for their invisibility is that the origin of self-portraiture is always explained through male examples. A wish to put a personal stamp on their work moved male scribes to draw images of themselves in their manuscripts and sculptors to chisel their likeness into church carvings. Italian and particularly Flemish and German artists of the fifteenth and sixteenth centuries inserted themselves into their religious paintings, peering out of windows, round corners or through doorways. Self-portraits finally came out of their corners at the end of the fifteenth century with the German artist Albrecht Dürer's famous succession of self-portraits.

The few books on the subject show only a token selection of self-portraits by women. While it would be ridiculous to deny that men have dominated the field of self-portraiture, just as they have dominated the artistic profession, this history has hidden the fact that women have been there all along, thinking as hard as the men about how to represent themselves in paintings. One of them, the sixteenth-century Italian Sofonisba Anguissola, painted the longest series of self-portraits between Dürer and Rembrandt.

GWEN JOHN, *Self-Portrait Nude, Sketching*, 1908–9 (above right). The twentieth century with its new freedoms and ferment of ideas saw the first nude self-portraits by women artists.

CLARICIA, from a German Psalter from Augsburg, twelfth century (above left). The illuminator draws herself for posterity as the tail of a letter.

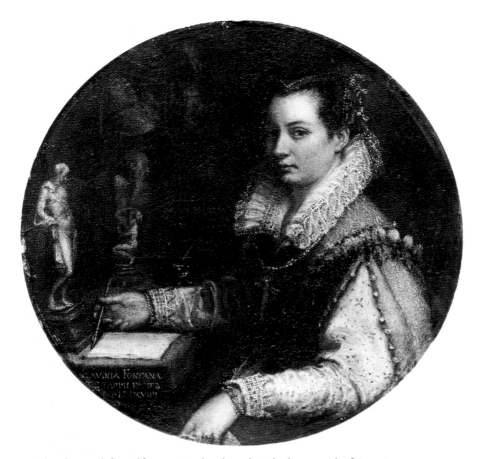

The demand for self-portraits developed with the spread of Renaissance ideas. Images of the famous were an area of Renaissance collecting, and artists' portraits were a sub-section within this. Artists developed an aura of glamour in the sixteenth century. One event which helped raise their profile was the publication in 1550 of Vasari's *Lives of the Most Eminent Painters, Sculptors and Architects*, which by its second edition in 1568 had acquired 144 woodcut images of the artists, about 95 of which are thought to be genuine likenesses. Information about the lone female image, the portrait of the sculptor Properzia de' Rossi who had died over thirty years earlier, was said to have come from her friends, though it is unclear whether visual or verbal clues were supplied.[4]

References to the collecting of artists' portraits and self-portraits date from the sixteenth century.[5] In 1578, Lavinia Fontana was asked by the Spaniard Alonso Chacon for a painting of herself for reproduction in his projected 'museo', a collection of prints of famous men and women . The first collection devoted entirely to self-portraits was instigated in the middle of the 1660s by Leopoldo de' Medici, Grand Duke of Tuscany. Before the Uffizi collection closed its doors in the early twentieth century, it had gathered a number of self-portraits by women artists.

This interest in self-portraits developed into a fashion in the eighteenth century, and it is not unusual to find self-portraits on the walls of the great houses whose art collections were formed at this period. In March 1790, as soon as she

THE PRESENTATION OF SELF

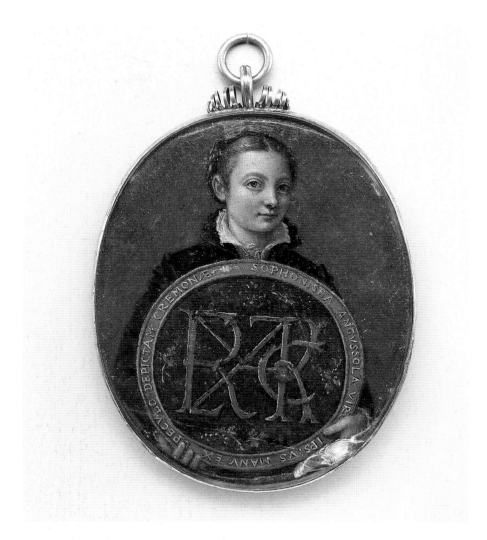

SOFONISBA ANGUISSOLA, *Self-Portrait*, c. 1555
(left). The mysterious monogram doubtless
had meaning for the recipient of this miniature.
Anguissola painted herself many times from
extreme youth to extreme old age. To record
that these were not portraits of her by another
hand, she frequently included books or papers
bearing inscriptions informing the viewer of
her age and marital status.

had completed the self-portrait requested by the Uffizi collection, Vigée-Lebrun
must have begun the copy for the Bishop of Derry, fourth earl of Bristol, which
still hangs in the family home at Ickworth in Suffolk. He probably saw the original
in her studio in Naples when he was sitting for his portrait and requested a copy.

Not all women artists' self-portraits were painted in response to a request. A
self-portrait painted when Sofonisba Anguissola was in her seventies, and bearing
the inscription 'To his Catholic Majesty, I kiss your hand, Anguissola', was possibly
a gesture of respect to the new Spanish ruler, Philip III, whose father had protected
her interests during her years at the Spanish court in the mid-sixteenth century.
Unable to journey from Italy to pay her respects in person, she paid them in paint.

Professional regard was another motive for self-portraiture. The miniaturist
Giulio Clovio owned a self-portrait by a female miniature painter, possibly Levina
Teerlinc.[6] When Gauguin and Van Gogh exchanged self-portraits, they were
continuing a practice that had been in place for centuries.

Some self-portraits seem to have served the purpose of a photograph today.
In an oil-on-copper miniature of about 1555 the young Sofonisba Anguissola

SOFONISBA ANGUISSOLA, *Self-Portrait*,
c. 1610 (opposite). In an image of pride and
dignity as she approaches eighty, the artist
pays her respects to the Spanish royal family
for whom she had worked in the mid-sixteenth
century. This self-portrait of the artist as
enthroned matriarch makes an interesting
contrast with Alice Neel's self-portrait (p. 160).

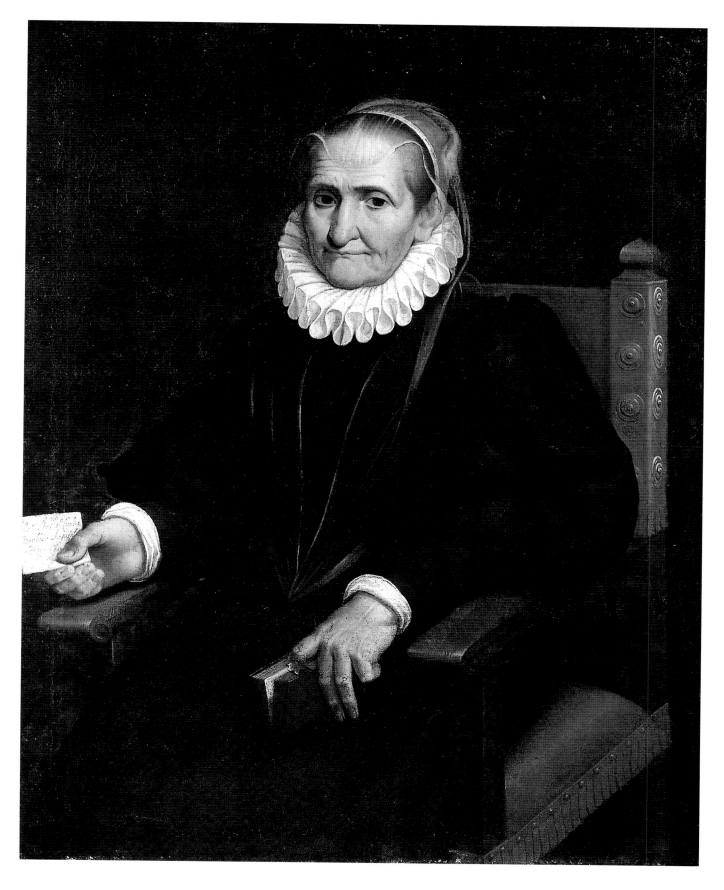

accords more space to the monogram she holds than to her head. Surrounding the entwined letters and the crown signifying her nobility are the words, 'Sofonisba Anguissola, maiden, painted herself by her own hand in the mirror, Cremona.' So far uncoded, her biographer suggests that the monogram contains a message to her family as she was about to leave them to work in Rome.[7]

Self-portraits were done for self-promotion. When Elisabeth Vigée-Lebrun painted a portrait of herself in imitation of a famous portrait by Rubens (p. 77), she knew exactly what its value was: 'I must say it did much to enhance my reputation. The celebrated Muller made an engraving of it; but you must feel as I do that the black shadows of an engraving take away all the particular effect of a painting such as this.'[8]

Self-portraits were frequently kept by the painters to show to prospective clients. A comparison of painter with painted was the best way to prove one's skill at catching a likeness.[9]

Sometimes self-portraits were done for practice. The variety of poses, moods, styles and media in which Rembrandt painted, etched and drew himself suggests that his own face served as model for a restless hand and exploring mind when other models were not available. In the same century in England, Mary Beale's husband recorded that she was painting herself for 'study and improvement'.[10]

All these reasons for producing self-portraits applied equally to men and women. But one reason belonged to women alone: to satisfy collectors' curiosity. The relative rarity of women artists before the twentieth century gave them huge curiosity value, and collectors were greedy to own their likeness. This curiosity is the reason for the large number of autograph copies of self-portraits by certain painters. Vigée-Lebrun's self-portrait at Ickworth is one of six autograph copies of the Uffizi original and several of her other self-portraits were replicated two or three times.[11] It also explains the number of engravings of female self-portraits, particularly in the eighteenth century, the artistic equivalent of the photograph on the book jacket for connoisseurs wishing to see the face behind the work.

There was a belief that women were more likely than men to produce self-portraits. This idea has a long history: for example, except for a brief reference in Chapter 38 of his *Natural History* to a sixth-century BC sculptor who made self-images, Pliny's reference to Marcia painting a self-portrait is the *only* reference to self-portraiture in his chapter on painting. However, there really is no evidence to support it. While awareness of their rarity value obviously encouraged some women to use their self-portraits as a form of publicity – with so many doors closed against them, they would have been stupid not to take any opportunity to promote themselves that offered – this is hardly grounds for claiming they made the field their own.

This belief in the female affinity for self-portraiture may have drawn strength from the personification of the vice of vanity, and is actually a subtle insult. Since vanity was for centuries personified as a woman looking in a mirror, a female self-portrait is evidence of this female vice, a real-life personification in the manner of Gentileschi's *Self-Portrait as La Pittura* (p. 10), but far more damning.

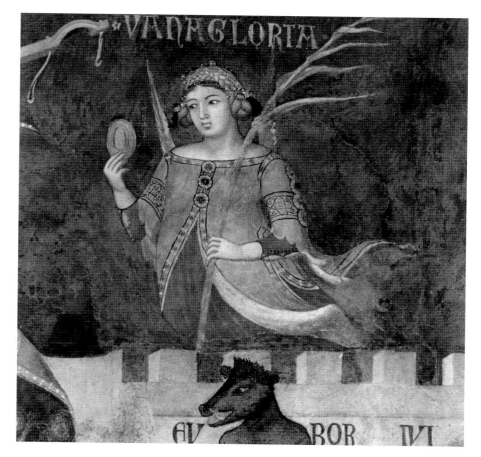

AMBROGIO LORENZETTI, *Vanagloria* (detail), 1338–40. The sin of vanity was always personified as a woman studying herself in the mirror. This may be the reason why, compared with men, so few women artists before the twentieth century incorporated the mirror into their self-portraits.

This negative view of women and their self-portraiture is part of a larger set of attitudes about women and art, all stemming from the fact that the female artist was a minority member of the art world with little control over the judgments, views and rules affecting her.

When Vigée-Lebrun was accepted into the French Academy in 1783, she doubtless felt she was standing on the same rung as her male counterparts. When Angelica Kauffman painted four ceiling panels in Somerset House in 1779 she must have felt the equal of the men who worked on the programme with her. Unfortunately it was hard for the men to return the feeling. The women may have seen themselves as professionals on a par with the men, but the men saw them as women as well as artists, treating them with an unhelpful mix of gallantry and curiosity – unhelpful because praise replaced constructive criticism and curiosity increased self-consciousness.

What is an artist? If the answer were simply a practitioner of art, women artists would have no problems. But from recorded history, the artist is always assumed to be male. A female artist is an exception, a prodigy. In the sixteenth century Vasari wrote that Giovan Battista Mantovano had two engraver sons and 'what is even more astonishing, a daughter, called Diana, who also engraves so well that it is a thing to marvel at; and I who saw her, a very gentle and gracious girl, and her works, which are most beautiful, was struck with amazement.'[12]

In discussing Sister Plautilla, Vasari wrote that she would have done marvellous things 'if she had enjoyed, as men do, advantages for studying, devoting herself to drawing, and copying living and natural objects.'[13] This sentence, which could have come from the mouth of a twentieth-century feminist, is a fine example of how ideas have to find a time in which to flourish. Despite his sympathetic analysis, Vasari was unable to forget the women artists' female role. 'But if women know so well how to produce living men, what marvel is it that those who wish are also so well able to create them in painting?' he wrote.[14] During a period which believed that creating life disqualified the female from any other kind of creation, it was an elegant conceit to turn the belief on its head to justify the few exceptions. But it was no more than a flattering compliment, whose wit was to be admired but not to be taken seriously. Vasari's view that it was unnatural for women to be artists – natural meaning something which could pass without comment – survived until well into this century. Even today, the stereotype of the artist is a man with a black beret, striped T-shirt and giant palette.

The art world was also predominantly male. Men had the money and contacts which allowed them to commission. Men had the freedom to travel which broadened their minds and the education which prepared them to write the theory that set the standards for practice and the agenda for discussion. Men ran the organizations, from the schools where students learned their skills to the guilds and academies which conferred professional status. And men decided the terms on which women entered the profession.

Sometimes whole flocks of women were allowed to walk through the door marked Art. They accounted for one-fifth of the Salon entries in early nineteenth-century France, wrote criticism for journals in late nineteenth-century England and opened galleries in mid-twentieth-century America. Academies occasionally invited a woman to become a member, though if too many female names came up, a reinterpretation of the constitution served to limit their numbers. Sometimes a wealthy Renaissance lady commissioned an altarpiece. Occasionally male painters welcomed female students. When feminism was strong, as in the mid-nineteenth century, women organized themselves to make a dent in the smooth surface of male solidarity. But though history offers many such examples, until recently women were never allowed to tilt the balance of the male-run art world.

The problem for women was that from medieval times, femininity was understood in terms of permissible behaviour, necessary duties and admired accomplishments. This construction of femininity was legitimized by religion, medicine, philosophy and convention, and legalized through concepts of marriage, property and rights.

Women were trained to put themselves second, be supportive to a husband, serve their families. It was not thought seemly for them to put themselves forward, let alone compete or excel, nor proper for them to go about the world alone. Their sphere was private while men's was public. A woman who practised as an artist had to operate in a context set up for men and to behave in a manner thought to be unwomanly.

Virginia Woolf's insight into a man's freedom to fail in his chosen career without the debilitating chorus of comment which accompanied every move a woman made, and Germaine Greer's 'obstacle race' metaphor for women's journey to professionalism have summed up women's difficulties in pursuing an artistic career.[15] Despite this, images of pride, wit and and intelligence kept staring back at me from the self-portraits.

THE PARALLEL WORLD

Women artists inhabited a kind of parallel art world to that of the men. Their education, for example, was not standardized. A talented young man could learn his skills through working in a master's studio, or through attending an academy where he could progress in the accepted international manner from drawing from drawings, to drawing from casts, to drawing and painting from life. If he had the money or was adventurous, he could bolster these studies by travelling to see the most famous paintings of the day and of the past.

These learning paths were closed to girls. Until the second half of the nineteenth century, when art schools began accepting female students, would-be women artists lacked access to the training their brothers took for granted. But still they learned. The variation in artistic and social attitudes from age to age and country to country left gaps in which women could train. At times there was acceptance and even encouragement. Renaissance Bologna had a tradition of female education (its university accepted women from the thirteenth century, and a local saint, the fifteenth-century Caterina dei Vigri, had a reputation as an artist and musician);[16] and late eighteenth-century France was sympathetic to women's artistic ambitions.

Young women with talent, like Tintoretto's daughter, Marietta Robusti, or Luca Longhi's daughter Barbara Longhi (whose portrait appears in his *Marriage at Cana, c.* 1580), might be taught by their artist fathers to whose advantage it was to train an extra pair of hands for the family business. They might have lessons in art paid for by wealthy parents, and then take it up seriously. Or they might undergo a diluted version of male apprenticeship, anything from staying in the house of an artist to watching one at work.

The biggest barrier against their full development was the taboo against women drawing from the nude male model. This mattered because artists were judged on their mastery of the figure. There was a hierarchy of subject matter in which portraits and still-life, the areas most women worked in, carried far less status than scenes from the Bible, mythology and history which were based on the figure.

While male artists were supported by a studio, assistants, pupils and apprentices, the demands of propriety made it difficult for a woman to set up in business as an artist. To cope, she needed a support system. And for most women, until their nineteenth-century emancipation and the camaraderie resulting from their access to institutional training, this meant the family. Whether or not a

woman continued a career after marriage was in the hands of her husband. Vigée-Lebrun clearly thought a husband was a hindrance, leaving hers in Paris when she escaped with her daughter and nursemaid on the eve of the French Revolution. What might be termed virtual marriage suited her well, conferring the necessary status as she painted her way across the courts of Europe. The divorce granted to her husband in her absence in 1794 went unrecorded in her memoirs. Given the legal power of husbands over wives, spinsterhood combined with help from a father or sister was often a more productive option than marriage.

Professional support came from a variety of sources – patrons, friendships with the famous, engravers who helped to publicize their paintings. They had little of the institutional support that men could rely on, and even when they became a member of an academy they either had no voting rights or chose not to use them in the interests of femininity.

Women with drive, talent and support were able to negotiate their way round this parallel world. Dealing with intangible attitudes was harder, from female artistic stereotypes to patronizing opinions about women's abilities. The male artist might be seen, for instance, as the mad genius, the outlaw or the mystic. Vasari's *Lives* is full of strange tales – Piero di Cosimo boiled forty eggs at a time to live on for a week, Filippo Lippi ran off with a novice nun, and so on. This fascination with the artist as nonconformist continued into the nineteenth century with the appearance of the bohemian artist, an engaging antisocial law unto himself.

Female artistic types are less entertaining, and stress the fact that a woman artist was both a deviant artist and a deviant woman, seen as at best pretentious and at worst a grotesque transgressor of womanliness. She stands at her easel losing hairpins by the handful and taking herself ridiculously seriously given the second-rate quality of her work. Or she was seen as a prodigy (which has monstrous as well as flattering connotations), as sexually suspect (not half so positive as bohemian), or as an amateur (which encodes the idea of the second rate).

Like men, women were driven by the desire for a good reputation, but, unlike men, they knew that 'good reputation' carried a double meaning for them, not just that their art was highly regarded, but also that their behaviour was above reproach. The seventeenth-century artist Caravaggio murdered a man. The twentieth-century artist Augustus John saw women as sexual prey: Dora Carrington wrote, 'On Sunday morning I looked at Augustus's pictures, and had my usual proposal.' [17] And all this did was to add a glamorous notoriety to their artistic and social reputations. For a woman, with prurient eyes fixed on every move she made, professional status was a more difficult pedestal on which to balance. Female ambition risked being lampooned as pretentiousness, as in the 1789 cartoon of the British amateur Anna Damer chiselling a statue of Apollo; or as licentiousness: the same cartoon shows a female visitor to the studio leaping back in amazement at the well-endowed statue (a visual pun on his spear) while two other nude statues cover their genitals in the manner of a Venus Pudica.

Women fared better in the area of artistic mythology, even boasting a myth which was theirs alone, the myth of the two talents. Though several male artists

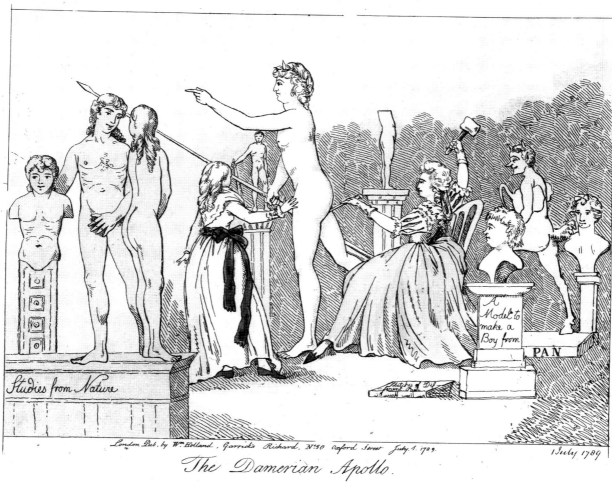

In Holland's Exhibition Rooms may be seen the largest collection in, Europe of Humorous Prints. Admitⁿ 1 Shilⁿ.

were known as accomplished musicians, less was made of this in the literature. In contrast, there are many accounts of the woman artist's equal talents in music and painting.

The myth of the child prodigy figures largely in the biographies of male artists. A famous artist chances upon an undiscovered boy genius, like Cimabue stumbling on the young Giotto scratching a drawing of a sheep with a stone. A boy's talent has almost miraculous powers – when Filippo Lippi was seventeen, he earned his freedom from the Moors by drawing his captor's portrait. Or a gifted boy is apprenticed to a famous master, thus ensuring the continuation of the line of genius.

Childhood brilliance in the biographies of women artists has a slightly different twist, pointing to the social truths which lie behind the myth. There are no accounts of discoveries of young female talent by established women painters, which is hardly surprising given that critics and historians have tended to see

ANONYMOUS, *The Damerian Apollo*, 1789.
In past centuries, women artists were frequently the target of ridicule and sexual innuendo. Though Anna Damer was a successful English amateur sculptor, her gender aroused salacious thoughts in the male art world.

women artists as isolated freaks of nature rather than a link in a chain of women artists. Commentators suffered a kind of artistic indigestion at the thought of more than one female artist at a time. When a woman artist became famous, like Rosalba Carriera, every woman who could hold a brush was compared to her for the following fifty years. There are no accounts of Lippi-style life-saving works of art – another convincing lack given the circumscribed lives most women led. The teacher-pupil pattern is also absent. By the late eighteenth century, a few leading women artists had female pupils and protégées, but normally a young female artist needed a male mentor to introduce her into the art world. The female version of the childhood talent myth is simpler, a matter of noting that the artist drew from a very young age. Anna Waser proudly inscribed the information that she was twelve years old in her self-portrait of 1691.

This parallel world affected women's self-portraits. As a minority member of the profession, a recipient of impoverished training and unhelpful attitudes, aware that her image would be scrutinized in a way self-portraits by male artists were not, a woman artist had to think hard about her presentation of herself. Producing a self-portrait meant reconciling the conflict between what society expected of women and what it expected of artists. The problem for women – and also the challenge – was that the two sets of expectations were diametrically opposed. The answer was a creative defensiveness. It is only by understanding the women's desire to out-manoeuvre the critics by anticipating their responses that one can begin to make sense of why their self-portraits look as they do. They wanted to show they were as good as painters past and present, but dared not risk looking boastful. They wanted to show themselves at work but they could not look peculiar – no dirty workclothes or untidiness, no overly dramatic self-presentation – because they could not risk comment on their appearance or their morality.

These constraints meant that many of the most striking male self-portrait types were of little use to women. Meléndez's self-portrait with male nude study could not be borrowed by a woman of the time, who would never have worked from the male nude, or, if she had, would never have advertised the fact. The dramatic presentation of the cloaked Salvator Rosa as Silence could not be used by a woman, not because it was beyond her imagination but because she knew that a self-portrait as Silence would have exposed her to derision in the seventeenth century. The link of women with gossip is as old as language – indeed, Rosa painted his mistress for the companion portrait representing Speech.

Women artists could not afford to ignore the rules of acceptable female gestures and dress. The depiction of women in portraits is governed by convention and codified in art theory, and is never a simple matter. Throughout the centuries, artistic rules have dictated that women could not show their teeth, could not show their hair unbound, could not gesticulate and certainly could not cross their legs, as Gainsborough learned from the shocked reception of his portrait of Mrs Philip Thicknesse in 1760: 'handsome and bold; but I should be very sorry to have anyone I loved set forth in such a manner.'[18] In order to avoid ridicule women had to take these conventions into consideration.

ANNA WASER, *Self-Portrait Aged Twelve*, 1691 (opposite). A child prodigy, Waser was encouraged to paint this self-portrait by her teacher, Johannes Sulzer. The portrait on her easel is of him. Several other woman artists produced the self-portrait as a young girl, including Sofonisba Anguissola in the sixteenth century and Angelica Kauffman in the eighteenth century.

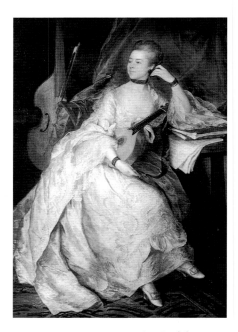

THOMAS GAINSBOROUGH, *Ann Ford, later Mrs Philip Thicknesse*, 1760 (above). Propriety in pose and gesture was the rule in ladies' portraits. The crossed legs in this portrait made a break with convention that did not go unnoticed.

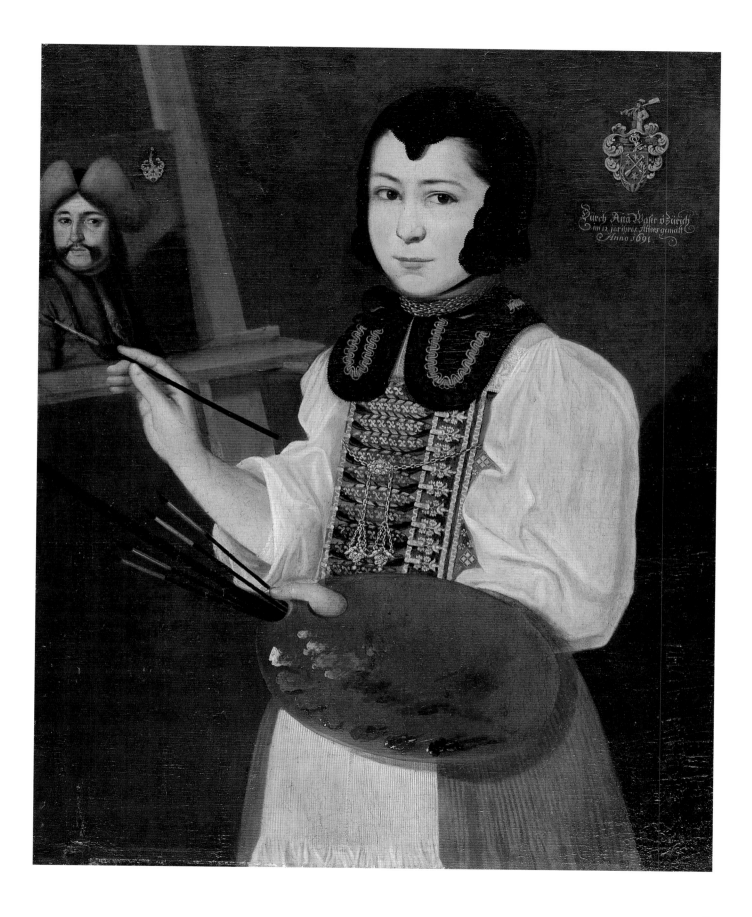

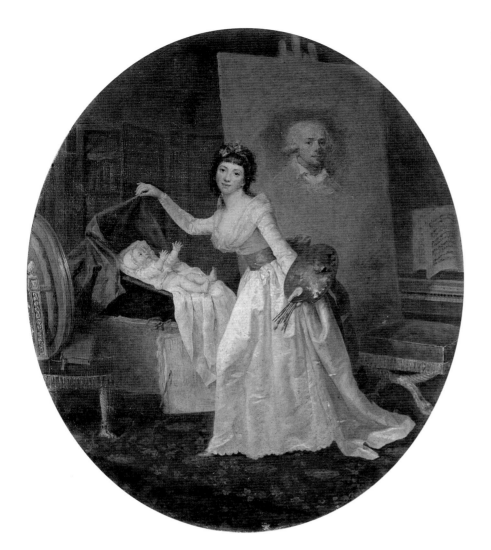

Women artists tend to stress their comeliness in their self-portraits and several of them look impossibly young for their age. In part this is a simple case of looking one's best for one's public, but there is more to it than that. While no one ever says specifically that a woman's portrait must make her look prettier and younger than she is, those are the sentiments that lie close to the surface of advice to artists. Vigée-Lebrun wrote that, 'You must flatter them, say they are beautiful, that they have fresh complexions, etc. This puts them in a good humour and they will hold their position more willingly. The reverse will result in a visible difference.... You must also tell them that they are marvellous at posing; they will then try harder to hold their pose. Tell them not to bring their friends to the sitting, for they all want to give advice and will spoil everything, although you may consult artists and people of taste.' Painting men was simpler: 'When painting a man's portrait, especially that of a young man, he should stand up for a moment before you begin so that you can sketch the general outline of the body. If you were to sketch him sitting down, the body would not appear as elegant and the head would appear too close to the shoulders. This is particularly necessary for men since we are more

used to seeing them standing than seated.' A whole culture is contained in those last ten words.[19]

Like the Elizabethan lyricists who transcended the constraints of metre, line and rhyme-scheme to produce exciting poetry, women artists rose above the constraints of the parallel world to produce some original self-portraits which reveal their reality as women artists in a male art world. They show the women taking pains to meet society's criteria for womanliness, while presenting their professionalism in a credible manner. Their training, support system, claim to a place in the artistic tradition, musical talent, motherhood, charm and good looks were themes they returned to again and again. In the twentieth century, these subjects have been treated with a new outspokenness, and some new themes have emerged – pain, sexuality, race, gender, disease.

Over the centuries, influenced by their role as women and their position in the art world, women have come back to the same themes in their self-portraits. Marie-Nicole Dumont's *The Artist at Her Occupations*, poised between her baby and her brushes, was painted in France in 1789, two centuries before Gillian Melling's *Me and My Baby* painted in England in 1992. These are not themes that should be categorized as 'feminine' or 'womanly', but rather themes that relate to women's experiences as they juggle the plate marked Artist and the plate marked Woman, trying to keep them both spinning in the air at the same time.

In considering how to present themselves, women extended and inflected the range of self-portraiture. For this reason, female self-portraiture deserves to be treated as a genre in its own right.

GILLIAN MELLING, *Me and My Baby*, 1992. The artist as mother-to-be, twentieth-century style. Melling shares Dumont's pride in work and in motherhood, but the necessity to conform to society's feminine stereotypes is less compelling. Or perhaps the stereotypes have changed.

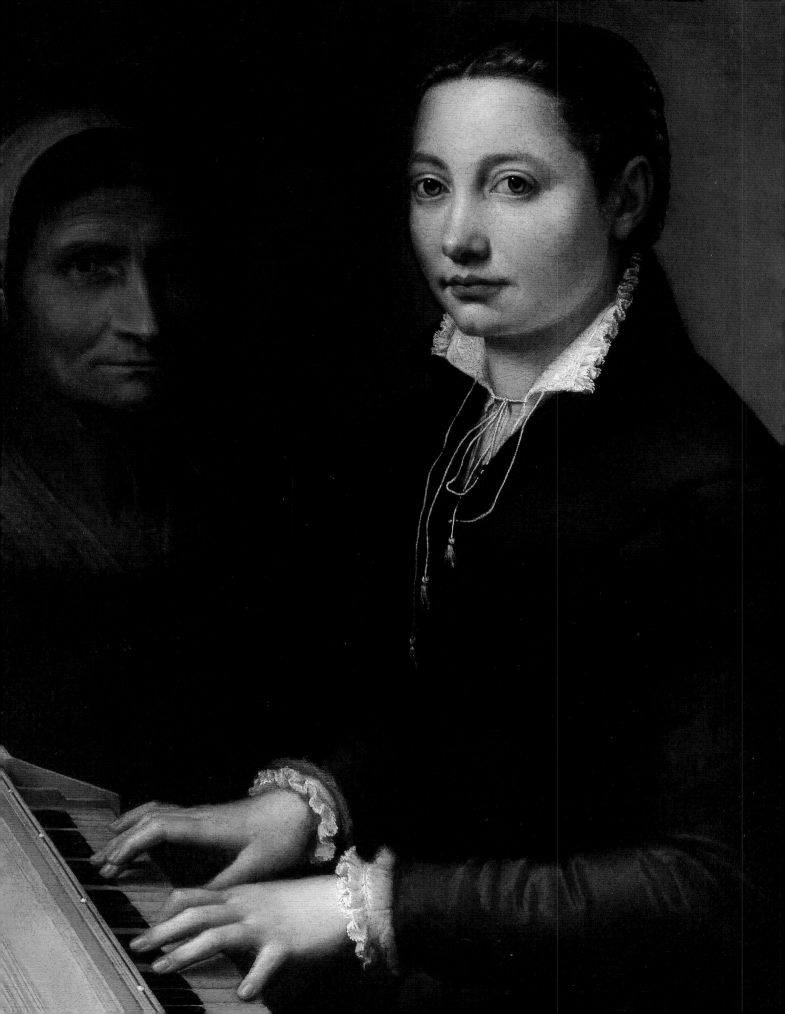

SOFONISBA ANGUISSOLA, *Self-Portrait at the Clavichord*, 1561. The self-portrait displaying musical talent, of which this is an early example, was a type which women artists made their own. Its origins lie in sixteenth-century ideas of necessary accomplishments for gentlewomen. The inclusion of an older woman adds a note of propriety as well as underlining the talented artist's youthfulness.

THE SIXTEENTH CENTURY IN THE BEGINNING

The convents of medieval Europe supplied protection and support to women of intelligence and talent at a time when the secular world did not consider them worth training or educating above a basic level. Inside their walls, women with artistic abilities copied, wrote and illustrated manuscripts.[1] Among their pages can be found the earliest self-portraits by women. We have already met Claricia. Diemudis sits inside the initial S in a manuscript which probably dates from the twelfth century and Guda encases herself in the letter D. Maria Ormani paints her own portrait into her *Breviarium cum Calendario* of 1453, describing herself as 'handmaid of God, daughter of Orman and writer of the book.'

It is not until the sixteenth century, however, that the names of women artists, accompanied by biographical information and a body of work, crop up with any frequency. These women were the pioneers of female self-portraiture, the first to work out ways of depicting themselves that would show their pride in their talent while retaining the modest demeanour advocated as truly womanly by preacher, teacher and conduct manual.

DIEMUDIS, initial S with self-portrait, from a twelfth-century manuscript.

Their problem was that they were starting with a blank canvas. There were no prototypes for an image of a woman painting, drawing or sculpting. Male artists had a patron saint, St Luke (the reason for the number of art institutions and academies bearing that name). From the late medieval period when his tale was popularized by inclusion in *The Golden Legend* by Jacopo de Voragine, St Luke painting the Virgin was a popular subject, particularly in northern art. More often than recorded, one suspects, St Luke was the painter's self-portrait: his features are often so plain they could only be the product of self-scrutiny. In the sixteenth century this image of the painter was joined by another, that of the classical artist Apelles painting the portrait of the mistress of Alexander the Great. Apelles made his appearance when painting was attempting to forget its humble craft origins, an intellectual change which brought with it the first image of a woman holding a brush, La Pittura, the personification of painting. However, the allegorical image of Painting was always young, pretty, frequently bare-breasted and only occasionally at work at an easel. While male artists could depict St Luke in any way they wished, even as themselves, not surprisingly the idealized semi-nude female image of Painting held no appeal for sixteenth-century women artists.

Contemporary depictions of women in portraits were helpful because the pressure to paint oneself as a gentlewoman fitted conveniently into the drive to upgrade the artist's status. Since most portraits were of women of means and birth, they helped the painter project an image of breeding, distancing herself from the touch of the lowly crafts as so many post-Renaissance artists were doing. In 1498 Dürer painted himself stylishly dressed in black and white stripes with a matching hat; in the early 1550s Titian showed himself as a man of means, elegant and austere. Neither picture contains a single reference to the way the artist earned his living. Even when paintings did speak of their master's trade, or liberal art, as it became as the sixteenth century progressed, working clothes were replaced

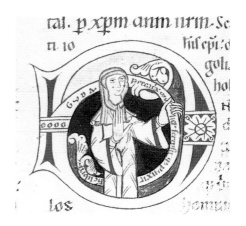

GUDA, initial D with self-portrait from a twelfth-century manuscript. The self-portrait within an initial letter clearly pleased female illuminators, perhaps because it enabled them to record themselves wittily but modestly. The banner she grasps proclaims in Latin: 'GUDA, woman and sinner, wrote and painted this book'.

MARIA ORMANI, self-portrait in *Breviarium cum Calendario*, 1453. Her self-image of piety and pride is framed by scroll naming her as the 'handmaid of God' and scribe.

by finery and elaborate visual programmes introduced to show that learning was necessary to the reproduction of an image. Antonis Mor in 1558 shows himself gorgeously clad before an easel blank but for a poem which describes him as excelling the classical painters Zeuxis and Apelles.

Female sitters in sixteenth-century portraits are always presented in a dignified manner. Dress is always modest, though it could also be luxurious and elaborate. Whether seated or standing, their poses approach the regal: hands do not wave, bodies do not twist, mouths do not smile, elbows rarely stray far from the body. This code of representation was closely followed by the artists. A survey of sixteenth-century self-portraits reveals a group of serious women painters who manage to combine dignity, pride and modesty. Even when they depict themselves at the keyboard or in the act of painting, elbows are tucked in, expressions are solemn, decorum is observed.

MAERTEN VAN HEEMSKERCK, *St Luke Painting the Virgin and Child*, 1532. It is thought that representations of St Luke, the patron saint of artists, were frequently self-portraits of the painters.

Nobody smiles in self-portraits, just as no one smiles in conventional portraits. The exception is a chalk sketch done by Sofonisba Anguissola in 1545 when she was about thirteen (overleaf). She grins out of the drawing and points to her elderly companion who looks down through her glasses at the book she is holding. Her gesture is surprisingly free given the conventions of female portraiture, and suggests her youthful high spirits. Her solemn expression in a chalk sketch done three years later shows she has learned the lesson of dignity, although she still cannot hide her pride in her talent, pointing to herself and eyeing us to make sure we have understood she is the author of the work.

While all women artists wanted to look as gracious as the ladies in portraits, the passivity and limited range of activities they displayed was of little use in inventing ways to show off a painter's professional skills. When an activity is shown, it is with decorum. The sitter holds a small book or lays a calming hand on a small dog which nestles in her voluminous skirt. Frequently she clasps her hands in a pose which resonates with prayer, constriction and passivity. Accessories were limited to a book, flower, child, animal, fan or piece of embroidery. Since lady and career were contradictory concepts, women in portraits were expected to look neither active nor skilled, so there was no help for the artist there.

Although it might seem the most obvious format of all, self-portraits showing artists at work at the easel are rare at this date, and it has been suggested that the very first self-portrait of this type came from the hand of a woman.[2] In 1548, a solemn Catharina van Hemessen looks out at the spectator or the mirror, caught in the act of appraisal – of us or herself? While her modest dress leaves us in no doubt of her propriety, everything about this painting is designed to show that, although a lady, she is certainly no amateur. She was trained as an artist by her father, and this image radiates professionalism. Her right hand adds a touch to the painting on the easel; the mahlstick helps her to steady her painting hand; her palette is gripped by her left thumb, with more brushes held ready in her

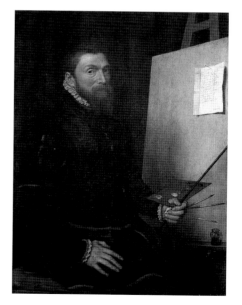

ANTONIS MOR, *Self-Portrait*, 1558. The poem pinned to the easel equates Mor with the renowned artists of classical antiquity, Zeuxis and Apelles.

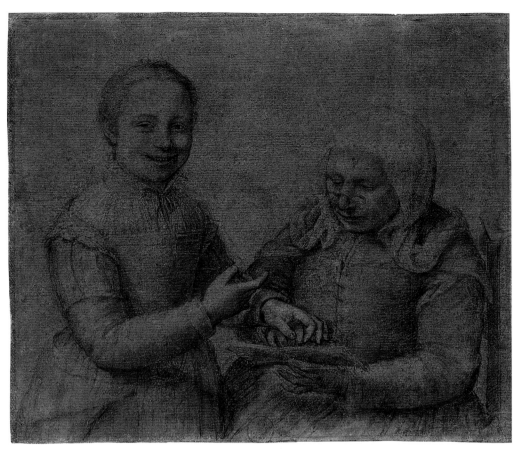

SOFONISBA ANGUISSOLA, *Self-Portrait with Old Woman*, *c.* 1545 (above). Portraits of ladies followed strict conventions: elbows were tucked in, bodies did not twist, mouths did not smile. The artist was about thirteen at the time, which is probably why she presents this unusual smiling self-image.

SOFONISBA ANGUISSOLA, *Self-Portrait Aged Sixteen*, 1548 (right). Three years later, the artist has learned to present a face of conventional seriousness to the world.

CATHARINA VAN HEMESSEN, *Self-Portrait*, 1548 (opposite). This has been claimed as the first self-portrait showing an artist of either sex at work at the easel.

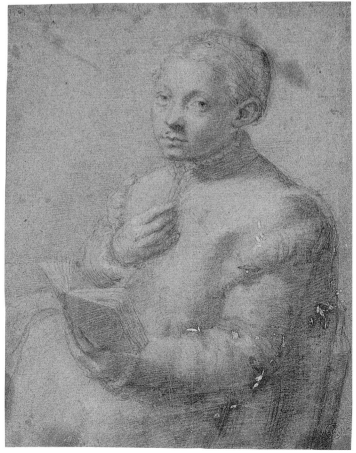

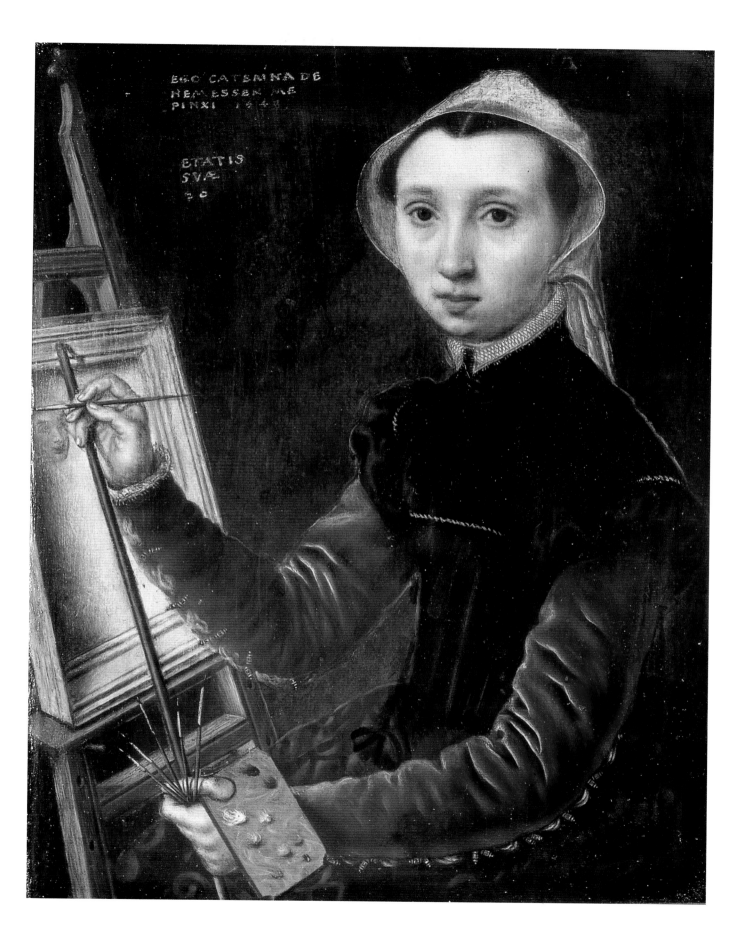

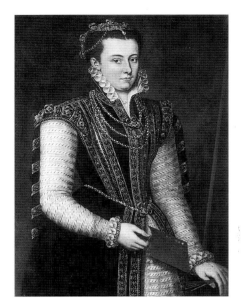

LAVINIA FONTANA, *Self-Portrait with Palette and Brushes*, 1579. A compromise presentation of the artist as a lady as well as a painter. Sixteenth-century women had to work out ways of presenting themselves in their self-portraits that showed them as ladies as well as professionals.

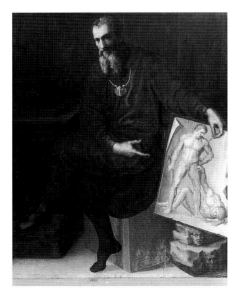

BACCIO BANDINELLI, *Self-Portrait*, c. 1550. Male artists displayed their ability to draw from the nude model. A woman artist (see Fontana, p. 22) could only draw from casts and sculptures.

fist. Through her brush she tells us she is a working artist; through her modest demeanour and neatly tucked-in elbows she tells us she is a respectable woman. If it is true that this is the first self-portrait of an artist at work, it could be because she came from the northern tradition which specialized in depictions of St Luke painting the Virgin, and she had the wit to adapt this example of a working artist for herself.

In 1579, Lavinia Fontana painted a cross a between a self-portrait as a lady and a self-portrait as a working artist. It seems unlikely that the brushes she clasps in one hand and the palette she holds in the other will ever be put to use while she stands bejewelled and and richly clad in so formal a pose. This disjunction between hieratic pose and clothes and the tools of her trade offers an insight into the problems of uniting female status and professionalism in one image (though there is a theory that the palette and brushes were added later).[3]

She seems far more at ease in the circular image of herself at work, only sixteen centimetres (six inches) in diameter, in which she surrounds herself with casts and bronzes (p. 22). It was painted in response to a request from Alonso Chacon, who already owned three portraits by her and wanted a small self-portrait that he could reproduce for a series of prints.[4] She sent it on 3 May 1579 with a letter modestly stating her feelings of inadequacy at appearing next to works by artists such as Anguissola. It is an ambitious work and a virtuoso performance. Despite the miniature format, she has managed to include as much detail as would normally be found in a much larger painting.

What makes this image so bold is her claim to be the equal of an educated male artist. Ambitious male students and artists familiarized themselves with casts of classical statues in order to attune their eye to what was thought to be the finest art on offer. Since the greatest subjects in art were expressed through the human figure, the highest praise was heaped on those who could draw and paint the figure most successfully. Showing herself with classical casts was a clever way to present her erudition and knowledge of figure drawing, thereby making claims for the seriousness of her art, associating herself with the artistic values of her time and proving that her artistic education was equal to that of any man. This is the first example of a manifesto self-portrait from a woman's hand. It should be considered as a female counterpart of Baccio Bandinelli's self-portrait with a drawing of a two nude figures, one of which resembles the Hercules figure of his sculpture of Hercules and Cacus which had been installed in the piazza in Florence in 1534.

Evidence of training tends to sidle into women's self-portraits. It is there in Lavinia Fontana's painting of herself surrounded by casts and it is present in an innovative self-portrait in which the twenty-year-old Sofonisba Anguissola paints herself as a portrait on the easel by her teacher Bernardino Campi. When she was fourteen, she and her sister Elena were sent to stay in the Campi household where, with Campi's wife as chaperone, they learnt the principles of painting. Anguissola painted this double portrait in 1550 about a year after she had left the Campis' home to study with Bernadino Gatti, and the evidence of ambition it displays was fulfilled by her long and successful career.

She has found a way of presenting herself that is witty and unthreatening, gracefully bowing to her teacher's superior talent by allowing herself to be shown as the product of his hand. She defuses the conflict inherent in the unnaturalness of being a female artist in the sixteenth century by making herself as pretty as a picture – the object of the gaze and not the maker of the object.

This painting is an early example of the recurring arguments over the attribution of self-portraits. Her biographer points to the remains of a signature to prove that Anguissola is the author of the image; another scholar suggests that it is by Bernardino Campi, exploiting his fame as Anguissola's teacher. [5]

In the fifteenth century, art began its climb from a mechanical to a liberal art. Being a liberal art meant that it was a product not of mere skill but of thought, of intellect and even, according to Leonardo da Vinci, of divine inspiration. Arguments were needed to prove this point and where better to look than the classical world? Greek and Roman history and mythology supplied the pedigree for art in the Renaissance. Apelles and Zeuxis were paraded as great painters of antiquity and their stories – Alexander the Great gave his mistress to Apelles – were read as illustrations of their exalted social position.

SOFONISBA ANGUISSOLA, *Bernardino Campi Painting Sofonisba Anguissola, c. 1550.* In an original move, the artist shows herself as a portrait on her teacher's canvas.

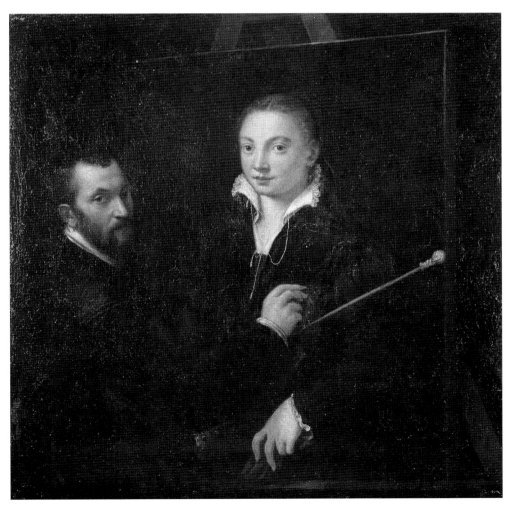

Women artists, too, had classical ancestors. Their earliest Italian appearance is in Boccaccio's *Concerning Famous Women* which includes three grudging entries on women painters in its one hundred and twenty-four biographies. Thamyris barely runs to a few fact-free lines. Irene earns the comment that, 'I thought that these achievements were worthy of some praise, for art is very much alien to the mind of women, and these things cannot be accomplished without a great deal of talent, which in women is usually very scarce'.[6] Marcia of self-portrait fame fares better. Boccaccio expands Pliny's statement that she chiefly painted portraits of women: 'I think that her chaste modesty was the cause of this, for in antiquity figures were for the greater part represented nude or half nude, and it seemed to her necessary either to make the men imperfect, or, by making them perfect,

SOFONISBA ANGUISSOLA, *Self-Portrait Painting the Virgin and Child*, 1556. She includes a religious subject on the easel to display the breadth of her artistic abilities.

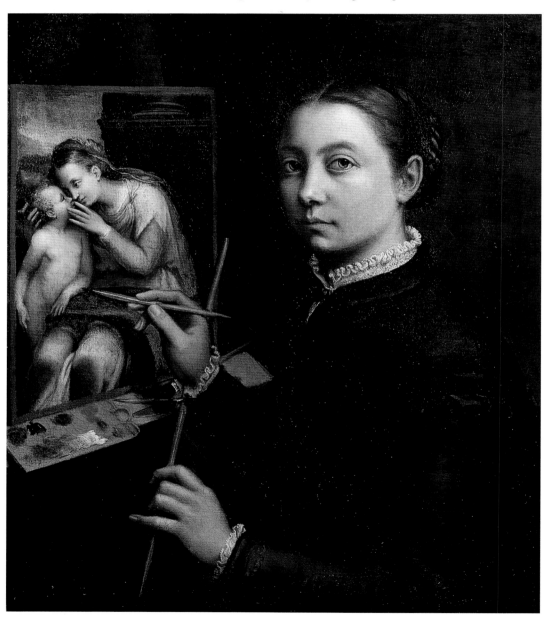

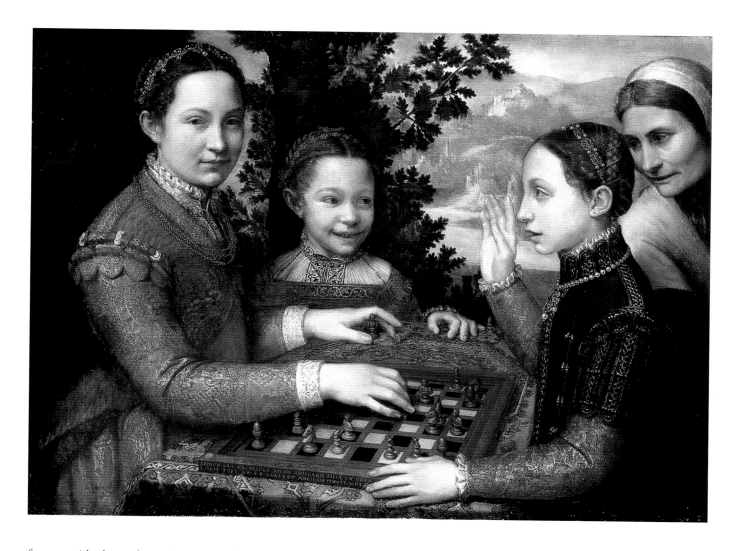

forget maidenly modesty. To avoid both these things, it seemed better to her to abstain from both.' [7]

Concerning Famous Women went into several printed editions in the first half of the sixteenth century, and Marcia is mentioned in the first treatise on art of the Italian Renaissance, Alberti's *Della Pittura*, 1435–36: 'It was also an honour among women to know how to paint. Marcia, daughter of Varro, is praised by the writers because she knew how to paint.'[8] Despite this, the women artists of antiquity failed to grip the sixteenth-century imagination in the same way as the names and stories of the classical male artists. Even obvious opportunities were missed. Vasari's chapter on the female sculptor Properzia de' Rossi lists women of the past who won fame in war, poetry, philosophy, oratory, grammar, prediction, agriculture, science, but not sculpture, a surprising omission given Pliny's explanation that sculpture originated with a woman outlining the shadow of her departing lover on a wall.

It is therefore no surprise to find the following inscription in one of Anguissola's self-portraits showing her painting the Virgin and Child (Zeri Collection,

SOFONISBA ANGUISSOLA, *The Chess Game*, 1555. It was a convention of female self-portraits of the sixteenth century to include an older woman, perhaps as chaperone and foil to youth and beauty. Behind the three girls (thought to be Sofonisba's sisters) appears an older woman – a servant or maybe their mother – who bears a strong resemblance to the shadowy face in Anguissola's 1561 *Self-Portrait at the Clavichord*.

Mentana): 'I, the maiden Sofonisba, equalled the Muses and Apelles in performing my songs and handling my colours.'[9] As an educated woman, Sofonisba Anguissola would have been familiar with the names of classical women artists, but she clearly felt there was more advantage in allying herself to Apelles than to some lesser known female painter.

The Virgin and Child self-portrait (a version is shown on p. 44) is also interesting in revealing the painter's desire to show off her versatility. Since the education offered to women was rarely as thorough as the training for men, most women felt best equipped to concentrate on portraiture. This was an acceptable field for women since it did not involve a knowledge of anatomy; it was one step up from copying (something women were thought to do well – not a compliment when the superior alternative, the painting of imaginative subjects, is considered); and it did not involve complex figure compositions. However, several women artists produced religious paintings ranging from small panels to large altarpieces, and it is fascinating to find one of them making a public statement about her skill.

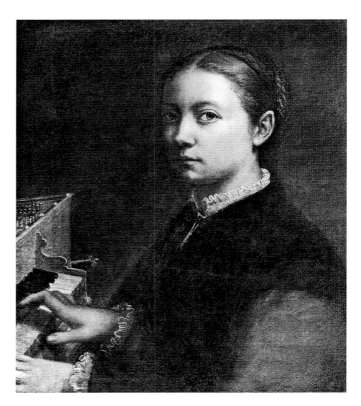

SOFONISBA ANGUISSOLA, *Self-Portrait at the Clavichord*, c. 1555–56. The earliest female self-portrait displaying musical talent. Women artists' use of the self-portrait theme of the two talents continued into the twentieth century.

YOUTH AND AGE, ART AND MUSIC

The depiction of the painter in the company of an old woman is a female self-portrait invention and one that seems specific to the sixteenth century. It is first seen in Sofonisba Anguissola's chalk sketch of herself as a girl in 1545 (p. 40), and she returned to the motif in 1561 (p. 36) when she painted herself at the keyboard.

Affection for a family retainer, or perhaps a mother, does not fully explain the inclusion of an elderly woman in a self-portrait: men saw no need for this device. Given the allegorizing habit of the sixteenth century, it is possible that the thirteen-year-old artist was making a comparison between youth and age, a familiar theme of the period, and contemporary ideas about youth versus age and youth becoming age are also echoed in the 1561 painting. In this later self-portrait the soberly dressed woman has a secondary role in setting off the artist's elegance and accomplishment, highlighting the refinement and style of the multi-talented young artist, and also acting as a kind of chaperone. The face is similar to that of the woman in Anguissola's *The Chess Game* of 1555, a group portrait of her sisters with an older woman.

The 1561 painting is an early example of another type of self-portrait which women made their own: the self-portrait displaying musical talent. Anguissola had invented this theme six years earlier in 1555, the year after her arrival in Spain to work in the service of Queen Isabella. Though she had been invited as Isabella's court painter, the nobly born Anguissola occupied a hybrid position as artist and

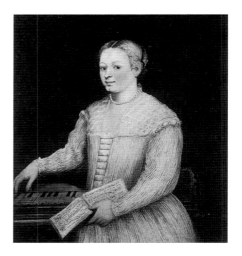

Attributed to MARIETTA ROBUSTI known as La Tintoretta, *Self-Portrait*, c. 1580. Tintoretto's daughter, a painter trained by her father, here chooses to present herself as a musician.

lady-in-waiting. She enjoyed a close relationship with the young French-born queen – it is likely that Anguissola's invitation to the Spanish court was due as much to her impeccable social status as to her talent – for, besides painting royal portraits, her duties included choosing fabrics for the gowns that she helped design for the queen and teaching the queen to paint. She may have reworked the clavichord theme of the 1555 self-portrait as a tribute to the enjoyment she and the queen felt in playing this instrument,[9] or perhaps because it was one of the accomplishments listed by Baldassare Castiglione as necessary for the gentlewoman in his influential book of 1528 *The Courtier*.

It is a tribute to the originality of the 1561 self-portrait that it influenced Lavinia Fontana's depiction of herself thirty years later when she was in her mid-twenties, the first example of one woman's self-portrait influencing another (overleaf). It, too, shows an older woman and uses a similar pose, although Fontana has turned her body towards the spectator in a more exaggerated manner than her predecessor. Unlike the older artist, she found a way to stress both her accomplishments: her easel is located in the deep space to her right, which also serves to display her ability in handling perspective.

Fontana was twenty years younger than Anguissola, and, like her, a northern Italian artist. Her admiration for the greatest woman artist of her time, then in her fifties and still painting, is pleasing because so many women artists of the past have hesitated to associate themselves with other female artists.

A variation on the music theme is offered by a self-portrait in the Uffizi attributed to Marietta Robusti, Tintoretto's daughter, from the time that it entered the collection in the seventeenth century. A painting of a well-dressed and bejewelled young woman ascribed to Robusti in Goldscheider's *Five Hundred Self-Portraits*, and widely reproduced, has since been reattributed to Tintoretto.[10]

This urge to match self-portraits to painters is often unsatisfactory. Although a number of women painted miniatures in this period, not one self-portrait of a miniaturist exists. A severe likeness of a woman with pointed nose and piercing eyes, which used to be labelled a self-portrait by Levina Teerlinc from her years as a miniaturist at the court of Henry VIII, is now thought to be by Isaac Oliver.[11] Perhaps her empty frame could be filled by the tiny self-portraits drawn by the calligrapher Esther Inglis at the beginning of two of her manuscripts, differing styles of headgear marking the twenty-five years between the two. In the dedication to Prince Charles (the future King Charles I) in the later manuscript of 1624, Esther Inglis writes 'to offer to your Highness this two years labours of the small cunning, that my totering right hand [which she represented as a drawing of a hand instead of a word], now being in the age of fiftie three yeeres, might afford.' The dedication is an example of the kind of arguments necessary to justify a woman's emergence from her customary role: 'Yet what beauteous floure: what medicinable herbe, may not be found in the womans garden: was not Sara and Rebecca meek; Deborah and Judith couragious: was not Naomi patient: Hanna humble: Abigail wife: Elizabeth zealous: Susanna chast.'[12] It was a philosophy of the separate but equal.

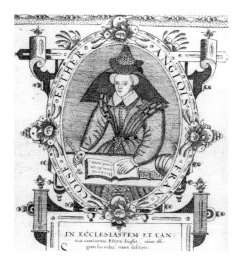

ESTHER INGLIS, *Self-Portrait*, late sixteenth century. Famous for her fine calligraphy, the artist inks an image of herself at the beginning of her manuscript.

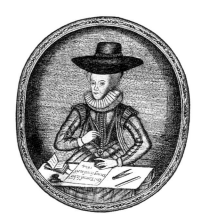

ESTHER INGLIS, *Self-Portrait*, 1624. Twenty-five years later, Inglis continues to present the reader of her manuscript with the seventeenth-century version of the dust-jacket photograph.

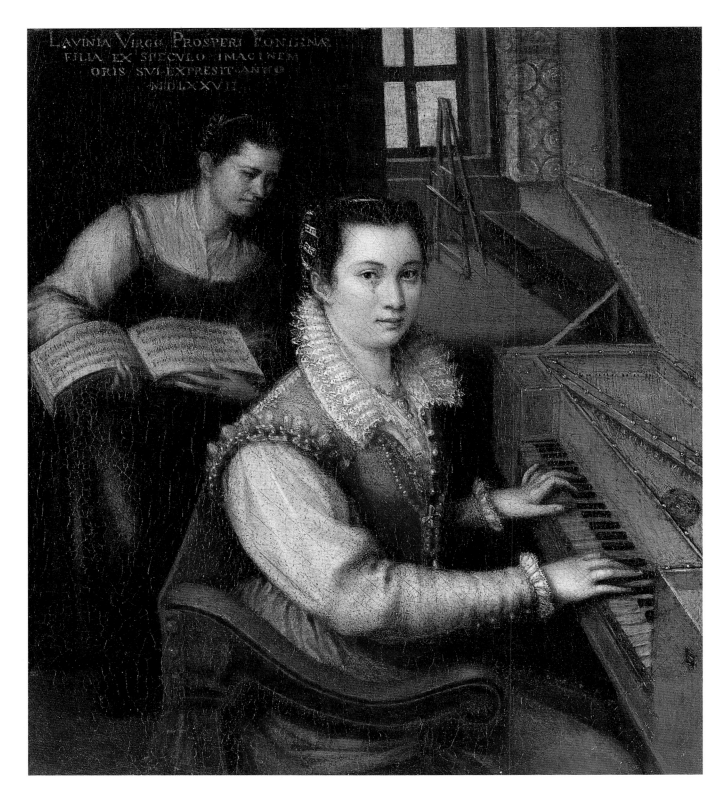

LAVINIA FONTANA, *Self-Portrait at the Clavichord with a Servant*, 1577. Fontana must have known of Sofonisba Anguissola's 1561 *Self-Portrait at the Clavichord*.

THE SIXTEENTH CENTURY

It was common practice for portrait painters to give their sitter's identity on a page in a book or piece of paper which is sometimes held in the sitter's hand, sometimes fixed to the furniture, sometimes attached miraculously to the background. Sofonisba Anguissola took this device from portraiture and used it at least three times when she painted her own portraits, yet another of her innovations in self-portraiture.[13] In a painting of 1552 (Uffizi), six years before the Mor self-portrait, she holds brushes in her left hand and a sheet of paper in her right. Though the words on the paper have faded, 'Sofonisba Anguissola, Cremona, painted this at 20' is inscribed into the background. It clearly pleased her to label herself, for she did it again two years later with a bust-length portrait (p. 9) in which the tiny book she holds is open at the page that says, 'Sofonisba Anguissola the unmarried maiden painted this herself 1554'. The format of this painting is close to a self-portrait by her sister Lucia painted about this time. Years later she returned to words, holding a piece of paper up to face us which reads 'To his Catholic Majesty, I kiss your hand, Anguissola.' The pose is dignified and the self-scrutiny unflinching as she depicts her long nose with its slightly bulbous tip and the lack of teeth which stitches her lips together in a horizontal line (p. 25).

Sofonisba Anguissola has left the earliest female self-portraits in old age. In the 1610 portrait (p. 25), approaching eighty, she is still upright, proud and strong. Ten years later she showed herself as a frail old woman, with the flesh fallen from her face and the slight stoop that had finally bent her body (Nivaagaards Art Museum, Niva). This same ancient face was sketched four years later in 1624 by Van Dyck when he recorded his visit to her in a letter to a friend.[14] He reported that her greatest sorrow was that failing sight had stopped her painting.

There is an intriguing absence of self-portraits at this time showing the artist with her husband. A husband's support was necessary if a sixteenth-century woman artist was to work – for example, no respectable woman could travel alone.[15] In 1556, Queen Mary of Hungary, Regent of the Netherlands, took the painter Catharina van Hemessen and her organist husband to the court of her nephew, Philip II of Spain. One might have expected a double portrait from Hemessen's hand, particularly as she came from the northern tradition which had already produced several self-portraits of artists with their wives, but if there was one it has been lost. The only contender, *Portrait of Husband and Wife*, may show Sofonisba Anguissola with Don Fabrizio de Moncada, the Sicilian husband whom Philip II of Spain found for her, but doubt hangs over the painter and the subject. I only signal it to show how much research remains to be done in this area.

The serene surfaces of sixteenth-century self-portraits hide the thought that must have gone into meeting contemporary standards of female decorum while also announcing the artists' professional skill. In the process, the women produced what has been suggested are several self-portrait firsts (at an easel, holding a paper and at a musical instrument); a self-portrait type which seems to be solely the possession of women (with an older companion); and an adaptation of a male self-portrait type (the self-portrait with small casts). These achievements should alert us never to take women artists' self-portraits at face value.

LUCIA ANGUISSOLA, *Self-Portrait*, c. 1557. The sixteenth-century historian Vasari reported the Anguissola sisters' artistic talent in his *Lives of the Artists*. Here Lucia borrows her sister Sofonisba's book device to display her authorship of this image.

ANONYMOUS, *Portrait of Husband and Wife*, c. 1570–71. This was long thought to be Sofonisba Anguissola's self-portrait with her first husband, Don Fabrizio de Moncada.

MARY BEALE, *Self-Portrait* (detail), *c.* 1675–80.
The foremost woman professional painter in
seventeenth-century England, shows herself as
a lady of fashion, continuing a sixteenth-century
convention. Painted on sacking (cheaper than
canvas), this may be one of the self-portraits that
her husband recorded her doing for 'study and
improvement'. The complete painting is
shown overleaf.

THE SEVENTEENTH CENTURY THE NEW SELF-CONFIDENCE

Female self-portraiture gets into its stride in the seventeenth century, a
reflection of the growing number of women all over Europe working as
professional painters. Several sixteenth-century formats become accepted as
conventions. At the end of the 1670s the English artist Mary Beale paints herself
as a gentlewoman, informing the spectator of her appearance but giving no clues
as to her profession. Painted when she was in her forties, the self-portrait shows
her as a toned-down version of the ladies portrayed by Sir Peter Lely, the painter
to King Charles II and the leading portraitist of the day. Every lady painted by Lely
is shown as a fine figure of a woman (one suspects that if nature had not helped
her, Lely did), graceful and comfortable in her femaleness, and this is exactly the
impression, minus the déshabille and large eyes, that Beale gives in this work.

Since self-portraits use a language all their own, Mary Beale's portrait is
not merely a depiction of herself as a lady, but also illustrates her current artistic
concerns. This is one of several self-portraits done 'for study and improvement'
when she was branching out into allegorical and mythical subjects. The burning

ANNA MARIA SCHURMAN, *Self-Portrait*, 1633.
Dutch scholar, poet and mystic, she was also
an acclaimed amateur painter and engraver.

incense and funerary urn might be meant to suggest a meditation on death, or she may just be trying out a future female portrait pattern.[1]

The working-artist format is adopted by the Italian Elisabetta Sirani who stands sedately painting at her easel (p. 54), and the theme of the two talents resurfaces in a self-portrait by the French painter and poet Sophie Chéron who holds a sheet of music to tell us that painting was merely one of her many skills.[2] Chéron clearly wished to be known as multi-talented: in the self-portrait she painted on her reception into the French Academy in 1672, the fourth of only fifteen women to be so honoured between 1648 and 1789, she holds a scroll in allusion to her fame as a poet.

At the same time that women's self-portraiture is consolidating its patterns, a new trend emerges. There is a robustness about several seventeenth-century self-portraits which has not been seen before in women's painting. The artists situate themselves confidently within their frames, shoulders back, arms not quite so close to the body. It is tempting to read the frame as a metaphor for their lives and to conclude that the artists are equally at ease in either. Stylistic changes play a huge part in expanding the way women artists feel they can paint themselves. The bravura approach of the Baroque with its dash and diagonals frees the artists' imaginations. When the Dutch artist Judith Leyster paints herself in 1633 with her elbow raised and resting on the back of her chair (p. 55), in a pose that is reminiscent of Frans Hals's 1626 portrait of Abrahamsz Massa (p. 54), the result transcends the borrowing to become the first self-portrait by a woman to brim with down-to-earth self-assurance. On the Massa portrait it has been commented: 'It seems that Hals never portrayed a professor, a preacher or a woman in the informal pose he gave Massa but not enough is known about his sitters to make a firm correlation between this attitude and the profession, personality or sex of his patrons.'[3] Though the precise nature of Leyster's link with Hals is unknown, she was possibly taught by him, and in the 1630s she sued him for poaching one of her pupils.

The self-confidence which sings out of this painting is supported by her early career. While she was still in her twenties and before she was married, she had established her own studio and joined the Haarlem Painters' Guild – this self-portrait may have been her presentation piece on her

MARY BEALE, *Self-Portrait*, c. 1675–80. There is no evidence of tragedy at this period of her life, suggesting that the inclusion of the funerary urn and burning incense in this work was an experiment with new portrait formats.

SOPHIE CHÉRON, *Self-Portrait Holding a Sheet of Music*, late seventeenth century. The theme of the artist as musician continued to appear in women's self-portraiture.

admission. Though little is known of her career after she married the artist
Jan Miense Molenaer, on the evidence of this self-portrait it is hard to believe
that she shut up shop after marriage and motherhood. Its feeling of immediacy
is remarkable. The intervening centuries vanish as Leyster leans back in her chair
and turns to us, her lips slightly parted as if to speak. There is nothing of the
primness of so many self-portraits by women who have internalized the restrained
gestures of femininity. The painter who turns to acknowledge the viewer is
comfortable with herself and her profession. Her cap, pancake collar and filmy
cuffs tell us she is no paint-stained craftswoman; the painting in progress on her
canvas and the eighteen or more brushes in her hand attest to her pride in her skill.
It is a pose that expresses the artist's comfort with her place in the world.

It has been argued that this self-portrait possesses an intellectual programme
and should not be taken at face value.[5] Originally the character on her canvas was
female, but the painter changed it to a man in *commedia dell'arte* costume from
her lost work *The Merry Company*, in order, the argument goes, to illustrate
the equality of painting to poetry, regarded in classical times as the superior art.
This debate between poetry and painting had resurfaced during the Renaissance.
Artists claimed that if poetry is a speaking image then painting should be equally
respected as mute poetry. The importance of this reference to classical debate in
Leyster's painting is that it shows a female painter ambitious to ally herself with
the intellectual ideas of her age.

The sixteenth century's interest in classical versions of the origins and
importance of art grew much stronger in the seventeenth. Many ideas about
art were expressed visually through the female figure. Painting was personified
as a female; so was Design; the nine muses, including Erato the muse of art,
were female. Verbal links with these allegorical figures became more common:
it was with the name Erato that Sophie Chéron was received into the
Accademia dei Ricoverati in Padua in 1699.

The first woman artist to see the potential of these classical female figures
for a self-portrait was Artemisia Gentileschi. In the 1630s this young Italian had
the original idea of painting herself as La Pittura, the personification of Painting
(p. 10). Some twenty years earlier, in 1611, Felice Antonio Casoni had made a
medal of Lavinia Fontana – her profile portrait with the veiled hair of a matron
on one side, and on the other wild-haired Painting at work. Gentileschi's genius
was to combine the woman and the allegory, following the recipe for the
personification of Painting from a much-consulted mid-sixteenth-century book
published in Italy, the *Iconologia* by Cesare Ripa: a female with disordered hair
representing the frenzy of creation, with attributes of medallion, brush and palette.
All the symbols of Gentileschi's brilliant painting show her intention: the energetic
and absorbed pose, the palette and brushes, the mask which hangs from the chain
around her neck. In boldly hijacking this figure, the artist created an exclusively
female self-portrait type.

Apart from its display of scholarly knowledge, always important to the
ambitious artist of the seventeenth century, the painting bristles with an energy

FELICE CASONI, *Portrait Medal of Lavinia
Fontana*, 1611, (reverse). The frenzy of creation
is symbolized by Painting's wild hair.

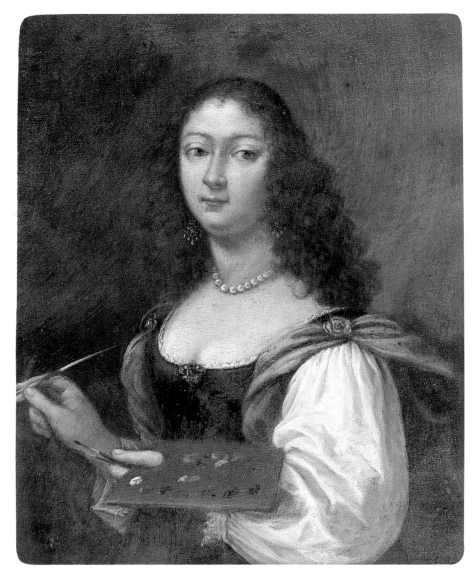

ARTEMISIA GENTILESCHI, *An Allegory of Painting*, c. 1650 (above). This is thought to be a late self-portrait.

ELISABETTA SIRANI, *Self-Portrait*, c. 1660 (left). The pose is similar to the Gentileschi, but the refined image follows convention. During the artist's short life, her work was sought by royalty and her beauty praised.

and drama unusual in female self-portraiture, even in a century which sees the appearance of a new liveliness in self-portraits by women. Its rockily asymmetric composition, so typical of the Baroque, helps create an atmosphere of wild activity; the spotlight falling on the painter's flesh adds drama; her obliviousness to her audience strengthens the impression of intensity. The style may owe much to the influence of Caravaggio, but the subject is unique in that the artist has created a self-portrait pattern which can only be used by a woman.[5]

A similar air of intensity pervades a work known as *An Allegory of Painting,* and thought by some (but not all) to be a late self-portrait by Artemisia Gentileschi.[6] The elements in common with Elisabetta Sirani's self-portrait make clear the novelty of this second Gentileschi self-portrait. Both painters show themselves in the classic self-portrait three-quarter pose. Both are at work, brush in their right hand, palette in their left. Both look out at the spectator as if the spectator

FRANS HALS, *Portrait of Isaac Abrahamsz Massa,* 1626. It is possible that Judith Leyster knew this painting and borrowed the pose, one that Hals reserved for men, for her self-portrait (opposite).

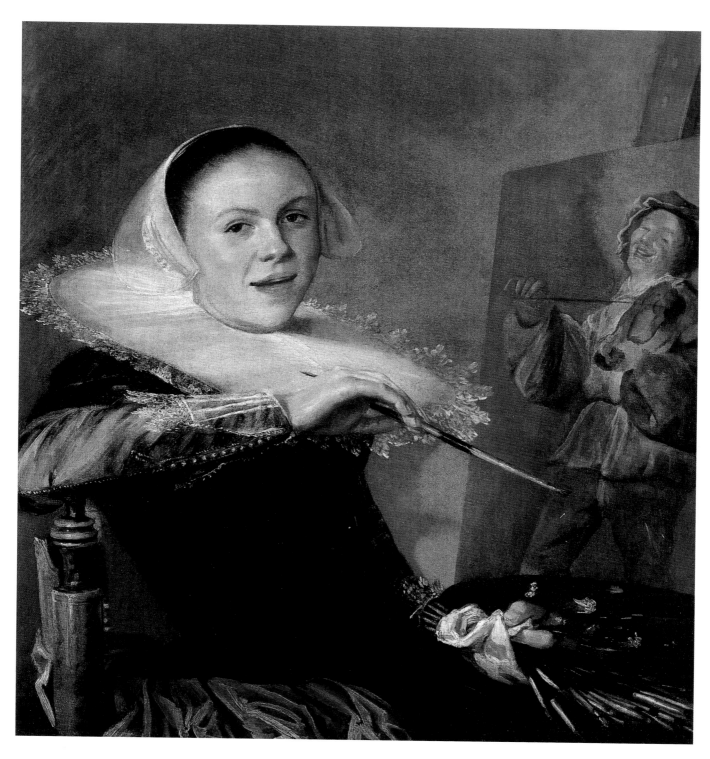

JUDITH LEYSTER, *Self-Portrait*, c. 1633.
This relaxed self-confidence is a seventeenth-
century development in female self-portraiture.
There is nothing of the primness of so many
of the earlier self-portraits by women artists.

is their model. Both wear the shoulder brooch and full sleeves of the age. And yet Sirani breaches no conventions of acceptable femininity while Gentileschi crashes through them all. It is not just that Sirani is the younger and conventionally more attractive of the two. It has far more to do with the pose. Sirani is all composure as she tilts her head with elegance on a swan-like neck, her posture guaranteed to enchant the eye of any dancing master. Remove the brush and palette and she is interchangeable with a hundred female portraits of the time.

Artemisia Gentileschi's image, on the other hand, is clearly not that of a lady. The face is too intent, the posture too hunched and the dress too dishevelled. It is a great achievement to show a woman looking unseductive in an off-the-shoulder dress. This unblinking depiction of an older woman artist is far from Sofonisba Anguissola's dignified characterizations of herself as an enthroned matriarch awaiting the homage due her age. As a young woman working in her father's workshop, Artemisia Gentileschi had been raped by one of his assistant painters. When he denied it, she fought for her good name, undergoing torture by thumbscrew in a seventeenth-century version of the lie detector test. The absence of any artistic equivalent of gauze on the lens suggests this is the work of a woman unafraid of facing facts.

Since the personification of Painting was traditionally shown as a lovely woman with nothing to mar the beautiful blandness, it is certain that this is a portrait. What bothers scholars is whether it is a *self-portrait*. This disagreement highlights the difficulty in telling the difference. While convention identifies the three-quarter pose as a self-portrait, it can as easily be used by a painter doing a portrait of an artist at work, as in Manet's 1870 portrait of Eva Gonzalez (National Gallery, London). Only the existing documentation and signature stop this image finding its way into a book as a self-portrait by Gonzalez. In the absence of documentation or distinguishing information within the portrait – both hard to come by in earlier centuries – doubt can easily arise. Those books and pieces of paper bearing her name in Sofonisba Anguissola's self-portraits might not be visually exciting but at least they serve her purpose of identifying herself for posterity.

More self-portraits than have survived showed women painters in allegorical guise in the seventeenth century. One is known only from a poem. In 1664 the English poet Samuel Woodforde wrote a poem *To Belisa* dedicated to 'the Excellent Mrs Mary Beale upon her own Picture, done by herself, like Pallas but without any Arms, except Head-piece and corselet'. It concludes with the flattering thought:

　　And were she to be born again
　　Would from your hand desire it rather than Jove's brain.
Since Pallas Athene was the Greek goddess of arts and crafts, as well as of war, it shows the confidence Mary Beale had in herself at an early stage in her career.

Verve was not the only hallmark of the Baroque. Grandeur was a mark of its portraits, a grandeur which occasionally gave the sitter the effect of sitting in a stage set. This format seems to have held little appeal for women in their self-portraits, although there is a portrait of an artist, said to be Rachel Ruysch, in full-blown Baroque style by a man. One who did attempt the mode was the

MICHIEL VAN MUSSCHER, *Portrait of an Artist in Her Studio*, c. 1680–85. The Netherlands produced many highly successful women painters in the seventeenth century, and their fame and status is reflected in the way Musscher has chosen to present this artist as the enthroned heroine of a Baroque opera. Fame sounds the trumpet, a putto crowns her with laurel and a statue of Minerva stands guard over the artist's painting hand. It has been said that this is a portrait of Rachel Ruysch, the greatest flower painter of her age, her fame sung by poets and rewarded by the high prices fetched by her paintings. In 1685, however, she would have been barely twenty. Her only known self-portrait is the miniature reflection shown on p. 61.

THE SEVENTEENTH CENTURY

young English poet and painter Anne Killigrew who painted herself dwarfed by a Baroque configuration of urns, draperies and classical reliefs. Her intellectual and worldly relatives moved in court circles and Anne painted members of the royal family, so she was familiar with the style. I shall give the rather artless and awkward air of this painting the benefit of the doubt and assume that she was deploying the grandeur of a Baroque portrait to enhance her youth and femininity. She died in 1685 from smallpox and Dryden wrote an ode to front the posthumous volume of her poems. The classical allegiance of the self-portrait and the landscape in the background are explained by his description of her fantastic landscape paintings:

> The Ruines too of some Majestick Piece
> Boasting the Pow'r of ancient Rome or Greece
> Whose Statues, Freezes, Columns broken lie....

MULTIPLE REFLECTIONS

Early in the seventeenth century, another new type of female self-portrait appeared. The Antwerp-born still-life painter Clara Peeters specialized in a form of miniaturized self-portraiture in which the distorted reflection of herself at work can be seen in the shiny surfaces of bowls and jugs. Though she did not invent it, she was among the earliest and most enthusiastic practitioners of this device in seventeenth-century still-life painting.

The miniaturized self-portrait was a continuation of a Flemish tradition first seen in the early fifteenth century. When Jan van Eyck painted *The Arnolfini Portrait* in 1434 (p. 61), he included his own tiny full-length portrait in a convex mirror behind the couple; two years later he repeated the trick with a miniaturized self-portrait in St George's shield in *Canon van der Paele*. In the first two decades of the century, Clara Peeters put herself into her paintings in a similar manner but with a twist. Her addition to the genre was her conviction that one reflected self-portrait per painting was never enough. *Still-Life with Dainties*, 1611, displays her image six times, three of them standing at her easel, in the teardrop decorations of the gilt cup (p. 60). In 1612 she painted her self-portrait holding a brush and palette at least five times times in a gilt cup (p. 65). Two images of herself, one clear and one less so, are reflected in the pewter wine pitcher in a painting of the 1620s.

These multiple images, which are realistically distorted and of variable clarity, are exactly what one would expect from an important still-life artist whose reputation depended on her ability to render textures and objects with a precision that dazzled spectators. Her desire to place herself in the Flemish miniaturized self-portrait tradition is evidence of her ambition to be judged with the greatest.

Clara Peeters influenced later still-life painters in Flanders, Holland and Germany.[7] Two other women who painted their reflections in the shiny surfaces of their paintings are Maria van Oosterwijck in 1663 (p. 60) and Rachel Ruysch, the foremost flower painter of her age, early in the eighteenth century (p. 61).[8] It is possible that Rachel Ruysch in particular was knowingly carrying on the

ANNE KILLIGREW, *Self-Portrait*, c. 1680–85. Though this young poet and painter seems lost among the fashionable Baroque trappings of the time, she moved in royal circles and was familiar with this grand portrait style. According to her funeral ode by Dryden, she was known for imaginative classical landscapes, which suggests that this is a manifesto self-portrait expressing her artistic allegiances.

CLARA PEETERS, *Still-Life with Dainties*, 1611. The miniature reflected self-portrait was a Netherlandish tradition, but Peeters made it her own by including several self-images in one painting. She reproduced her reflected portrait six times in the objects in this still-life.

MARIA VAN OOSTERWIJCK, *Vanitas Still-Life* (detail), 1663. Every item in this painting, including the artist's self-portrait, signals the passage of time. The hourglass, the skull, the flowers and grasses in different stages of their life-cycle, and the butterfly, a classic symbol of change, are reminders of the inevitability of decay and death.

RACHEL RUYSCH, *Still-Life with Reflected Self-Portrait* (detail), early eighteenth century. This is the only known self-portrait by this artist and marks the continuation of the Clara Peeters's tradition into the next century.

JAN VAN EYCK, *The Arnolfini Portrait* (detail), 1434. The mirror reflects the painter in this early witness self-portrait.

female tradition begun by Clara Peeters, since her teacher, Willem van Aelst, had been a member of Peeters's circle and had himself produced reflected self-portraits.

Still-life specialists like Clara Peeters were familiar with the type of still-life known as the *vanitas*, an arrangement of objects chosen to illustrate the transitory nature of the pleasures and treasures of life. Woman's beauty has traditionally embodied the idea of a short and poignant flowering before a fading, and in a clever self-portrait Clara Peeters uses her own good looks to add a female dimension to the *vanitas* theme (p. 65). Her image and the costly objects signify the beauty and wealth the world can offer and are contrasted with the bubble hovering beside her unlined face. This bubble is both witty and serious. Witty because it alludes to the rounded breasts of the young artist, the beauty of objects, the pleasures of life. Serious because it is a symbol of the fragility of life, youth, pleasures and beauty. The inclusion of oneself in a *vanitas* still-life relates this painting to a type of northern portrait, the portrait as *memento mori*, in which the sitter is paired with the skull that lies beneath the skin. A particularly macabre version is the portrait of Hans Burgkmair and his wife reflected in the mirror as skulls. Although less disturbing, the painting by Peeters shares a similar philosophy.

The traditional attribution of this painting to Clara Peeters has been questioned on the grounds that, while the style is typical of Peeters before she was twenty, the woman's appearance suggests a date a decade later.[9] But should tiny self-portraits, with the inevitable distortions returned by convex surfaces, be accepted as the definitive image of the artist? And would not a treatment of the *vanitas* genre in which the artist is the major vehicle for the meaning call for a self-presentation in keeping with the subject and require the jewels and fashionable clothes that will one day turn to dust?

In the mid-seventeenth century, Mary Beale introduced a female self-portrait type acknowledging the family support which enabled her to function as a professional. The 'support system' self-portrait is particularly the property of women because family support was a necessity if a woman was to take up painting as a career. While a helpful wife was doubtless welcome, a male artist did not have to rely on her aid and goodwill in order to work. This was not the case for married women artists.

In 1663–64 Mary Beale painted herself with her husband Charles and son Bartholomew (p. 64). It is not merely our first documented example of a self-portrait with a husband, but also undercuts seventeenth-century family portrait conventions. Although she and her husband frame their son in the traditional way, the artist sets herself apart from the two males in a manner that has nothing to do with a modest feminine acknowledgment of male superiority. Instead, the son and

LUKAS FURTENAGEL, *The Painter Hans Burgkmair and His Wife Anna*, 1527. The theme of the triumph of death, which lies beneath the *vanitas* still-lifes of Peeters and Oosterwijck, has resurfaced in women's self-portraits at the end of the twentieth century.

GIOVANNA FRATELLINI, *Self-Portrait*, 1720. The family self-portrait was a recurring theme of women's self-portraiture. Fratellini, a Florentine artist, shows herself vivaciously painting a miniature, and tradition has it that it is an image of her son Lorenzo. A promising artist, he died aged thirty-nine, two years before his mother. However, in contrast to Mary Beale's portrayal of the family as a source of support (overleaf), Fratellini emphasizes her pride in her creation of an artistic dynasty.

THE SEVENTEENTH CENTURY

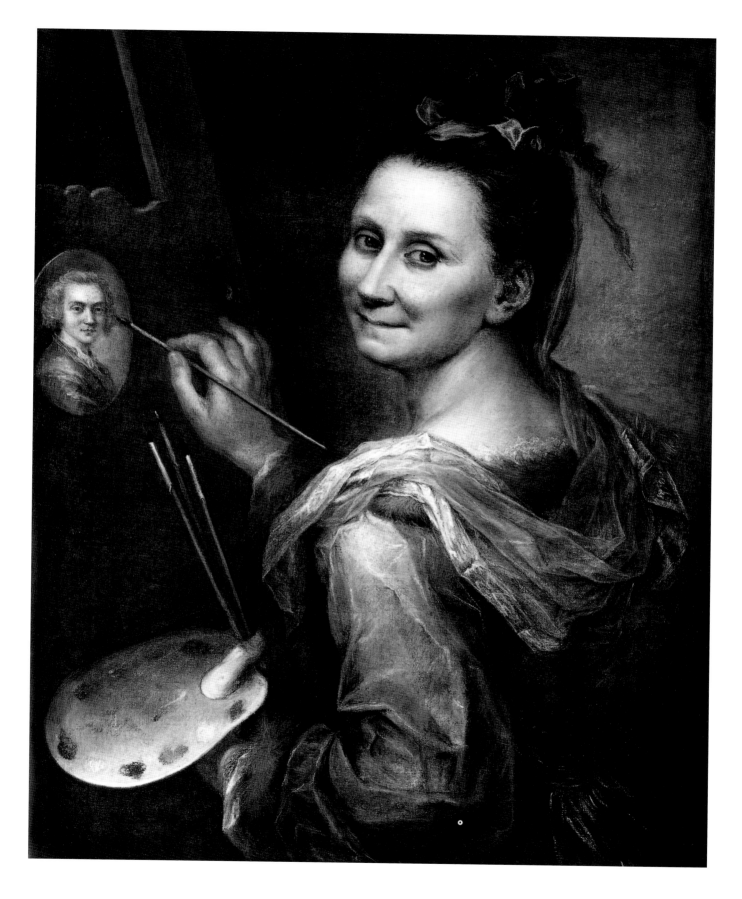

THE NEW SELF-CONFIDENCE

father are linked in an embrace, the father looks across at his wife, and she looks out to the spectator, pointing to herself with her index finger in a pose similar to that of the young Sofonisba Anguissola in the previous century. 'I did this,' the artist says. 'I am the one who deserves the respect.'

Mary Beale's acknowledgment of the family which made her career possible, as well as her desire to keep them in their place, reappears in a self-portrait of 1665 with the two sons she trained to assist her (p. 66). Once more Mary Beale paints herself as a matriarch with a great pride in her profession. The matriarchal power comes from the absence of any placatory gesture, from the subservient position of her sons Charles and Bartholomew, and from the monumental quality of her body which touches the frame on three sides. Her professionalism is signalled by the palette on the wall and her proprietorial hand on the portrait of her sons. It was a touch of inspiration to show it unframed, since a frame could have brought its authorship into question. Mary Beale achieves three things in this painting. She

MARY BEALE, *Self-Portrait with Her Husband Charles and Son Bartholomew, c.* 1663–64. Typical of this artist is her manner of acknowledging the people who made it possible for her to practise her profession, while at the same time keeping them in their place.

CLARA PEETERS, *Vanitas Self-Portrait,*
c. 1610–20. While capturing this moment of
her own youth and beauty, the artist intimates
that it is in reality as evanescent as the bubble
beside her. The beautiful objects that surround
her provide an equally hollow satisfaction.

CLARA PEETERS, *Still-Life with Flowers and*
Gilt Cups, 1612. Her reflected self-portrait
holding a brush and palette appears at least
five times in this still-life.

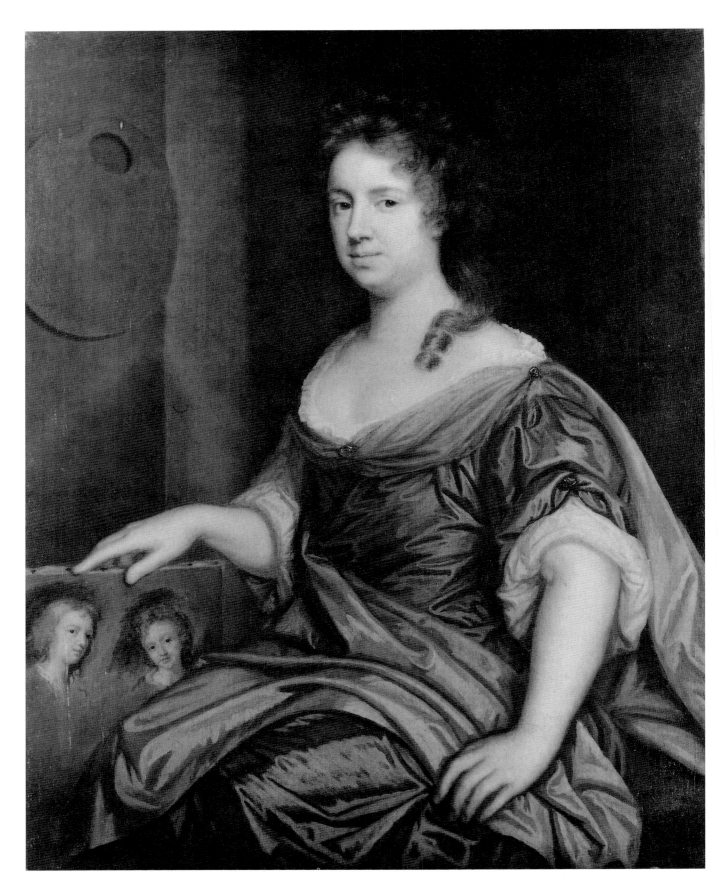

THE SEVENTEENTH CENTURY

is generously showing her gratitude, she is proving her respectability and she is announcing her position as head of the family business.

This self-portrait was painted in Hampshire, where the family had moved after the collapse of her husband Charles's post in the Patents Office in London, and it was a companion to a portrait of her husband. For the rest of his life, Charles managed his 'dearest hearte's' workshop, responsible for sitters, the preparation of materials and the accounts. Her decision to include her palette on the wall behind her signals her strong sense of her identity as an artist – even stronger perhaps as a result of her husband's loss of income which had turned her into the family breadwinner.

All classifications create a certain blindness in that everything that does not fit is either excluded or dragged in with the feeblest link. However, one result of grouping women artists' self-portraits into centuries is that it is possible to see changes over time, changes linked to attitudes towards women and women artists but also to developments in artistic style. The claim that the seventeenth-century self-portraits are more robust than the sixteenth has probably every bit as much to do with stylistic as social conventions concerning women. The move to theatricality in paintings during this period affected women's self-portraits just as much as it affected the increasingly dramatic façades of buildings or the operatic presentation of Biblical stories in paintings. It even encouraged the change in acceptable facial expressions in self-portraits in the shape of Judith Leyster's smile.

MARY BEALE, *Self-Portrait Holding Portraits of her Sons*, c. 1665 (opposite). This was painted at the time that she became the family breadwinner. The artist's palette on the wall points to her profession, and she rests a hand on the portrait of her sons, shown unframed to underline that she herself painted it.

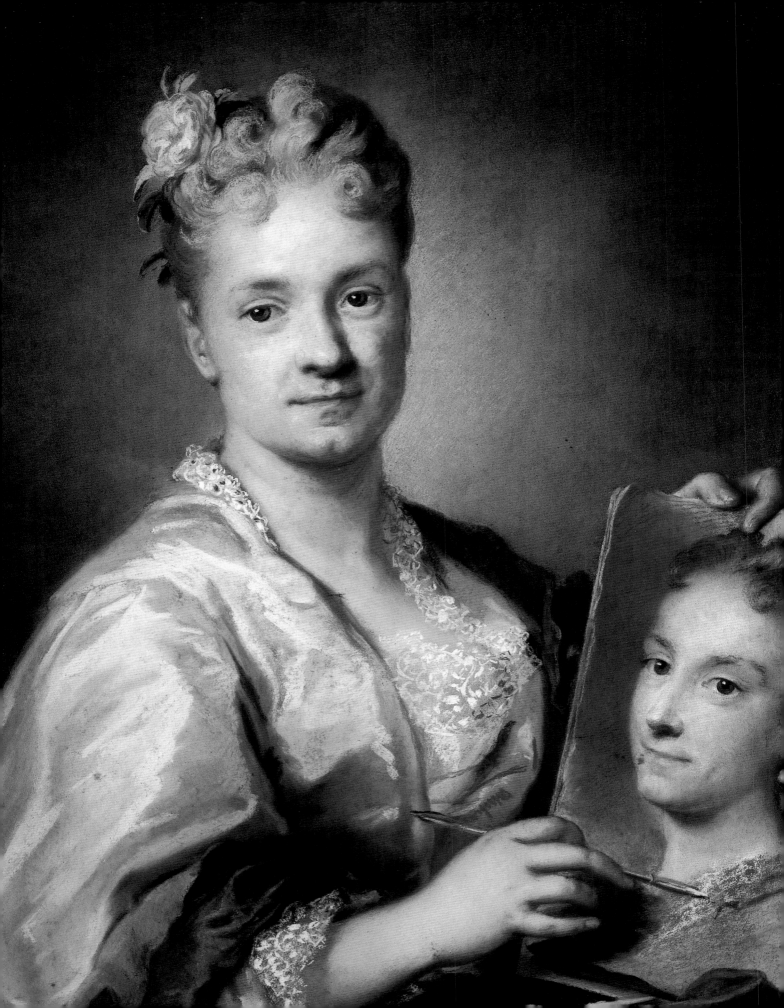

ROSALBA CARRIERA, *Self-Portrait Holding a Portrait of Her Sister* (detail), 1715. In portraying herself for the Uffizi self-portrait collection, the artist generously gives credit to her sister. Several women artists trained family members to work in the family business, avoiding the gossip that would inevitably follow a woman employing male assistants. Rosalba Carriera, the most famous pastellist of her day, here shows herself at work on her sister's lace collar.

THE EIGHTEENTH CENTURY PROFESSIONALS AND AMATEURS

THE PROFESSIONALS

Existing patterns of female self-portraiture continue into the eighteenth century. The depiction of the artist's family support system, for instance, is further developed. Mary Beale had painted herself with her husband, but what if an artist were unmarried? Employing a man would only lead to gossip. Rosalba Carriera solved the problem by training her sister as her assistant.

In 1715, for the Uffizi self-portrait collection, Rosalba Carriera painted herself holding a pastel portrait of this sister. Carriera leaves the spectator in no doubt that she is the author of the portrait on the canvas, showing herself in the process of drawing the intricate white lace of her sister's collar with a white pastel in a holder. Pastels lie randomly on the table, emphasizing the particular talent with which she had made her name. As well as a tribute to a valued sister, the inclusion of her image adds an element of familial propriety to an unmarried woman living an 'unfeminine' working life.

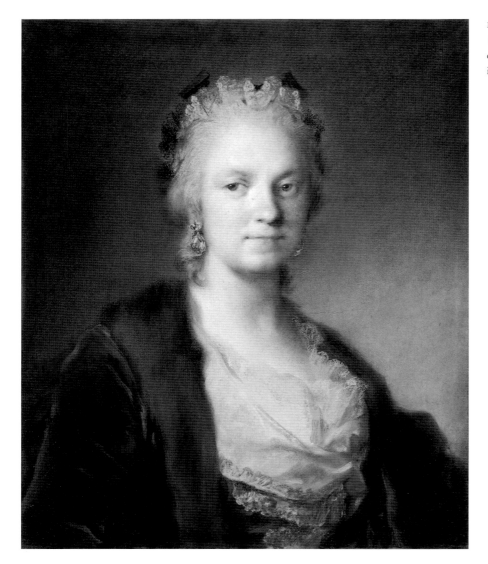

In Rosalba Carriera, the eighteenth-century art world found its first great female star. Born into a relatively humble Venetian family, she had a sequence of skilled jobs – lace designer, snuff box decorator – before emerging as a major portraitist whose pastels of the rich, noble and famous became fashionable all over Europe in the early decades of the eighteenth century, and inspired a generation of amateurs to work in pastel. So high was her profile in the eighteenth century that it was customary to praise a professional woman artist by calling her the English, Dutch or German Rosalba whether her work had any similarities with Carriera's or not. In the 1780s, Elisabeth Vigée-Lebrun recalls that she was overcome with embarrassment when La Harpe read the lines he had written about her at the French Academy:

> Lebrun, of beauty both painter and model,
> The modern Rosalba, but more brilliant even than she,
> Unites the voice of Favart with the smile of Venus.[1]

Although Carriera punctuated her career with self-portraits, the elaborate programme of the self-portrait with her sister is an exception. Her real gift was far more economical. She had a talent for personalizing a basic format of head and shoulders with a telling accessory, a device she uses to portray herself at fifty-five in a self-portrait as Winter (p. 19). Pastels of Winter, personified by a pretty young girl swathed in ermine, were part of her standard repertory, but when the ermine is placed round an older face it suggests that age has whitened her hair and that she is in the final season of her life. It seems unlikely that this portraitist of the grand and the great forgot that ermine is also the badge of royalty. After centuries of critics presenting Rosalba Carriera as an artist of feminine delicacy, with all its undertones of the second-rate, it would be a pleasing corrective if *Self-Portrait as Winter* was hinting that she saw herself as the queen of artists.

Rosalba Carriera lost her sight when she was seventy, not overnight, but gradually, with a false blindness before the final loss of vision. The evidence of hovering blindness shows up in the slightly mismatched eyes and drooping lid of a self-portrait painted when she was about seventy. About the same time, after 1746, she produced a self-portrait with a garland of laurels round her head (p. 11). The positive link of laurels with victory is undercut by the unshrinking close-up of her ageing face. Scholars have identified this as the *Self-Portrait as the Muse of Tragedy* which the artist did at this time, a searching look at age which did not recur in women's self-portraiture until the twentieth century.[2]

The second half of the eighteenth century is a richly inventive period in female self-portraiture. 'Women reigned supreme then; the Revolution deposed them,' wrote Elisabeth Vigée-Lebrun, who believed pre-revolutionary Paris was a golden age for women.[3] But it was also the age of the bluestocking, an age where women who paraded their learning were mocked. The challenge of walking a tightrope between being good enough to deserve praise but not so pompous as to elicit mockery led to some enchanting self-portraits that hid their cleverness beneath their charm.

The need to protect themselves from the lorgnettes lifted in inspection encouraged some imaginative strategies of self presentation. Enlightenment ideas about woman as a witty, beautiful enchantress, a complement, but never a rival, to man, led to self-portraits specializing in a kind of non-threatening professionalism. There has been a tendency to underrate these images as chocolate-box prettiness, but on analysis they reveal a formidable complexity.

The importance of good looks in this period is clearly expressed by Batoni in *Time Orders Old Age to Destroy Beauty*, in which pink-and-white Beauty vainly pulls back her head to avoid the touch of the crone Old Age. This meant that warts-and-all self-portraits such as those of Chardin in spectacles and eyeshade, Chardin in pince-nez and bow-tied turban, and Hogarth seated wigless, squat and inelegant at the easel, are rare from the hands of women artists. It is clear from their writings that women painters felt that a description of an artist's absent-minded absorption made a charming story for the reader to imagine but was too risky an image for a woman to put before the viewer.

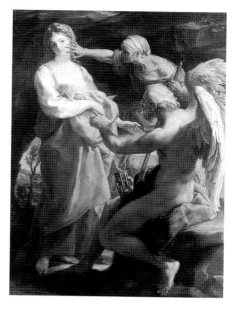

POMPEO BATONI, *Time Orders Old Age to Destroy Beauty*, 1746. The worship of female youth and beauty and its fleeting nature formed a constantly recurring theme of art and literature.

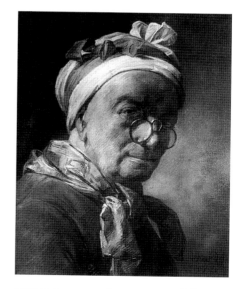

JEAN-BAPTISTE-SIMÉON CHARDIN, *Self-Portrait*, 1771. It was acceptable for a male artist to represent himself in so unvarnished a manner, but women artists would rarely dare to do so.

Elisabeth Vigée-Lebrun gives several accounts of bewitching absent-mindedness in her memoirs. Expecting visitors in London in 1802, she was reminded by her maid to remove her paint-spattered smock and cap before they came in. 'I put on a charming white dress under my smock, and Adelaide brought in my pretty, classical-style wig, for this was the fashion in those days; she told me to listen for a knock at the door and as soon as I heard it, to take off my nightcap and smock and to put on my wig. Absorbed in my work, I didn't hear any knock; but I did hear the ladies climbing the stairs; quickly I grabbed my wig and pulled it on over my nightcap; I completely forgot about my painting smock. I thought the English ladies looked a little quizzical, but I couldn't imagine why; finally after they had left, Adelaide returned and seeing my state of dress scolded me: "Go and take a look at yourself in the mirror"; then I saw that the lace from my nightcap stuck out from underneath the wig, and I was still wearing my smock.'⁴

A brave exception to the tyranny of beauty at this time is a self-portrait by Anna Dorothea Therbusch in which she leans forward with a book in her hand, one foot on a stool and a single eyeglass contraption suspended from under her headcovering. Therbusch, painter to the Prussian king and the Elector Palatine, and her sister Rosina de Gasc-Lisiewska were both successful Polish artists. In 1765, when she was approaching fifty, Therbusch spent two years in Paris where she was accepted into the French Academy. It was impossible for a distinguished female painter's presence to go unnoticed, and the *Correspondance Littéraire* carried the immortal sentence: 'One thing I know, is that on receiving Mme Therbusch, the Academy cannot be suspected of having submitted to the rule of beauty, so powerful in France, for the new academician is neither very young nor very pretty.'⁵

The comments of the critic Diderot on the work she exhibited at the 1767 Salon are a revelation of the way in which women artists were discussed. He damns her work and her feminine charms with faint praise and a touch of ridicule, saying that it is not without merit for a woman, and yet despite this her singularity comes through to modern readers. She places herself intrepidly before the nude model, he wrote, refusing to believe that vice alone has the exclusive right to undress a man. (She had asked him to undress when painting his portrait.) She is so sensitive to judgments about her work that a great success makes her crazy or die from

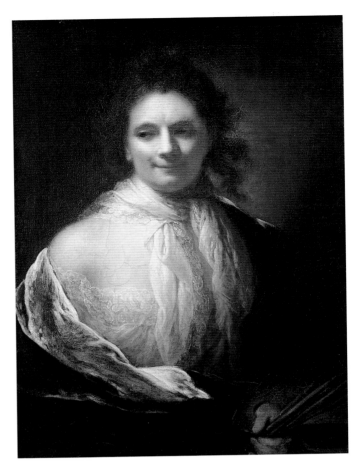

ANNA DOROTHEA THERBUSCH, *Self-Portrait*, 1761. Painted in her forties, this shows the artist conforming to the contemporary ideal of femininity, an interesting contrast to the frank self-portrait opposite, painted the following year.

ANNA DOROTHEA THERBUSCH, *Self-Portrait*, 1762 (opposite). A portrayal, rare at this time, by a woman artist of herself as she really is — short-sighted and well into middle age. This portrait, more than life size, is a proud and unapologetic self-presentation.

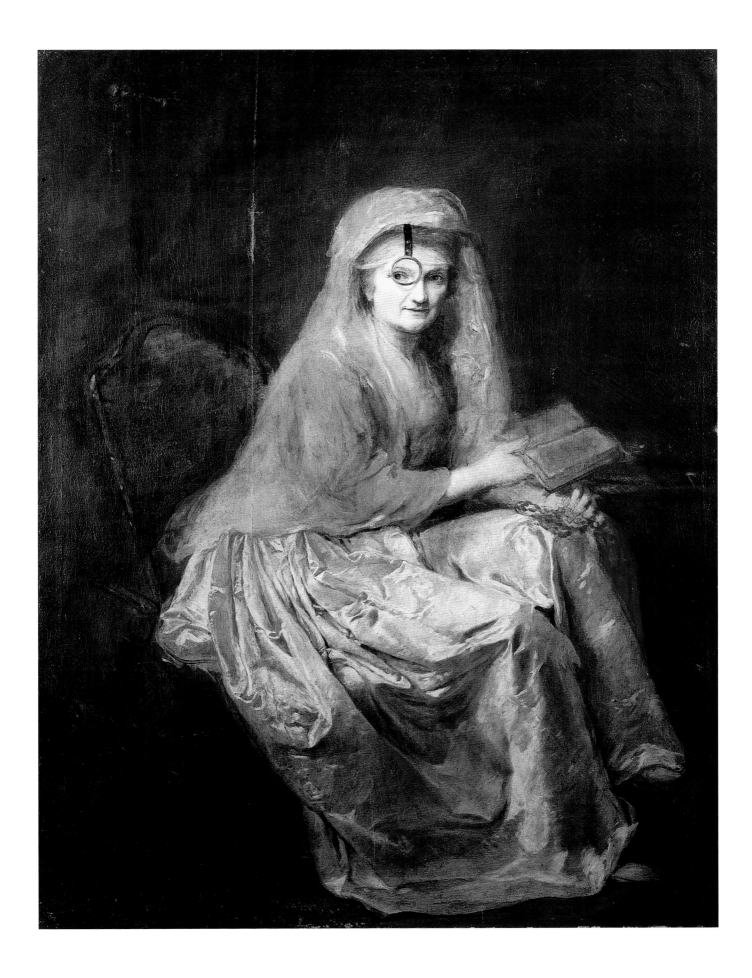

pleasure. And then, in an extraordinarily revealing passage he says that it is not talent which she lacked to create a sensation in France, but youth, beauty, modesty, flirtatiousness. 'She should have been ecstatic about the works of our great artists, taken lessons from them, abandoned her breasts and bottom to them.'[6] Fortunately she was back in Poland by the time Diderot's Salon comments were circulated. With such attitudes in mind, one can only look at this self-portrait with respect. It reveals a determined – and brave – acceptance of her short-sighted, middle-aged appearance.

DISARMING THE ENEMY

Although Angelica Kauffman runs her a close second, the greatest practitioner of the appealing self-portrait is Elisabeth Vigée-Lebrun. In all her self-portraits there is not one in which she looks anything but decorative and unthreatening. Underrated today for their high sugar content, they are examples of a sophisticated woman manipulating the imagery of fine art to illustrate her ambition and artistic intelligence without upsetting the rules of artistic and social acceptability.

Her *Memoirs* suggest some of the obstacles she faced as a woman artist – and hence some of her considerations when painting her self-portraits. For much of the first ten years of her professional life, she was painter to Queen Marie Antoinette, leading a high-profile existence in a court full of enemies. Her memories of this time reveal the slander and jealousy she attracted from both sexes.

In order to work, she had to appear as Madame Acceptable to the women she relied on for commissions, presenting herself as innocent and non-threatening, the absolute image of refinement. To have been seen as a rival to her clients would have been professional suicide. Her memoirs ring with admiration for her own sex: she describes women as friendly, pretty, lively and fashionable, and she has the knack of finding the redeeming feature in an unrewarding façade. Mme Dubarry's complexion was starting to fade but her features were pretty; Queen Marie Antoinette was plump but had the most majestic gait. Far from simple flattery, these observations reveal why she was sought after as a portrait painter and illustrate her strategy for keeping her footing in the treacherous world in which she moved. The self-portraits are a part of this strategy. This shows at its clearest in the self-portraits where she adopts some of the most famous images in Western art, revealing herself to be just as inventive and ambitious as the men in linking herself with the greatest artists of the past.

A widely admired female image of the late eighteenth century and one frequently used by male portraitists as a pattern for their own portraits of women, was Rubens's *Le Chapeau de Paille* (p. 77). The twenty-four-year-old Vigée-Lebrun realized its possibilities for a self-portrait, and used it to prove herself the technical equal of Rubens and as pretty as the subject of his painting. She exhibited her self-portrait (p. 77) at the 1783 Salon where it attracted a great deal of attention and paved the way for her acceptance into the Royal Academy the following year.

She saw the original in 1782 when she went with her picture-dealer husband to inspect the Prince of Orange's collection which had come on to the market. 'Its great power lies in the subtle representation of two different light sources, simple daylight and the bright light of the sun. Thus the highlighted parts are those lit by the sun and what I must refer to as shadow, is, in fact, daylight. Perhaps one must be a painter to appreciate the brilliance of Rubens's technique here. I was so delighted and inspired by this painting that I completed a self-portrait whilst in Brussels in an effort to achieve the same effect. I painted myself wearing a straw hat with a feather and a garland of wild flowers, and holding a palette in one hand.'[7]

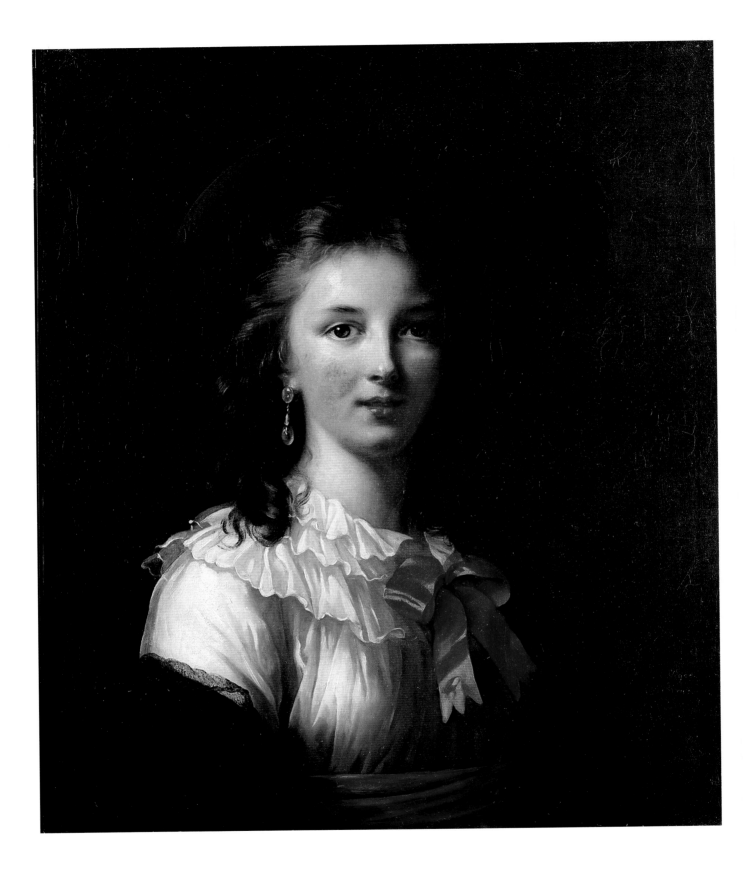

THE EIGHTEENTH CENTURY

ELISABETH VIGÉE-LEBRUN, *Self-Portrait in a Straw Hat, c.* 1781 (opposite). Vigée-Lebrun negotiated her way through the treacherous waters of court society by presenting herself as innocent, unthreatening and refined.

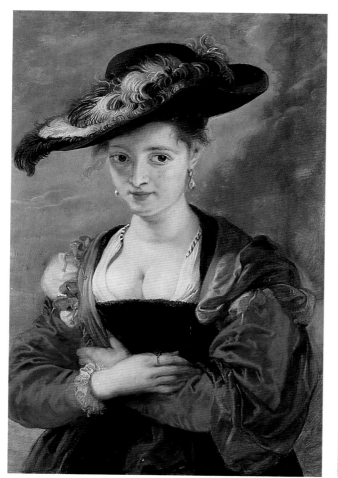

A comparison of the two paintings illustrates the possibilities for expression in the language of portraiture. There are certain elements in Vigée-Lebrun's painting that are the same as in the Rubens. She shows herself standing and to below the waist; she is outdoors, wearing a low-cut dress and a shady hat; the light touches her cheek and falls on to her bosom. But far more extraordinary are the differences. Though her dress is cut low, she minimizes her cleavage. Instead of clutching herself in a body language of timidity, she graciously extends a hand to the viewer. Rather than poking her head slightly forward, she stands straight with her head slightly back in the shadows. Her level gaze meets ours and the angle of her head

PETER PAUL RUBENS, *Le Chapeau de Paille,*
c. 1622–25 (above left). This portrait was widely used as a model for female portraits in the late eighteenth century.

ELISABETH VIGÉE-LEBRUN, *Self-Portrait,*
after 1782 (above right). With huge ambition, the artist modelled herself on the portrait by Rubens, attempting to achieve similar effects of light.

commands us to draw closer to her on her own terms, in contrast to the Rubens, whose subject's shadowed face coquettishly invites the viewer to respond. Finally, Vigée-Lebrun's palette gives her an identity beyond her beauty. She has reworked the Rubens into a statement about herself as a woman and an artist.

She used this self-portrait to promote some favourite convictions. She disapproved of the silhouette supplied by corsets, draping her sitters with shawls or scarves instead. The natural placing of her bosom advertises this belief as well as the fine figure of which she was so proud.[8] Nor is her hairstyle the innocent transcription of reality that it seems. In her memoirs, she claims the credit for changing the fashion when she persuaded the Duchesse de Grammont Caderousse not to powder her hair when she sat for her portrait: 'Her hair was as black as ebony and I parted it on the forehead, arranging it in irregular curls. After the sitting, which ended about dinner time, the Duchess did not alter her hair at all and left directly for the theatre; being such a pretty woman she was quite influential and her hair style gradually insinuated itself into fashionable society and eventually became universal.'[9] In this self-portrait, Vigée-Lebrun's hair is neither powdered nor elaborately set, evidence of her practice of dressing it herself.

Two self-portraits with her daughter are not as artless as they appear. Raphael was an artistic god for this generation of French artists, and Vigée-Lebrun was no exception. She considered Raphael's holy family compositions when she was working on her great portrait of Marie Antoinette and her children of 1787, and she called on him again in these self-portraits.

In the 1785 painting (p. 12), she takes Raphael's *Madonna della Sedia* as her prototype. It was a shrewd move to give overtones of the most admired Madonna and Child of the age to her own portrait with her daughter. As always with this painter, it is far from a copy – she has changed the Madonna's blue to the white she liked to wear and she ignores the John the Baptist figure – but it remains highly suggestive of the original. In this arresting image, which has been reproduced on everything from tins to trays, the artist succeeds in uniting herself with one of the greatest artists of the past while simultaneously underlining her femininity. The visual power of the embrace is convincing evidence of the mother-daughter bond, a useful weapon in this hard-working artist's negotiation with the attitudes of an age that officially 'loved' women but only if they conformed to its notions of femininity.

Two years later came the painting with her daughter in Greek-style draperies (Louvre, Paris) and this also drew on Raphael's Madonna and Child compositions. Scandal fell on Vigée-Lebrun's head like rain. She was reputed to have been the mistress of the finance minister Calonne, a charge she indignantly denied: 'One night the Duchesse de... asked if she could borrow my carriage. She did not return it till the next morning during which time it was seen all night outside the finance minister's house.'[10] When the singer Sophie Arnould saw Vigée-Lebrun's three-quarter portrait of Calonne, she accused her of cutting off his legs to stop him getting away. In silent answer to these critics, this consummate professional presents herself as above reproach in these disarming visions of motherhood.

MARGUERITE GÉRARD AND JEAN-HONORÉ FRAGONARD, *The Beloved Child*, c. 1780–85 (opposite above). Many of Gérard's three hundred and more genre scenes depicted the ideal family life of the era. Rousseau's writings had led to a cult of motherhood, a fashion exploited by several women artists in the eighteenth-century.

ELISABETH VIGÉE-LEBRUN, *Portrait of Charles-Alexandre de Calonne*, 1784. 'Madame Le Brun has cut off his legs so that he cannot escape,' it was said of an artist who could not escape gossip.

The Enlightenment cult of motherhood is responsible for an upsurge of images of maternity in the second half of the century, and women artists saw their potential for self-portraits.[11] In a lively self-portrait, *The Artist at her Occupations,* done shortly after her marriage in 1789, Marie-Nicole Dumont paints herself as parent and professional artist (p. 34). It is hard not to smile at the dancing grace of the artist's pose, echoed by the baby's outstretched arms. By lifting the veil of her son's cradle she suggests that he is as important a creation as the portrait on which she works. Though surrounded by men – the portrait on the easel is thought to be either her artist husband or her artist father – she is the pivot of this image

which owes an influence to a group of happy family paintings of this period, of which *The Beloved Child* by Fragonard and Marguerite Gérard is a typical example.

Neoclassicism gave Greek and Roman classical subject matter a boost in the second half of the century. Followers of this movement, like Angelica Kauffman, chose to express ideas allegorically and illustrate scenes from the classical world in a new style derived from relief sculpture and wall paintings. Personification can kill as often as it breathes life into the ideas it represents, but Kauffman had a gift for making her abstract concepts live. In 1782, she turned this talent to the *Self-Portrait in the Character of Painting Embraced by Poetry.* Since poetry was characterized as more intellectual than painting, this gentle image of two young women is actually a bold, and justified, claim by the artist that she possessed the imagination to produce the highest kind of art, far from the mere copying of appearances expected from most women. There were certain rude – and routine – critical responses: Kauffman's male figures in the androgynous classical style admired by the scholar Winckelmann were either criticized for effeminacy or said to portray the men she wished to marry but never did. [12] Nevertheless, her scenes from classical myth and history were exhibited, purchased and widely reproduced.

ANGELICA KAUFFMAN, *Self-Portrait in the Character of Painting Embraced by Poetry,* 1782. Kauffman expresses the intellectual ambitions of her art with the figure of Poetry.

Between 1770 and 1820, the story of the origin of painting became a popular theme.[13] In his *Natural History*, Pliny had described how an artist had outlined his departing lover's profile on the wall. By the eighteenth century the artist in Pliny's story had – wrongly – become a female called Dibutade, a confusion between the stories of the origin of painting and the origin of sculpture in which a girl traced her lover's profile on the wall which her father then filled with clay. This story was treated at least twice in Angelica Kauffman's years in England, by Alexander Runciman in 1771 and David Allan in 1773. Kauffman ignored it, as did most women artists. It was not until the 1793 Salon that Mlle Guéret painted *Une Moderne Dibutade* (which I have not been able to trace but must surely have a woman artist as its subject) and not until 1810 that Mme Jeanne Elisabeth Chaudet, one-time pupil of Vigée-Lebrun, painted *Dibutade Coming to Visit Her Lover's Portrait*. No woman chose it for a self-portrait, though one would have thought that a woman as comfortable as Kauffman with the classical world and with the imagination to turn such myths and history to her advantage would have seen its potential. Apparently tailor-made for her, an eighteenth-century equivalent of Artemisia Gentileschi's adoption of La Pittura, there can only be two reasons

ANGELICA KAUFFMAN, *Zeuxis Selecting Models for His Painting of Helen of Troy*, *c.* 1778. Kauffman has painted herself into a classical artistic myth by giving her features to one of the five beautiful women from whom Zeuxis created his picture of perfection. But this fifth woman is also an artist who picks up a brush to begin work at the easel. The myth was read as proving the superiority of perfect art over flawed nature; Kauffman's reworking of it makes it a manifesto self-portrait.

why she shunned it: it showed the imitative as opposed to the imaginative power of women – a criticism she was desperate to avoid. And it risked opening herself up to embarrassing speculation on the identity of the departing lover.

Although she shunned this subject, she kept on searching for ways to give herself a classical pedigree. In the late 1770s, in *Zeuxis Selecting Models for His Painting of Helen of Troy*, she did what women had done before and associated herself with a classical male painter, though she did it with a twist. She took the story of Zeuxis who, painting Helen of Troy, combined the best features of five women of Crotona in order to achieve perfection, and subversively re-ordered the facts. Kauffman depicts Zeuxis with four models. The fifth, on the far right of the painting, has Kauffman's features. She stands in front of Zeuxis' easel, about to take up a paintbrush and start work on the canvas. Since the Neoclassicists used this story to illustrate the superiority of art over nature, this painting is also an affirmation of Kauffman's artistic beliefs, a manifesto painting.[14] A few years later, around 1780, she painted herself face to face with a helmeted goddess who is surely Minerva, the Roman version of Athene and patron of the arts (Kunsthaus, Coire). It is an efficient expression of her allegiance to Neoclassicism, but she has also finally found a way to give herself a female classical ancestor.

The myth of the two talents flourished in the eighteenth century, in a culture that encouraged ladies to nurture a tolerable talent in at least one of, and ideally all of, the accomplishments of drawing, singing and playing a musical instrument. The artist Maria Cosway recalled that, when she was a girl, music held the first place in her affections until it was replaced by painting. Elisabeth Vigée-Lebrun says that she did not disgrace herself when called on to sing: 'I was not particularly polished never having the time to take lessons. All the same, my voice was passable; that kind man Grétry even commented on a certain silvery quality.'[15]

When she was thirteen, Kauffman painted a self-portrait that celebrated her talents in both music and painting. At fifty she returned to this subject in a brilliant self-portrait recalling an episode in her youth when she had asked a priest whether she should follow art or music as her profession. His reply was that painting would be less disruptive to her religious observations. In 1791 she painted *Self-Portrait Hesitating Between the Arts of Music and Painting*. The cleric had also told her that painting was a more difficult hill to climb, though ultimately more satisfying. The figure of Painting accordingly points to a temple on top of a hill.

ANGELICA KAUFFMAN, *Self-Portrait Aged Thirteen*, 1754. As a child, Kauffman was equally talented in music and art. Here she proudly combines two self-portrait types – the youthful artist and the two-talents.

ANGELICA KAUFFMAN, *Self-Portrait Hesitating Between the Arts of Music and Painting*, 1791. The dramatic presentation of her difficult choice illustrates Kauffman's gift for infusing myth and allegory with life.

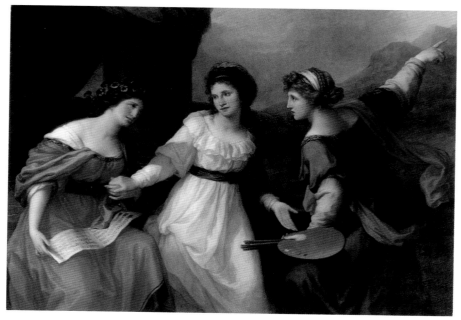

Her conception of the subject links with the classical tradition through a motif deriving from the story of Hercules' decision between vice and virtue. 'Choice' paintings were popular – in 1762 Joshua Reynolds, who would later become Kauffman's friend and (so said the gossips) lover, painted a portrait of the actor David Garrick hesitating between comedy and tragedy. No artist before Kauffman, however, had seen its possibilities for self-portraiture.

The charm of her work, like that of Elisabeth Vigée-Lebrun, should not blind the viewer to the intelligence behind it. Traditionally the muses and personifications of the arts were female and artists were male. By inserting herself, a woman, between two other women, she creates a world of female creativity. The dynamic line of the composition, taking the viewer from the sheet of music bottom left to Painting's arm, top right, tells a story of female energy and aspiration. Her lively use of the Neoclassical vocabulary has turned a potentially self-aggrandizing image into a decorative but serious statement about her artistic career.

HANDING ON THE BATON

From this period comes the earliest painted evidence of a female teacher-pupil relationship. Women artists had always taught other women. They taught the rich and royal, like Sofonisba Anguissola and the queen of Spain and Angelica Kauffman and the daughters of the queen of Naples. They taught their sisters, like Sofonisba Anguissola. They taught their students, like Elisabetta Sirani[16] and Mary Beale. However, the fact that two of the most famous self-portraits showing female teachers and pupils are French and date from the end of the eighteenth century makes perfect sense given that women artists were flourishing in France at this period. The foundation of the Académie de St-Luc in 1751 and of the Salon de la Correspondance in 1779 offered exhibiting space to women excluded from the Salon by its policy of showing only the work of academicians.

Magnificent is the only word for the self-portrait by Adélaïde Labille-Guiard in terms of its size, technique, ambition and the dazzling combination of self-portrait strategies marking her bid for artistic status (above right and detail p. 2). The finely-dressed artist, as elegant as any aristocrat in her décolletage, swooping hat and sumptuous satin, is also portrayed as the serious artist working on a life-size canvas, her back upright, her face and hand caught in the act of checking the model whose image she is painting. And there is also the artist as star and teacher, her pupils hanging on her every brushstroke as they decorously watch from behind her chair. The bust of Labille-Guiard's father in the background is the only male presence in this painting filled with female pride and energy.

Much admired at the 1785 Salon, this painting inspired Jean-Laurent Mosnier to do his own version the following year. Unfortunately, the concept could not survive the artist's change from female to male: leaning back in his chair he merely looks smug as two young women inspect the portrait on the easel.

ADÉLAÏDE LABILLE-GUIARD, *Self-Portrait with Two Pupils, Mlle Marie Gabrielle Capet and Mlle Carreaux de Rosemond*, 1785 (top). The artist as star, and also as teacher of the next generation of women artists.

JEAN-LAURENT MOSNIER, *Portrait of the Artist in His Studio*, 1786. The artist based his composition on the Labille-Guiard of 1785.

Labille-Guiard drew up a plan in the revolutionary years for a school for women artists, but not all artists were sympathetic to the idea of training women. In the early 1780s Vigée-Lebrun felt that teaching got in the way of her painting, and only took students because her new husband wanted the extra income 'from young ladies learning how to paint eyes, noses and faces.' In her entertaining account of her short-lived attempt at teaching, she presents herself as girlish as her pupils: 'One morning I climbed the stairs to the studio only to find that my pupils had attached a rope to one of the beams and were happily swinging back and forth.... I adopted a serious manner and scolded them; I also gave a fine speech on the evils of time wasting. Then of course I wanted to try out the swing and soon I was enjoying myself even more than my pupils. It must be obvious to you that a personality such as mine found it difficult to assert authority. This problem, combined with the irritation of having to revert to the ABC of painting whilst correcting their work soon made me renounce the idea of teaching altogether.'[17]

In 1796 Marie-Victoire Lemoine painted Vigée-Lebrun with a student (p. 84). What makes *Atelier of a Painter* so remarkable is that it shows a young woman, possibly herself when young, at work at the feet of Vigée-Lebrun, gaining status and a claim to respect from her connection with the famous woman painter. Since Lemoine was not a pupil of Vigée-Lebrun, this painting is a tribute to her importance to other women in the manner of Reynolds's self-portrait with a bust of Michelangelo. The respectful theme is underlined by a pictorial metaphor: the subject of the life-size painting on which Vigée-Lebrun is working is the goddess Athene with a votary.

In France, this generation of successful women painters did much to promote painting as a profession for women. The Salon opened itself to women artists in the final decade of the eighteenth century. A fifth of the exhibitors at the 1808 Salon were female and it became known as the Women's Salon. One result of their increased numbers was that they became a feature of the art world and then a subject for it. Between 1795 and 1800, the painter Louis-Léopold Boilly, always alert to contemporary trends, produced several paintings of the new genre of women artists at work. *The Painter in Her Studio* of 1796 is treated with far more dignity than *The Artist at Work* of eleven years earlier in which a young woman in a huge and fashionable hat turns from drawing the cast of a female nude to beam at the spectator (p. 85). The increase in the number of talented women artists in France accounts for his newly respectful tone.[18]

Although male artists were quick to exploit the appeal of this new subject, women did not resign their right to paint women artists at work. Around the turn of the century, Marguerite Gérard painted *Artist Painting a Portrait of a Musician* (p. 86). This is a dignified depiction of a woman painter. She is presented from the back with a determined profile and an upraised arm, at work on a life-size painting.

LOUIS-LÉOPOLD BOILLY, *The Painter in Her Studio*, 1796. A serious view of a woman artist, reflecting women's increasing prominence in the art world of the time.

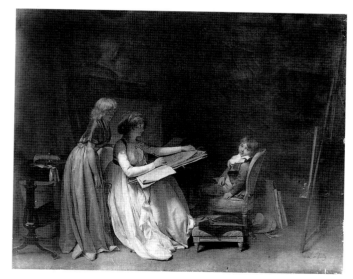

LOUIS-LÉOPOLD BOILLY, *The Artist at Work*, 1785–88. A patronizing view of the woman painter, more frivolous amateur than serious professional. The same painter shows a very different view of a woman artist ten years later (p. 83).

MARIE-VICTOIRE LEMOINE, *Atelier of a Painter, probably Mme Vigée Le Brun and Her Pupil*, 1796 (opposite). Painted eleven years after Labille-Guiard's self-portrait with pupils (p. 82), it links to the new self-portrait type introduced in the late eighteenth century, the female artist with female pupil.

It is not known for sure whether this is a self-portrait, though the Leningrad experts think the resemblance of the artist's face to a drawing of Marguerite Gérard by Fragonard makes it likely. The handsome nose and clearcut features of another drawing of her by Fragonard, this time in profile, make an even stronger case.

The paintings by Marie-Victoire Lemoine and Marguerite Gérard are only two of a number of putative French self-portraits from this time. In 1801 Constance Mayer painted a father pointing to the bust of Raphael as a model for his artist daughter (p. 88), the second inclusion of a father in a French woman's depiction of a woman artist. A magnificent life-size portrait of an artist drawing at a window was the subject of an authorship battle between champions of Jacques-Louis David (a portrait of a woman painter) and of Constance Marie Charpentier (a self-portrait). Neither side won, and it has now been labelled by the Metropolitan Museum of Art in New York as *Portrait of a Young Woman, Called Mademoiselle Charlotte du Val d'Ognes.* As all three – the Gérard, the Mayer and the putative Charpentier – have a strong case for being considered self-portraits, I shall claim them as such to compensate for the ones that have been lost or reattributed.

THE EIGHTEENTH CENTURY

ARCHDUCHESS MARIE CHRISTINE, *Self-Portrait at the Spinning Wheel*, late eighteenth century. From the sixteenth century, drawing and painting in watercolour was a desired accomplishment for upper-class ladies, and many professional women artists, from Sofonisba Anguissola onwards, taught aristocratic women. In this variation on the two-talents self-portrait, the Austrian archduchess, a skilled amateur painter, presents herself at the spinning wheel, an incongruous but fashionable image of simple toil in a luxuriously feminine interior.

THE AMATEURS

A new character joined the cast of the art world in the eighteenth century: the amateur woman artist. Although wealthy, well-born and educated women had been drawing and painting for two centuries, the ability to draw and paint became fashionable in the eighteenth century and sightings of the ubiquitous amateurs taking likenesses and sketching views were frequently noted in the fiction, letters and journalism of the time. The one unproblematic way for women to learn to paint was to learn it as an accomplishment. Society admired the lady who developed her artistic skills and showered her with praise for doing so.

The amateurs' history begins with the publication of Baldassare Castiglione's *The Courtier* in 1528, which stated that the well-born woman should be able to

CONSTANCE MAYER, *Self-Portrait with Her Father*, Salon of 1801 (opposite). Although many women artists from the sixteenth century onwards were taught by their artist fathers, the first self-portraits with fathers date from the late eighteenth century. Labille-Guiard includes a bust of her father in her *Self-Portrait with Two Pupils* and here Mayer's father points to a bust of Raphael as a model for his gifted artist daughter to follow.

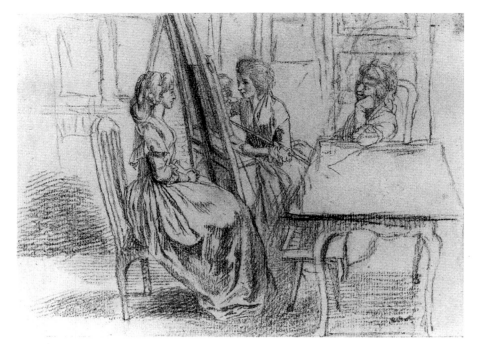

sing, dance, draw and play a musical instrument. Within a hundred years
The Courtier had been translated into several languages, and high-born ladies
all over Europe could follow its model of elegant behaviour. By the eighteenth
century, accomplishments which had originally been the province of the royal
and aristocratic were now within the grasp the gentry and middle classes. The self-
portrait at the spinning wheel by the Austrian Archduchess Marie Christine stands
as the emblem of the nobly born women all over Europe who produced amateur
art to a high standard (p. 89). But the point about the amateur phenomenon in
the eighteenth century is that it was linked with the emerging middle class.

The spread of the culture of accomplishment was encouraged by a river of
writing about women's nature, rights and role. By far the most readable – and
influential all over Europe – were the ideas expressed by Jean-Jacques Rousseau
in *Emile* and *Julie* in the early 1760s. As attention turned to the education of girls,
their curriculum broadened, although it was not until the nineteenth century
that their studies benefited from the breadth of their brothers' education. All
over Europe, girls in their schoolrooms were offered painting and drawing as
desirable accomplishments.

Accomplishments, not skills. For while Castiglione helped create a climate
of acceptance for the woman who drew and painted, he, and everyone after him,
was recommending an *amateur* practice that had nothing to do with the technical
expertise or the chemicals, smells, and mess that went with the professional
practice of painting in oil. And Rousseau's influential ideas about male and female
roles were informed by his belief that women had taste and intuition while men
had intellectual capacity – a little light drawing would suit the girls while the
boys, as providers and thinkers, deserved a more rigorous training.

The addition of dancing, singing, music and art to the curriculum essential for a lady was particularly encouraging to women in Protestant countries where female education tended to stress the self-effacing virtues rather than the socially glamorous ones – needlework was recommended as a domestic skill rather than drawing as an ornamental one. The English embraced the idea of becoming amateur artists with enthusiasm. (There is a theory that women in non-puritanical Catholic countries had always been encouraged to develop their talent. Research into the rise of the European female amateur would reveal much about the history of women, education, religion and class.)

The basic way of learning was by copying, either from plates in the amateur guides which seem to have held out dreams like those of gardening guides today, or from prints of famous landscape paintings and classical sculptures. Zoffany painted Mr and Mrs Dalton absorbed in watching their young niece copying a drawing of the *Spinario*, a classical sculpture of a boy pulling a thorn from his foot which was much admired at the time.

Sometimes upper-class wives sought drawing lessons, inspired by a portrait painter's working visit to their home. The English Royal Academician Joseph Farington was regularly asked by husbands to recommend teachers for their wives. His response was either to instruct the ladies himself by lending them landscape prints to copy and return for his criticism, or else to put them in touch with women in his circle who made their living as artists. These female professionals, none of whose names are familiar today, made copies, painted miniature portraits, taught and did engravings, though according to Farington, Letitia Byrne complained that 'there is a prejudice against employing women as engravers.'[19]

British professional academies did not allow women amateurs as students – not that any lady could have been comfortable in the smoky, hot and dirty atmosphere. Though tuition for adult amateurs in particular was always on an individual basis, there were occasional attempts to set up schools for them. In Scotland, Alexander Nasymth set up classes for women, managed by his daughters, at the academy he opened in Edinburgh at the end of the eighteenth century. A student recalled: 'I was not taught to draw, but looked on while Nasymth painted; then a picture was given me to copy, the master correcting the faults.'[20] In France and Germany, female amateurs were welcomed into some academies, a process that accelerated in early nineteenth-century France. This is an area still largely unresearched; my impression is that the barrier between amateur and professional was stronger in England than it was in France or Germany in the second half of the eighteenth century.

JOHAN ZOFFANY, *Mr and Mrs Dalton and their Niece Mary de Heulle, c.* 1765–68. The young girl, probably about eight years old, copies a drawing of the *Spinario*, the classical sculpture of the boy removing a thorn from his foot.

The training that the woman amateur received was a shadow of that of her professional counterpart, whose own education was a version of the male programme tailored for women. While it is true that copying was the point where everyone, male or female, amateur or professional, began, serious students went on to copy famous works of art and, if they were male, to draw from life models. Both practices were out of the question for ladies, who could neither wander unescorted round art galleries nor draw from the naked body. They could, of course, look at paintings in public places if they were chaperoned, but drawing

ANONYMOUS, *Self-Portrait*, c. 1740–50. Although this entered the Uffizi in 1853 as one of two self-portraits by the Italian artist Teresa Arizzara, the attribution has been removed. We do not know if the painter was amateur or professional, why she was fashionably dressed in Turkish style, or whether the second figure was her child or her pupil.

ANGELICA KAUFFMAN, *Self-Portrait*, 1787. Unusually for a professional, Kauffman shows herself here (and on p. 100) with unused crayon and portfolio. This pose was developed during the eighteenth century, notably in England, for portraits of lady amateurs.

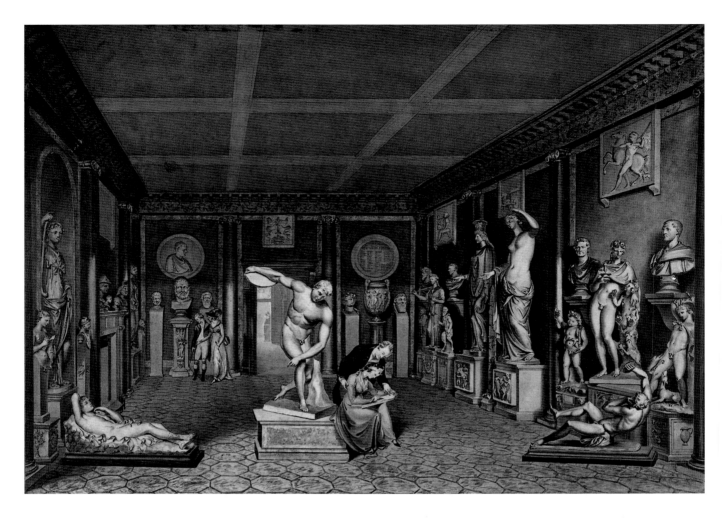

under someone's eye was not likely to encourage concentration. A watercolour of 1793, at one time attributed to Maria Cosway, shows a young woman with a companion drawing the antiquities in Charles Townley's dining room in Park Street in Westminster.[21] Townley, who had an admired collection of Greek and Roman sculptures, had given Maria Cosway away at her marriage to the artist Richard Cosway twelve years earlier. Amateurs were not encouraged to paint in oils, the medium of the professionals. Farington reports that Mrs Charles Long's husband was less than enthusiastic at his wife's desire to learn oil painting.

The major hindrance to the amateurs' improvement was the lack of expectation of those around them. *The Art of Painting in Miniature* recommends flower painting as an easy route to success for amateurs: 'You maim and bungle a face, if you make one eye higher or lower than another.... But the fears of these disproportions constrain not the mind at all in flower painting; for unless they be very remarkable, they spoil nothing. For this reason most persons of quality who divert themselves with painting, keep to flowers.'[22]

For the sake of harmony between the sexes, excellence was neither expected nor encouraged. In *Practical Education*, written by Maria Edgeworth and her

WILLIAM CHAMBERS, *The Sculpture Collection of Charles Townley, c. 1794.* A lady with an attentive companion draws from the most famous collection of antiquities in London, kept in Townley's dining room in Park Street, Westminster.

father Richard at the end of the eighteenth century, women were told not to decide their tastes too early so that they should be able to develop any talent their mate desired: 'If, for instance, a woman were to marry a man who was fond of music, or who admired painting, she should be able to cultivate those talents for his amusement and her own. If he be a man of sense and feeling, he will be more pleased with the motive than with the thing that is actually done.'[23] In Book V of *Emile*, Rousseau had stated that the whole education of women should be relative to men.

The education manuals never listed excellence as a reason for learning to draw. Drawing was used to improve visual taste, imagination, memory and accuracy; to refine the design of embroidery patterns; to play a part in catching a husband – 'increase a young lady's chance of a prize in the matrimonial lottery' as the Edgeworths starkly put it; to pass time. Readers of *The Polite Lady* were told: 'The most active and busy stations of life have still some intervals of rest, some hours of leisure....And if these are not employed in innocent amusements, they will either lie heavy on our hands, and instead of raising, depress our spirits; or what is worse, tempt us to kill the time, as it is called, by such amusements as are far from being innocent.'[24] This image of eighteenth-century upper-class women in a state of chronic boredom crops up constantly. The author of *The Art of Painting in Miniature,* which went into several editions throughout the century, recommends his instructions for the 'great numbers of both sexes, of fortune and leisure, who with a genius for painting are devoted to a country life, and languish away many a heavy hour for want of some intelligence in this art, which they might pass very agreeably with a little skill in it.[25]

Despite their half-hearted training, thousands of female amateurs attained some skill and derived great pleasure from their ability to draw and paint. Lady Lucan took sixteen years to illustrate the plays of Shakespeare with watercolour views of castles in imitation of illuminated manuscripts. Lady Diana Beauclerk helped Josiah Wedgwood with designs for jasper ware. And after a lifetime of painting, drawing and embroidering, the sixty-nine-year-old Mrs Delaney began her masterwork, the construction of over a thousand paper images of flowers. Ladies could even, if they wished, exhibit their paintings, drawings and engravings at selected institutions. In England, their superior non-professional status was indicated by the prefix 'Honorary' before their names in the exhibition catalogues.

A huge chasm existed between amateur and professional. One of the definitions of the lady amateur was that she could not sell her work. A book of engravings by women put together in England at the start of the nineteenth century states on the title page: 'Etchings and Engravings by the Nobility and Gentry of England; or, By Persons not exercising the art as a trade.[26] Just to underscore the barrier between the two, the few engravings by professional female artists are bunched together at the end under the heading 'by female artists for their amusement'. The words 'mem: never sold' are written in pencil underneath, as if to underline that here we have the ladylike, and not the professional face of the artists.

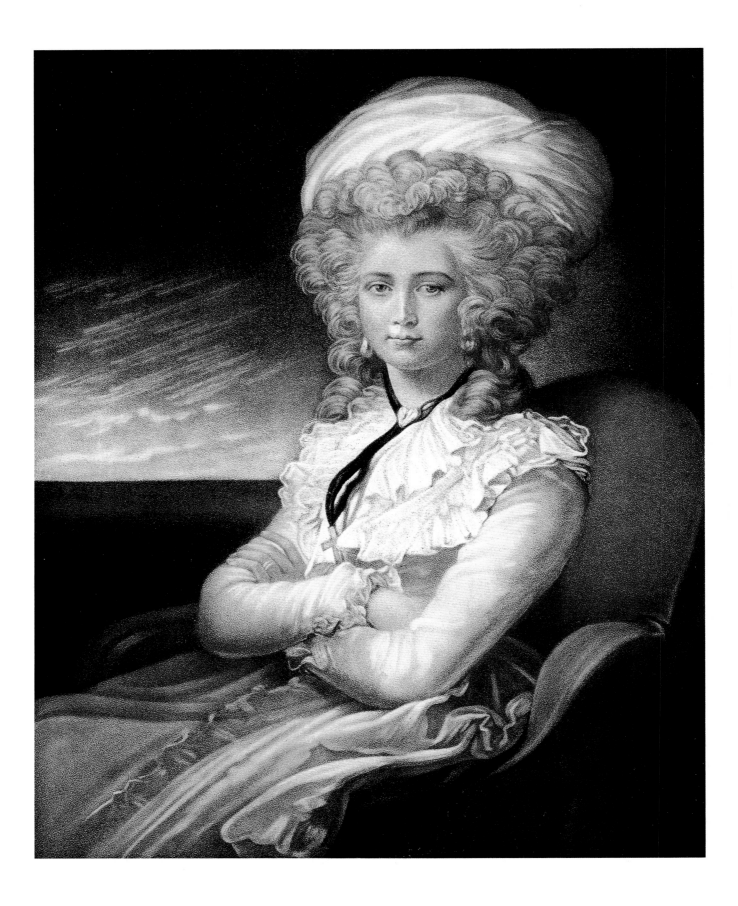

The failure of the amateurs' training to develop a high level of skill fuelled the belief that women were incapable of producing the highest kind of art, the art of imagination rather than imitation. On the surface this does not seem true, since amateurs often earned wild praise from their admirers. Horace Walpole in *Anecdotes of Painting in England* describes three famous amateurs of his day in such glowing terms that the actual works can only disappoint. Lady Diana Beauclerk's drawings were 'sublime'. The terracotta model of a dog by the sculptress Mrs Damer rivals the marble one by Bernini in the Royal Collection. Lady Lucan's copies of English miniaturists show a genius that 'almost depreciates' her masters.[27]

Among all these flattering protestations, the voice of the painter Gainsborough injects a note of reality. In a letter of 1764, when his daughters were sixteen and twelve, he wrote, 'I'm upon a scheme of learning them both to paint landscape, and that somewhat above the common fan mount stile. I think them capable of it, if taken in time, and with proper pains bestowed. I don't mean to make them only Miss Fords in the art, to be partly admired and partly laughed at at every tea table; but in case of an accident that they may do something for bread.[28] Around this time he painted a portrait of the two girls with an artistic slant. One of them holds a portfolio and they share the space with a statuette of the Farnese Flora (*The Artist's Daughters*, c. 1763–64, Worcester Art Museum, Mass.)

With these stinging remarks on accomplished women of fashion, Gainsborough makes clear the gulf between the amateur and the professional. Farington's references to amateur women painters are equally patronizing. The professionals are spoken of in terms of prices, earnings, students and the types of work undertaken; the amateurs are treated politely, their pretensions indulged. Mrs Phipps draws from 10 o'clock to 3 o'clock and then her husband collects her. Lady Essex has a den at Cashioberry House where she paints miniatures 'with some portion of skill' and exhibits her framed copies in the drawing room. Lady Mary Lowther declines to go riding, explaining that 'she must go to her trade'.[29]

Visual proof of the lady amateur's existence appears in the second half of the century when the portfolio and pencil were added to the existing range of female portrait accessories. Reynolds paints Lady Diana Beauclerk with a portfolio by her side and a pencil in her hand. Joseph Wright of Derby depicts Mrs d'Ewes Coke with her hands resting on her portfolio while her husband's friend and distant cousin compares her sketch with the view from which it is taken. Particularly magnificent is Francis Cotes's portrait of Mrs Thomas Crathorne dressed à la Van Dyck, her right hand languidly holding a drawing pen, her left holding open a book at a drawing of Cupid. Her husband's subservient position is due to the fact that this is a posthumous portrait: he died in 1764, three years before the date on the painting.

It is relatively rare to find an oil portrait of an amateur artist at work, and very rare in England. She is most commonly gracefully seated with her hands resting on her portfolio or with a brush in a hand dropped delicately to her side. Nathaniel Dance's portrait of the Honourable John Pratt and his Sisters Jane and Sarah is unusual in showing one of the sisters painting the portrait of the artist as he paints

FRANCIS COTES, *Portrait of Thomas Crathorne and His Wife Isabel Crathorne*, 1767. A typical visual presentation of a female amateur, all grace and elegance.

NATHANIEL DANCE, *Portrait of the Honourable John Pratt and His Sisters Jane and Sarah*, 1767. Unusually for an oil portrait of an English amateur, the young girl is shown in the act of drawing.

MARIA COSWAY, *Self-Portrait with Arms Folded*, 1787 (opposite). The artist 's husband forbade her to sell her paintings, perhaps disliking the risk of gossip which stalked women artists. The effect of the folded arms and the hidden hands is of a woman unable to practise her profession.

her. Perhaps her youth encouraged a break with the matronly formula. For evidence of the amateur at work, watercolours, a less formal medium than oil, are more revealing. Paul Sandby painted a number of watercolours of busy young ladies who may have been his pupils. One enchanting and informative image shows a young woman at a painting table, her colours held in oyster shells. These well-connected women enjoyed the best equipment. Sir Joshua Reynolds lent Lady Yates paintings to copy in silks and gave her a *camera obscura*, and Sandby recorded Lady Frances Scott drawing from a *camera obscura* in 1770.

Despite their high profile, the effusive praise, and the industry of teaching and manuals which grew up to service their desire to draw, amateurs did nothing for the reputation of professional women artists. Their visibility played a part in making familiar the pairing of women and art, but the second-rate quality of much of their work meant that the professionals moved their skirts away from any touch of amateurism. Since the professionals gained their identity and status in opposition to the amateurs, they were careful in their self-portraiture to keep away from the modish new portrait format of amateur with pencil and portfolio.

PAUL SANDBY, *Lady Frances Scott Drawing from a Camera Obscura, with Lady Elliot, c.* 1770. Watercolour, a less formal medium than oil, was usually chosen for pictures of amateurs at work.

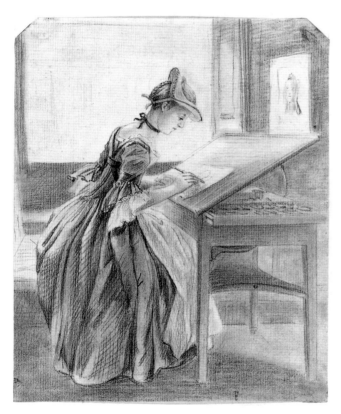

PAUL SANDBY, *A Lady Copying at a Drawing Table, c.* 1770. Amateurs learned by copying drawings and etchings. This is perhaps a portrait of one of the young ladies taught by Sandby. Her watercolours are held in oyster shells.

This makes the exceptions of great interest. Angelica Kauffman, who spent fifteen years in England from 1766 to 1781, drew heavily on the new formula in several self-portraits. Her single status and life of travel, work and association with the opposite sex meant that scandal and innuendo followed her as a kitten follows string. An unfortunate first marriage to a bigamist in 1767 was followed by a vicious pictorial attack in 1775 by the Irish artist Nathaniel Hone. He submitted a painting to the Royal Academy of Sir Joshua Reynolds and a lady naked save for black boots, reputed to be Angelica Kauffman (the Academy authorities ordered the offending area to be removed). So titillating was the idea of a female painter drawing from life that, twenty years after her death in 1807, the writer John Thomas Smith questioned an eighty-two year-old retired Academy model to find out if there was any truth in the rumours: 'He assured me that he did frequently sit before Angelika Kauffmann at her house on the south side of Golden Square, but that he only exposed his arms, shoulders and legs, and that her father...was always present.'[30] Somehow, helped by the constant presenceof her father, the protection of aristocratic women, her professionalism, that particularly eighteenth-century package of charm and intelligence, and a succession of superficially anodyne self-portraits, she emerged unscathed. 'Who me?' she seems to be asking innocently as she modestly clasps her fichu close in a self-portrait painted in her English years (p. 100).

One can only admire the way she used the accomplishment self-portrait as a shield against the potshots of gossip and malice. In a self-portrait aged forty-six she presents herself with all the boneless grace of the accomplishment pose, one hand on her portfolio in the manner of Mrs d'Ewes Coke in Wright of Derby's painting, the other holding a porte-crayon that looks as if it has never been used (p. 93). Even the most disarmingly feminine of eighteenth-century self-portraits with the tools of the trade exhibit some tautness of pose and evidence of artistic energy: backs are straight and elbows sharp as the brush is brought to the canvas. Far from vapid posturing, however, this self-portrait represents an effort to use the new vocabulary to create a desired persona.

By the time she painted it, she was living in Rome in great respectability with her second husband, Antonio Zucchi. Goethe met her at this time and recounts in *Italian Journey* how he loved to look at paintings with her: 'She is sensitive to all that is true and beautiful, and incredibly modest.'[31] This picture of charm and calm is also the picture she chooses to present to the public in the self-portrait, and may well have contained an element of wish fulfilment. Thanks to Goethe, we learn that even in Rome with her sedate second husband, life was not quite as she hoped: 'She is tired of commissions, but her old husband thinks it wonderful that so much money should roll in for what is often easy work. She would like to paint to please herself and have more leisure to study and take pains, and she could easily do this. They have no children and they cannot even spend the interest on her capital.'[32] She painted this portrait to replace one done years earlier and sold

without her permission to the Uffizi self-portrait collection. She knew exactly how she wanted to present herself among the other self-portraits on the walls, and her control of the outcome is an eighteenth-century example of image management.

This icon of refinement belongs to a woman who was no amateur, but a survivor of a very public career. A clue to her tenacity, and the clever charm with which she hid it, can be found in the cameo on her belt, a copy of a gem in Naples which illustrates the contest for control of Attica between Minerva, patron of the arts, and Neptune, god of the sea. Each had to produce a gift for the people. Neptune brought forth a salt spring while Minerva created the olive tree. Minerva won.[33] It was a charming way to suggest the superiority of the female sex.

An engraving of the English artist Maria Cosway, (all that survives of the original self-portrait) sums up the amateur-professional divide of the eighteenth century. Born in Florence to English parents who ran hotels for travellers on the Grand Tour, she discovered her talent when she was eight years old. (Eight is a special age in the mythology of women artists. Elisabeth Vigée-Lebrun was eight when she covered her convent school walls and friends' schoolbooks with drawings.) 'At eight years I began drawing, having seen a young lady draw I took a passion for it more than I had for Music. I was taken home and put under the care of an old Celebrated lady whos[e] portrait is in the gallery.... This lady soon found I could go further than she could instruct me, and Mr Zofani being at Florence my father ask'd him to give me some instructions. I went to study in the Gallery of the Palazzo Pitti, and copied many of the finest pictures.'[34]

Her father's work ensured that artists and people of influence came within her orbit, and, after she was elected to the Florence Academy as *pittora inglese*, one of them, Mrs Gore, took her to Rome and Naples. Here, in a version of the male artist's study tour of Italy, she made contact with the art and artists of what was then the centre of the art world. Naturally much was made of her beauty and talent. 'We have now in Rome a Miss Hadfield, who studies painting.

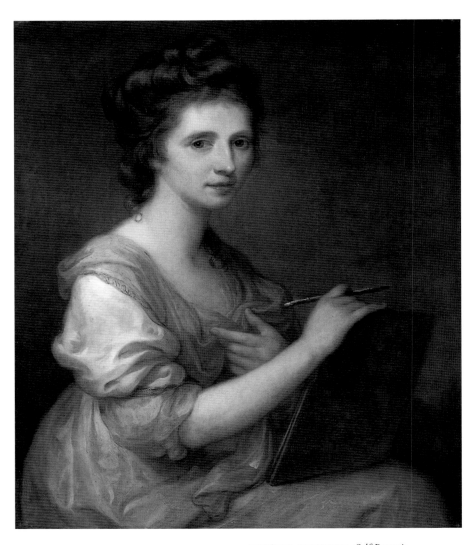

ANGELICA KAUFFMAN, *Self-Portrait*, *c.* 1770–75. The portfolio and elegant pose is borrowed from the portraits of lady amateurs. Perhaps the professional Kauffman is attempting to emphasize her respectability by associating herself with these refined images.

She plays very finely on the harpsichord, and sings and composes music.…and will be another Angelica,' the artist Northcote wrote home to England.[35] In 1779, the twenty-year-old Maria came to England with her mother, armed with letters of introduction to the first people of fashion and to important artists like Angelica Kauffman and Sir Joshua Reynolds, then president of the Royal Academy. In 1781 she married Richard Cosway, a painter to the royal family, and in the nine years between her marriage and the birth of her daughter in 1790 she exhibited over thirty paintings at the Royal Academy.

In all this she was paralleling the career of a professional like Kauffman in that her talent was discovered early, she received professional instruction, she made copies of works in art galleries and she went to Rome and Naples to see – and meet – the best the art world had to offer. Like Kauffman, she arrived in England with the reputation of having broken a heart or two in the English community in Rome.

In 1787, Maria Cosway produced the self-portrait based on Rubens's *Le Chapeau de Paille*. Known today only as an engraving (p. 96), it is an extraordinary image. Where are the tools of her trade? Where is the evidence that she is an artist? Above all, where are her hands? They are firmly tucked away, a most unusual choice of pose for an artist.

The answers are to be found in her failure to fulfil her early promise and produce an impressive body of work. She herself had no doubts how this had happened: her husband would not allow her to sell her paintings. 'Had Mr C permitted me to rank professionally, I should have made a better painter; but left to myself, by degrees, instead of improving, I lost what I had brought from Italy of early studies.'[36]

Although she exhibited at the Royal Academy all through the 1780s, her husband preferred her to be celebrated for her musical talent in a domestic setting rather than for her art in a public one. Her looks, her charm, her voice and her harp made her an infinitely greater asset to his career than any success as a working painter. It is possible, too, that as a member of the royal entourage, he did not wish his wife – and through her, himself – to be tainted by the touch of trade or by scandalous innuendo, those occupational hazards of professional eighteenth-century women artists.

Is it possible that in this revealing self-portrait Maria Cosway is showing us – perhaps unconsciously – that her hands are tied as far as her professional career as a painter is concerned?

By the end of the eighteenth century, accomplishment art had spread down through the ranks to become a symbol of gentility for every shopkeeper's daughter, and by the second half of the nineteenth century the reign of the accomplished amateur was over. By then a woman serious about studying art could do so at a school set up for that purpose. The element of class which marked amateur off from professional lost its meaning, and henceforward a woman, in theory at least, could choose to paint as a hobby or as a career.

HORTENSE HAUDEBOURT-LESCOT, *Self-Portrait* (detail), *c.* 1825. A rare early example of a female artist basing her self-image on a celebrated male portrait. The first woman in Western art to show herself in an artist's beret, she has added a brush and a gold chain, symbols of her professional status.

THE NINETEENTH CENTURY THE OPENING DOOR

The nineteenth century was the century of change for women artists. Alongside the conventional view of women as tender, emotional, and less rational than men, there had always existed a strand of ideas which argued for their equal treatment. When times were right, these ideas would receive a sympathetic hearing – for example, Adélaïde Labille-Guiard's plea to the French royal academicians at the time of the French Revolution that there should be no limit on women Academicians. Half way through the course of the nineteenth century, there was another wave of feminist advance, and the doors into art schools all over Europe began to give way before the women's pushing hands. The first half of the century, however, saw the retreat of feminist ideas, and self-portraits exhibit the charm and grace familiar from the previous century.

In 1825 Antoinette-Cécile-Hortense Haudebourt-Lescot, a successful French portrait and genre painter, produced a self-portrait which must be one of the first attempts by a woman to inhabit a male portrait. The boldness of this move is not immediately apparent. The first impression is of a middle-aged woman artist of

good sense. The measured placing of the hands, the tilt of the head, the relaxed and barely opened lips – is she about to speak or smile? – present an image of a poised artist aged forty-one in complete command of herself and her profession. But the clothing, the artist's beret and gold chain favoured by male artists anxious to show the dignity of their profession, is an unusual choice for a woman painter. When this is considered alongside the flowing strokes, the dramatic light and the subdued colouring, the image takes on the ambitious overtones of an old master. So daring is the transposition that it is not immediately apparent that she has modelled herself on Raphael's great portrait of Baldassare Castiglione.

Rembrandt had also been influenced by Raphael's portrait of Castiglione. He based a self-portrait of 1640 (National Gallery, London) on this painting after he had seen and sketched it in an Amsterdam saleroom the previous year.[1] Like Haudebourt-Lescot he included the beret, an attribute of the artist since the fifteenth century. And also like Haudebourt-Lescot he added a gold chain, traditionally an honour conferred by a ruler on an artist, and therefore a mark of the artist's status: Titian had painted himself wearing the chain awarded him by Charles V. Rembrandt could boast of no such award but nonetheless included a gold chain in the 1640 self-portrait. Haudebourt-Lescot, who also had no right to a chain, has been subtle in the way she suggests hers. It could pass as personal jewellery and its overtones of artistic status are only accessible to the initiated.

Haudebourt-Lescot was a figure of standing in the French art world. She was an early practitioner of Italian genre scenes – her first Salon submission in 1810 consisted of eight paintings of local customs – and she had spent several years in Italy, still the capital of Western art, when the artist who had taught her to paint when she was seven years old became director of the French Academy in Rome. Not surprisingly, her self-portrait exudes self-confidence. She makes a claim to be included in the history of Western painting by inhabiting a famous image by a famous artist. She shows herself in time-honoured male artistic dress without compromising her femininity. And she displays her imagination through her ability to visualize a transposition from male to female.

Compared to France, where several male artists accepted female students, and women professionals were part of the art world, England had few professional women artists at this time. Rolinda Sharples was one of them. Though her father James was a successful pastel portraitist and taught his daughter to paint, it was her mother Ellen, also an artist, who was the greatest help to her career. Ellen Sharples kept a diary which is a corrective to the theories, guesses and gaps that riddle the subject of women artists. Mrs Sharples shows that it was possible to make a living as a provincial woman painter in the last years of the eighteenth century and the first decades of the nineteenth, and that this could be managed with ease and without a hint of scandal. Her diary brings the world of the woman artist down to earth and in so doing supports the observations made by Farington.

At the age of thirteen Rolinda 'drew the portrait of a young lady of her acquaintance in crayons, which was greatly admired for the correctness of the

RAPHAEL, *Baldassare Castiglione*, c. 1514–15. The inspiration for Haudebourt-Lescot's self-image.

likeness, and which decided her becoming a professional artist. The praises bestowed on her performances, with the small gold pieces in exchange, were very exhilarating and made her apply with delighted interest, improving rapidly.'[2] Rolinda had the perfect temperament for her chosen career. Her mother became 'exceedingly agitated when attempting original portraits'. Not so her daughter 'who conversed with a person sitting for a portrait with as much ease as if unemployed and made her sitters equally at ease'.[3]

Rolinda's father died when she was eighteen, and his widow devoted herself to her daughter's development: 'It is very delightful to me to see her always cheerful and happy, ardently engaged in various intellectual pursuits, particularly that of painting, for which she has a decided taste. Exercising it as a profession she views it as attended with every kind of advantage. The employment itself is a positive pleasure; it procures many articles of utility and luxury that otherwise would be

regarded as extravagance; the persons she draws entertain her whilst sitting, become her friends and continue to be so, ever after meeting her with smiling countenances and kind greetings....'⁴

Rolinda's mother smoothed her daughter's professional life and acted as a travelling companion, supplying the envelope of propriety necessary for a provincial artist in nineteenth-century England. In 1831, when Rolinda was twenty, they took a letter of introduction to Mr Stothert's who 'showed Rolinda how to make up her palette and some new vehicles to be used in painting.'⁵ Such accounts throw light on the random quality that was typical of many women's art training. On that same London visit they discovered that Philip Reinagle, whose paintings they admired, gave lessons for two guineas: 'We spent a whole morning there, and she received instructions that have been extremely advantageous to her. Mr R bestowed uncommon attention, omitting no information that he considered would be useful, employing me the whole time she was practising to write down the instructions according to his dictation – his daughter, a pleasing girl, was copying a landscape.'⁶

ADRIENNE GRANDPIERRE, *Interior of the Studio of Abel de Pujol, c.* 1822. There were many professional women artists in early nineteenth-century France, and Abel de Pujol was one of several male artists who took female pupils. This painting is by his wife.

So it is no surprise to find that Rolinda Sharples painted a self-portrait with her mother, a warm tribute to a one-woman support system which reveals their mutual intimacy, trust and comfort (p. 113). To contemporary eyes, the placing of the heads has the energy of two people moving close together for a photograph. It is a surprisingly dynamic treatment for an artist usually dismissed as provincial. Her decision to pose with her back to the piano in a self-portrait as musician exhibits a similar air of immediacy.

Rolinda Sharples specialized in painted records of local events. In 1820, when she was twenty-seven, her painting *The Market*, painted partly on the spot and including portraits of the people of Bristol, the city where she lived, was a huge success at the Royal Academy: 'We always had the pleasure to see a crowd round the *Market* similar to the crowds round the *Opening of the Will from Waverley* by Wilkie, the *Wolf and Lamb* by Mulready, *Londoners Gypsying* by Leslie and a few other paintings by distinguished artists.'[7] In 1834, she put herself into her record of a local court case, *The Trial of Colonel Brereton*, a large work containing about a hundred portraits, in the process producing what may be the first female witness self-portrait. The witness self-portrait, in which artists paint themselves into the events they are recording, was not a type that had been of use to women, given the difficulties faced by genteel ladies working in public. The nearest thing to it is Clara Peeters's record of herself at work in the shiny surfaces of her still-lives. But in 1834 Rolinda Sharples tells us she was there by painting herself next to her mother with an open sketchbook in her hand.

Another category of self-portrait that first appears early in the century shows the artist at work in a domestic interior. In *Self-Portrait with the Ward Family* (Kennedy Galleries, Inc.), the American Ann Hall shows herself drawing at a table. Behind her is a painting on a large easel and the parents, grandmother and two children are disposed about the living room as the artist works. The spectator should be wary of assuming that this depicts an actual room. One should never forget the tradition, exemplified by the eighteenth-century English painter Arthur Devis, of inventing surroundings for sitters. In this case, it seems unlikely that the artist would take a large easel into the sitters' home and equally unlikely that a family of five and their dog would come to the artist's house to be painted all at the same time. The easel may have been included as a sign of her professionalism.

In England at about the same time, the watercolour artist Mary Ellen Best pictures herself at work in her painting room in her mother's house at York (p. 116). She sits at her easel which is placed next to the window in order to catch the light. Her watercolours, palette and water mug are to hand, and her prints and sketchbooks are on the far side of the room.

ROLINDA SHARPLES, *Self-Portrait, c.* 1814. This English artist brings the theme of the artist-as-musician into the nineteenth century. A competent musical performer, she chooses an unusual pose with her back to the piano.

ROLINDA SHARPLES, *The Trial of Colonel Brereton* (detail), 1834. Sharples records herself with sketchbook in what may be the first female witness self-portrait.

Mary Ellen Best is an early example of a woman painter who uses her watercolours to document her life as others use a journal. She was taught to paint at boarding school, could produce a creditable portrait when she was twelve and kept on painting portraits and places until the mid century when she was about forty, perhaps discouraged by the recording powers of photography. Certainly her practice of mounting her personal work into albums was a forerunner of the family photograph album.

Mary Ellen Best seems to have a been a sort of hybrid artist, a cross between an amateur and professional. Encouraged by her mother, grandmother and sister, she painted for her own pleasure, but would take portrait commissions when she could to supplement her income. Although as a middle-class lady she was unable to do anything so aggressive as advertising her skills, she entered work in local exhibitions and always ensured she had a picture at the local framer's, a good way to catch the public's eye. Like Rolinda Sharples, hers was an artistic life devoid of stress and insults, probably because her medium (watercolour), her subjects (domestic and scenic) and her lifestyle (provincial and unambitious) posed no threats to established artists.

The originality of her four hundred watercolours lies in their completeness as a view of a middle-class lady's life and travels. This completeness means that she includes herself in her pictures when necessary, a practice lost when photography took over visual record-keeping. Before she married in 1840, she works in her painting room in York. In 1842 she holds her newborn Caroline while the eldest,

SARAH PEALE, *Self-Portrait*, c. 1830. Peale, a member of a North American artistic dynasty, presents herself in ladylike and modest guise.

Frank, takes his first steps in the doorway and her German husband Anthony offers her coffee. In 1846 she sits with her husband at breakfast while the children, now numbering three, are tended by the nursemaid. Most charming of all are the two self-portraits she painted at the time of her wedding. In one she is a painting held by her husband; in the other she holds a portrait of him (pp. 116–17).

For three successive summers in the early 1850s, the amateur Louisa Paris kept a watercolour record of the places where she stayed with her family in the south of England.[8] In one of them, she paints her own traces, the sketching stool, palette and parasol abandoned on the downs. She did not know it, but she was fitting into a tradition of absent self-portraits. Fifty years earlier, for example, Boilly had painted a table of objects that marked his profession (*Trompe-l'oeil*, Fondation Rau pour le Tiers-Monde); fifty years later Gwen John would paint a corner of her room in Paris (p. 128).

Although there were exceptions, women did not begin to benefit from institutional art education in any great numbers until the 1870s. Berthe Morisot trained in the traditional way in the 1850s and '60s, being handed on to ever better teachers as her talent developed.

In 1884, she painted herself sitting by the side of her seven-year-old daughter (overleaf). Compared to the mother-daughter paintings of Vigée-Lebrun, this painting charms through the technique and not the manipulated imagery. In terms of self-portrait types, this is a manifesto painting. It represents everything she valued artistically and emotionally. Family was important in her life. Her mother was supportive of her prickly and perfectionist daughter's ambitions and set up social situations where she could meet important artists. Her husband was the brother of the painter Edouard Manet, a fact always offered to explain how after marriage and motherhood she was able to continue her commitment to the avant-garde painting of the day. (The trouble with this explanation is that it gives her no marks for sticking power. It could not have been easy. Her letters reveal that she once gave up sketching outdoors because Eugène so hated her hair to get windblown.[9])

She was a committed member of the Impressionist movement, exhibiting in every one of the group's exhibitions except for the year her daughter was born. Her family supplied much of her subject matter – Impressionism was the one style where domestic subject matter was not despised – so it is particularly fitting that it is her daughter Julie who sits beside her in this self-portrait. Though unfinished in exhibiting terms, it displays the sketchy yet descriptive brushstrokes so typical of this artist. Apart from her daughter's face, which is yet to emerge out of the gauzy web of marks and dashes, this ravishing painting reveals the skill which lay behind the appearance of spontaneity. This self-portrait is a first sighting of a type to

HELENA J. MAGUIRE, *Self-Portrait Sketching, c.* 1880 (above). An early example of an outdoor self-portrait. The intensity of this work by a young Irish artist owes much to the Pre-Raphaelite device of bringing the subject close to the picture frame.

LOUISA PARIS, *The Old Town of Eastbourne,* 1852 (opposite). By describing herself through the sketching materials, parasol and stool left on the downs above Eastbourne, this amateur artist has produced the first female self-portrait *in absentia.*

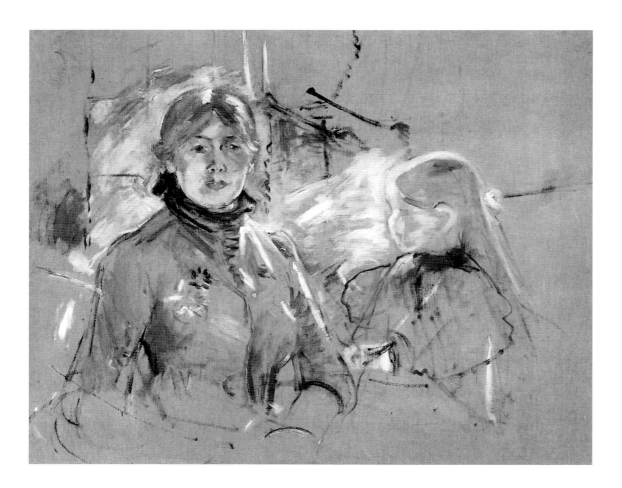

become common in the twentieth century, the self-portrait in which style is
as important as content in speaking about oneself.

Like the men in the group, the women Impressionists left few self-portraits:
it was the following generation, artists such as Van Gogh and Gauguin, who
painted themselves. The women's features are known through the men's portraits
of them rather than through their own self-scrutiny. Manet's many portraits of
Morisot ceased just before her marriage, when he painted her with half-veiled
face, as if she were about to go into purdah. Degas produced several etchings
of Mary Cassatt at the Louvre. Félix Bracquemond made an etching of his
wife Marie at work on a drawing.

Not only are the women Impressionists' self-portraits rare, they are remarkably
reticent. Berthe Morisot had a little flurry of self-portraiture in 1885, with a pastel
head (Art Institute, Chicago) and another related to the self-portrait with her
daughter (Private Collection). Mary Cassatt has left an unfinished gouache of
herself at the end of the 1870s (Art Institute, Chicago) which is as unrevealing of
her looks – she averts her eyes from the spectator – as it is of her profession – her
hands are clasped in her lap. About two years later she did a self-portrait at the
drawing board (National Portrait Gallery, Washington) and this too is strangely
retiring: the board is only suggested and her face is deeply shadowed.

BERTHE MORISOT, *Self-Portrait with Her
Daughter Julie*, 1885. An unfinished oil painting,
this maternal image by one of the leading French
Impressionists is typical of the domestic subject
matter that inspired her.

The improved institutional opportunities for women to train as artists in
the second half of the nineteenth century produced no immediate explosion
of self-portraits in response. The reason for this was the shakiness of the women's
position. However seriously they took themselves, in many ways the art world
was not ready for them. There was a vast difference in women's experience as
students and professionals from family to family, within the same country, from
country to country, and from decade to decade. Progress was erratic: to take just
two examples, in England the semi-official Royal Academy schools let women in
from the early 1860s while in France the state-supported Ecole des Beaux-Arts
held out till the eve of the twentieth century.

A serious problem was that although women's entrance into the art world
paralleled their efforts to enter other fields, the training for art was less codified
than training for professions like law or medicine, which also faced a hail of
would-be women students. All over the Western world, women could buy an
art training from an assortment of sources, but the suppliers of that education
could not be relied on for rigorous standards. With some exceptions, the female
academic curriculum was diluted. Furthermore, art school owners could limit

The Mixed Antique Class at the Slade School,
from *The Illustrated London News,* 1881. Art
schools began to open their doors to women
in the second half of the nineteenth century.
The accessibility of institutional training
encouraged women to take their artistic
careers as seriously as the men.

entry by indulging their prejudices. For example, Hubert von Herkomer, who ran a respected school outside London at the end of the century, was not alone in refusing married women as students.

Female advances in training and the setting up of organizations, exhibiting structures and support groups of various kinds marched alongside more repressive views of women's role. Even at times of advance, women's conditioning and the paralysing effect of conventional attitudes about female behaviour could prevent women making the most of their talent. The journey towards towards a career took place on a snakes and ladders board, with all the element of chance that this involved. They might go up a ladder to art school if they could afford it/had a supportive family/lived in a country offering education for women. They might slide down a snake to marriage/motherhood/lukewarm family support. But, despite this, more and more women began training as artists.

ALICE BARBER STEPHENS, *The Women's Life Class*, 1879. The life class – this one was in Philadelphia – was the last bastion against the artistic desegregation of the sexes.

ROLINDA SHARPLES, *Self-Portrait with Her Mother, c.* 1820 (opposite). In this surprisingly dynamic image from an artist usually dismissed as provincial, Sharples pays a warm tribute to the mother who was her companion and support.

Although they are not strictly self-portraits, the paintings which depict their classes bear witness to their excitement at this new life.

The young Russian Marie Bashkirtseff, one of the generation of women who went to Paris to study art in the 1870s, painted a large group portrait of sixteen fellow students working from a child model for the 1881 Salon. The genesis of this painting as revealed in her journal throws light on the attitude of her teacher, who had suggested the subject on the grounds that, 'A woman's studio had never been painted. Besides, as it would be an advertisement for him, he would do all in the world to give me the wonderful notoriety he speaks about.' [10]

A woman painter's reputation, both social and professional, still depended on her respectability as much as her talent. Until the end of the century, there was no such creature as a bohemian woman artist. Even the extraordinary Frenchwoman Rosa Bonheur, the outstanding animal painter of mid-nineteenth-century France, made sure she was never interviewed in the masculine clothes which were her habitual form of dress. Hoping to exchange female visibility for male anonymity, she applied for a permit from the Paris police to dress as a man in public when she was doing the preparatory drawings for her masterpiece *The Horse Fair* in 1851. [11]

Perhaps her awareness of the disjunction between her private and public selves explains the absence of any self-portrait after the youthful doll-like cameo in the Uffizi, although she was fond of putting her own touch on other people's portraits of her. In 1857 when Edouard Louis Dubufe was painting her portrait aged thirty-four, she was irritated by its bland flattery, and persuaded him to let her paint in the head of her favourite bull in place of the table he had planned. It is tempting to view this painting as a form of self-portrait, since she has ensured that what matters most to her artistically is present in the painting. This desire to leave her mark on others' paintings of her continued throughout her life. In 1893, she wrote to Consuelo Fould who was painting her portrait: 'When once the portrait is finished, or even before, if you prefer, you can send me the canvas and I will paint the dog.' In 1895, *Rosa Bonheur in her Studio* by Achille Fould was exhibited at the Salon. 'She herself painted on my canvas the pictures she was engaged upon at the time and which formed a part of my composition.' [12]

The classic expression of the conflict between the period's notions of femininity and the raising of women's expectations that was the inevitable result of allowing them into the art world, comes from Marie Bashkirtseff: 'What I long for is the freedom of going about alone, of coming and going, of sitting on the seats in the Tuileries, and especially in the Luxembourg, of stopping and looking at the artistic shops, of entering the churches and museums, of walking about the old streets at night; that's what I long for; and that's the freedom without which one can't become a real artist. Do you imagine I can get much good from what I see, chaperoned as I am, and when, in order to go to the Louvre, I must wait for my carriage, my lady companion or my family?' [13]

She also reveals that the teachers were unable to let the women forget they were women. With one eye on her older classmate Louise Breslau and one on her work, she wrote: 'It is that rogue of a Breslau whom I fear most. She is admirably gifted,

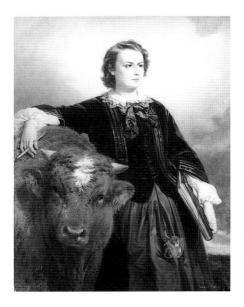

EDOUARD LOUIS DUBUFE, *Portrait of Rosa Bonheur*, 1857. A celebrated animal painter, Bonheur herself painted the bull in this portrait. Though not a self-portrait, it is a portrait of the artist that is partly from the artist's hand.

and not bad-looking; I assure you she will make her way.'[14] One can hardly blame
her for her competitiveness when the teachers themselves lumped women together:
'And I must tell you that M. Julian and the others said at the men's studio that I
had neither the touch, nor the manner, nor the capabilities of a women;'[15] – and
this from the head of a studio considered the most sympathetic to women artists.

The only way Marie Bashkirtseff could reconcile the conflict was by being
both the best-looking woman and the best artist. This tension between her
ambition and her femininity is displayed in a self-portrait done two years before
she died from consumption at twenty-six (p. 120). Her serious commitment to
art is signalled by the huge palette and the unsmiling gaze, and her vanity by
the flattering neckline, the silhouetted figure, the allusion to her musical talent
supplied by the harp. This revelation of herself as vulnerable, vain and intense
is echoed by her journal.

The exploration of gender appears earlier in women's photographic
self-portraits than it does in painted self-portraits, where it has to wait until the
twentieth century. Two reasons for this suggest themselves, both based on the way
in which there seemed to be a more direct link between the mirror and the camera
than the mirror and the brush. The first is speed. Although most self-portraits were
and are set up, the camera encouraged the belief in immediacy, particularly after
the box camera made photographing oneself as simple as looking through a
viewfinder and pressing a lever. Photographing oneself is
as close as it is possible to get to the experience of trapping
the image that looks back from the mirror. It is painting
without the element of time, of decision making, of work.
It is possible that this instantaneous quality encouraged
photographers to seize the moment, to act on impulse,
to trap images of their imagination, to try new personas on
for size. The second reason is privacy, which seems to have
encouraged a spirit of play. This may be connected to the
ephemeral nature of photography, its link with news and
newspapers, its uncertainty as to whether it is an art or a
craft, its aura of 'anyone can do it'. Whatever the reason,
time and again, right up to the present, this playfulness
surfaces in photographic self-portraits. In 1898 the American
Frances Benjamin Johnston posed herself in a 'male'
manner. Elbow out, mannish cap on her head, tankard
in one hand and cigarette in the other, she leans forward
with the calf of one leg resting on the thigh of the other,
in an image that prefigures the gender explorations of
the 1970s.

It took time for women to find their place in the
art world, and it is not until the last two decades of the
century that a new female self-portrait type appears, one
that resonates with the painter's seriousness and application.

FRANCES BENJAMIN JOHNSON,
Self-Portrait, c. 1896. The exploration of gender
appeared first in photographic self-portraits.

THE NINETEENTH CENTURY

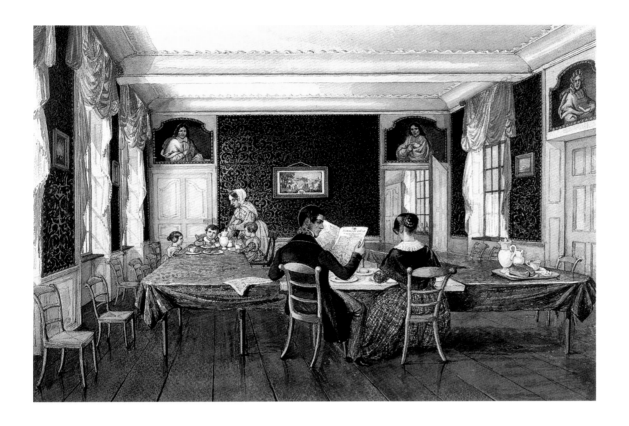

MARY ELLEN BEST, *The Artist in her Painting Room, York*, 1837–39 (opposite above). Best's hundreds of watercolours are a visual diary of her life. Though usually considered an amateur, she painted portraits to supplement her income.

MARY ELLEN BEST, *Ellen and Anthony with Frank and Caroline in their Home on the Bockenheimer Landstrasse, Frankfurt*, 1842 (opposite below).

MARY ELLEN BEST, *The Sargs at Breakfast in a Hotel at Liège*, 1846 (above). The artist and her husband sit apart from their three children.

MARY ELLEN BEST, *Portrait of Johann Anton Phillip Sarg*, 1840 (left). At the time of their wedding, Ellen painted Anthony holding her self-portrait.

Gone is the need to resemble a lady, the glamour and the self-conscious femininity. The women depict themselves at their easels, sensibly clad in smock or apron, clutching their brushes and palettes and deep in concentration, a testament to the earnestness with which they take their entry into the world of art. The symbol of their seriousness is the palette, which tends to play an extremely assertive role in these paintings, highly visible and apparently larger than life. 'Apparently' because palettes had in fact grown bigger by the end of the nineteenth century. A larger range of colours, oil paint in tubes, a faster freer style of applying paint had all contributed to change the palette's shape from the neat rectangle of the sixteenth century to the curved expanse of the nineteenth, a development traceable through self-portraits.

One cannot help wondering if the increased importance of the palette in many late nineteenth-century self-portraits has anything to do with photography. The portable box camera, quickly adopted by amateurs, was invented in the 1880s, but studio photography still relied on large, heavy and unwieldy apparatus. When women photographers carried on the self-portrait tradition, they substituted the camera for the palette. While palettes could be handled like an accessory, flaunted or cradled in order to create the desired impression, women photographers had to work out how to present their visual relationship with the camera.

The camera offered women a formidable image of control which painters could not match. Around 1903, in *Under the Skylight* (Museum of Modern Art, New York), A.K. Boursault photographed Gertrude Käsebier in charge of her monstrous machine. Käsebier was admired for her romantic portraits of women and children, but Boursault has caught the tension involved in producing such softness by making her clenched hand controlling the apparatus the focus of his image. At the turn of the century, the American Kate Matthews masculinizes her camera, standing small, smiling and feminine next to it, the image of a sparky little woman. It is a parody of centuries of husband-and-wife portraits, except that in this case she is active and controls the male element with her femininity. This playing with power is a new element in self-portraiture.

The Dutch painter Thérèse Schwartze is typical of the new breed of self-confident women artists who changed the face of the Western art world at the end of the nineteenth century. She was invited to paint herself for the Uffizi when she was thirty-six, and in the seriousness with which she takes her art; in her trust in her talent and not her coquettishness (she has kept her glasses on); in the suggestion of a pause between movements; in the heavy paraphernalia of her artist's equipment, this self-portrait could be a symbol for all the ambitious woman artists of the day. The hand above the eyes, a traditional viewing gesture used a century and a half earlier by Reynolds in a youthful self-portrait suggests that she needed no convincing that she was living at a time of female advance.

Many female self-portraits of the period display a similar sense of the artist wrestling with her art. In 1889, the English artist Milly Childers considers with head on one side how to progress with her painting. Her brushes are held in the same hand as the palette, giving the impression of thought before choosing one to

KATE MATTHEWS, *Self-Portrait, c.* 1900. In their self-portraits, the photographers had to work out how to present their relationship to the camera. The American Kate Matthews masculinizes her machine.

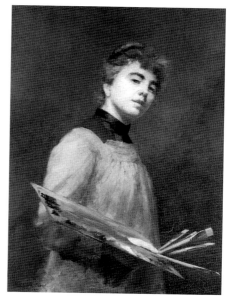

MILLY CHILDERS, *Self-Portrait*, 1889
(above). The palette, which had grown larger
by the nineteenth century, owing to paints in
tubes, new colours, a faster style of applying
paint, became a symbol of the seriousness
with which many late nineteenth-century
artists took their profession.

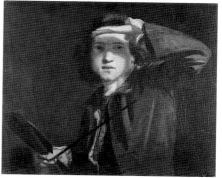

JOSHUA REYNOLDS, *Self-Portrait*,
c. 1747 (above). Perhaps this was too free
and 'masculine' a gesture to have been used
by women artists before Schwartze's time.

THÉRÈSE SCHWARTZE, *Self-Portrait*,
1888 (above left). The caught-in-the-action
gesture and the large palette symbolize the
new commitment of women artists.

take in her right hand and make a mark. The palette and brushes form a barrier
between the artist and spectator, and the tilt of her head demands that we view
her as a serious working artist. The eighteenth-century necessity for ingratiating
femininity has been left far behind.

The Polish artist Anna Bilinska paints herself taking a break from her work
(p. 121). She is convincingly scruffy. She has not bothered to remove her apron,
and, although her hair began the day pinned up, some tendrils have escaped. As
she sits on a homely bentwood chair, she bends forward to stare at the spectator,

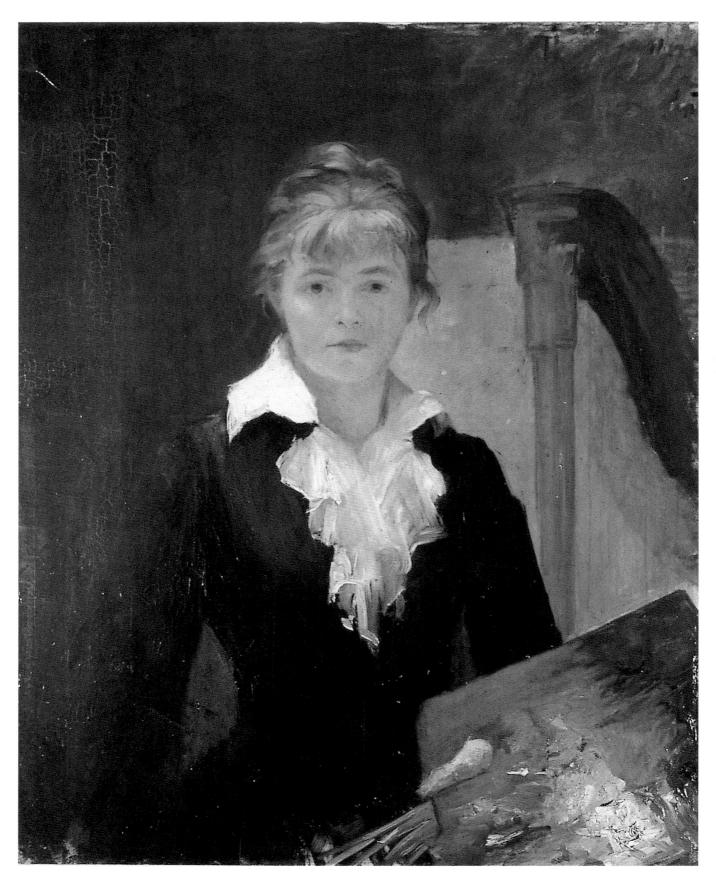

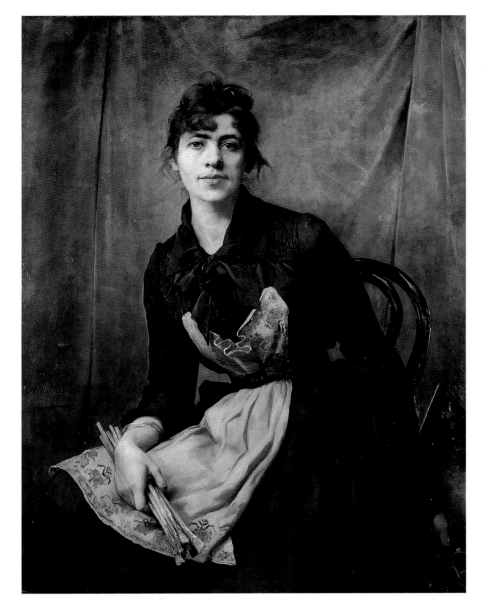

a bunch of brushes held across her apron in one hand and her palette hanging down at the extremity of the other. The capacity of the language of self-portraiture to deal with women's changing view of themselves is revealed by comparing this image with Angelica Kauffman's submission to the Uffizi (p. 93). This pose of Bilinska's has not been seen before. She has set herself down in front of the curtain which forms a background for the model. The combination of transitory pose and backcloth is an understated but witty way of telling the spectator that she has become – but only temporarily – the model not the artist.

One male self-portrait type that women had never touched, the migrating self-portrait, was finally attempted in the closing years of the century. Michelangelo had painted his distorted features on the wall of the Sistine Chapel; Caravaggio

MARIE BASHKIRTSEFF, *Self-Portrait with Jabot and Palette, c.* 1880 (opposite). This ambitious young Russian, who died in her twenties, presents herself in a late nineteenth-century version of the artist with musical talent.

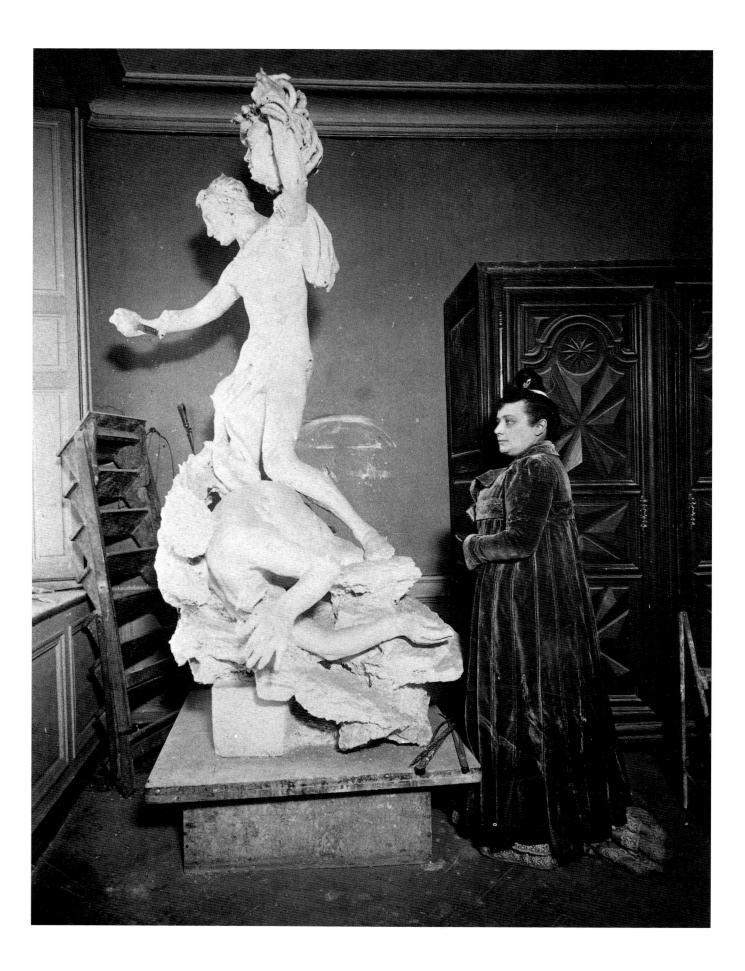

had painted his likeness as the head of David held by Goliath. At the end of the century, Camille Claudel began her sculpture of Perseus holding the severed head of Medusa to which she gave her own features. Made at the time of her rejection by her lover and teacher Auguste Rodin, her self-portrait as the snake-haired Gorgon whose eyes turned her enemies to stone was a wish-fulfilling piece of vengeance as well as a powerful image of the impotence she must have felt.

There appears to have been more room for fantasy in photographic self-portraits than in paintings at the turn of the century, perhaps because the heavy investment of time was an inhibiting factor in painting frivolous subject matter. Early photographic fantasies have an air of the dressing-up box about them. The American Alice Austen and friends clearly had fun one sunny afternoon producing *Julia Martin, Julia Bredt and Self Dressed up as Men, 4:40 pm, October 15th 1891*. Marie Bashkirtseff, that most feminine of painters and yet one of the most frustrated by that femininity, would have understood the point of the freedom offered by the poses and gestures. But are the women mocking the men at the same time as they imitate them? Games again.

In *Trude and I Masked, Short Skirts, 11 pm, August 6 1891*, Alice Austen produces a less innocent image: white underwear, cigarettes, masks and is that bedclothes? The image has disturbing overtones: girls trying to be older than they are, prostitution, night-time privacy, bizarre double imagery.

Whatever the realities, the opening up of institutional art education to women encouraged them to take their ambitions seriously. When she was in her sixties and resident in Paris, the Irish artist Helen Mabel Trevor painted a self-portrait which radiates self confidence. Her erect posture, huge palette, searching eyes and painter's smock show that she is more than happy to proclaim 'identity: artist'. Like Haudebourt-Lescot sixty years earlier, Trevor wears an artist's beret. But no longer does it have to be worn so subtly, for this painter feels she is as entitled as any man to her place in the art world. It is a telling symbol of the changes the century brought about for women artists.

ALICE AUSTEN, *Julia Martin, Julia Bredt and Self Dressed Up as Men*, 1891 (above left); *Trude and I Masked, Short Skirts*, 1891 (above right). Games and humour appeared earlier in photographic self-portraits than in painting and sculpture.

CAMILLE CLAUDEL photographed (opposite) with her sculpture, *Perseus and the Gorgon*, 1898–1905. Perseus holds aloft the severed head of Medusa which bears Claudel's features.

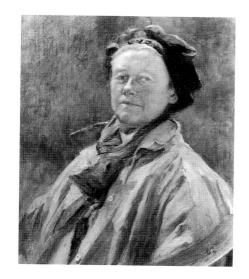

HELEN MABEL TREVOR, *Self-Portrait with Cap, Smock and Palette*, 1900. By appropriating the traditional smock and beret of the artist, this Irish painter shows herself the equal of any man.

HELENE SCHJERFBECK, *Self-Portrait, Black Background* (detail), 1915. In 1914, the Finnish Art Society commissioned nine self-portraits for its boardroom. Schjerfbeck was the only woman among the nine artists. In her words, the resulting self-portrait, executed when she was aged fifty-three, 'has a black background and against the background, silver lettering like on a gravestone.' Her pride and confidence is offset by a vigorous curl of hair.

THE TWENTIETH CENTURY BREAKING TABOOS

The twentieth century opens with a new type of woman artist: independent and unshackled by conventional notions of feminine behaviour. A penniless Gwen John in Paris at the start of the century earns money by posing nude for Rodin. Paula Modersohn-Becker periodically leaves her artist husband in Germany to keep up with avant-garde developments in Paris. Suzanne Valadon discovers a talent for drawing and, encouraged by the artists for whom she models, starts a new career as an artist. These pre-First World War women are the first of the female bohemian artists, the female heroines of the modern movement.

It had taken about fifty years – not very long – for women to claim their own space in the art world. As they set up their easels next to the men in the art classes, they began to feel – or at least some of them did – that they could put *their* concerns, *their* way of seeing things into their paintings without the disguise and defences of previous centuries.

There is an exhilarating sense of breaking taboos in much self-portraiture as the century begins. The bohemian-artist persona became acceptable for women

and encouraged new behaviour and new subject matter. Women's accelerated entry into the art world at the turn of the century coincided with the birth of psychoanalysis, and there must surely be a link between the new interest in self-knowledge and the sudden rash of female self-portraits in the nude, of self-portraits revealing personal passions, of self-portraits exploring the problems and excitements of entering a man's world.

The new boldness did not come easily to everyone. It is the nature of accounts like this to concentrate on change and advance, but, despite improved access to education, women still had to be more determined than men if they wanted to follow an artistic career. Women were still hampered by patronizing attitudes towards their talent, determination and rightful place: Sickert excluded women from his Camden Town Group in 1911 probably because they were complicating both his private and professional life. Women artists were still surrounded by male eyes, correcting and assessing as of old: when Gwen John's father came to see her in Paris in 1898 he thought her low-cut neckline made her look like a prostitute. They were still victims of their own conditioning, too willing to run, walk or stop when a man said so. It took strength to survive all this.

And a room of one's own. A twentieth-century development of female self-portraiture is the painting of the artist's room, evidence of the importance of their own space to these women artists. *A Room of One's Own*, Virginia Woolf's argument that a room and an income were necessary if a woman was to write, was published in 1929, but visual evidence of its application to artists was available in 1900 when Emilie Charmy painted the first of her several portraits of the rooms she worked in (p. 128). Gwen John twice painted the room she loved in the Rue du Cherche-Midi in Paris, once with an open window, once with an umbrella propped against the chair (p. 128).

The Parisian Marie Laurencin was the first woman to paint herself into a group portrait of artists, alongside Picasso, Apollinaire and Fernande Olivier, in *Group of Artists*, 1908. Group portraits have a long history and Marie Laurencin's second version of her painting, *Apollinaire and His Friends*, 1909, has a compositional relationship with Eustache Le Sueur's *Gathering of Friends* of 1640–42, which she knew from the Louvre. The tradition was revivified at the start of the nineteenth century with a flurry of paintings of studio gatherings, and again at the time of Impressionism with group portraits of the like-minded, exemplified by Fantin-Latour's homage to Manet of 1870, *The Studio in the Batignolles Quarter*. For a woman to originate a group portrait and to include herself shows her feelings of equality in this new artistic world. The fact that Apollinaire was Laurencin's lover and Picasso and Fernande Olivier her friends makes this a twentieth-century version of a support-system self-portrait.

Research has shown that the paintings are imbued with Rosicrucianism, a mystical Christian belief which intrigued many Parisian artists at the time.[1] In both versions, Laurencin wears a blue dress, the colour of the robe of her namesake the Virgin Mary. Using a style all her own to make her points, she ensures that everyone she depicts, male or female, is an element in a scheme

THE TWENTIETH CENTURY

HENRI FANTIN-LATOUR, *The Studio in the Batignolles Quarter*, 1870. A group portrait proclaiming its subjects' artistic beliefs.

MARIE LAURENCIN, *Group of Artists*, 1908. Laurencin, at the apex of this triangular composition showing her friends and her lover, paints a twentieth-century version of the female support-system self-portrait. The protection and encouragement, supplied in earlier centuries by the family, can now be drawn from artistic affiliation.

of line and shape and colour. This graceful placing of the characters to accord everyone equal emphasis is her visual expression of her beliefs in the interdependence of male and female and the links between artists and writers. Despite this, she has subtly distinguished herself from the others in the 1908 painting as she sits above them holding a rose. It is a strategy of power through grace that her eighteenth-century ancestors would have understood.

Laurencin's inclusion of herself in a group portrait is evidence that every major twentieth-century stylistic movement has had its women members. Gabriele Münter's house in Murnau before the First World War was a centre for the avant-garde art of her companion Wasily Kandinsky and friends Marianne von Werefkin and Alexei Jawlensky. Until 1916, the year Kandinsky left her, there is a quizzical quality in her many self-portraits, and she is often at the edge in her portraits of the group. These group portraits raise the peculiarly twentieth-century problem of distinguishing style from content. The semi-abstract art favoured by the group (in Kandinsky's case, completely abstract by the First World War) meant that detail would never be her main concern. In decoding the self-portrait in her studio (p. 129), is she merely an element in the arrangement of shapes and colour or are we justified in claiming that her personality was less assertive than her art? After all, the language of self-portraiture did not die when abstraction came along, and the placing, size and pose of characters still carried meaning. Nina Simonovich-Efimova's *Self-Portrait in an Interior, Sokolniki*, 1916–17 (p. 128), raises similar questions.

The self-portrait with female model was a type favoured by male artists in the second half of the nineteenth century as a way to advertise their bohemian status.

EMILIE CHARMY, *Interior in Lyons: The Artist's Bedroom*, 1902 (above left). Charmy did several studies of her surroundings. The freedom to leave home, and even country, to train and attempt a career was a revolutionary development in women's lives, and their rooms became a symbol of this new liberty.

NINA SIMONOVICH-EFIMOVA, *Self-Portrait in an Interior, Sokolniki*, 1916–17 (above). The mirror for a time lost its associations with vanity and became more a symbol of introspection. It is often included in early twentieth-century self-portraits.

GWEN JOHN, *A Corner of the Artist's Room in Paris*, 1907–9 (left). John's studies of her room were further examples of the self-portrait theme adopted internationally to express women's new freedom to practise their art.

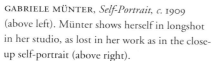

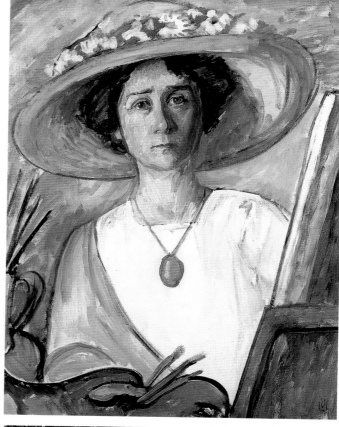

GABRIELE MÜNTER, *Self-Portrait, c.* 1909 (above left). Münter shows herself in longshot in her studio, as lost in her work as in the close-up self-portrait (above right).

GABRIELE MÜNTER, *Self-Portrait at the Easel, c.* 1911 (above right). A gentle self-image of the artist looking out at her subject as she paints. She used the same straightforward style for a portrait of her friend Marianne von Werefkin.

MARIANNE VON WEREFKIN, *Self-Portrait,* 1908–10 (right). The Russian-born artist was more flamboyant and intellectual than Münter in her approach to painting: her ideas on Symbolism and Expressionism had been published by this time. The non-realistic colours, exaggerated shapes and swirling brushstrokes express her own dramatic view of herself.

Lovis Corinth holds a glass in one hand and his model's breast in the other in a portrait which flaunts his disregard of conventional behaviour. This artist-and-model format evolved into a less sexually charged form in female self-portraiture of the early twentieth century. Corinth's model Charlotte Berend, who was to become his wife the following year, was his student and a painter. In 1931 she produced *Self-Portrait with Model* which undercuts a sexual reading by showing both women looking at Berend-Corinth's work, suggesting a kind of equality. I am willing to accept the current orthodoxy that the fact that the painter is female changes the tone of the artist-model self-portrait, but I am uneasy about the absence of context in discussions of the model in male artists' work of the late nineteenth century.[2] Corinth's image is shocking, but for fifty years artists had been attempting to establishing their anti-bourgeois credentials by a visual alliance with the model in their self-portraits. From Courbet's *The Painter's Studio* of 1855 to Thomas Eakins's *William Rush and His Model* of 1908, in which the sculptor hands his model down from the dais like a queen, there are notable painters who reject the traditional presentation of models as objects of voyeurism.

The British painter Laura Knight was a product of the new accessibility of institutional art education for women. When she was thirteen, her art-teacher mother entered her at the Nottingham School of Art as an artisan student, which meant she paid no fees, and she had the luck, dedication and talent to succeed as a professional. In a wonderful self-portrait of 1913, she lays out for the viewer the change in the lives of women artists. Before the twentieth century, credibility and propriety forbade the inclusion of a naked model of either sex in a work by a

GLUCK, *Self-Portrait with Cigarette*, 1925 (opposite above). The expression of sexual tastes and ambiguities was now permitted.

ROMAINE BROOKS, *Self-Portrait*, 1923 (opposite below). She presents herself in a stylish image of masculine glamour.

LOVIS CORINTH, *Self-Portrait with Charlotte Berend and a Glass of Champagne*, 1902 (below left). In this painting, which refers back to Rembrandt, Corinth challenges bourgeois values. Berend was the first pupil in Corinth's Berlin art school for women. They married some months after this was painted.

CHARLOTTE BEREND-CORINTH, *Self-Portrait with Model*, 1931 (below right). Twenty-nine years later Berend paints her own self-image, presenting her model almost as an equal in her artistic undertaking.

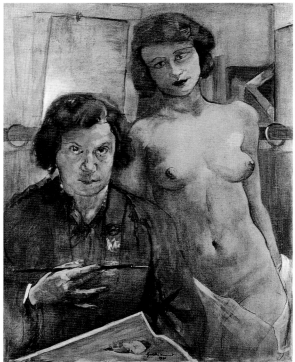

woman artist. Living in Cornwall with her husband Harold before the First World War, Laura Knight 'found something all my own'. 'How holy is the human body when bare of other than the sun,' she wrote in her autobiography. Sadly, apart from this self-portrait (overleaf), almost nothing of this work remains today. Her sketch books of female nudes were destroyed by damp: 'Among the work crowding my studio there is no record of that intensive study covering many years – that of the nude figure in its natural surroundings.'[3]

Several elements in this painting announce its importance to the artist in speaking about her beliefs. The painting is life size. It emphasizes the female figure – Knight was well known by this time for her paintings of female circus and theatrical performers. It shows off unashamedly by including not one but two nudes, encouraging the viewer to judge how well Knight's work is progressing. And it challenges the stereotype of the artist as male by replacing the familiar male-artist/female-model combination with a female-artist/female-model variation.

The German artist Lotte Laserstein's *Self-Portrait in My Studio* (p. 133) expresses how normal a subject the woman artist and her model had become by 1928. The brilliance of this image arises from the exclusion of the undercurrents of sexuality which traditionally cling to artist and model paintings. The model's breasts flatten truthfully as she lies on her back and the artist translates flesh into paint with deep absorption. You can hear the quiet in this painting. Whatever the sexual preferences of Laserstein and Knight, they do not allow us to read them from their paintings – even the ambiguous nature of Laserstein's appearance could be due to the fashionable androgyny of the day. All the same, the choice of a female model is intriguing. Does it mean that women took over the male-artist/female-model stereotype unthinkingly, or did they realize the public was not yet ready to see them painting a male nude?

Artists who wished could now speak freely about their sexuality, even when it was not of the most conventional kind. Though Rosa Bonheur was careful not to reveal her masculine image in public, the freedom of the 1920s allowed the British artist Gluck to paint herself in the guise of a dashing man in a black beret and striped tie, with a cigarette between her lips, and the American Romaine Brooks to present herself as a wonderfully glamorous mannish woman. Like Gluck, the French photographic artist Claude Cahun

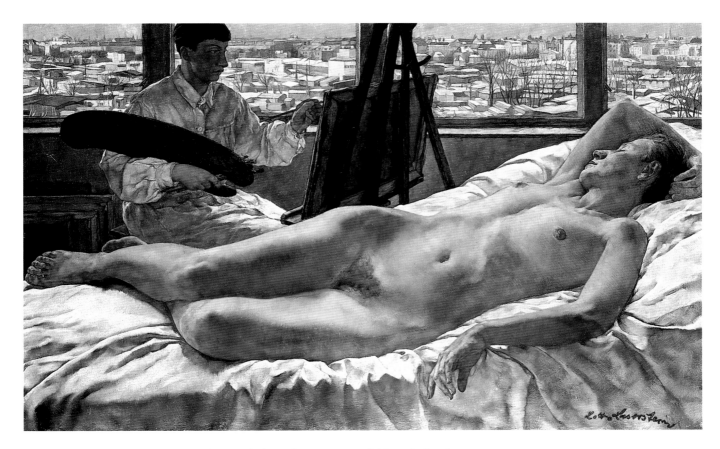

(an invented and ambiguous name) was a lesbian from a successful Jewish family. When she dresses up as a girl with braids round her head in one of the many sensitive self-portraits she created from 1912 until the 1930s, she looks doll-like and artificial – no doubt how she felt (p. 134). But when she photographs herself as a man, she produces androgynous images of subtlety and imagination (p. 134).

Photographers continued to play with the masculinity of the camera. In 1933, Margaret Bourke-White employs a male camera, clothes and stance to emphasize her powerful femaleness in a work which has the quality of a film still of the period (p. 135). In 1925 Germaine Krull photographs herself with cigarette and camera in a classic photographer's gesture, applicable to either sex, which brilliantly sums up the image of the interwar photographer (p. 135).

Painters were still unable to compete with photographers in creating an image of power. The reflex cameras of the interwar years were often used in self-portraits as a powerful extension of the body. (The strategy has an interesting precedent in Mary Cassatt's painting of 1880 of a woman turning her opera glasses on the audience.) The ability of the third eye to put a barrier between the photographer and the world shares overtones of authority with the doctor's torch that looks into our eyes and ears and down our throats. Ilse Bing inspects us in an image that is neither comfortable for us nor a friendly presentation of herself (p. 142).

Though more restrained than the revelations in male self-portraits (for example, Egon Schiele's depiction of his sexual tastes), women begin to speak in public

LOTTE LASERSTEIN, *In My Studio*, 1928. A twentieth-century artist presents herself through her professionalism rather than her person. But women painters still followed male artists in showing themselves painting a female model.

LAURA KNIGHT, *Self-Portrait*, 1913. The female body was Laura Knight's inspiration. This makes this painting a manifesto self-portrait announcing the painter's artistic convictions.

CLAUDE CAHUN, *Self-Portrait*, 1929 (above left), and *Self-Portrait, c.* 1928 (above right). Cahun was one of several artists at this period who explored masks, roles, gender and perception. Born Lucy Schwob, Cahun adopted her sexually ambiguous name in 1918.

MARGARET BOURKE-WHITE, *Self-Portrait with Camera, c.* 1933 (opposite). Her self-image links with the trouser-wearing glamour of such 1930s film stars as Marlene Dietrich and Katharine Hepburn.

GERMAINE KRULL, *Self-Portrait with Cigarette and Camera,* 1925 (right). In a classic image of the interwar photographer, androgynous and disturbing, Krull relishes the power of being able to turn the camera's eye on the world.

ZINAIDA SEREBRYAKOVA, *Self-Portrait at the Dressing Table*, 1909. A more intimate self-scrutiny was finding its way into women's self-portraits. The young Russian's hair crackles with electricity and her person with sexuality.

about the private early in the twentieth century. The portrait that the Russian artist Zinaida Serebryakova paints of herself in her underwear, chemise slipping seductively off one shoulder, her eyes hinting at the intimacies suggested by the bed, washbowl and loosened hair, is an example of the freedom felt by female artists at this time to commit their secret selves to canvas. Painted in 1909 when she had been married for a year, *Self-Portrait at the Dressing Table* crackles with the confidence, energy and pleasure in her femininity that earned her admiration in the World of Art group of pre-revolutionary Russia.

THE NAKED SELF

Related to this new freedom is the self-portrait in the nude. Gwen John was not shy about her body. Penniless in Paris in 1904, she modelled for Rodin's projected memorial to Whistler, a job which ended in a short and passionate affair – short, that is, for Rodin. Gwen John's obsession with the great sculptor affected her life

and art for several years. In 1909, with Rodin in mind, she did a number of drawings and watercolours of herself nude in her room in the rue du Cherche-Midi. The standing self-portrait on p. 21 is from a set of identical drawings produced by tracing, intended as skeletons on which she could practise applying the tones and colours of the gouache she had recently taken up.

In 1911, Serebryakova painted herself naked in *Bather: Self Portrait*, bought the following year by the Russian Museum of St Petersburg, and in 1917, while still a student, the sculptor Renée Sintenis drew herself drawing in the nude.

Like the painters, the photographers took their clothes off. Pictorialism, the style whose conventions the photographers were following, dictated an 'artistic' representation of the body. Imogen Cunningham's photograph of herself in 1906 lying nude in the grass or Ann Brigman's *The Lone Pine* of 1909 showing herself naked and at one with nature, seem more contrived than Gwen John's self-portrait sitting naked on the bed – a response that reveals our unsophisticated tendency to view painted self-portraits as straightforward transcriptions of reality.

The nude self-portraits are evidence of the curiosity with which women artists were turning their gaze on themselves. They were not merely interested in what

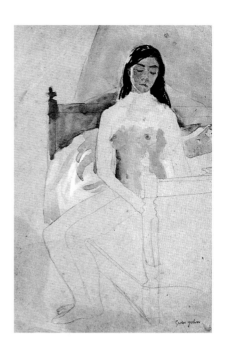

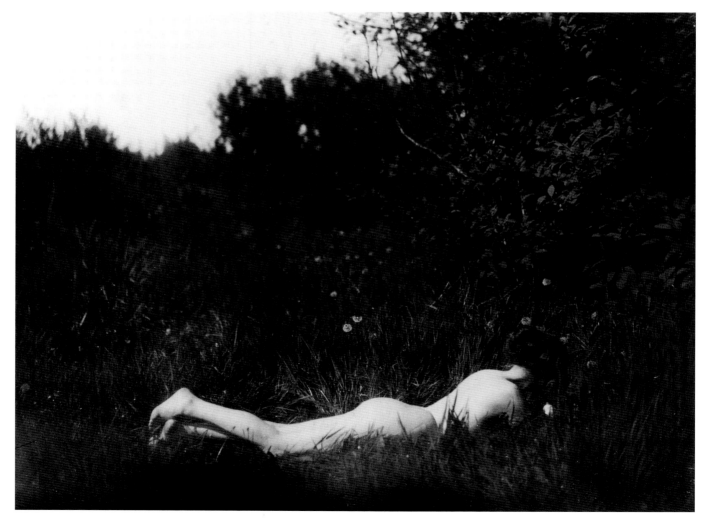

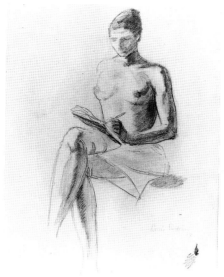

their bodies looked like but also seem to have been reaching for some kind of inner reality, as in Gwen John's searching examination of her face in a self-portrait of 1900 (Tate Gallery, London). The mirror had finally thrown off its allegorical link with vanity and became a symbol of the search for the truth behind the surface: a number of self-portrait drawings early in the century include the mirror from which the artist works. Reflections fascinated women photographers. In her 1931 self-portrait (p. 142) Ilse Bing borrows a device from painted portraits and employs a mirror to display her profile as well her three-quarter face. She also uses reflections to release the secrets of the image slowly, as if to disprove the claim that photographs hold less than paintings: it takes a moment for her face to materialize in her self-portrait on the New York subway (p. 142). It is the same impulse that drove Clara Peeters to paint herself reflected in the shiny surfaces of her still-lifes.

The large number of self-portrait series and cycles is a product of this new climate of introspection. Many of these are well known, such as the flow of self-portraits from the German artist Paula Modersohn-Becker, all marked by the searching gaze of her dark eyes (pp. 140 and 145). But it has been a widespread twentieth-century practice to turn to oneself repeatedly. The German-born, English-by-adoption Marie-Louise von Motesicsky painted self-portraits throughout her life. There is a poignancy in comparing the grey-haired artist contemplating herself in a mirror, *Self-Portrait with Pears* of 1965, with her younger self at the dressmaker (pp. 140–41).

The twentieth-century project of self-scrutiny was tailor-made for photographers, and many of them charted their lives through their self-portraits. Imogen Cunningham begins as a female Pictorialist, as pretty as a picture, and

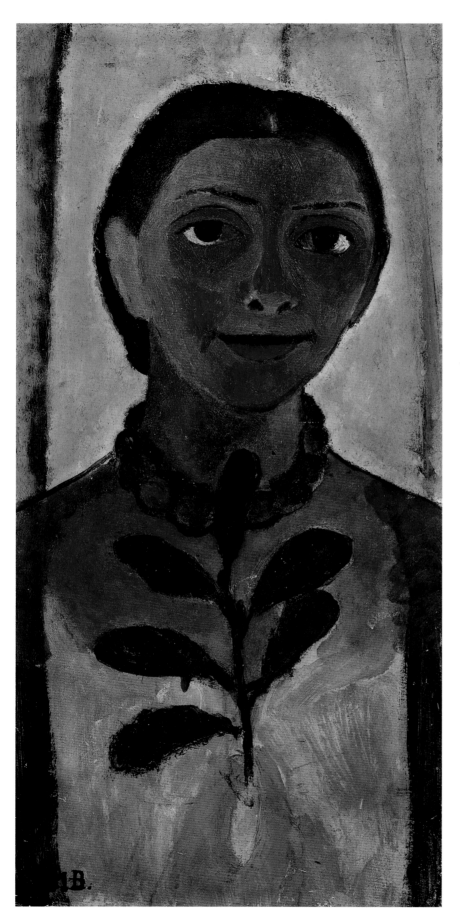

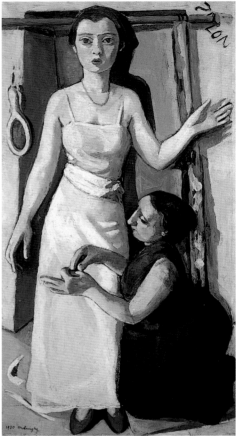

MARIE-LOUISE VON MOTESICSKY, *At the Dressmaker's*, 1930. The mirror represented the glamorous self she presented to the world as a young woman in Austria.

MARIE-LOUISE VON MOTESICSKY, *Self-Portrait with Pears*, 1965 (opposite). Years later, in England, the mirror is a symbol of a thoughtful search to find the truth behind appearance.

PAULA MODERSOHN-BECKER, *Self-Portrait with Camellia Branch*, 1906 (left). The increasing number of self-portrait series and cycles in the twentieth century is evidence of a new climate of introspection.

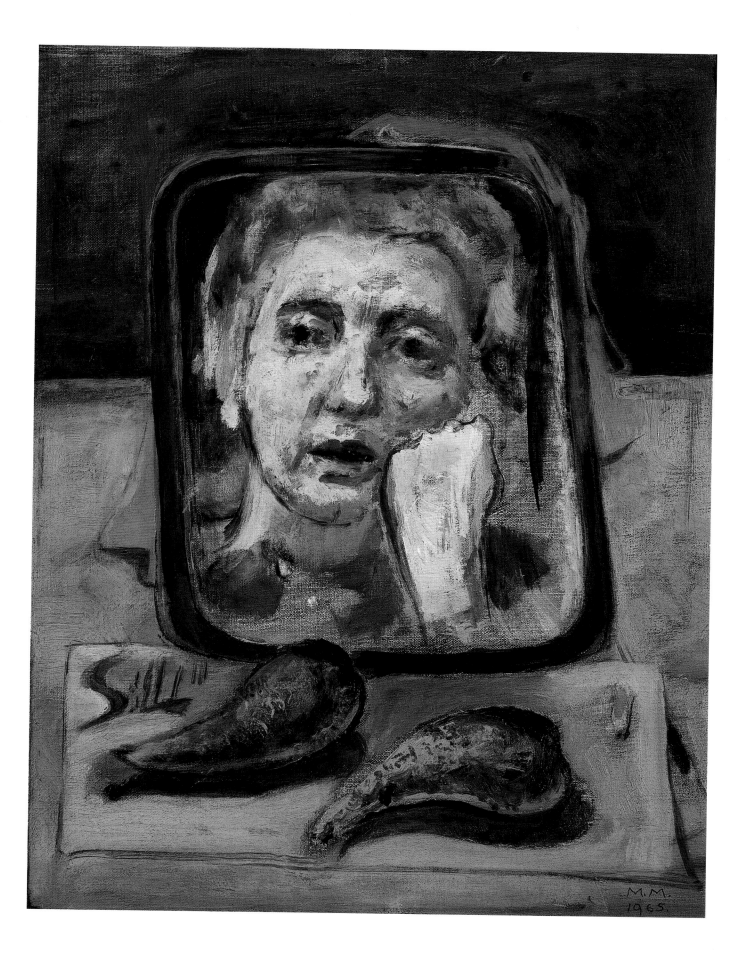

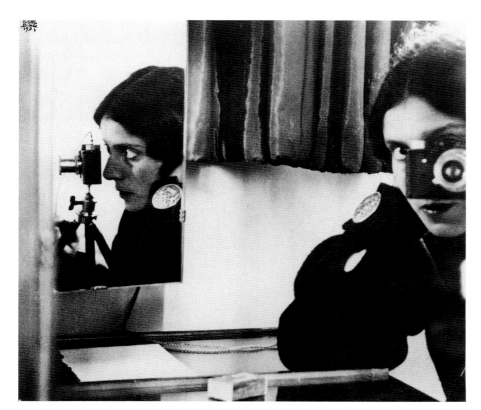

ILSE BING, *Self-Portrait with Leica*, 1931. The camera expanded the possibilities of self-portraiture. It can bar the viewer from possessing the photographer.

ILSE BING, *Self-Portrait with Metro*, 1936 (below). Reflections fascinated photographers, as they fascinated the still-life artists three centuries earlier. Small reflected self-portraits add depth, encouraging the viewer to search the image for information.

develops into a serious photographer who brings her cheek down to the camera as if it were a child. Florence Henri sets the image of the strong and stylish European with her artistically sophisticated self-portraits from the 1920s.

Introspection, freedom to speak out and the self-portrait series were united by the Mexican artist Frida Kahlo: all her paintings are self-portraits, an account of her pain and passion-filled life. No artist, male or female, has produced a body of autobiographical work to touch its orginality. A bus accident broke her spine when she was eighteen, and by the time of her death in 1954 aged forty-seven she had suffered through more than thirty-five operations, culminating in the amputation of a gangrenous leg. None of it stopped her living a life of passion in artistic, personal and political terms (Trotsky was a lover, the artist Diego Rivera twice her husband). Out of this came her extraordinary paintings, each a self-portrait and all together making a visual diary. It is Mary Ellen Best taken to extremes.

Life-shaking events have always affected artistic vision. It is possible that Artemisia Gentileschi's choice of women-centred themes of violence was due to her rape and subsequent torture. While her style and subject matter is shared by all the seventeenth-century artists influenced by Caravaggio, the fact that she did three versions of Judith cutting off the head of Holofernes is at least worth

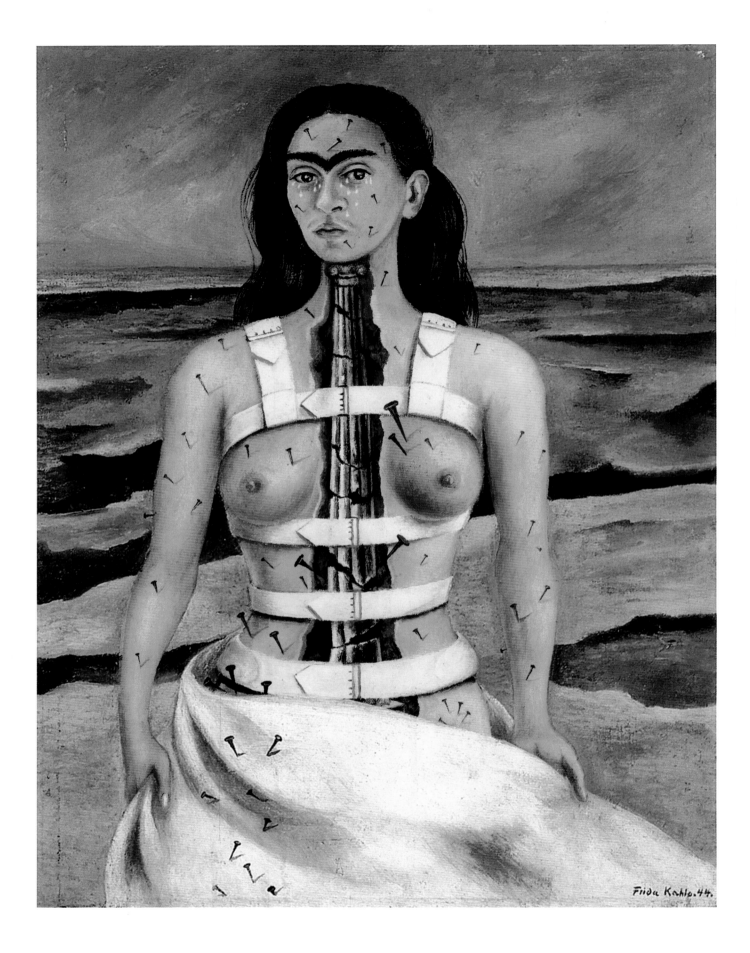

some thought in the context of her rape. The twentieth century gave permission for artists' obsessions to appear openly in their art. A body of work like Frida Kahlo's that offers a visual diary of the horrors and joys of her personal life could not have existed in an earlier age in so unmediated a form.

Frida Kahlo is responsible for bringing pain into female self-portraiture. The self-portrait of the tormented artist has a long history from Dürer as the suffering Christ to Goya in the grip of demons. Physical degeneration was brought into self-portraits by the demands of honest reporting, Rosalba Carriera's drooping eyelid, for example. But in *The Broken Column* of 1944 Frida Kahlo united the two and painted herself in both physical and mental pain. At the time of this painting, she had to wear a steel corset to support her back. Her agony is made visible by the tears dripping from her eyes and the nails stuck into her flesh like the arrows of St Sebastian in one of the primitive Mexican religious images that fascinated her. The broken column, a metaphor for her untrustworthy spine, has troubling sexual overtones, for while it helps her head to balance proudly it also rams unwelcomed through her body.

In its twentieth-century artistic incarnation, maternity begins with pregnancy. Elisabeth Vigée-Lebrun may have mentioned it in her memoirs, but Paula Modersohn-Becker painted it. On her sixth wedding anniversary in 1906, alone in Paris at a time of increasing discontent with her marriage, she painted herself pregnant. With an expression which defies decoding, she encircles her pregnant belly with her hands, one resting at waist level, the other cupping its base. There is a self-contained quality to this image as she observes herself alone with the child she is expecting – or, more precisely, imagines she is expecting, since as far as is known, she was not pregnant at the time. As her eyes examine herself examining her belly, she appears dignified and quizzical at the same time, introducing ambivalence into the mother and child self-portrait popularized in the eighteenth century: 'Will a child change my life?' she seems to ask. This self-portrait gains an added poignancy from the viewer's knowledge that when she actually became pregnant the following year, she died three weeks after giving birth. With this image, Paula Modersohn-Becker invented an archetypal pregnancy pose, equal to the classic Venus Pudica pose of classical Greece.

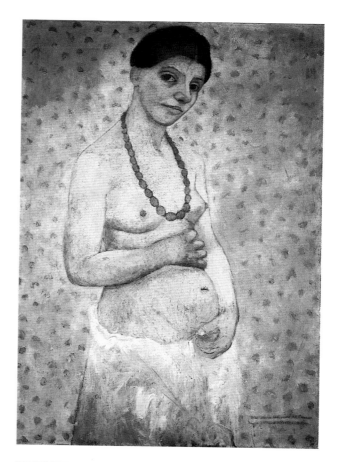

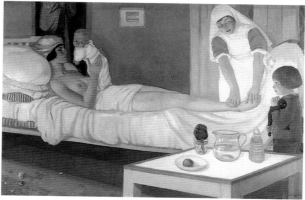

FRIDA KAHLO, *The Broken Column*, 1944 (opposite). A picture of pain and personal beauty from the visual autobiography which is the sum of Kahlo's paintings. The nails in her body represent the agony she suffered from the steel corset she wore to support her damaged spine.

PAULA MODERSOHN-BECKER, *Self-Portrait on her Sixth Wedding Anniversary*, 1906 (top). In an extraordinary use of self-portraiture she imagines herself pregnant. But imagined or not, the German artist created an archetypal image of pregnancy.

CECILE WALTON, *Romance*, 1920. The artist portrays birth as a sacrament, herself half-draped like a classical statue. The title of this large work suggests love at first sight with her newborn child.

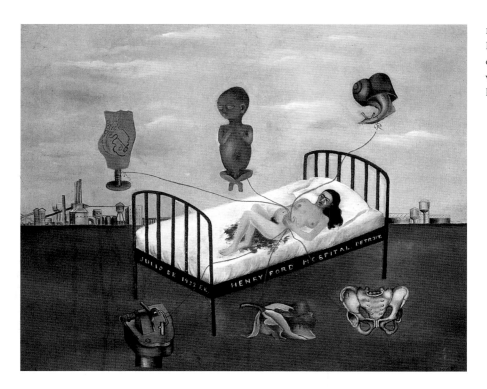

FRIDA KAHLO, *Henry Ford Hospital*, 1932.
Painted after a miscarriage, this is a self-portrait
of pain and loss. Kahlo, who remained childless,
was always unsure whether her relationship with
Diego Rivera could survive the birth of a child.

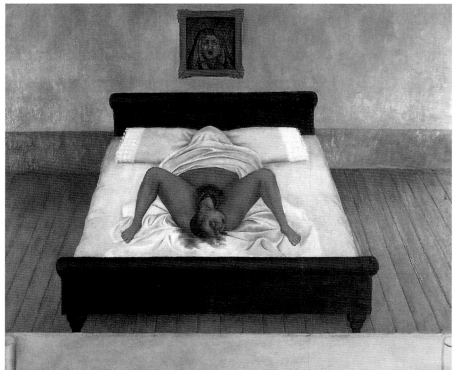

FRIDA KAHLO, *My Birth*, 1932 (below left).
A self-portrait almost unique in Western art,
this work expresses Kahlo's conviction of the
proximity of life and death, pain and pleasure.

GUSTAVE COURBET, *The Origin of the World*,
1864 (below). Painted by a man for a man, this
male gaze on a woman's body presents female
sexuality as ideally passive and faceless.

Birth follows pregnancy into twentieth-century self-portraits. A sacramental attitude to birth and motherhood is presented by the Scottish painter Cecile Walton who paints herself half-nude like a classical statue and holding her baby solemnly aloft (p. 145). A far grittier treatment comes from Frida Kahlo who never succeeded in carrying a baby to term. In *Henry Ford Hospital*, 1932, she painted her miscarriage, placing herself on a hospital bed in a pool of blood. *My Birth* belongs to the same year, a shocking image of her huge head with its black bar of an eyebrow emerging from between her own legs. In its explicitness it demands to be compared with Gustave Courbet's *Origin of the World*, the portrait of a woman's genitals painted in 1864 for the Turkish ambassador in Paris. While both paintings make a voyeur of the viewer, Courbet's painting fades into a smooth example of pornography while Kahlo's uncomfortable image forces confrontation with all the issues – birth, pain, and the grotesque – that Courbet had no desire to consider in relationship to sex. On a variety of levels – the power of the image, its originality, its incorporation of Mexican artistic traditions, its autobiographical revelation – this self-portrait is unique in Western art.

Children are no longer presented as adjuncts to the artist, for example as assistants (Mary Beale) or accessories (Vigée-Lebrun). The twentieth century brings respect for children – and respect for children's art. When the British artist Jean Cooke was painting her self-portrait in the 1950s, her son, whose cot can be seen in the background, toddled to the easel, picked up her brushes and added his own marks to his mother's painting. Rather than remove them, she incorporated them into her final image.

Familiar themes, like the self-portrait with family, take on a twentieth-century twist. In Suzanne Valadon's hands, the placing of the figures suggests the complications of relationships rather than their role as a source of support and respectability (p. 148). Suzanne Valadon had first-hand knowledge of female strength. She had supported herself from an early age and was the pillar of her family, which is why she puts herself at the centre. Placing her mother by her side suggests her acceptance of ageing – she did at least two self-portraits recording the effect of time on a body which in its youth had posed for Renoir (p. 149). The men form a diagonal line with Valadon at the centre and seem strangely powerless. The placing of her son, the artist Maurice Utrillo, suggests subservience, and although her companion André Utter is traditionally placed to her right and is taller, his gaze out of the frame suggests absence. Though each person is strongly characterized, it is Valadon who demands the viewer's attention, partly by her pivotal position, partly by her upright posture, partly by the hand that points to herself in pride and rests on her body in a gesture of ease with herself.

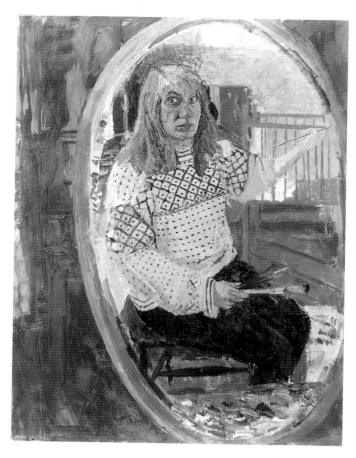

JEAN COOKE, *Self-Portrait*, 1958. A mid-twentieth-century expression of the maternal self-portrait. The second half of the century saw a new respect for children and their art. The artist incorporated into her painting the marks her child had daubed on her canvas.

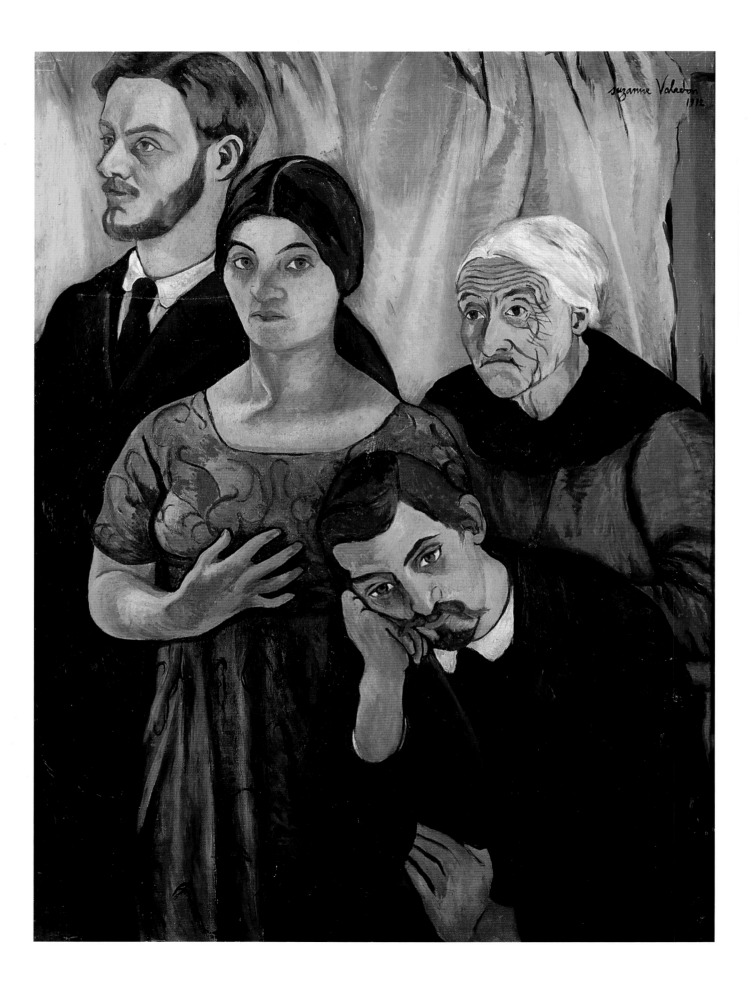

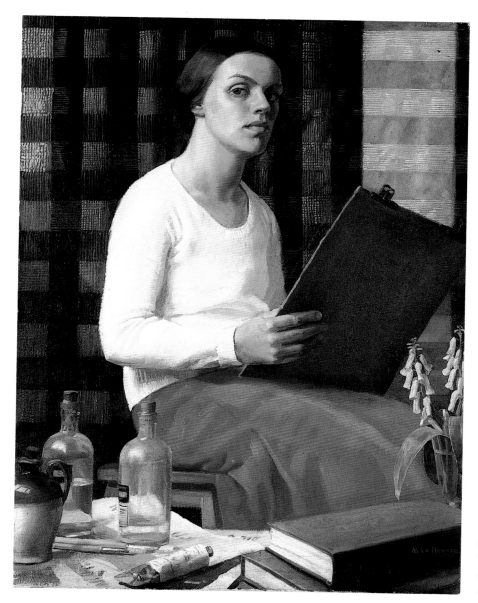

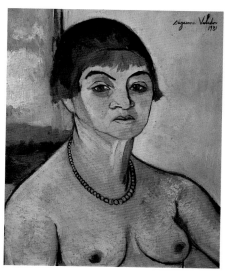

SUZANNE VALADON, *Self-Portrait with Bare Breasts*, 1931 (above). An artist who in her luscious youth modelled nude for Renoir turns a cool eye on her middle-aged self.

NORA HEYSEN, *A Portrait Study*, 1933 (left). This Australian painter produced a number of powerful self-portraits in the 1930s, each distinguished by the intensity of her gaze.

The increased number of women artists combined with improved life expectancy meant that self-portraits when old or less than lovely appeared more often. The proud portrait of the artist in old age, as revered for her years as her talent, becomes in Käthe Kollwitz's hands a dispassionate chronicle of her ageing self and its despairing response to the horrors of life (overleaf). Like Rembrandt, she was fascinated by the marks left by time, and even seems to have hastened the process in her self-portraits: after the age of thirty she never looked young again, recording the effect of life on her features through drawings, etchings and sculptures. The Finnish artist Helene Schjerfbeck painted her dying self as life and strength left her when she was in her eighties (p. 151).[4] As she removes the surplus paint from her canvas, she seems to be removing her own skin, trying

SUZANNE VALADON, *Family Portrait*, 1912 (opposite). Like Mary Beale (p. 64), Valadon separates herself from her family to stress her authorship and authority, but as an artist of her time she also suggests the emotional complexities of family relationships. She shows her companion (painter André Utter, whom she married two years later), her son (painter Maurice Utrillo) and her mother (an aged version of herself).

KÄTHE KOLLWITZ, *Self-Portrait*, 1926–32
(left). Kollwitz drew, etched, and sculpted
herself throughout her life in a self-portrait
series that chronicles the features of a caring
and despairing woman. During the years when
she was making this self-portrait, she lived with
her doctor husband in a Berlin slum, and had
visited the Soviet Union only to be disappointed
by the realities of its social experiment. In 1933
she was expelled from the Prussian Academy
of the Arts for her powerful pacifist and
left-wing works.

KÄTHE KOLLWITZ, *Self-Portrait*, 1910 (below).
Kollwitz was never interested in presenting
herself as younger than her years. Here, aged
forty-three, she supports her head on her hand
in a new self-portrait gesture of resignation
that casts a shadow on her strong features.

HELENE SCHJERFBECK, *An Old Woman Painter*, 1945 (above). Painted the year before she died, this self-portrait, one of a series of twenty between the ages of seventy-seven to eighty-three, shows the skull evident beneath the skin.

CHARLEY TOOROP, *The Three Generations*, 1941–50 (left). The bust of her father, the artist Jan Toorop, and her black-browed son could have dominated the painting, but Toorop has created a brilliantly balanced image, wielding her brush like a conductor's baton.

to expose the skull she knows is waiting for her. These stark images are an extraordinary *memento mori*, uniting the skull and portrait in one.

Age is not automatically a grim business. When she was eighty in 1980, the American Alice Neel painted a portrait of herself stark naked (p. 160). Taboos have never frightened Alice Neel. Nude portraiture is an area which she made her own, beginning in 1933 with her notorious portrait of Joe Gould with three sets of genitals. The same decade saw the first portraits of naked pregnant women as well as a nude portrait of a child which was refused a showing. Portraits of naked couples followed. This life-size self-portrait can therefore be seen as an artistic manifesto, a statement of her belief that nudity helps bring the viewer closer to the sitter. Though she has the air of a soft little grandmother, nothing fits the stereotype, from the young, strong colours to her acceptance of her nudity.

SONIA DELAUNAY, *Self-Portrait*, 1916 (left). The artist's appearance takes second place to the artistic style to which she and her husband Robert Delaunay were committed at this time.

JEANNE HÉBUTERNE, *Self-Portrait*, 1916 (below left). A simplified graphic style is used to convey a feline and predatory look.

TAMARA DE LEMPICKA, *Self-Portrait, c.* 1925 (below right). Her self-image of style and speed has become an icon of the 1920s.

ALICE BAILLY, *Self-Portrait*, 1917 (opposite). Artistic style and personal representation are given equal weight in this self-portrait. Emerging from the patterns and elegant lines is a picture of the artist as a sophisticated woman.

Far from appearing pathetic or ugly, the right hand grasping the end of the paintbrush, the left hand holding the paint rag, the feet askew on the floor and the spectacles askew on her nose draw attention to the concentration on her face and add an air of matter-of-factness to her elderly nakedness. As a former Communist, she believed that art is a form of history, and wanted to capture the era as well as the individual in her portraits. In this she has succeeded, for such a self-portrait could only have been acceptable in the twentieth century.

The twentieth century is often classified in terms of styles, and one of the attractions of its self-portraits is the way they wear the clothes of the artists' stylistic allegiance. Sometimes, as with Sonia Delaunay's reduction of herself to geometry in 1916, Alice Bailly's depiction of herself in Cubist terms or Tamara de Lempicka's depiction of herself as a classic icon of Art Deco, style can seem to swamp the content (pp. 152–53). In fact these artists – like Berthe Morisot before them – were applying their particular modernist belief that narrative had no place in modern art. With Expressionism, content, and in particular feeling, was given a place.

LEONORA CARRINGTON, *Self-Portrait 'A L'Auberge du Cheval d'Aube'*, *c.* 1938. This wild-haired, wild-eyed self-portrait was painted while the artist was living with Max Ernst in France. In her personal mythology, the horse symbolized rebirth and freedom, and the hyena her sensuality.

In 1914, Sigrid Hjertén painted herself in a way that it was impossible to imagine from the hand of a man (p. 156). Her pose, both graceful and bowed-down, is the key to her conflict as mother, wife and artist. She is a mother (her child looks towards her) but a painter too. She is a desirable woman (the fashionable hat and clothes), who follows a messy profession. She is surrounded by her husband's work (it is his decorative scheme in the background) but wants to find her own professional way. In 1941 the New Zealander Frances Hodgkins paints herself as a collection of objects in a semi-abstract still life (p. 156) because, her biographer suggests, she thought herself 'plain to the point of ugliness'.[5]

Surrealism expanded the artists' ability to speak about their dreams and desires. With its licence to reveal a reality which had nothing to do with logic, it enhanced the century's strand of self-portraits which told an interior truth. In *Self-Portrait 'A L'Auberge du Cheval d'Aube'*, painted when she was twenty-one and living with the Surrealist painter Max Ernst in France, the British artist Leonora Carrington used her private mythology to express her feelings about the pull between freedom and femininity. Clues to this work can be found in her fiction and her life. A hyena stars in a story written at this time and the rocking horse is a portrait of one she had recently bought in Paris. Her identification with horses as symbols of freedom and the sensuality of her fiction have both been transferred into this painting. Disquieting sexual and maternal suggestions in the hyena and the artist's hypnotically curving trousers contrast with the desire to lift above such physical matters expressed by the rocking horse which levitates on its way to freedom through the window.

At the start of the Second World War, Ernst was briefly interned. Leonora Carrington fled from France, suffered a severe breakdown and their relationship ended. In 1942 Ernst, exiled in New York, encountered Dorothea Tanning. 'Woman' with all the myths and fantasy the word encapsulates, was a Surrealist obsession, and Tanning was well equipped for the role of enigmatic beauty as her self-portrait *Birthday* shows (p. 157). As she tells it, she was illustrating advertisements for a department store when Ernst found her: 'It was this sad state of affairs that Max Ernst found one day after gazing at a portrait called *Birthday* (he was choosing pictures for an exhibition). See him leaning over the big piece of paper upon which Dorothea, with India ink black as pitch and a tiny brush, is painting the sparkle on glass gems. "Do you like doing that?" he asks. "No I hate it." "But then you should stop.... Listen. I have always earned my living by my painting. I think I can do it for two." It was 1942, December.'[6] No wonder he was fascinated. The lovely face and body, the disturbing imagination, the blank past and uncertain future suggested by all those open doors must have been irresistible.

KAY SAGE, *Small Portrait*, 1950. Sage's self-portrait relates to other work by this American Surrealist, which often featured abstract constructions. She loved enigma and wrote that there is no reason why anything should mean more than its own statement. The only clue to the artist's identity is the red hair.

SIGRID HJERTÉN, *Self-Portrait*, 1914
(above left).Open expression of the conflict
between women's roles enters female self-
portraiture at this time. Hjertén creates a
mood that contrasts sharply with Dumont's
proud picture of motherhood in the
1780s (p. 34).

FRANCES HODGKINS, *Self-Portrait:
Still-Life*, 1941 (above). A rose, a belt, a
collection of scarves symbolize the artist in
this absent self-portrait by a New Zealander
who was said to think herself too plain to
be painted.

ANTONIETTA RAPHAËL, *Self-Portrait
with Violin*, 1928 (left). The Russian-born
artist visualizes herself as an angel-musician
from an altarpiece of Renaissance Italy,
the country of her adoption.

DOROTHEA TANNING, *Birthday*, 1942
(opposite). Male Surrealists saw 'Woman'
as childlike, beautiful, erotic. Perhaps this
is why so many women Surrealists stress
their beauty in their self-portraits. Tanning
at thirty stands at the doors opening on to
the unknown; the beast at her feet suggests
the power of dreams.

THE TWENTIETH CENTURY

With the 1960s and '70s came the feminists, the century's second wave of heroic women artists whose influence is still felt today. From a feminist perspective, the art world seemed a strangely distorted place. Where were the women? Feminist art historians began the search for women artists of the past and examined women's roles in paintings, discovering that they were either saints (the Virgin Mary, Dutch housewives, good mothers) or sinners (castrating women like Delilah, lazy servants, witches). Feminist cultural commentators held art institutions up to the light and wondered why, when fifty per cent of art students were female, so few women made it into positions of power in the art world. Much of what is now taken for granted by art historians – male and female – dates from the anger and enthusiasm which fuelled these researches.

The feminists discovered previously unsung heroines, such as Louise Bourgeois whose art owed much to Surrealism's sexual suggestiveness and anthropomorphic shapes. Her work is informed by early family experiences (for example, her awareness of her father's unfaithfulness), and although it follows no specifically feminist programme, the concerns of its subject matter – maleness and femaleness, pain and power – were recognized by feminists as forerunners of their interests. Her disturbing bronze self-portrait of 1963–64 combines female fecundity and female helplessness in a pear-shaped torso which can also be read as phallic.

Bolstered by the belief that the personal is political, women artists sat down to create art that expressed their feelings as women artists in a man's world, as women in a man's world, and just as women. These were the glory days of feminist art, when indignation fuelled the artists and everything seemed possible.

The artist Sylvia Sleigh knew her feminist history of art, and, typically for her time, wanted to show women taking control of the image. In her self-portrait *Philip Golub Reclining*, 1971, she upended the traditional male-artist/female-model representation by painting herself upright at the easel in the background and her male model reclining across the foreground (p. 161).

The support system put on new clothes. The feminism of 1970s USA was a time of solidarity and sisterhood – in theory always, and frequently in practice in those idealistic days of the women's movement. This era of organizations, groups and manifestos has been celebrated in a number of paintings, and in 1975 Sylvia Sleigh painted herself into the group of women involved in the planning of an all-female gallery in New York (*Soho 20 Gallery*, Private Collection).

Women's concerns about pornography found their way not just into art but in Joan Semmel's case, into self-portraiture. *Me Without Mirrors*, painted in 1974, was one of a series of huge paintings intended to present an image of sexuality recognizable to women (p. 161). The lack of a head in these paintings is a powerful device. It is the artist's body, but it is also all female bodies. Not on display as in Courbet's painting, but the view a women sees as she looks down at herself.

It could be said that the feminist artists of the 1970s went behind the scenes of femininity. In previous centuries, women artists, with only one or two exceptions,

LOUISE BOURGEOIS, *Torso/Self-Portrait*, c. 1963–64. The power of this disturbing self-portrait comes from a recognition of the complexity of women's sexuality, suggesting helplessness as well as fecundity. The feminist movement shared Bourgeois's concerns with maleness and femaleness, pain and power.

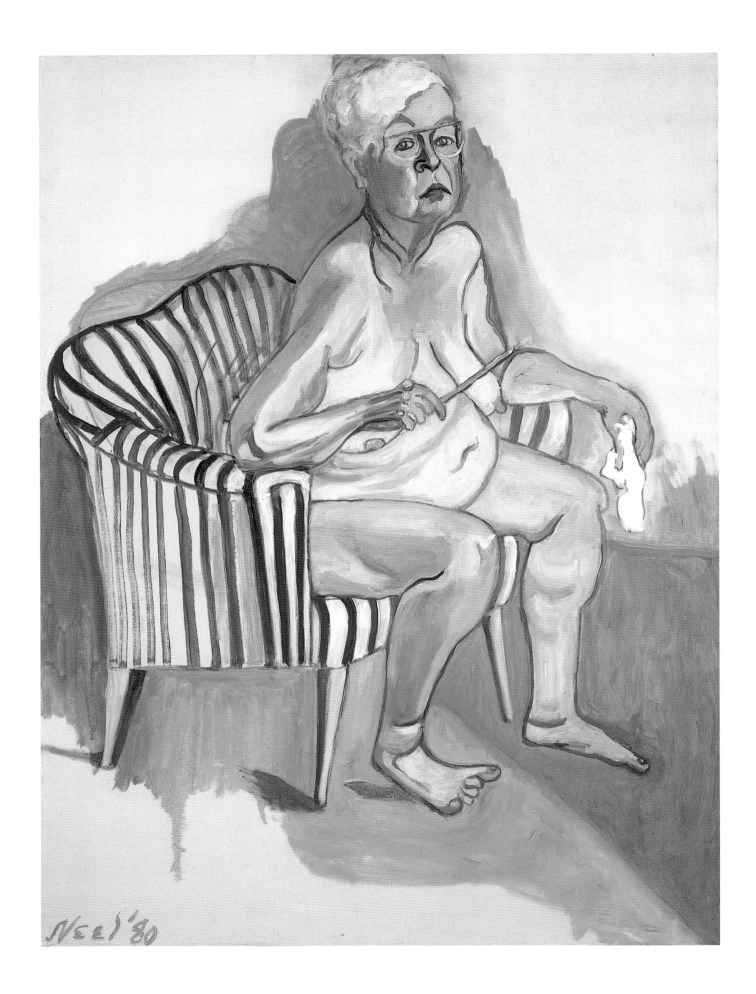

ALICE NEEL, *Nude Self-Portrait*, 1980 (opposite). The eighty-year-old artist turns her clear eye on herself in a self-image unprecedented in the twentieth century. The grandmotherly persona is balanced by the young colours, the alert pose and the self-confidence in painting herself life size. This is a manifesto self-portrait embodying Neel's belief that nudity brings the viewer closer to the subject.

SYLVIA SLEIGH, *Philip Golub Reclining*, 1971 (left). This reversal of the male-artist/female-model pattern is inspired by feminist research into the position of women in art as muses, mistresses and models.

JOAN SEMMEL, *Me Without Mirrors*, 1974 (below). The artist shows us her body as only she can see it. Mirrors reverse the image and play tricks with reflections.

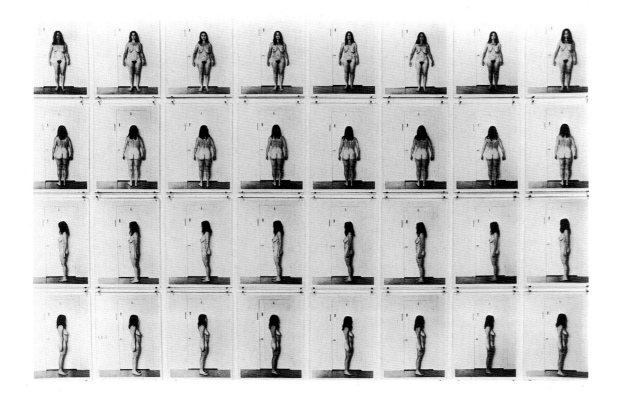

THE TWENTIETH CENTURY

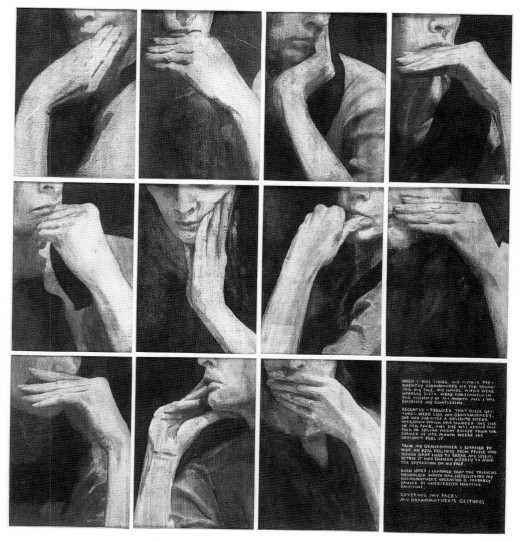

put their best face forward in their self-portraits. The freedom of the twentieth century allowed the expression of the complexity of being female – Claude Cahun played with masks and make-up in her self-transformations of the 1920s and '30s, and Marisol made a many-headed self-portrait sculpture in 1961. But the new wave of women artists was armed with feminist theory, and explored the drive to fit into the mould of media perfection. In 1972, the American Eleanor Antin produced 148 photographs depicting her body changes over a five-week diet. Its title was *Carving: A Traditional Sculpture.*

Women became interested in their female antecedents, converting the psychoanalysts' 'bad mother' into something good. In 1973, Nancy Kitchel created a photographic work, *Covering My Face (My Grandmother's Gestures),* which 'traces the origin of a particular gestural characteristic to a strong connection with my Grandmother in a critical period of identity formation.'

Mythology, last painted with conviction by Neoclassical artists like Angelica Kauffman, made a surprising reappearance. This time it was not classical

NANCY KITCHEL, *Covering My Face (My Grandmother's Gestures)*, 1972–73 (above). Feminism's interest in female forebears and their legacy to the 'self' brings new ideas into self-portraiture.

MARISOL, *Self-Portrait*, 1961–62 (opposite above). Marisol, beautiful and enigmatic, offers several versions of herself in this work, recalling the 1920s interest in masks and identity.

ELEANOR ANTIN, *Carving: A Traditional Sculpture* (detail), 1972 (opposite below). The sequential self-portrait charted her weight loss, with witty reference to the sculptor liberating the perfect form from the marble. Feminism's concern with the tyranny of media stereotypes of feminine beauty now entered art.

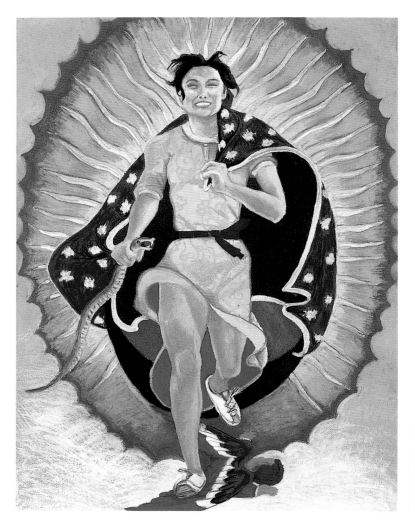

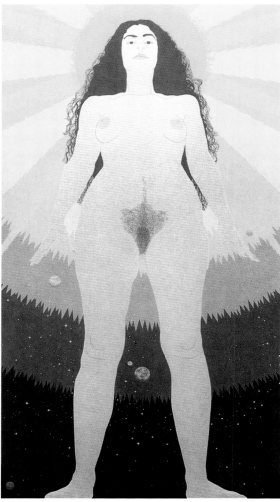

mythology which supplied the inspiration, but female mystics and goddesses, part of the movement to replace patriarchal religion with matriarchal antecedents. In the late 1970s, a group of American feminists created the Sister Chapel, a collection of three-metre (nine-foot) high paintings of strong women. Cynthia Mailman's contribution was a self-portrait as God, an overpowering image of her naked self which rears up before viewers, forcing them to travel up the strong legs, past the genitals and breasts to the head with its black and curly waist-length hair. She left out her navel to signify that as God she was indeed the originator of life.

Religious iconography, last used by Marie Laurencin and Frida Kahlo, took on a new lease of life when the Mexican-American artist Yolanda M. Lopez painted herself in 1978 as the Virgin of Guadalupe, patron saint of Mexico, in *The Guadalupe Triptych*. Clad in running shoes and clutching a serpent to symbolize the Virgin's pagan powers, she runs beaming towards the spectator, the traditional gold-starred cloak billowing behind her.

Mystical ideas of rebirth were suggested by the silhouette pieces which Ana Mendieta began creating in the 1970s. Mendieta was sent to the United States by

YOLANDA M. LOPEZ, *Portrait of the Artist as the Virgin of Guadalupe*, 1978 (above left). The Mexican-American Lopez envisages herself as the patron saint of Mexico (also known as the Great Mother) in the main panel of *The Guadalupe Triptych*. The two other panels show her mother and grandmother.

CYNTHIA MAILMAN, *Self-Portrait as God*, 1977 (above right). Eleven women created huge female images to be installed in the Sister Chapel, the feminist answer to the Sistine Chapel. Though the works were exhibited, the chapel was never built.

ANA MENDIETA, *Silueta Works in Mexico*, 1973–77 (top). Sent to the United States from Cuba when she was twelve, Mendieta explained her silhouette works as an attempt to find the roots she had lost through exile. The flowers on sand speak of the relationship between herself, the earth and her art.

ANA MENDIETA, *Silueta Works in Iowa*, 1976–78 (above). Transience and rebirth are suggested through her silhouette traced in flowers against a tree.

ANA MENDIETA, *Silueta Works in Iowa*, 1976–78 (left). This silhouette expresses her need to belong to nature.

her Cuban family when she was twelve: 'My exploration through my art of the relationship between myself and nature has been a clear result of my having been torn from my homeland during my adolescence. The making of my *silueta* in nature keeps (makes) the transition between my homeland and my new home. It is a way of reclaiming my roots and becoming one with nature.'[7] In works so moving and suggestive that they qualify as poetry, flowers grow out of the sand-shape of her body, or outline her silhouette against a tree.

Mendieta was using developments in performance and land art to expand self-portraiture's ability to speak. The German artist Rebecca Horn offers another example of the flexibility of this new kind of self-representation. She developed lung poisoning from making polyester and fibreglass sculptures without wearing a mask, with the result that she was unable to live with the freedom she wished. Some sensual, imaginative and often frightening works emerged from her need to communicate at this relatively isolated period of her life. In a work of 1972 she wore mechanical gloves with long fingers with which she explored the boundaries of a room. In *Cornucopia, Seance for Two Breasts*, 1970, she covered her breasts with horns. These were joined to a mouthpiece through which she spoke to her breasts in a vivid evocation of talking to oneself.

In 1976, the American critic Lucy Lippard published an article noting how much recent art by women was based on the body.[8] It may have been the male artists who brought the living body into art – Yves Klein in 1960 dragging women covered in blue paint across paper, Vito Acconci in *Seedbed*, 1972, masturbating beneath the gallery floor – but it was the women artists who exploited its possibilities. Fresh from consciousness-raising, alight with the desire to speak about themselves and their experience as women, the body was their vehicle. A great deal of the feminist work of the period was performance based, and took as its subject an exploration of what it meant to to be a contemporary women and a contemporary woman artist. Menstruation came out of the bathroom with *Red Flag*, 1971, Judy Chicago's photolithograph of herself from the waist down withdrawing a tampon. In 1973, friends entered the open door of Ana Mendieta's apartment and found her face down, naked and bloody: it was her first rape piece.

Housework has always had an honourable place in art – in fact, it was practically sanctified in seventeenth-century images of hard-working housewives and servants by Dutch artists who believed that cleanliness was next to godliness. In 1973, Mierle Laderman Ukeles exposed its repetitiveness by spending all day washing and rewashing the floor of the Wadsworth Athenaeum, piling the rags she had used – the outcome of her day's work – into a heap.[9]

REBECCA HORN, *Arm Extensions*, 1968 (above). Performance art expands self-portraiture's ability to speak. Working with her own body, Horn expresses the precariousmess of being human in a hostile world.

MARINA ABRAMOVIĆ AND ULAY, *Imponderabilia*, June 1977 (opposite above). The artists force gallery-goers to decide which of their nude bodies to face at the entrance. This photograph of the artists performing suggests the complexities of defining self-portraiture. Are they actors or do they speak for themselves?

CAROLEE SCHNEEMANN, *Interior Scroll*, 1975 (opposite below). Schneemann wrote a poem imagining a male filmmaker's view of female art, and read it from a scroll pulled from her vagina. As an expression of her views, the performance is a form of self-portrait.

A main theme of this book has been the need of women painters of the past to present themselves in an acceptable manner, breaking no taboos, upsetting no viewers. A great change of the last three decades is that some women artists are consciously trying *not* to please in traditional ways. In 1979 Marina Ambramović and her male partner Ulay stood naked facing each other inside a doorway in an art gallery in Bologna, leaving only a narrow gap for people to squeeze through sideways. Visitors had to decide which of the naked couple to face – the naked woman or the naked man. As with all perfomance work, the event exists only as photographs. While it might not have occurred to the gallery visitors that they were involved in an extension of self-portraiture, it is harder to dismiss the idea when faced with the photograph of the event.

A major concern of the period was to reclaim the female body from its imprisonment in art as a beautiful, voiceless object to be judged by male spectators. One strategy was for women artists to use their own bodies in their performance, photo and video works, on the principle that as they were in control they could direct the viewer's response. In *Interior Scroll*, 1975, Carolee Schneeman stood naked in front of an audience and read from a scroll pulled from her vagina, 'I Met a Happy Man', an indictment of male artistic sensibility.

Only later did the questions arise: was female nudity any less eroticized or objectified because a woman was choosing to display herself instead of being painted by a man? One question which was not asked – not even by Lucy Lippard – was whether such performances were a development of self-portraiture. As we have seen, women have always managed to get their concerns into self-portraits – consider Kauffman's belt clasp with its male-female battle for supremacy. Was this new performance art any different?

The work of the 1970s blurred the line between self-portraiture and the art of ideas. Because the women were expressing concerns close to their hearts, their work, whether poetic or conceptual, carried an air of integrity and authenticity. Men as well as women artists were convinced by this, and so much contemporary art has since been based on the body that self-portraiture seems to have invaded the art world. Everywhere you look, you see the artists, male as well as female: they star in their videos, they pose in their photographs, they appear in their paintings, they put their hair combings and nail clippings into their installations, they freeze their blood into self-portrait busts. This invasion has been encouraged by the century's willingness to tell all in art; by the feminist conviction that the

personal is political; and by the adoption of new art forms, such as performance art, that put the artist centre stage. These sources have fed into complex art works which are arguably a contemporary development of self-portraiture.

Though it might seem a contradiction in terms, body art does not have to be personal. In the 1990s Mona Hatoum uses her own body in her video journey inside its orifices, but it remains just that, a use. Despite the sound effects and oddly pulsating bits of flesh, the video does not say anything personal about herself. It is a self-portrait, but a universal one which could be interchanged with a voyage round any woman's interior.

Body art may be totally personal to the artist and yet abstract and evocative to the viewer. The British artist Helen Chadwick's *Piss Flowers* (Zelda Cheatle, London) is a celebration of the mutual confidence between her and her lover. Casts were made after each had urinated in the snow. The result – tall peaks for the woman and tiny mounds for the man – is a total inversion of what is traditionally meant by phallic symbols. Artistically it is an intriguing collection of shapes and intellectually it undercuts conventional notions of masculinity and femininity. But is it in any sense a self-portrait?

Even when based on the artist's face, the resulting work is not necessarily a self-portrait. In the 1980s, the American Susan Hiller began a series of artworks based on photo booth self-portraits. She cut them, tore them, placed them against new

RENATA RAMPAZZI, *Self-Portrait from Below*, 1975 (above left). The frank examination of the female body was a Western phenomenon in the 1970s in literature as well as art.

MONA HATOUM, *Corps étranger*, 1994 (above right). On the floor of a cylindrical construction the viewer was shown a video of the exterior and the interior of the artist's body filmed by means of a scientific probe. Her heartbeat and breathing formed the accompaniment.

SUSAN HILLER, *Midnight, Euston*, 1983. The work began as four photo-booth self-portraits and ended as a statement about women and the menace of cities at night. The presentation of complex issues through the artist's face and body is a feminist development of personification.

CINDY SHERMAN, *Untitled Film Still, #16*, 1978. Though Sherman says that her work is not self-portraiture, the fact that she poses for each image raises questions of the roles women play and the faces they present to the world.

backgrounds and marked them, until the familiar format took on an air of unfamiliarity. Each work is named after a London station at midnight, and this adds an air of unease to the images. *Midnight Euston* conjures up an area of female experience to do with fear and cities at night. There is menace in the coloured marks, which are reminiscent of the graffiti whose implications of inadequate supervision give an abandoned air to public places. Both nervousness and intimidation are suggested by the changes in position of the heads, the confusion making the work more suggestive.

What is new about the development of self-portraiture typified by Hatoum, Chadwick and Hiller is that the artist uses herself as a way to present much broader issues and ideas. These issues and ideas make a greater impact because of the viewer's knowledge that they are based on a specific woman's face and body.

By using themselves as the starting point for their work, today's women artists are successfully humanizing the world of ideas. This presentation of abstract issues through the artist's body is a feminist development of personification and should be celebrated as such.

It is no longer clear when a self-portrait is a self-portrait. The American Cindy Sherman disguises herself as different female types, then photographs the result in a powerful commentary on the social roles of women. By using herself as the model for every one of her photographs she is arguably producing self-portraits. But by disguising herself in every image she is negating the concept. Cindy Sherman denies that her work is self-portraiture, but it is certainly a fascinating development of it. Whichever side one takes, it is unarguable that the power of the images of women she has made, starting with the *Untitled Film Stills* at the end of the 1970s, depends on the viewer's awareness that they are all modelled by Sherman herself: *Untitled #122* (1983) is one of a series of life-size photographs using clothes made available to her by a dress designer that prompted her to create characters from scratch (p. 7). In its yoking of blonde 1940s elegance (reminiscent of the film star Veronica Lake) and tightly reined-in rage (the clenched-fist pose), the image first nonplusses then sets off a train of questions about how we express emotion. Is she restraining herself? Does she really feel that angry or is she merely performing for effect? *Untitled Film Still, #16* (1978) shows a completely different character. Neither image is of Sherman and yet Sherman is present in the manner in which she has imagined them, dressed them, lit them, composed them and posed for them, photographed them. Our knowledge that the artist lies beneath them forces the consideration of ideas about the roles women play as well as the stereotypes which are projected on to them by others, familiar to every woman as well as to every woman artist who ever produced a self-portrait.

Many of the themes that have threaded through the past – illness, age, children, the family, professionalism – are explored by contemporary artists in their self-portraits. But though the subjects which concern today's artists would be recognized by their predecessors, the contemporary treatment of them would not. Susan Hiller's training as an anthropologist feeds into her technique of arranging and classifying: a work of the late 1970s, *10 Months*, is a photographic record, with commentary and artist's book, of the growing bump of her unborn baby. In 1982, Mary Kelly made a room-size serial document out of her son's development, using nappy liners, drawings (his as well as hers) and explanatory text. Her face is nowhere to be seen, but embedded in the work are her feelings, observations, handwriting and acceptance of psychoanalytic theory as her son grows up and away from her. Since neither of these works hides the maker's identity and since both are concerned with

MARY KELLY, *Post Partum Document, Documentation VI* (detail), 1978–79. In a modern version of the artist as mother, Kelly documents her feelings about her son's development, his scribbles and the psychoanalytic theory on the subject.

JO SPENCE, *Included?* from *Narratives of (Dis)ease*, 1989. Illness became a powerful self-portrait theme in the seventies. Jo Spence developed her 'politics of illness' during her fight with breast cancer. She took into hospital a nude photograph of herself with 'property of Jo Spence' written on her breast. Here the artist portrays herself as the frightened little girl beneath the adult woman undergoing treatment.

the appearance and feelings of their makers, they can surely be considered self-portraits.

The British artist Jo Spence used her own person in much of her work but never to such effect as in her recreations of the people in her family, trying to understand their feelings and experiences by becoming her mother, her father, herself as a child. This kind of work, which she called phototherapy, enabled her to present visual proof of how her parents became her and how she became her parents.

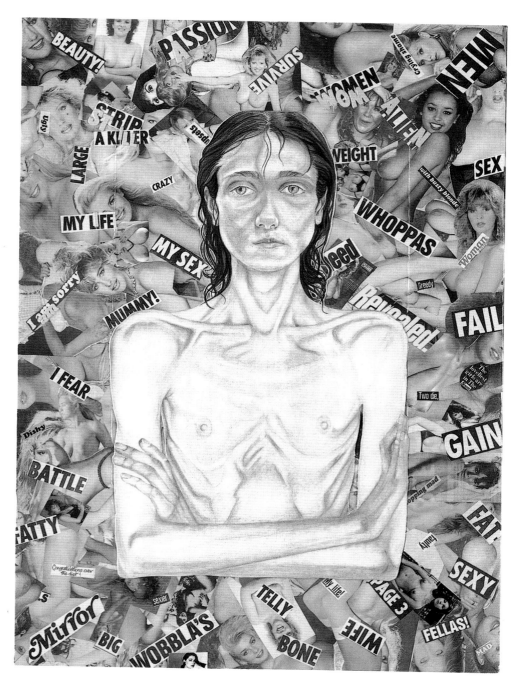

Health has become a subject of particular interest to women artists in the last two decades. *Am I Still a Woman?* asked Rachel Lewis in 1990, a painful portrait of her anorexic self against a collage of pin-up girls and screaming tabloid words like 'fail', 'gain', 'sexy', 'whoppas'. After her mastectomy, the American artist Nancy Fried produced self-portrait sculptures in which she equates her loss of breast with her loss of identity. In *Hand Mirror* (overleaf) she has literally lost her head: there is no self to be reflected back to her in the mirror. In another, her head has migrated to her hands in a powerful image of the displacement she was feeling.

RACHEL LEWIS, *Am I Still a Woman?*, 1990 (opposite). The artist's portrayal of her anorexic body has a background collage of the tabloid headlines and pin-up pictures that oppress her.

NANCY FRIED, *Hand Mirror*, 1987. There is no 'I' to be reflected back to the artist from the mirror. A fear of loss of identity as a woman can accompany the removal of a breast.

HANNAH WILKE, *June 15, 1992/January 30, 1992: #1* from *Intra-Venus Series*, 1992–93 (opposite above). The late self-portraits record the artist's cancer. She had earlier documented her mother's decline from this illness.

In the 1990s, Hannah Wilke produced self-portrait photographs of herself dying from cancer. Wilke had begun to work nude in performance after her mother's mastectomy in 1970, almost as if she wished to convince herself of her own body's perfection. In her most famous performance, *S.O.S. – Starification Object Series*, 1974, she shaped chewing gum taken from the audience into labial folds and stuck them all over herself, making reference to African scarification rituals and the female body as a receptacle for male pleasure. However, the overwhelming impression of the *S.O.S.* self-portraits, disturbing in the light of her future cancer, is of disease.

HANNAH WILKE, *S.O.S. – Starification Object Series*, 1974 (opposite below). In performance two decades earlier, Wilke shaped gum, chewed into softness by the audience, into labial folds which she stuck to her body. Her references were scarification rituals and the discomfort suffered by Western women in pursuit of beauty.

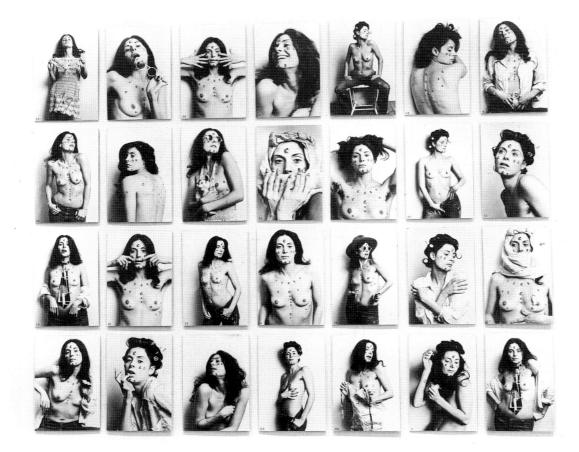

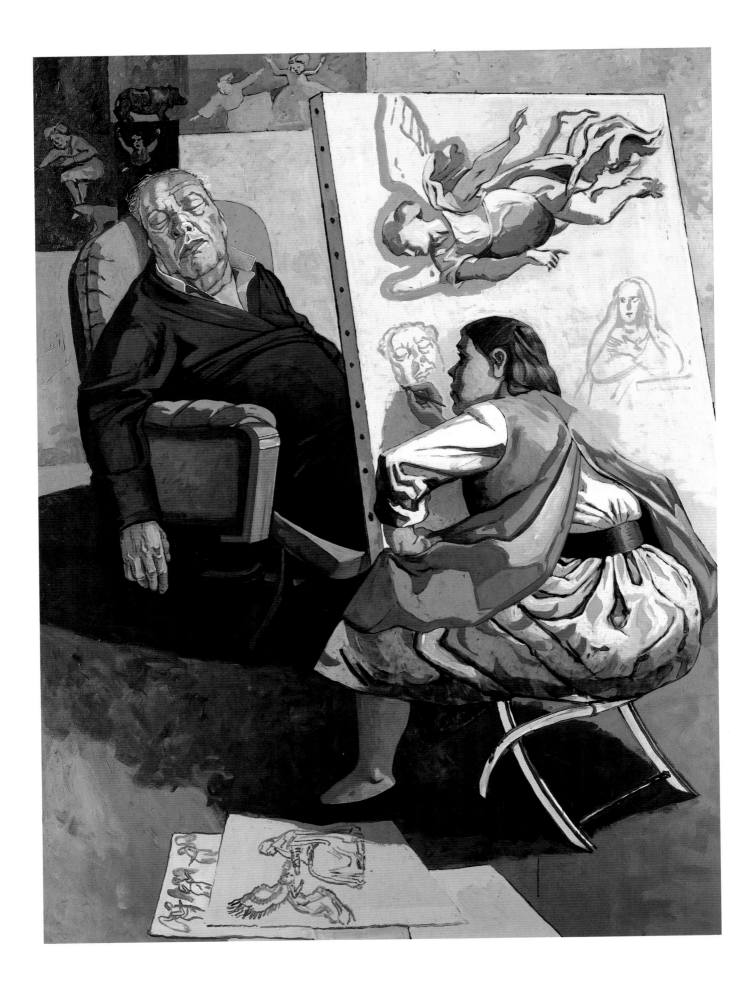

The disquieting and limpid imagery of the triptych by the Scottish artist Alison Watt, *Anatomy I–III*, painted in cool and pretty colours, forces the viewer to consider its meaning (pp. 178–79). The woman and the pig are compared: both are pink, hairless and have openings into their bodies. The woman holds her skeleton before her as she might a dress in front of the mirror. Her nudity, far from seductive, belongs to the context of the hospital, not the artist's studio: the X-ray, the shaved pudenda, the bowl to catch blood, the bandaged stump of the head, the white bed sheet which hobbles her rather than gracefully setting off her melting flesh in the traditional depiction of the nude.

It is not a photograph of Watt's own body, it is not covered with words explaining her feelings and it is not labelled as a self-portrait. Yet the figure resembles the artist and it was painted after the artist's body had been scrutinized and cut into by medical procedures. The closest comparison is with fiction, when a writer turns a personal event into art. The work is not exactly autobiography, yet it is full of the autobiographical impulse. By uniting a meticulous technique with the metaphorical imagination of a poet, she has transformed a personal experience into a visual essay on what it means to be reduced to a purely physical assemblage of flesh, blood and bones, a piece of meat.

A similar fictionalizing process is offered by Paula Rego's presentation of the artist painting a sleeping corpulent male model. In *Joseph's Dream*, 1990, the young woman strains forward to work, too absorbed in her task to consider the niceties of grace and elegance. Her buttocks bulge over the seat and her pose bristles with intensity. Paula Rego says that the women she paints are the stocky short-legged Portuguese of her own type, so while this is not called a self-portrait, it could be described as a surrogate self-portrait. Paula Rego is, after all, painting the same subject as the artist in her painting. Paula Rego has spoken about how hard it is to be a mother, wife and artist, and yet she has had the energy to build a successful career.[10] As a painter of women, she never gives us the plaints of the victimized but a more disturbingly sinister – and exciting – picture in which women have specifically female powers, for evil as well as good, different from those of men and able to control them. All of this is present in the energetic figure of the painter, a kind of Delilah to the sleeping Samson.

In the 1990s the British artist Jenny Saville has painted a series of portraits of her head on top of an outsize naked body. Though artists at the start of the century showed themselves nude, Jenny Saville takes matters further to discuss the issues and arguments which surround nudity. After five hundred years of painted female nudes one might wonder whether the genre is exhausted, but in this monumental group of works Jenny Saville has produced a view of the female nude which shakes the viewer's assumptions and prejudices, in life as well as in art. The stare on the face of the larger-than-lifesize images forbids a clichéd response. She defies us to be revolted or to pity her, so that is not an option. Can she be proud of her divergence from the media ideal? Should we admire her indifference to conventional notions of female beauty? The words 'delicate' and 'petite' scribbled across her belly are not merely ironic but raise more complex

PAULA REGO, *Joseph's Dream*, 1990. Though not a self-portrait, this subversion of male authority was painted when Rego was working as the first associate artist at the National Gallery in London, where works by eight hundred male artists and eight women artists hang on the walls. Rego has said that the women she paints are the stocky Portuguese of her own type and this woman is an artist. It could therefore be considered as a surrogate self-portrait.

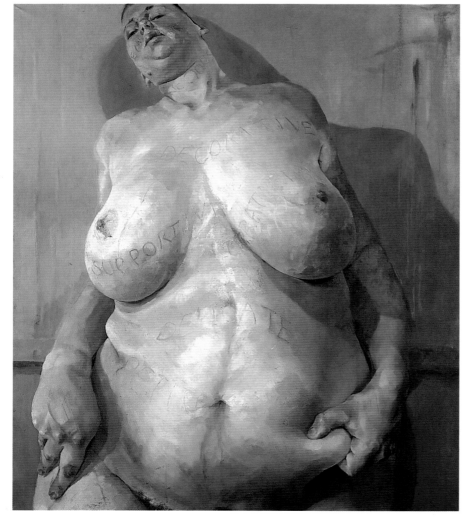

JENNY SAVILLE, *Branded*, 1992 (left). This is one of a group of issue-based self-portraits in which Saville paints monumental nude bodies surmounted with her own head. In the paintings the flesh is branded with words, or marked with contour lines or scribbled-on as if awaiting the plastic surgeon's scalpel. The boldness of her strategy and the overwhelming impact of the paintings force viewers to confront their conventional response to 'imperfect' bodies.

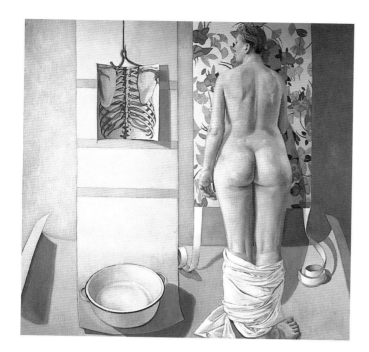

ALISON WATT, *Anatomy I-III*, 1994–95.
Though based on the artist's personal medical
experiences, this life-sized triptych is not a self-
portrait. Perhaps the closest comparison is with
a novelist's transmutation of personal events into
fiction, for, although full of the autobiographical
impulse, it is not autobiography.

questions: surgeons use felt tip pens to mark the areas to be 'reduced' in
fat-reduction surgery; cattle are permanently branded. When Anna Dorothea
Therbusch painted her self-portrait with an eyeglass, she showed that she was
comfortable with her middle-aged appearance. Though Saville is only in her
twenties, her paintings show a similar acceptance, but also question conventional
standards of beauty. Her work is a textbook example of the way contemporary
women artists have expanded the self-portrait tradition, in this case to raise
questions about accepted ideas of beauty in fine art and in life.

Age is an inevitable process that artists deal with according to temperament,
choosing to look younger than their years (Angelica Kauffman) or to announce
their pride in living so long (Sofonisba Anguissola) or to record the changes
dispassionately (Käthe Kollwitz). Mary Kelly took a serious look at middle
age in *Interim*, 1983–85, a thirty-panel mixed-media work based on over a
hundred conversations with women. Her aim was to show how 'a woman is
defined primarily by her body, its procreative capacity and as a fetishized object,
representations from which a woman in middle age is predominantly excluded.'[11]
Typical of her meditations on ageing are the words that she wrote over the perspex
box housing an image of her leather jacket: 'Sarah interrupts to tell me the leather
jacket is lovely but she distinctly remembers that I said I'd never wear one. I
confess I finally gave in for professional reasons, that there's so much to think
about now besides what to wear, that the older you are the harder it seems
to be to get it right and that the uniform makes it a little easier.' This kind of
self-portrait by symbol – the metonymic self-portrait? – is a descendant of all
those paintings in which objects represent the artist, but with the difference that
opinions have replaced the simple transcription of object to paint. In a gesture

familiar to most women, the American photographer Anne Noggle explores getting older, showing herself and her sister lifting their slack skin with their fingers for an instant facelift.

The construction of femininity retains its fascination. Judy Dater, in a strategy that resembles Cindy Sherman's, explores the ludicrous impossibility of fitting into female stereotypes. Rosy Martin, who worked for a time with Jo Spence on phototherapy, explores the way femininity is taught to women, presenting photographs of herself which reveal the feminine ploys and poses she learned as a girl (p. 182). Catherine Opie presents us with a self-portrait *Bo* (p. 183), making us ask ourselves if all women are a blank canvas on which male or female identities can be projected.

Through all these developments, self-portraits that announce themselves as such continue, though even these often deal with issues. In *Self-Portrait*, 1986, Rose Garrard draws on items from her personal iconography to broaden her experiences as an artist into a comment on the position of contemporary women artists in general (p. 184). 'Though a self-portrait,' she has written, 'this piece again used the bird and gun as symbols of peace and violence, hope and anger, and through these represents the inner tensions and turmoils behind the public face of many women professionals, particularly artists, including myself'.[12]

JUDY DATER, *Ms Clingfree*, 1982 (opposite). Dater's farcical housewife points up the futility of attempting to live up to female stereotypes as presented and exploited by advertisers.

ANNE NOGGLE, *Reminiscence: Portrait with My Sister*, 1980. Noggle sees ageing as positive as well as negative, for example photographing women airforce pilots of the Second World War. Here she and her sister adopt the instant face-lift pose familiar to every woman over forty.

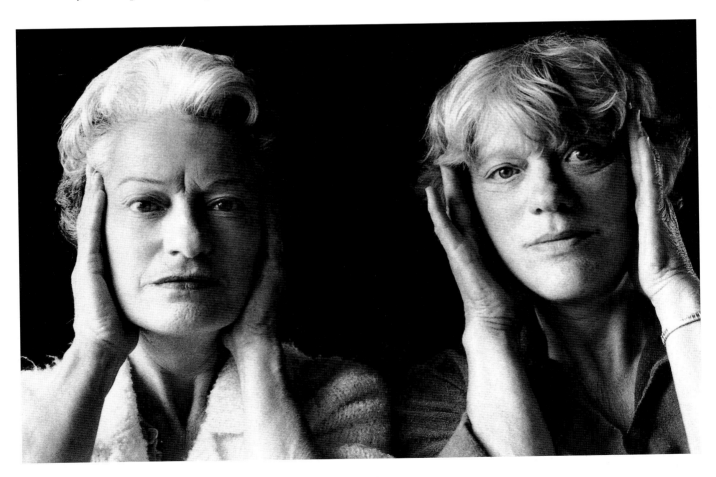

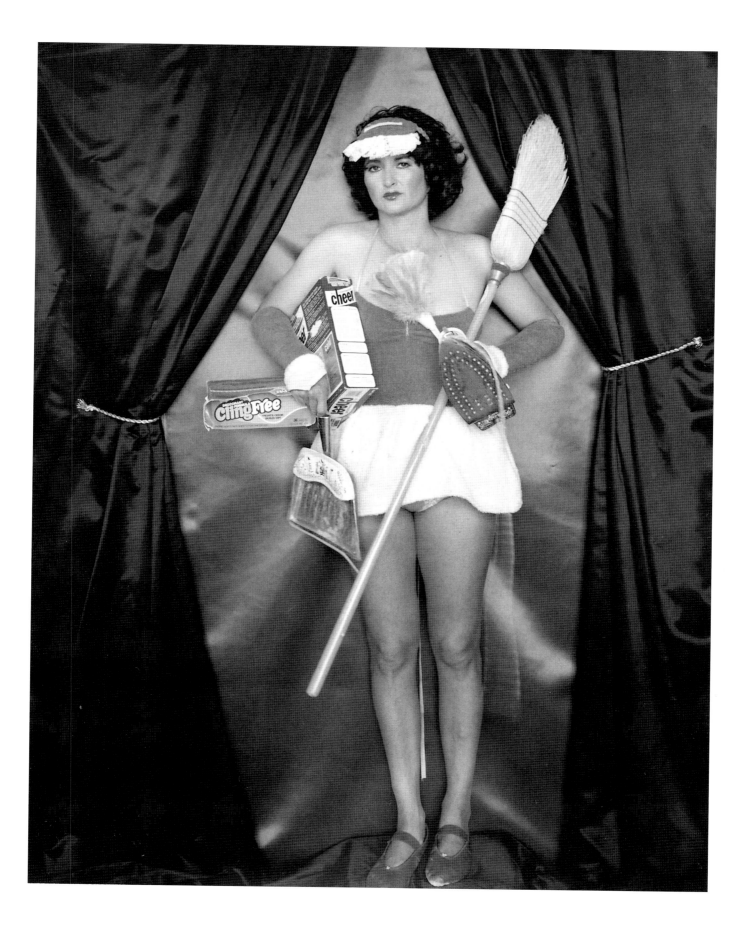

ROSY MARTIN, *The Construction of Heterosexuality – Part 4: An Act of Duplicity,* extract from *The Minefield of Memory: A Day in the Life of a Schoolgirl: circa 1962,* 1986 (left). Martin becomes her younger self to reveal her teenage strategies in constructing an acceptably feminine image.

NAN GOLDIN, *Self-Portrait in Blue Bathroom, Berlin,* 1991 (left). Goldin's work chronicles the life of her friends, many of whom are outsiders because of their sexual preferences or their addictions. Here she turns her non-judgmental gaze on herself to present a self-image which could only be a product of the late twentieth century in its apparent disregard for conventional appearance and its overtones of dissipation.

CATHERINE OPIE, *Bo,* 1994. Opie's work is a late-twentieth-century version of the woman artist's adoption of a male persona, first seen a century earlier in the work of her fellow-American Frances Benjamin Johnson (p. 115).

Women of colour have added their distinctive voices to female self-portraiture. Chila Kumari Burman says: 'My self-portraits construct a femininity that resists the racist stereotype of the passive, exotic Asian woman, imprisoned by male patriarchal culture. Rather I become the maker and definer of my own image.'[13] Inspired by Indian wild women and warriors, she defines her image in a range of surprising ways – she runs, she kicks, she fights and leaps, she presses her breasts to paper – Yves Klein reclaimed! – and in *28 Positions in 34 Years*, 1993, she presents brightly coloured versions of her face ranging from trendy to traditional.

Sonia Boyce put her views about being a black British artist into a self-portrait of 1987, *From Tarzan to Rambo: English Born 'Native' Considers her Relationship to the Constructed Image/Self Image and Her Roots in Reconstruction*. She sees the work's narrative content as a visual version of the story-telling tradition of black communities. The cinema screen format, the references to Tarzan, and 'natives'

peering through jungle leaves illustrate the power of the media's negative images. Balancing these are positive images of black culture, such as African textiles. The artist's twelve self-images vary: some exaggerate the white-eyed stare of religious abandonment while others carry marks of facial hair, a reference to the white male fantasy of black women's bestial sexuality. The artist demands that we think about the relationship of myths and stereotypes to reality .[14]

Carrie Mae Weems is an African-American photographic artist whose goal is to present her community from the inside. With *Untitled (Kitchen Table Series)*, 1990,

SONIA BOYCE, *From Tarzan to Rambo: English Born 'Native' Considers Her Relationship to the Constructed/Self Image and Her Roots in Reconstruction,* 1987 (above). The artist confronts the viewer with positive and negative images of blackness in her presentation of herself as a black, British, female artist.

she ventured into fiction, telling a photostory of a woman – played by Weems
herself – caught between her politics and her emotions. One of the most touching
photographs is the image of the mother and daughter putting on lipstick (p. 188).
The accompanying caption reads: 'He wanted children. She didn't. At the height
of their love a child was born. Her sisters thought the world of their children.
Noting their little feats as they stumbled, teetered and stood. When her kid finally
stood and walked, she watched with a distant eye, thinking, "Thank God! I won't
have to carry her much longer!!" Oh yeah, she loved the kid, she was responsible,
but took no pleasure in motherhood, it caused deflexion from her own immediate
desires, which pissed her off. Ha. A woman's duty! Ha! A punishment for Eve's sin
was more like it. Ha.' Does it count as a self-portrait? Is it fiction or faction? In
an earlier work, Weems had photographed her family, noting with admiration
her sisters' ability to cope with their children. The experiences of Adrian Piper
as a black American woman underpin everything she produces from
performance to photomontage to self-portraiture (p. 189).

One of the points made by the first generation of feminist artists was the
importance of making large works of art. Women were not supposed to spread
themselves in art as they were not supposed to spread themselves in life. On public
transport, women sit neatly packaged with their knees together while men sit with
splayed legs invading the space on either side. The sheer size of Judy Chicago's

Dinner Party installation of the late 1970s – a triangular table fifteen metres (almost fifty feet) long on each of its three sides – was part of its political message. In 1989, Barbara Bloom made an installation self-portrait, *The Reign of Narcissism*, in the form of a Neoclassical room with an accompanying book (p. 186). Two reliefs on the wall, depicting the artist measuring and painting her self-portrait, were supported in the book by thirteen self-portraits of artists at work, including Meret Oppenheim's X-ray of her head (see p. 202) and Angelica Kauffman with portfolio. They are evidence of a new development of the 1980s, the

CARRIE MAE WEEMS, *Untitled* from the *Kitchen Table Series*, 1990. Not a self-portrait, but a photograph of herself in a story that expresses her deep feelings about family, childhood and her own community. One more example of how the boundaries of self-portraiture are blurring.

acknowledgment by women artist of the self-portraits of their predecessors.

Behind all Janine Antoni's work is the ritual of creating with her own body. In *Loving Care*, 1992, she dipped her hair in dye and mopped the floor with it. For *Gnaw*, 1992, she chewed away at cubes of chocolate and lard until she had enough hearts and lipsticks to fill a window display. *Lick and Lather*, 1993, (p. 186) are two self-portrait busts in Neoclassical style, one made of soap (shaped in the bath) and one of chocolate (shaped by licking). The whole work is imbued with Christian references from the artist's Caribbean Catholic background: light and dark, suggesting good and evil; devotional and self-lacerating rituals; transubstantiation.

The most extreme extension of self-portraiture is when the artist becomes her own canvas. The French artist Orlan explores conventional attitudes to beauty by undergoing plastic surgery to change her looks and photographs and films the progress of the operation (p. 190). She refers to her work as an ongoing self-portrait and to herself as a work in progress. Not for the squeamish, it is an example of a contemporary development entering into art. Although plastic surgery is beginning to seem as necessary for women's bodies as orthodontic work is for adolescents' teeth, Orlan questions the impossibility of reaching perfection by using it to shape her face in extraordinary and unique ways that flout accepted ideas of human beauty. It is far removed from the traditional practice in self-portraiture of putting one's best face forward.

Alienated by the high seriousness of much contemporary work, younger artists often present themselves with a much lighter touch. Many feel that the feminist battles have been won. But though their refusal to analyse the society that fascinates them might seem to have little to do with feminist seriousness, their confidence in working with the personal owes much to the artists who preceded them.

In the hands of the British artist Tracey Emin, the confessional autobiographical work rivals the kiss-and-tell of the tabloid press. In *Everyone I Have Ever Slept With*, 1963–95, she chronicles all those who have shared her bed (p. 190). In her willingness to put everything about herself into her art – she videos a day at the seaside, an artists' outing to Niagara Falls – she walks a very fine line between art and life. Before she understood this, she says she made no progress: 'I had a studio, and I had the idea to make something beautiful. And I'd go to the studio every day with that ambition and I'd leave every day feeling depressed and feeling a failure. I couldn't live up to my ideas of what I truly believed art to be.... I thought it was more important the way things looked. And now I don't necessarily believe that.

ADRIAN PIPER, *Self-Portrait Exaggerating My Negroid Features*, 1981. Piper's photographic work is informed by her belief in feminism and her abhorrence of racism, and focuses on the experience of feeling oneself different from the majority.

That has become the lesser issue in the way that I make things.'[15] Although her work is autobiographical, 'it goes beyond that. I start with myself and end up with the universe.' Asked whether art had a part to play in society, she replies, 'It should have but it doesn't. I think the problem is that artists are too content with making things which look nice. There should be something revelationary about it. It should be totally new and creative, and it should open up doors for new thoughts and new experiences.'[16]

British artist Sarah Lucas has been producing photographic self-portraits since 1990. Like the works of the Surrealists, their oddness magnetizes the spectator. In *Self-Portrait with Fish*, 1996, the meeting of the fish ('I've always liked fish. I think it's the smell – the sexual connotation'), the gentlemen's public lavatory, the drab surroundings and the artist's concentration as she puts a finger in the fish's mouth sends the imagination racing in the most unladylike directions. Although it is tempting to explain all contemporary self-portraiture as a development of what has gone before, her images of herself seem to be a totally new departure. She says of her deliberately non-seductive self-portraits: 'I define myself by what I don't want to be, really.'[17]

ORLAN, *Le Visage du 21 siècle*, 1990 (above). Metamorphosis has been an important thread of twentieth-century female self-portraiture. Orlan uses plastic surgery, though not, as is conventional, to become more beautiful. The Botticelli Venus behind her refers to the futility of attempting to achieve aesthetic perfection.

TRACEY EMIN, *Everyone I Have Ever Slept With 1963–1995* (exterior), 1995 (above top). Emin is the subject of all her work, and keeps nothing back in her project of documenting the raw story of her life.

TRACEY EMIN, *Everyone I Have Ever Slept With 1963–1995* (detail of interior), 1995 (above left). Inside her 'Love Tent' are Emin's written accounts of all those with whom she has shared a bed.

SARAH LUCAS, *Self-Portrait with Fish*, 1996.
A self-portrait by an artist whose outrageous
and ironic work has little in common with the
earnestness of earlier feminist art. Like Emin,
she continues to break taboos by speaking the
unspeakable. Fish recur in Lucas's work: 'I've
always liked fish. I think it's the smell – the
sexual connotation.'

Wanda Wulz
Trieste

WANDA WULZ, *Myself + Cat*, 1932. By
superimposing a cat's face over her own,
the photographer suggests ideas of femininity,
sexuality, metamorphosis and masks, all
concerns of women's self-portraiture in the
twentieth century. At the same time, this self-
image looks forward to the problem faced by
many contemporary artists: the question of
identity. In this post-Freudian age, there are
so many stories we can tell about ourselves that
we have trouble knowing which one – if any –
is true. How does this lack of certainty affect
contemporary self-portraits? And how is this
different from the choices made by the artists
of the past in deciding which persona to
present to the world?

CONCLUSION DRAWING BREATH

Is there a female self-portrait tradition? If tradition is taken to mean that certain
themes, like motherhood or musical ability, recur through the centuries, then
there is a tradition. Tradition in this sense refers to the women artists' response
to their minority position within their profession, a position which forced them
to present themselves in certain ways.

But a female self-portrait tradition also implies historical awareness. And
that there most certainly was not. Women artists of the past seem to have had
little knowledge of the work of the women who preceded them. There are a few
examples of women painters knowingly following in the self-portrait footsteps
of their predecessors. The self-portrait that Lavinia Fontana painted of herself at
the clavichord must surely have been inspired by Sofonisba Anguissola's similar
treatment of the subject. Lucia Anguissola borrowed her sister's book device.
But such homages and recognitions are rare before this century.

It is only possible to speak of a female self-portrait tradition in connection with
contemporary artists who have absorbed the findings of three decades of feminist

art-historical research. In 1983, the English artist Rose Garrard produced *Models Triptych* in which she surrounded the self-portraits of Judith Leyster, Artemisia Gentileschi and Elisabeth Vigée-Lebrun with disintegrating frames to symbolize their escape from the conventional world of women. It was selected for the New Art exhibition at the Tate Gallery in London: 'I was thrilled that the images of these three self-portraits which encompass a large part of our forgotten history, should appear in a mainstream exhibition reminding people of this absence. However, when I looked around the exhibition I was disheartened to find that only six of the eighty-four artists selected were women, and two of these appeared as partners of male exhibitors.' [1]

The contemporary *vanitas* self-portrait illustrates how a female self-portrait tradition is in the process of inventing itself. In the 1940s, '50s and '60s, a number of women artists portrayed themselves as skulls – Meret Oppenheim (p. 202), Alice Neel (p. 196) and Helene Schjerfbeck (p. 151), each one a twentieth-century example of women artists' recurrent concern with ageing. In the last two decades this theme has been transformed by a self-conscious borrowing of the *vanitas*, the traditional artistic expression of the victory of time over the delights of life. In 1977–78, Audrey Flack painted *Wheel of Fortune (Vanitas)* which contained a photograph of herself with a camera beside a skull, hourglass, calendar and mirror (p. 197). In 1984–86, Helen Chadwick produced an installation, *Of Mutability*, which included a photograph of herself naked in front of an oval mirror, an image of transient beauty (p. 187) descended from sixteenth-century paintings of Vanity, Venus and Vainglory. In the book accompanying her self-portrait installation, *Reign of Narcissism* 1989 (p. 186), Barbara Bloom includes a variety of Renaissance portraits of women at the mirror, symbolizing Vanity. The whole work speaks of

MARY BETH EDELSON, *Some Living American Women Artists/Last Supper*, 1972 (above). In this poster the artist challenges organized religion's practice of excluding women from positions of authority and its assumption that women have no access to the sacred. Faces of women artists – Georgia O'Keeffe in the centre – are superimposed over the male faces in Leonardo da Vinci's *Last Supper*. The information about women and art presented by feminist artists and art historians has helped today's artists understand that they have a history.

ROSE GARRARD, *Madonna Cascade* from *Models Triptych*, 1982–83 (opposite). The women artists of today are beginning to see themselves as the inheritors of a female self-portrait tradition. Garrard's work is based on Judith Leyster's self-portrait of the 1630s.

ALICE NEEL, *Self-Portrait, Skull*, 1958.
Neel was one of several women artists of
the mid-twentieth century whose self-portraits
starkly revealed the skull beneath the skin.

time passing, down to the plaque awaiting the artist's date of death. All three pieces
are informed by feminist theories about the roles of women in the art of the past.

Women artists are beginning to develop new self-portrait themes. For example,
many of today's artists include their mothers in their portraits of themselves.
Of course, this is not the first time that this subject has been treated. The youth-
age contrast takes us back to the sixteenth century and Sofonisba Anguissola's
self-portraits with a servant, and the mother-daughter closeness to the nineteenth
century and Rolinda Sharples's self-portrait with her mother. But the theorization
and exploration of the mother-daughter relationship had to wait for the feminist
writers and artists of the 1970s. In a development of self-portraiture which owes
much to these new ideas, Melanie Manchot's photograph of herself with her
mother, naked, concerns itself with the presentation of alternative images of
beauty, the mutual trust between the two and the poignant contrast of youth
and age (p. 198).

The lack of historical awareness of women artists' self-portraits is not the same as the lack of a history: the two hundred images from the twelfth to the twentieth century make that quite clear. Cynthia Mailman paints herself as God. Follow the stream to its source and you pass Frida Kahlo stuck with pins like a female St Sebastian, Marie Laurencin in the blue of the Virgin Mary and Angelica Kauffman linking herself to a classical goddess. Nadine Tasseel remakes herself in the image of the art of the past. Haudebourt-Lescot did the same in 1824 and Vigée-Lebrun in 1784. In 1971, Sylvia Sleigh showed herself painting a male model

AUDREY FLACK, *Wheel of Fortune (Vanitas)*, 1977–78. The work grew out of this American artist's discovery of the women still-life painters of the seventeenth century, but also reflects late twentieth-century fascination with the cycle of life. In Flack's rounded consideration of her life the skull becomes less macabre. Her miniature reflected self-portrait is top right, presiding over symbols of chance, time and worldly pleasures.

in *Philip Golub Reclining*. In 1784, Angelica Kauffman painted a woman looking very like herself taking up a paintbrush in *Zeuxis Selecting the Models for His Painting of Helen of Troy*. It is clear from the two paintings that women artists have always searched for ways to show themselves as makers of, and not merely models for, art. Hindsight has created a history.

I ended the Introduction by asking for female self-portraiture to be considered as a genre in its own right, and I tried to make a case for this in the chapters that followed. Admittedly, there is one odd aspect to this particular genre. Normally artists who work within a genre, whether it is landscape, still-life or flower painting, do so with a knowledge of their predecessors' achievements in the field. Until recently, this has rarely been the case with women artists, who have had to think anew from generation to generation about how to represent themselves. Their binding factor has been their situation in the art world rather than their knowledge of a female tradition of self-portraiture, and the fascination for me has been to see how their situation, mediated by contemporary ideas and artistic styles, has resulted in certain recurrent themes across the centuries. It is as if, unbeknown to the artists involved, circumstances forced them to conform to a hidden history and to create a hidden tradition. Now all this looks about to change. Contemporary women artists' awareness of their problems and powers, combined with a fashionable outspokenness and their ever-expanding knowledge of their predecessors, means that female self-portraiture is in the throes of producing new themes which are informed with the past and expressive of the present. And as if this were not enough, the feminist innovation of the presentation of abstract issues through the artist's own body has complicated the whole idea of the self-portrait. It is a most exciting moment at which to end this book.

MELANIE MANCHOT, *Double Portrait – Mum and I*, 1997 (opposite). This work on the mother-daughter relationship also ties in with the *vanitas* theme. In Manchot's words: 'By looking at my mother's ageing body, I am also looking at my self, my own corporeality as well as my future. Ageing obviously affects us all but working with my mother, her body and her very specific process of ageing becomes a more personal investigation including such notions as lineage, genetics and heredity.'

NADINE TASSEEL, *Untitled*, 1992 (below). Tasseel's magical and disturbing work loads a modern medium, photography, with references to an old-fashioned medium, painting. About to take the mask of fifteenth-century beauty from her face, she suggests the links of time and fashion with beauty. She typifies the way contemporary women artists are making art that refers to a specifically female art history and the roles of women within the images of the past.

FRANCESCA WOODMAN, *Providence*, 1975–76 (above). Woodman features in almost every photograph she took in her short life. An air of mystery emanates from all her images; distress is the strongest emotion suggested here. Why have so many women artists portrayed themselves locked in small spaces? Is she dead? What is her relationship to the stuffed animals which seem oddly alive? Many contemporary self-portraits ask questions and do not always offer answers.

NATHALIE HERVIEUX, *Untitled*, 1986 (opposite). A graphic portrayal of the dilemma of identity felt by many contemporary artists. It is one of a set in which the artist's shadowy presence hovers but never quite materializes.

MERET OPPENHEIM, *X-Ray of My Skull*, 1964 (p. 202). An extraordinary image of a gendered skeleton, its femininity signalled by its jewelry.

HANNAH WILKE, *S.O.S. – Starification Object Series* (detail), 1974 (p. 203). In this chilling image, Wilke undergoes the rituals of beauty (hair clips and hair rollers) in a parody of preparing herself as a receptacle for male pleasure, signified by the pieces of chewing gum formed into labial shapes and stuck to her face.

NOTES

INTRODUCTION

1 *The Memoirs of Elisabeth Vigée-Lebrun* (Paris, 1835–37), trans. S. Evans, London, 1989, p. 28: 'I was not in the least prepared for the birth of my baby. The day my daughter was born, I was still in the studio, trying to work on my *Venus Binding the Wings of Cupid* in the intervals between labour pains.'

2 Pliny the Elder, trans. K. Jex-Blake, *Chapters on the History of Art*, London, 1896, p. 171; pp. 170–71, n. 147 refers to two Pompeian wall paintings, one of a woman painting a statue, the second of a woman seated at her easel.

3 G. Boccaccio, trans. G.A. Guarino, *Concerning Famous Women*, New Brunswick, 1963; London, 1964, pp. 144–45.

4 T.S.R. Boase, *Giorgio Vasari: The Man and the Book*, Princeton, 1979. See pp. 68–72 for a discussion of artists' portraits in the second edition of Vasari's *Lives*.

5 N. Turner, 'The Gabburi/Rogers Series of Drawn Self-Portraits and Portraits of Artists', *The Journal of the History of Collections*, vol. 5, No. 2, 1993, pp. 179–216.

6 Mentioned by L. Campbell, *Renaissance Portraits*, New Haven, 1990, p. 272, n. 117; C. King, 'Looking a Sight: Sixteenth-Century Portraits of Woman Artists', *Zeitschrift für Kunstgeschichte*, vol. XVIII, 1995, p. 395.

7 Ilya Sandra Perlingieri, *Sofonisba Anguissola: The First Great Woman of the Renaissance*, New York, 1992, p. 63.

8 *Memoirs of Elisabeth Vigée-Lebrun*, p. 38.

9 Campbell, *Renaissance Portraits*, pp. 215–16: 'When Jovis Hofnagel met the Duke of Bavaria, the duke asked him whether he had any of his work with him: Hofnagel showed him a portrait of himself and his first wife, which he was evidently carrying with him on his travels.'

10 MS note book for 1681: 1681 NB Charles Beale, National Portrait Gallery, London. Discussed in E. Walsh and R. Jeffree, *The Excellent Mrs Mary Beale*, exhib. cat., Geffrye Museum, London, 1975, p. 26.

11 H.T. Douwes Decker, 'Gli Autoritratti di Elisabeth Vigée-Lebrun (1755–1842)', *Antichita Viva*, anno 22, No. 4, 1983, pp. 31–35.

12 Giorgio Vasari, trans. Gaston Du C. de Vere, *Lives of the Most Eminent Painters, Sculptors and Architects*, London; 1912–15, vol. 8, p. 42.

13 Ibid. vol. 5, p. 127

14 Ibid. vol. 8, p. 48.

15 V. Woolf, *A Room of One's Own*, London, 1929; G. Greer, *The Obstacle Race*, London, 1979.

16 W. Chadwick, *Women, Art and Society*, rev. edn, London, 1996, pp. 88–90.

17 *Carrington: Letters and Extracts from her Diaries*, introd. D. Garnett, London, 1970, p. 417.

18 C.E. Vulliamy, *Aspasia: The Life and Letters of Mary Granville, Mrs Delany*, London, 1935, p. 163.

19 *Memoirs of Elisabeth Vigée-Lebrun*, pp. 354 and 355.

CHAPTER 1 THE SIXTEENTH CENTURY

1 For further discussion of medieval women artists see Greer, *The Obstacle Race*, ch. 8; Chadwick, *Women, Art and Society*, ch. 1; Dorothy Miner, *Anastaise and her Sisters: Women Artists of the Middle Ages*, exhib. cat., The Walters Art Gallery, Baltimore, 1974.

2 King, 'Looking a Sight', 1995, p. 386.

3 M.T. Cantara, *Lavinia Fontana, Bolognese, 'Pittore Singolare'*, Milan, 1989, p. 88.

4 Ibid. pp. 86 and 87.

5 Perlingieri in *Sofonisba Anguissola* argues for on pp. 49 and 52; King in 'Looking a Sight', argues against on pp. 390–91.

6 Boccaccio, trans. G.A. Guarino, *Concerning Famous Women*, p. 131.

7 Ibid. p.145.

8 Leon Battista Alberti, trans. John R. Spencer, *On Painting*, 2nd edn, New Haven, 1966, p. 66.

9 King, 'Looking a Sight', p. 388.

10 L. Goldscheider, *Five Hundred Self-Portraits*, London, 1937, fig. 133.

11 Reproduced in E. Tufts, *Our Hidden Heritage*, London, 1974, p.42.

12 British Library, Royal MS 1624 17D xvi, f. 4.

13 King, 'Looking a Sight', p. 388.

14 Page from van Dyck's Italian sketchbook describing his visit to Anguissola, 12 July 1624, British Museum, Dept. of Prints and Drawings, 1874-8-8-23.

15 Perlingieri reports that when she went to the Spanish court, Sofonisba Anguissola was accompanied by 'two gentlemen, two ladies and a staff of six servants', p. 115.

CHAPTER 2 THE SEVENTEETH CENTURY

1 Discussed in *Mary Beale*, exhib. cat., Bury St Edmunds, 1994, p. 17.

2 *Hommage à Elisabeth Sophie Chéron*, Prospect No. 1, Presses de la Sorbonne Nouvelle, Paris, 1992.

3 Seymour Slive, *Frans Hals*, 3 vols, New York, 1974, vol. 1, p. 56.

4 F.F. Hofrichter, 'Judith Leyster's "Self Portrait": Ut Pictura Poesis', *Essays in Northern European Art Presented to E. Haverkamp-Begemann on his Sixtieth Birthday*, Netherlands, 1983, pp. 106–9

5 See M.D. Garrard, *Artemisia Gentileschi*, Princeton, 1989, for a full discussion of this work. Also M.D. Garrard, 'Artemisia Gentileschi's Self Portrait as the Allegory of Painting', *Art Bulletin*, 62, March 1980, pp. 97–112. This may be the self-portrait promised in a letter of 1630 to the Renaissance scholar and collector Cassiano del Pozzo, although it was not mentioned in the inventory of his collection of 1637. It actually ended up in the collection of Charles I of England, perhaps presented to him by the artist when she came to England at the end of the 1630s to join her father who was working in the king's service.

6 Garrard, *Artemisia Gentileschi*, pp. 86–87, thinks it may be a portrait of Gentileschi as Pittura by another artist. For a different view, see *Artemisia Gentileschi*, exhib. cat., Casa Buonarroti, Florence; Complesso Monumentale di S. Michele a Ripa, Rome, 1991–92, pp. 172 and 175.

7 Pamela Hibbs Decoteau, *Clara Peeters*, Lingen, 1992, p. 11.

8 The Ruysch self-portrait (Private Collection) has a reflected self-portrait to the right of the window in the bowl. It was exhibited in 'European Masters of the Eighteenth Century', see exhib. cat., Royal Academy, London, 1954–55. P. Taylor, *Dutch Flower Painting 1600–1720*, New Haven, 1995, p.107, quotes from the art historian Gérard de Lairesse's book on flower painting in the *Groot Schilderboek*, Haarlem, 1740: 'a certain famous young woman had been foolish enough to paint the reflection of herself, sitting at the easel, in the glass vase of one of her pictures.' To Lairesse, this practice was as illogical as flower painters painting in the reflections of windows, forgetting that they will be hung in room with no windows.

9 Decoteau, *Clara Peeters*, pp. 51–54.

CHAPTER 3 THE EIGHTEENTH CENTURY

1 *Memoirs of Elisabeth Vigée-Lebrun*, p. 28.

2 B. Sani, *Rosalba Carriera*, Turin, 1988, discusses the Winter self-portrait, p. 312; the mismatched eyes self-portrait, p. 319; the Tragedy self-portrait, p. 324.

3 *Memoirs of Elisabeth Vigée-Lebrun*, p. 63.

4 Ibid. pp. 249–50

5 D. Diderot, *Salons*, J. Seznec and J. Adhémar, Oxford, 1963, vol. 3, 1767, p. 34 (author's translation).

6 Ibid. p. 250 (author's translation)

7 *Memoirs of Elisabeth Vigée-Lebrun*, p. 38.

8 Ibid. p. 16.

9 Ibid. pp. 27–28.

10 Ibid. p. 47.

11 C. Duncan, 'Happy Mothers and Other New Ideas in Eighteenth-Century French Art', in *Feminism and Art History*, eds. N. Broude and M.D. Garrard, New York, 1982.

12 W. Wassyng Roworth, *Angelica Kauffman: A Continental Artist in Georgian England*, London, 1992, pp. 196–97. Note 72 quotes from a contemporary verse:
But were she married to such gentle males
As figure in her painted tales, I fear she's find
a stupid wedding night.

13 R. Rosenblum, 'The Origin of Painting', *Art Bulletin* 39, Dec. 1957, pp. 279–90, discusses the popularity of this theme at the period.

14 A. Rosenthal, 'Angelica Kauffman Ma(s)king Claims', *Art History*, vol. 15, No. 1, March 1992.

15 *Memoirs of Elisabeth Vigée-Lebrun*, p. 39.

16 The subject of female teachers and pupils is ripe for research. Mary Beale had two female pupils. The problem was that a male intercessor was needed to introduce a young woman into the art world and only men were seen as 'proper' artists. Maria Cosway's first teacher was a woman, but she was sent to a male teacher when she became serious about practising professionally.

17 *Memoirs of Elisabeth Vigée-Lebrun*, p. 27.

18 Susan L. Siegfried, *The Art of Louis-Léopold Boilly*, London and New Haven, 1995, pp. 174–80, for a discussion of the link between paintings of female artists and contemporary society.

19 *The Diary of Joseph Farington*, ed. K. Cave, London and New Haven, 1984, vol. 15, p. 5332.

20 M. Somerville, *Personal Recollections*, London, 1874, p. 49.

21 J. Walker, 'Maria Cosway, An Undervalued Artist', *Apollo*, May 1986, p. 318.

22 *The Art of Painting in Miniature*, London, 1752, p. 56.

23 M. and R.L. Edgeworth, *Essays in Practical Education*, London, 1815, 'On Female Accomplishments, Masters, and Governesses', Ch. 20, p. 182.

24 Portia (pseud.), *The Polite Lady: Or a Course of Female Education in a Series of Letters from a Mother to Her Daughter*, 2nd edn, London, 1769, p. 16.

25 *The Art of Painting in Miniature*, Preface.
26 British Museum Print Room 189*. 6. 23, f. 193.
27 H. Walpole, *Anecdotes of Painting in England*, ed. R.N. Wornum, 3 vols., 1888, vol. 1, pp. xviii–xxii.
28 *The Letters of Thomas Gainsborough*, ed. M. Woodall, Bradford, 1961, Gainsborough to James Unwin, 1 March 1764, p. 151. It is to be hoped that the reference to 'Miss Fords' is Gainsborough's generic name for untalented amateurs and not a reference to the Miss Ford of the famously crossed legs (p. 32), who was a talented amateur musician and at the time of the letter had been married for two years to Gainsborough's friend and patron Philip Thicknesse.
29 *The Diary of Joseph Farington*: Mrs Phipps, vol. 8, p. 2800; Lady Essex, vol. 10, p. 3506; Lady Lowther, vol. 10, p. 3675.
30 T. Smith, *Nollekens and His Times*, 2 vols, London, 1829, vol. 1, pp. 60–61.
31 J.W. Goethe, trans. W.H. Auden and Elizabeth Mayer, *Italian Journey*, London, 1970, p. 363.
32 Ibid. pp. 375–76.
33 L. Rice and R. Eisenberg, 'Angelica Kauffmann's Uffizi Self-Portrait', *Gazette des Beaux Arts*, March 1991.
34 Maria Cosway quoted in S. Lloyd, 'The Accomplished Maria Cosway: Anglo-Italian Artist, Musician, Salon Hostess and Educationalist', *Journal of Anglo-Italian Studies*, II, 1992, p. 111. The 'old celebrated lady' was Violante Cerroti.
35 Ibid. p. 112.
36 Quoted in J. Walker, 'Maria Cosway: An Undervalued Artist', *Apollo*, May 1986, pp. 318–24. The quotation is from the autobiographical letter of 24 May 1830, from Maria Cosway to Sir William Cosway, Victoria and Albert Museum, London, National Art Reference Library, MS (Eng.) L. 961-1953

CHAPTER 4 THE NINETEENTH CENTURY
1 H. Perry Chapman, *Rembrandt's Self Portraits*, Princeton, 1990. For a discussion of berets as a painter's attribute see pp. 49–50.

2 Catherine McCook Knox, *The Sharples*, New Haven, 1930, p. 86.
3 Ibid. p. 25.
4 Ibid. p. 52 .
5 Ibid. p. 53. Probably a reference to Thomas Stothard.
6 Ibid. p. 53.
7 Ibid. p. 54.
8 *Sketched for the Sake of Remembrance: A Visual Diary of Louisa Paris' English Travels 1852–54*, exhib. cat., Towner Art Gallery, Eastbourne, 1995.
9 *The Correspondence of Berthe Morisot*, ed. D. Rouart, introd. K. Adler and T. Garb, London, 1986, p. 102 .
10 *The Journals of Marie Bashkirtseff* (London, 1890), London, 1985, p. 444.
11 Dore Ashton, *Rosa Bonheur: A Life and A Legend*, London, 1981, p. 57 for a reproduction of a police certificate giving permission for her to wear male clothes in public 'for reasons of health'.
12 *Reminiscences of Rosa Bonheur*, ed. T. Stanton, New York, 1976. For the dog reference, see p. 259; for the pictures, p. 251.
13 *The Journals of Marie Bashkirtseff*, p.347.
14 Ibid. p. 291.
15 Ibid. p. 292.

CHAPTER 5 THE TWENTIETH CENTURY
1 Julia Fagan-King, 'United on the Threshold of the Twentieth-Century Mystical Ideal: Marie Laurencin's Integral Involvement with Guillaume Apollinaire and the Inmates of the Bateau Lavoir', *Art History*, vol. 11, no. I, March 1988.
2 F. Borzello, *The Artist's Model*, London, 1982, ch. 10.
3 L. Knight, *The Magic of a Line*, London, 1965, p. 140.
4 M. Facos, 'Helene Schjerfbeck's Self Portraits: Revelation and Dissimulation', *Woman's Art Journal*, vol. 16, Spring/Summer 1995, pp. 12–17.
5 E.H. McCormick, *Portrait of Frances Hodgkins*, New Zealand and London, 1981, p. 5.
6 D. Tanning, 'Souvenirs', in *Dorothea Tanning*, exhib. cat., Konsthall, Malmö, 1993, p. 39.
7 *Ana Mendieta*, exhib. cat., Centro Galego de

Arte Contemporanea, Santiago de Compostela; Kunsthalle, Dusseldorf; Fundació Antoni Tàpies, Barcelona; Miami Art Museum of Dade County; Musem of Contemporary Art, Los Angeles, 1996–97, p. 108.
8 Lucy Lippard, 'The Pains and Pleasures of Rebirth: European and American Women's Body Art', *Art In America*, 64, no. 3, May–June 1976, reprinted in L. Lippard, *From the Center: Feminist Essays on Women's Art*, New York, 1976.
9 *Washing, Tracks, Maintenance: Maintenance Art Activity III*, July 22, 1973, Wadsworth Atheneum, Hartford, Connecticut. Performance. 'Activity: l. Wash several areas of museum where spectator traffic occurs.... 2. Wait for people to track it up. Washing (damp/dry mop) will not be too wet to constitute a danger of slipping, and artist will warn people anyway to be careful. 3. Re-wash, keep washing until museum closes. Rags will be accumulated and piled on the site. Maintain for whole day. 4. Areas will be stamped with Maintenance Art stamp.' One wonders how many spectators realized that they were in the presence of art.
10 Author's interview with the artist.
11 *Mary Kelly: Interim*, exhib. cat., Fruitmarket Gallery, Edinburgh; Kettle's Yard Gallery, Cambridge; Riverside Studios, London, 1986, p. 3.
12 *Rose Garrard: Archiving My Own History. Documentation of Works 1969–1994*, Cornerhouse, Manchester; South London Gallery, 1994, p. 56.
13 L. Nead, *Chila Kumari Burman: Beyond Two Cultures*, London, 1985, pp. 61–62.
14 Information from the artist-approved description of this painting, Tate Gallery, London.
15 *Minky Manky*, exhib. cat., South London Gallery, 1995, quoting the artist Tracy Emin.
16 Ibid. quoting the artist.
17 Gordon Burns, 'Sister Sarah', *Guardian Weekend*, 23 November 1996, for Lucas quotations.

CONCLUSION
1 *Rose Garrard: Archiving My Own History*, p. 41.

ARTISTS' BIOGRAPHIES

Short-title references are given here to those books and publications cited in full in the Select Bibliography

Marina Abramović b. Belgrade 1946. Installation and performance artist concerned with the investigation of physical limits. 1965–72 Academy of Fine Arts, Belgrade. Visiting Professor at the Hochschule der Künste, Berlin, and Académie des Beaux-Arts, Paris. Performed with Ulay then Charles Atlas. Works include *Freeing the Body*, (Künstlerhaus Bethanien, Berlin, 1975); *Sur la Voie*, (Centre Georges Pompidou, Paris, 1990); *Boat Emptying – Stream Entering*, (Museum of Modern Art, Montreal, 1990). *Biography*, a performance-presentation of her life began its German tour at 'documenta 9', Kassel, and was published as *Biography*, Stuttgart, 1994.
 B. Pejić, J. Sartorius, D. Von Draten, *Abramović*, Stuttgart, 1993. *Marina Abramović: Cleaning the House*, London, 1995. *Marina Abramović*, exhib. cat., Museum of Modern Art, Oxford, 1995

Sofonisba Anguissola b. Cremona *c.* 1532 d. Palermo 1625. A life-long painter of portraits and some religious subjects. The oldest and best-known of six painter daughters of the nobleman Amilcare Anguissola and his second wife Bianca Ponzoni. She and her sister Elena (who became a nun) trained with Bernardino Campi from *c.* 1545 and Bernardino Gatti from 1549. She painted in Milan and Rome in the 1550s. She was invited by Philip II of Spain in 1559 to be lady-in-waiting to his young queen, Elizabeth of Valois. Married for the first time *c.* 1570 Fabrizio de Moncado and moved to Sicily; married for the second time 1580 Orazio Lomellino and moved to Genoa. Anthony van Dyck recorded visiting her in Palermo in 1624, when she could no longer see well enough to paint. She perhaps taught her sister Lucia Anguissola (b. Cremona 1536/8 d. before 1568), the third daughter of Amilcare Anguissola. Lucia was a portrait painter but few of her paintings are known.
 Ilya Sandra Perlingieri, *Sofonisba Anguissola: The First Woman Artist of the Renaissance*, New York, 1992. *Sofonisba Anguissola e*

le sue sorelle, exhib. cat., Cremona and Milan, 1994. *La Prima Donna Pittrice Sofonisba Anguissola*, exhib. cat., Vienna, 1995

Eleanor Antin b. New York 1935. Video and performance artist. Studied at the College of the City of New York and the Tamara Daykarhanove School for the Stage. Solo performances and shows include 'Eleanor Antin: The Angel of Mercy', La Jolla Museum of Contemporary Art, 1977; 'Eleanor Antinova: Recollections of My Life with Diaghilev', Ronald Feldman Fine Arts Gallery, New York, 1980.
 E. Monro, *Originals: American Women Artists*, New York, 1979

Janine Antoni b. Freeport 1964. Sculptor and installation artist. Solo shows include 'Gnaw', 1992, and 'Lick and Lather', 1993, both Sandra Gering Gallery, New York; 'Slip of the Tongue', Centre for Contemporary Arts, Glasgow, 1995; 'Art at the Edge', The High Museum, Atlanta, 1996.

Slip of the Tongue, exhib. cat., Glasgow, 1995. *Young Americans I*, exhib. cat., Saatchi Gallery, London, 1996. *Rose is a Rose is a Rose*, exhib. cat., Guggenheim Museum, New York, 1997

Teresa Arizzara b. *c.* 1720. Eighteenth-century Italian artist, about whom little is known apart from two paintings which entered the Uffizi collection in 1853 as self-portraits.

Alice Austen b. New York 1866 d. 1952. Documentary photographer. Self-taught, she began photography as a hobby at the age of twelve. Made over twenty trips to England, France and Germany until curtailed by arthritis and the 1920s stock market collapse. The Alice Austen House, Staten Island, New York and the Staten Island Historical Museum hold several thousand negatives.
 A. Novotny, *Alice's World: The Life and Photography of an American Original*, Old Greenwich, 1976. J.C. Gover, *The Positive Image*, Albany, 1988

Alice Bailly b. Geneva 1872 d. Lausanne 1938. Painter (often mixed media) and wood engraver. Student at the École des Beaux-Arts, Geneva. In Paris 1904–16 where she had her own studio and associated with the Cubists. Exhibited from 1906 to 1934 in Paris and Geneva. Won an award for *tableaux-laines* at the 1925 Art Deco exhibition. Established the Alice Bailly Foundation to help young Swiss artists.
 Vergine, *L'Altra Meta dell'Avanguardia, 1910–1940*. Perry, *Women Artists and the Parisian Avant-Garde*

Marie Bashkirtseff b. Gavrontsi 1858 d. Paris 1884. Painter of portraits and subject pictures and sculptor. Enrolled at the Académie Julian in Paris 1877 under Tony Robert-Fleury and Jules Bastien Lepage. Much of her work was destroyed in the Second World War, although a nude sculpture and a painting *The Meeting*, 1884, purchased by the French government, are in the Musée d'Orsay, Paris. Her journal is a powerful expression of the life and feelings of an ambitious young woman artist of the period.
 A. Theuriet, ed., *Le Journal de Marie Bashkirtseff*, 2 vols, Paris, 1887. A reprint of the 1891 English translation with introduction by R. Parker and G. Pollock published London, 1985. *Lettres de Marie Bashkirtseff*, Paris, 1891. C. Cosnier, *Marie Bashkirtseff: Un Portrait sans Retouches*, Paris, 1985. T. Garb, ' "Unpicking the Seams of Her Disguise": Self Representation in the Case of Marie Bashkirtseff', *Block*, 13 Winter 1987/8, pp. 79–86

Mary Beale b. Barrow 1633 d. London 1699. Portrait painter. Her father was an amateur still-life painter and she may have studied with Robert Walker. Married Charles Beale 1654, Deputy Clerk of the Patents and an art enthusiast. After her husband lost his post in 1665, Mary Beale supported the family, working from a studio in their London home. In 1672, when her career was well under way, the couple commissioned two portraits from Lely in order to study his technique. Unusually, Lely allowed them to watch him at work. Mary Beale trained her two sons as assistants, one of whom, Charles, trained with other teachers and went on to become an artist. Her husband ran the household and managed the business.
 1677 NB Charles Beale, MS note book for 1677, Bodleian Library, Oxford. 1681 NB

Charles Beale, MS note book for 1681, National Portrait Gallery, London. 'The Note-books of George Vertue', *Walpole Society*, xxix 1947, pp. 15–16. *The Excellent Mrs Mary Beale*, exhib. cat. by E. Walsh and R.T. Jeffree, Geffrye Museum, London, 1975. M.K. Talley, *Portrait Painting in England: Studies in the Technical Literature Before 1700*, London, 1981, pp. 270–305. *Mrs Mary Beale, Paintress, 1633–1699*, exhib. cat. by C. Reeve, Manor House Museum, Bury St Edmunds, 1994

Lady Diana Beauclerk b. London 1734 d. Twickenham 1808. Amateur painter and illustrator. After her divorce from the 2nd Lord Bolingbroke in 1768, she marrried Topham Beauclerk.
 H. Walpole, ed. R.N. Wornum, *Anecdotes of Painting in England*, (1762–71), 1849

Cecilia Beaux b. Philadelphia 1855 d. Gloucester 1942. Portrait painter. Trained at the Pennsylvania Academy of the Fine Arts, 1877–78; with William Sartain, 1881–83; at Académies Julian and Colarossi 1888–89. First full-time woman staff member at the Pennsylvania Academy 1895–1915. Critically acclaimed, and the painter of the socially prominent, she was appointed to the US War Portraits Commission in 1919.
 Cecilia Beaux, 'Why the Girl Art Student Fails', *Harper's Bazaar*, 1913. *Cecilia Beaux: Portrait of an Artist*, exhib. cat., Academy of the Fine Arts, Philadelphia, 1974. T. Leigh Tappert, *Cecilia Beaux and the Art of Portraiture*, Washington DC, 1995

Charlotte Berend-Corinth b. Berlin 1880 d. New York 1967. Painter of portraits and genre. Much of her work destroyed in the Second World War. Studied with the Berlin landscape artist Eva Stort and joined the art school for women set up by Lovis Corinth in 1902. She married Corinth in 1903 (two children). Exhibited at the Berlin Sezession from 1906. She catalogued her husband's works after his death in 1925 and escaped Naziism by emigrating to the USA. A solo show was held at the Knoedler Galleries, New York, 1945.
 Lovis Corinth, exhib. cat., Tate Gallery, London, 1997

Mary Ellen Best b. York 1809 d. Darmstadt 1891. Painted portraits and her surroundings in watercolour. Her father died when she was nine. Family tradition said that as a child she made brushes out of her own hair. At boarding school, she was taught by George Haugh, a Royal Academy exhibitor. After leaving school she drew from nature and looked at art in great houses. 66% of the watercolour portraits painted between 1828 and her marriage in 1840 were commissioned by women and nearly 60% of her sitters were female. Married Johann Anton Phillip Sarg and moved to Frankfurt. Gave up painting in the early 1850s.
 C. Davidson, *The World of Mary Ellen Best*, London, 1985

Anna Bilinska b. Ukraine 1857/8 d. Warsaw 1893. Portraits, seacapes, landscapes. Teachers were E. Andriolli (Russia); Adalbert Gerson (Warsaw); Bouguereau and Robert-Fleury (Paris). Married 1892. Exhibited in London (Royal Academy 1888–92), Paris from 1885, Munich and Warsaw. Won gold medals at the Paris Exposition Universelle 1889

for her self-portrait and at the Berlin International Exposition, 1891.

Ilse Bing b. Frankfurt am Main 1899. Photo-journalism, fashion, portraiture. In the vanguard of European 1920s and '30s photography and a pioneer of experimentation with the 35mm camera. Gave up doctoral studies in art history for photography. After internment by the Vichy government in 1940, she settled in the USA with her husband, the musician Konrad Wolff. In 1957 she gave up photography for poetry, drawings and collages.
 Nancy C. Barrett, *Ilse Bing: Three Decades of Photography*, exhib. cat., New Orleans Museum of Art, 1985

Barbara Bloom b. 1951 Los Angeles. Installation artist whose work often starts with herself.
 Here's Looking At Me/A Mes Beaux Yeux: Autoportraits Contemporains, exhib. cat., Espace Lyonnais de l'art Contemporain, Lyons, 1993. *The Century of the Multiple*, exhib. cat., Deichtorhallen, Hamburg, 1994. *Now Here*, exhib. cat., Humlebaek, Denmark, 1996. *Identity Crisis: Self-Portraiture at the End of the Century*, Milwaukee Art Museum, Sept.–Nov. 1997

Rosa Bonheur b. Bordeaux 1822 d. Thomery 1899. Painter and sculptor of animals. Trained by her father, Raymond Bonheur, who encouraged her feminism as as well as her career. She kept a small menagerie, dissected animals and frequented slaughterhouses. Her masterpiece, *The Horse Fair*, 1853 (Metropolitan Museum of Art, New York; copy, National Gallery, London) was based, like all her work, on drawings from life. In 1848 she received a state commission for *Ploughing in the Nivernais*, 1849 (Musée d'Orsay, Paris); she was the first woman artist to receive the Légion d'honneur, 1865. She remained outside the rapidly changing styles of nineteenth-century France, retiring in 1860 to the outskirts of Fontainebleau with her companion, Nathalie Micas. There, wealthy and independent, she lived and painted as she wished, fascinated by Buffalo Bill and his circus in the 1880s.
 T. Stanton, ed., *Reminiscences of Rosa Bonheur*, (1910), New York, 1976. D. Ashton, D. Browne Hare, *Rosa Bonheur: A Life and A Legend*, London, 1981. R. Shriver, *Rosa Bonheur*, Philadelphia, 1982

Louise Bourgeois b. Paris 1911. Sculptor. In her teens made drawings for the family tapestry restoration workshop. Studied briefly in 1935 at the Ecole des Beaux-Arts, then in artists' studios including those of Léger and Lhote. In 1938 married art historian Robert Goldwater (d. 1973) and moved to New York (three sons). Studied painting at the Art Students' League and created first large sculptures in 1940. Produced disturbingly sexual sculptural shapes in the 1960s. Represented the USA at 'documenta 9', Kassel, 1992, and the Venice Biennale, 1993. First major US retrospective, Museum of Modern Art, New York, 1982; first European retrospective Frankfurt Kunstverein, 1989.
 D. Wye, *Louise Bourgeois*, exhib. cat., Museum of Modern Art, New York, 1982. P. Weiermair et al., *Louise Bourgeois*, exhib. cat., German/English, Frankfurter Kunstverein, Frankfurt, 1989. *Louise Bourgeois*, exhib. cat., National Gallery of Victoria, 1995

Margaret Bourke-White b. New York 1904 d. Darien 1971. Documentary photographer. Set up a studio in 1927 in Cleveland. Appointed the first staff photographer on *Fortune* magazine in 1929, producing her Dust Bowl photographs in 1934. In 1936, she produced the cover for the first issue of *Life*. A war correspondent for *Life* 1942–45.
 M. Bourke-White, *Portrait of Myself*, New York, 1963. J.Silverman, *For the World to See: The Life of Margaret Bourke-White*, London and New York, 1983. V. Goldberg, *Margaret Bourke-White: A Biography*, New York, 1986

Sonia Boyce b. London 1962. Figurative artist concerned with explorations of race and gender. First group show '5 Black Women' (Africa Centre Gallery, London, 1983); first solo show, Air Gallery, London, 1987.
 Sonia Boyce, exhib. cat., Air Gallery, London, 1987. S. Boyce, 'Talking in Tongues', *Storms of the Heart*, ed. K. Owusu, London, 1988, pp. 219–24. M. Keen and E. Ward, *Recordings: A Select Bibliography of Contemporary African, Afro-Caribbean and Asian British Art*, Institute of International Visual Arts and Chelsea College of Art and Design, London, 1996

Marie Bracquemond b. Morlaix 1841 d. 1916. Impressionist painter. A student of Ingres, she married the engraver Félix Bracquemond in 1869. Exhibited with the Impressionists in 1879, 1880 and 1886. Her husband's lack of support caused her work to dry up after 1890.
 T. Garb, *Women Impressionists*, Oxford, 1986

Ann Brigman b. Honolulu 1869 d. 1950. Self-taught photographer. Her family moved to California in her teens. Married M. Brigman, a sea captain, in 1894, and lived with her mother after their separation in 1910. A pagan, she visualized humans as part of the landscape. Reputation established by 1903. In 1907 elected a fellow of the Photo-Secession, New York, and early issues of *Camerawork* reproduced her work. By 1933, failing sight caused her to turn to poetry.
 A Brigman, *Songs of a Pagan*, Caxton Printers, 1949. T. Thau Heyman, *Anne Brigman: Pictorial Photographer/Pagan/Member of the Photo-Secession*, Oakland Museum, California, 1974. M. Mann and A. Noggle, eds, *Women of Photography: An Historical Survey*, San Francisco Museum of Art, 1975

Romaine Brooks b. Rome 1874 d. Nice 1970. Portrait painter. After an extraordinary childhood during which her mother abandoned her in New York to her laundress, who encouraged her to draw, she studied at the Scuola Nazionale in Rome (1896–97) and the Circolo Artistico. In 1899, she studied at the Académie Colarossi in Paris. After inheriting a fortune in 1902, she spent 1902–4 in London where she painted her first female portraits. Her first solo exhibition was at the Galerie Durand-Ruel in Paris in 1910.
 M. Secrest, *Between Me and Life: A Biography of Romaine Brooks*, London, 1976

Chila Kumari Burman b. Liverpool *c.* 1958. Painter, printmaker, installation and photographic artist concerned with female cultural identity. Often works with self-portraiture. Degrees from Leeds Metropolitan University (1979) and Slade School of Fine Art, London, 1982. A monograph (see below) appeared at the same time as her retrospective, 1995–97,

'28 Positions in 34 Years'. She exhibited at the Havana Biennale, 1994, and the Johannesburg Biennale, 1995.
 L. Nead, *Chila Kumari Burman: Beyond Two Cultures*, London, 1995

Claude Cahun b. 1894 Nantes d. 1954 St Helier. Photographic artist. Studied philosophy at the Sorbonne. In 1917 she adopted Claude Cahun as her name (originally Lucy Schwob). In the 1920s, she began a lifelong partnership with Susanna Malherbe (Moore). In 1930 her autobiographical essay *Aveux nos avenus*, was published; in 1932 she joined the Association of Revolutionary Writers and Artists, in 1934 publishing *Les Paris Sont Ouverts*, a polemic against propagandist art. Associated with the Surrealists. From 1937 she lived in Jersey, narrowly escaping execution for resistance (including the use of photomontages) against the German occupation.
 Mise en Scène: Claude Cahun, Tacita Dean, Virginia Nimarkoh, exhib. cat., Institute of Contemporary Arts, London, 1994. *Claude Cahun, Photographie*, exhib. cat., Musée d'Art Moderne de la Ville de Paris, 1995

Rosalba Carriera b. Venice 1675 d. Venice 1757. Pastel portraitist. Guiseppe Diamantini and Federico Bencovich are two of the artists named in the conflicting accounts of the training of this daughter of a modest, non-artistic family. By the early eighteenth century she was painting portraits for snuffbox lids and the pastel portraits for which she became famous. In her thirties, she collected important sitters and was accepted into academies in Bologna and Paris. She did not marry and made her sister, Giovanna, her assistant. She went to Paris in 1720 and Vienna in 1730 in the company of her brother-in-law, the artist Giovanni Antonio Pelligrini, who had decorative commissions there, and worked in Modena in 1723. Patrons included Joseph Smith, the British consul in Venice and Francesco Algarotti, whose Dresden gallery contained over 100 pastels in the Rosalba Room.
 Harris and Nochlin, *Women Artists*, pp. 161–64. Bernardina Sani, *Rosalba Carriera*, Turin, 1988

Leonora Carrington b. Clayten Green, Lancs., 1917. Painter and writer. In 1936 studied under Amédée Ozenfant; in 1937 she moved to France with the German Surrealist Max Ernst. After his internment at the start of the Second World War left her stranded, she made a marriage of convenience to the Mexican poet and diplomat Renato Leduc, divorcing him a year later. In 1946 she married the Hungarian photographer Imre Weisz (two sons) and settled in Mexico City. A life-long Surrealist, her work uses a disturbing private mythology in which animals play an important part.
 J. Garcia Ponce, *Leonora Carrington*, Mexico City, 1974. Chadwick, *Women Artists and the Surrealist Movement*. L. Carrington, *The Seventh Horse*, London, 1989. *Leonora Carrington*, exhib. cat., Serpentine Gallery, London, 1991

Mary Cassatt b. Allegheny City 1844 d. Le Mesnil-Théribus 1926. Painter and printmaker. In 1860 studied at the Pennsylvania Academy of the Fine Arts; 1866–70 studied in Paris and Rome and copied in European museums. Unmarried, she settled in Paris in 1874 where her family joined her in 1877. Exhibited in the USA and the Paris Salon from 1868. In 1879, invited by Degas to exhibit for the first time with the Impressionists. Though her *Modern Woman* mural for the World's Columbian Exposition,

Chicago, 1893, has not survived, many associated works exist. Her retrospective in 1895 was held at Durand-Ruel's New York and Paris galleries. Légion d'honneur 1904. Encouraged American collectors to buy contemporary French art.
 A.D. Breeskin *Mary Cassatt: A Catalogue Raisonné of the Graphic Work*, New York, 1948. A.D. Breeskin, *Mary Cassatt: A Catalogue Raisonné of Paintings, Watercolours and Drawings*, Washington, 1970. G. Pollock, *Mary Cassatt*, New York, 1980. *Mary Cassatt and Edgar Degas*, exhib. cat., San Jose Museum of Art, Calif., 1981. N.M. Mathews, ed., *Cassatt and Her Circle: Selected Letters*, New York, 1984. F. Weitzenhoffer, *The Havemeyers: Impressionism Comes to America*, New York, 1986. N.M. Mathews, *Mary Cassatt*, New York, 1987. N.M. Mathews, *Mary Cassatt: A Life*, New York, 1994

Helen Chadwick b. Croydon 1953 d. 1996. An installation artist who also uses photography to explore the sensuality that lies beneath the skin. After Brighton Polytechnic, she attended Chelsea School of Art 1976–77. Influential as a lecturer. Her works include *Of Mutability*, a twelve-part work of 1986; *Piss Flowers*, 1991–92; *Glossolalia*, 1993, for which she stitched together lambs' tongues, cast them in bronze and circled them with a fringe of fox fur; *Cacao*, 1994, a fountain of chocolate.
 M. Warner, *Enfleshings: Helen Chadwick*, London, 1989. *Effluvia: Helen Chadwick*, exhib. cat., Folkwang Museum, Essen; Fundació 'la Caixa', Sala Catalunya, Barcelona; Serpentine Gallery, London, 1994.

Emilie Charmy b. Saint-Etienne 1878 d. Paris 1974. Landscapes, female nudes, flowers. Trained as a teacher and took private art lessons. In 1902/3, moved to Paris with her brother, began exhibiting and moved in Fauve circles. Although her life remained centred on her Paris apartment and studio, she married Georges Bouche in 1935 in order to legitimize their son, born 1915. She received portrait commissions from politicians and artists in the interwar years, and in 1927 became a chevalier of the Légion d'honneur.
 Emilie Charmy 1878–1974, exhib. cat., Stuttgart, 1991. Perry, *Women Artists and the Parisian Avant-Garde*

Constance-Marie Charpentier (née Blondelu) b. Paris 1767 d. Paris 1849. Painted genre scenes and portraits of women and children. Taught by François Gérard and Jacques-Louis David. Exhibited at the Salon 1795–1819. In 1788 she received a Prix d'encouragement; in 1801, *Melancholy* (Musée Picardie, Amiens) was bought by the state; in 1819 she was awarded a gold medal. Few works have been traced.
 De David à Delacroix: La Peinture française de 1774 à 1830, exhib. cat., Grand Palais, Paris, 1974, pp. 346–47

Elisabeth-Sophie Chéron b. Paris 1648 d. Paris 1711. Painter of portraits and genre subjects who was also known as a musician and poet. She was taught by her father, Henri Chéron, and was received in 1672 into the Académie Royale. Married the engineer Jacques le Hay in 1692, under whose name she was subsequently known. Some of her work is in the Pushkin Museum, Moscow, and an early self-portrait is in the Louvre collection, Paris.
 'Hommage à Elisabeth Sophie Chéron', *Prospect No.1*, Paris, 1992

Judy Chicago b. Chicago 1939. West coast feminist artist concerned with female experience. After graduating from the University of California at Los Angeles in 1964, her minimalist sculpture became more personal. At a solo show, 'Pasadena Lifesavers', 1969, she painted central core forms to express female orgasm and announced her denial of male dominance by changing her name from Gerowitz to Chicago. Developed the Fresno Feminist Art Program in 1970 (joined by Miriam Schapiro in 1971) at California State University so students would not have to choose between being a woman and an artist. *Womanhouse*, 1972, included her menstruation bathroom. *The Dinner Party* installation, 1974–78, highlighting famous women through butterfly/vaginal imagery, involved a collaboration of hundreds of volunteer craftworkers. *The Birth Project*, 1980–85, was a huge needlework installation. Now working on holocaust paintings.

J. Chicago, *Through the Flower: My Struggle as a Woman Artist*, New York, 1975. J. Chicago *The Birth Project*, New York, 1985. J. Chicago *The Dinner Party*, London and New York, 1996. *Sexual Politics: Judy Chicago's Dinner Party in Feminist Art History*, exhib. cat., UCLA at the Armand Hammer Museum of Art and Cultural Center, 1996

Milly Childers British artist who exhibited 1888–1921. The daughter of politician Hugh Culling Eardley Childers, she painted portraits, landscapes and church interiors and was employed as a copyist and restorer by Lord Halifax.

Face to Face, exhib. cat., Walker Art Gallery, Liverpool, 1994, p. 93

Claricia twelfth-century manuscript illuminator, active in Augsburg.

D. Miner, *Anastaise and Her Sisters: Women Artists of the Middle Ages*, exhib. cat., The Walters Art Gallery, Baltimore, 1974

Camille Claudel b. Fère-en-Tardenois 1864 d. Villeneuve-lès-Avignon 1943. Sculptor and painter. After her interest was fostered by sculptor Alfred Boucher, she attended the Académie Colarossi in 1881. The following year, she became a student of Auguste Rodin. Their subsequent affair (until 1898) ultimately destroyed her artistically and mentally, and she was committed to an asylum by her family in 1913.

Camille Claudel, exhib. cat. by B. Gaudichon, Musée Rodin, Paris, 1984 (includes cat. raisonné). F. Grunfeld, *Rodin: A Biography*, New York, 1987. *L'Age Mûr de Camille Claudel: Les Dossiers du Musée d'Orsay*, exhib. cat., Musée d'Orsay, Paris, 1988. C. Mitchell, 'Intellectuality and Sexuality: Camille Claudel, the Fin-de-Siècle Sculptress', *Art History*, vol. 12, No. 4, Dec. 1989

Jean Cooke b. London 1927. Still-life and portrait painter. Studied at Central School of Art, Goldsmith's College and with Carel Weight at the Royal College of Art. Married artist John Bratby 1953 (dissolved 1970), and appeared in many of his paintings. Exhibited at the Royal Academy and as part of the London Group.

Maria Cosway b. Florence 1759 d. Lodi 1838. Portrait and history painter. Studied with Violante Cerroti and Johan Zoffany, copied at the Uffizi and visited Rome and Naples. In 1778 she was elected to the Accademia del Disegno in Florence. Went to London in 1779 where she married the artist Richard Cosway in 1781 (one daughter, 1790–96). The couple established a salon at their London home, but in the 1790s they increasingly went their separate ways. During visits to Paris in 1786 and 1787 she had a love affair with Thomas Jefferson. Between 1794 and 1803 she was involved in a series of etching projects. She founded a school for girls in Lyons (1803) and in Lodi (1812). She returned to London in 1817 to nurse her dying husband and remained there until 1822. The college at Lodi brought her prestige and she was created a baroness by Francis I, Emperor of Austria. She was a noted musician and letter-writer.

Letter from Maria Cosway to Sir William Cosway, May 24, 1830, ms.(Ebg,) L.961–1953, Victoria and Albert Museum, London. J. Walker, 'Maria Cosway: An Undervalued Artist', *Apollo*, cxxiii, 1986, pp. 318–24. E. Cazzulani and A. Stroppa, *Maria Hadfield Cosway: Biografia, diari e scritti della fondatrice del Collegio delle Dame Inglesi in Lodi*, Orio Litta, 1989. S. Lloyd, 'The Accomplished Maria Cosway: Anglo-Italian Artist, Musician, Salon Hostess and Educationalist (1759–1838)', *Journal of Anglo-Italian Studies*, ii, 1992, pp. 108–39

Imogen Cunningham b. Portland 1883 d. San Francisco 1976. After early Pictorialist work, she concentrated on portrait and still-life photography 1935–65. Studied photographic chemistry at the Technische Hochschule, Dresden, 1909–10. Inspired by Gertrude Käsebier (q.v.), she worked in the studio of Seattle photographer Edward S. Curtis 1907–9 and had her own Seattle studio 1910–16. She married the printmaker Roi Partridge in 1915 (divorced 1934) and moved to San Francisco where she established a studio in 1917, working there until her death. Founder member of Group f/64. At her death she was preparing a book of photographs of nonagenarians (Seattle and London, 1977).

J. Dater, *Imogen Cunningham: A Portrait*, Boston, Mass., and London, 1979

Anne Damer b. Sundridge 1748 d. London 1828. Amateur sculptor of portrait busts and animals. Married the Hon. John Damer in 1767 (d. 1776). Taught by Guiseppe Ceracchi (for whose muse of sculpture she posed) and John Bacon. Exhibited as an honorary exhibitor (i.e. an amateur) at the Royal Academy 1785–1811.

H. Walpole, ed. R.N. Wornum, *Anecdotes of Painting in England* (1762–71), 1849, vol. I, pp. xx–xxiii. A. Cunningham, *The Lives of the Most Eminent British Painters, Sculptors and Architects*, London 1829–33, iii, pp. 247–73. M. Whinney, *Sculpture in Britain 1530–1839*, Pelican History of Art, Harmondsworth, rev. edn. 1988. G. Jackson-Stops, ed., *The Treasure Houses of Britain: 500 Years of Private Patronage and Art Collecting*, exhib. cat., National Gallery of Art, Washington DC, 1985

Judy Dater b. Hollywood 1941. Photographer of the human face and body, particularly female. Studied fine art at the University of California, Los Angeles (1956–59), and photography at San Francisco State University. Married Dennis Dater 1962 (divorced 1964) and Jack Welpott (divorced 1978). Has taught photography. In *Women and Other Visions*, she photographed women clothed and unclothed in their home environment, suggesting questions about the roles women choose to adopt.

J. Dater and J. Welpott, *Women and Other Visions*, New York, 1975. J. Dater, *Cycles*, Tokyo, 1992

Sonia Delaunay b. Ukraine 1885 d. Paris 1979. Painter and designer. Studied drawing with Ludwig Schmidt-Reutter in Karlsruhe, 1903–5; studied at the Académie de la Palette in Paris in 1905; learned print-making from Rudolf Grossmann. In 1908, she married William Uhde in order to stay in Paris, and had her first exhibtion that year at his gallery. After divorcing him in 1910, she married Robert Delaunay (d. 1941). By 1912, she was active as a designer and in 1917, she expanded her textile and interior design practice with the Casa Sonia in Madrid and then the Atelier Simultane in Paris ('simultaneity' was the name she and her husband had given their brand of Cubism). The Delaunays joined the Abstraction-Création group in 1931 and painted murals for the Exposition Universelle, Paris 1937. Awarded the Légion d'honneur in 1975.

S. Delaunay, *Nous irons jusqu'au soleil*, Paris 1978. *Sonia Delaunay: A Retrospective*, exhib. cat., Albright-Knox Art Gallery, Buffalo, 1980. S. Baron, *Sonia Delaunay*, London, 1995

Tamara de Lempicka b. Warsaw 1898 d. Texas 1980. Figurative painter, particularly of women. Fled Russian Revolution with her husband in 1917. Studied at the Académie de la Grande Chaumière, Paris, 1918; then with Maurice Denis and Andre Lhote. She depicted Parisian society in a hard-edged brand of Cubism which has since become synonymous with Art Deco. Moved to the USA in 1939. A retrospective was held in Paris in 1992.

Tamara de Lempicka 1925–1935, exhib. cat., Palais Luxembourg, Paris, 1972. G. Marmori, *The Major Works of Tamara de Lempicka, 1925–1935*, London, 1978. K. Foxhall and C. Phillips, *Passion by Design; The Art and Times of Tamara de Lempicka*, Oxford, 1987

Diemudis/Diemud twelfth-century illuminator from the Cloister of Wessobrun, Bavaria, responsible for forty-five manuscripts 1057–1130.

Rose Adélaïde Ducreux b. France 1761 d. St Domingo 1802. Portrait and landscape painter. Daughter of Joseph Ducreux, painter to Queen Marie Antoinette. Married M. de Montgirard, maritime prefect of St Domingo.

Marie-Nicole Dumont b. Paris 1767 d. Paris 1846. Daughter of the painter Antoine Vestier, and in 1789 married the painter François Dumont. As a wedding gift, the couple were presented with an apartment in the Louvre by Louis XVI. Exhibited at the Paris Salon in 1793.

Mary Beth Edelson b. Indiana c. 1935. Performance and multi-media artist. Graduated from New York University in 1959. Feminist artist who used her body in the 1970s to explore female spirituality, adding political and historical issues to her concerns in the 1980s.

L. Lippard, *Overlay: Contemporary Art and the Art of Prehistory*, New York, 1983. G. Battcock and N. Roberts, eds, *The Art of Performance: A Critical Anthology*, New York, 1983

Tracey Emin b. London 1963. Uses a variety of media to speak about herself and her life. Claims her work is not so much confessional as common to all and therefore cathartic. Studied at Maidstone School of Art; Royal College of Art, London. In 1993 ran 'The Shop' with Sarah Lucas (q.v.), selling art multiples. In 1994 toured the USA with a chair, her 'spiritual starting place', and her book, *Exploration of the Soul*. In 1995 opened the Tracey Emin Museum, London.
 Minky Manky, exhib. cat., South London Gallery, 1995. *Brilliant! New Art from London*, exhib. cat., Walker Art Center, Minneapolis, 1995. *I Need Art Like I Need God*, London, 1997

Audrey Flack b. New York 1931. Photo-realist painter. 1951–53 at Cooper Union, New York, then Yale University where she studied with Joseph Albers. Taught at the Pratt Institute, New York, 1960–68, and at the School of Visual Arts, New York, 1970–74. In 1971 she painted a huge reproduction of a Madonna by the seventeenth-century Spanish sculptor Luisa Roldan (*Macarena Madonna*, Private Collection, Virginia), and in 1974 a self-portrait that echoed Roldan's sculptural smoothness. Still-life was a preoccupation of the 1970s, using it to speak of her family. Maria van Oosterwijck's *Vanitas*, 1668, was the impetus for an exploration of the Holocaust.
 Audrey Flack on Painting, introd. L. Alloway, New York, 1981

Lavinia Fontana b. Bologna 1552 d. Rome 1614. Painter of portraits and mythological and religious subjects, including altarpieces. Trained by her father Prospero Fontana. In 1577 married her father's former pupil, Gian Paolo Zappi, who managed her career. Eleven children did not stop her prolific output, although a contemporary refers to her depression following the death of an artistically talented daughter (Harris and Nochlin, *Women Artists*). Invited to Rome in 1603 by Pope Clement VIII. First woman artist to paint large public works of religion and myth.
 V. Fortunati Pietrantonio, *La Pittura Bolognese del 1500*, Bologna, 1986, pp. 727–75. M.T. Cantaro, *Lavinia Fontana, Bolognese 'pittura singolare'*, Milan, 1989. E. Tufts, 'Lavinia Fontana, Bolognese Humanist' in *Le Arti a Bologna e in Emilia dal xvi al xvii secole/Recueils d'actes des Congrès Internationaux d'histoire de l'art*, Bologna, 1992, pp. 129–34. A. Ghirardi, 'Lavinia Fontana allo Specchio: Pittrici e autoritratto nel secondo Cinquecento', in *Lavinia Fontana*, exhib. cat., Bologna, 1994

Giovanna Fratellini b. Florence 1666 d. Florence 1731. History and portrait painter in pastel and oil. Trained with Livio Mehus and Pietro Dandini. Became lady-in-waiting to Vittoria della Rovere, Grand Duchess of Tuscany, and obtained further training in music, and enamel, pastel and miniature painting. Nobility commissioned portraits from her. Married in 1684. The artist Violante Beatrice Siries (1709–83) was her pupil.
 B. Viallet, *Gli Autoritratti Femminili delle Gallerie degli Uffizi in Firenze*, Rome, 1923

Nancy Fried b. Philadelphia 1945. Sculptor concerned with women's issues. Graduated 1968 University of Pennsylvania.
 M. Douglas, *Inside, Outside: Psychological Self-Portraiture*, exhib. cat., Aldrich Museum

of Contemporary Art, Ridgefield, 1995. C.S. Rubenstein, *In Three Dimensions: Women Sculptors of the 90s*, exhib. cat., Snug Harbour Cultural Center, New York, 1995. *Real(ist) Women*, exhib. cat., Selby Gallery, Sarasota; Ringling School of Art and Design, 1997

Rose Garrard b. Bewdley 1946. Sculptor, painter, performance and installation artist concerned with presenting issues of interest to women. Birmingham College of Art, 1966–69; Chelsea School of Art, 1969–70; Ecole des Beaux-Arts, Paris 1970–71. Residencies include the New Art Gallery, Calgary, 1991; Vancouver Art Gallery, 1992. Involved in teaching and exhibition organization. Her retrospective, *Living Archives*, was in 1994.
 Rose Garrard: Archiving My own History. Documentation of Works 1969–1994, Cornerhouse, Manchester; South London Art Gallery, 1994

Artemisia Gentileschi b. Rome 1593 d. Naples 1652/3. History and portrait painter. Taught by her father Orazio Gentileschi. Her perspective teacher, Agostino Tassi, raped her, resulting in a trial in 1612, Tassi's imprisonment for eight months and Artemisia's move to Florence after her marriage to Pietro Stiattesi. In 1616, she became the first woman to join the Accademia del Disegno. By 1630 she was in Naples and 1638–41 worked with her father (d. 1639) on his work for Charles I. A powerful and up-to-date artist (she brought her knowledge of Caravaggio's style to Florence, Genoa and Naples) she apparently had difficulty finding patrons in her later years, perhaps because her scenes of female nudity and female heroines were too strong and 'unfeminine' to titillate.
 N. Broude and M.D. Garrard, eds., *Feminism and Art History*, New York, 1982, pp. 146–71. M. Garrard, *Artemisia Gentileschi*, Princeton, 1989. *Artemisia*, exhib. cat., Casa Buonarroti, Florence; Complesso Monumentale di S. Michele a Ripa, Rome; Stuttgart; Zurich, 1991–92

Marguerite Gérard b. Grasse 1761 d. Paris 1837. Genre and portrait painter. Taught by her brother-in-law Jean-Honoré Fragonard, with whom she went to live at fourteen on her mother's death, and studied Dutch seventeenth-century little masters. Established herself as the leading female genre painter by the mid 1780s, her work popularized through engravings. After the French Revolution when the Salon was opened to women (not just elected members, as before) she exhibited 1799–1824, winning a Prix d'encouragement in 1801 and a gold medal in 1804. She did not marry. Over 300 genres scenes and 80 portraits are recorded.
 S.W. Robertson, 'Marguerite Gérard', in *French Painting 1774–1830: The Age of Revolution*, exhib. cat., Grand Palais, Paris; Michigan Institute of Art, Detroit; Metropolitan Museum of Art, New York, 1974–75, pp. 440–41. Harris and Nochlin, *Women Artists*, pp. 197–98. P. Rosenberg, *Fragonard*, exhib. cat., Grand Palais, Paris; Metropolitan Museum of Art, New York, 1987–88, pp. 573–77. J.P. Cuzin, *Jean-Honoré Fragonard: Life and Work*, New York, 1988, pp. 216–24, 338–40

Gluck (Hannah Gluckstein) b. London 1895 d. Steyning 1978. Painter of portraits, especially women, landscapes, cabaret subjects, flowers. A misfit in a wealthy family, by 1918 she was calling

herself Peter, smoking a pipe and designing her first mannish clothes. She resolved the pull between music and art by enrolling at the St John's Wood Art School. From 1915 she spent time at the artists' colony at Lamorna. Her first solo show was in 1924 at the Dorien Leigh Galleries. Subsequent exhibitions were at the Fine Art Society in Bond Street, London (1926, 1932, 1937). A final show there in 1973 revived her reputation.
 D. Souhami, *Gluck*, London, 1988

Nan Goldin b. Washington 1953. Photographer of friends and family, concerned with issues of gender and power. Began taking photographs at 18. First exhibition, *The Ballad of Sexual Dependency*, over 700 slides set to music, has had a wide international showing.
 N. Goldin, *The Ballad of Sexual Dependency*, New York, 1986. D. Armstrong and W. Keller, eds, *The Other Side*, Manchester, 1993. *I'll Be Your Mirror*, exhib. cat., Whitney Museum of American Art, New York, 1996

Adrienne-Marie-Louise Grandpierre-Deverzy b. Tonnerre 1798. Painter of interiors, genre, portraits and literary and historical subjects. Pupil of Abel de Pujol whom she later married. Salon exhibitor 1822–55.

Guda/Guta German illuminator working in the twelfth century. She produced a *Homiliary of St Bartholomew*.
 Chadwick, *Women, Art and Society*, p. 54

Louise Hahn b. Vienna 1878. Painter (genre, flowers, landscape, portraits) and wood engraver. Pupil of J. Karger in Vienna and H. Knirr in Munich. Married artist Walter Fraenkel.

Ann Hall b. Connecticut 1792 d. 1863. Portraitist and miniature painter. Exhibited from 1827 to 1858 at the National Academy of Design and was the first woman to be elected a full member. The daughter of a physician and amateur artist, she took a few lessons from Samuel King but was basically self-taught, improving her skills by making copies in miniature of prints of old masters.
 Fine, *Women and Art*, p. 100. C.K. Dewhurst, B. Macdowell, M. Macdowell, *Artists in Aprons: Folk Art by American Women*, New York, 1979

Mona Hatoum b. Beirut 1952. Uses installations, photography, performance, video and sculpture to produce works which disturb our sense of self and our notions of the space which surrounds us. Based in London since 1975. Graduated from the Slade School of Fine Art in 1981. A series of residencies followed: The Western Front, Vancouver; Contemporary Arts Centre, Seattle; Chisenhale Dance Space, London. Lectured at St Martin's College of Art and Design, London, 1986–94. Member of the artists' films and video committee of the Arts Council of Great Britain, 1992–94. Part-time professor at the Jan van Eyck Akademie, Maastricht, 1992–94. Has exhibited internationally.
 Mona Hatoum, exhib. cat., Arnolfini Gallery, Bristol, 1993, bibliography, list of works in English. *Mona Hatoum*, exhib. cat., Centre Georges Pompidou, Paris, 1994. E. Lajer-Burcharth, 'Real Bodies: Video in the 1990s', *Art History*, vol. 20, no. 2, June 1997

Antoinette-Cécile-Hortense Haudebourt-Lescot
b. Paris 1784 d. Paris 1845. Genre and portrait painter.
She became a pupil at the age of seven of Guillaume
Lethière, a family friend. She went to Rome in 1808,
a year after Lethière's appointment as director of the
Académie de France there, and stayed until 1816. She
married the architect Louis-Pierre Haudebourt in 1820.
She made her name with depictions of Italian customs,
and between 1810 and 1840 exhibited over 100
paintings at the Salon, winning second-class medals
(1810, 1819), a first-class medal (1827) and government
commissions. Engravings were made of many of
her works.
> S.W. Robertson and I. Julia, 'A.C.H.
> Haudebourt-Lescot', *French Painting 1774–1830:*
> *The Age of Revolution*, exhib. cat., Grand Palais,
> Paris; Michigan Institute of Art, Detroit;
> Metropolitan Museum of Art, New York,
> 1974–75, pp. 486–7. Harris and Nochlin,
> *Women Artists*, pp. 218–19

Jeanne Héburterne b. 1898 d. Paris 1920. Painter.
Studied at the Académie Colarossi and the Ecole des
Arts Decoratifs, Paris. Partner of the artist Modigliani.
Following his death, and pregnant with her second
child by him, she threw herself from a balcony.
> P. Chaplin, *Into the Darkness Laughing:*
> *The Story of Modigliani's Last Mistress Jeanne*
> *Héburterne*, London, 1990. Perry, *Women Artists*
> *and the Parisian Avant-Garde*

Catharina van Hemessen b. Antwerp 1528
d. Antwerp after 1587. Painter of portraits and
religious subjects. Trained by her father, the artist
Jan Sanders van Hemessen: she signs herself
'Catharina daughter of Joannes de Hemmessen'
in a portrait in the National Gallery, London.
Married Christian de Morien, organist at Antwerp
Cathedral in 1554. In 1556 the couple were taken to
Spain – perhaps in the capacity of artistic double act? –
by Mary of Hungary, sister of the Emperor Charles
V, who established her court there after abdicating as
Regent of the Netherlands. Van Hemessen's surviving
eight small portraits and two religious paintings
date from 1548 to 1552.
> Harris and Nochlin, *Women Artists*, p. 105

Florence Henri b. New York 1893 d. Compiegne
1982. Portrait, advertising and fashion photographer.
Studied piano under Egon Petri and Ferruccio Busoni,
Berlin 1911–14; painting under Schwitters, Berlin
Academy of Fine Arts 1914; art in Munich, 1915–19,
and Paris under Léger and Ozenfant, 1924–25;
painting and photography under Josef Albers and
László Moholy-Nagy at the Bauhaus, 1927. In the
1930s, associated with Cercle et Carré group in Paris,
where she practised professionally until 1963.
> *Florence Henri: Artist-Photographer of the*
> *Avant-Garde*, exhib. cat., San Francisco
> Museum of Modern Art, 1990

Nathalie Hervieux b. Normandy 1966.
Photographer. Educated Ecole Nationale Supérieur
des Beaux-Arts, Paris.
> C. De Zegher, *Inside the Visible*, Cambridge
> and London, 1996

Nora Heysen b. Hahndorf 1911. Flower, still-life
and portrait painter. Daughter of Australian artist
Sir Hans Heysen. Educated Australia (Adelaide School
of Fine Arts) and London (Central School, Byam
Shaw School of Art). An official war artist in New

Guinea 1944–46. First solo show 1933. Retrospective
Ervin Gallery, Sydney, 1989.
> L. Klepac, *Nora Heysen*, Sydney, 1989.
> *A Century of Australian Women Artists*, exhib.
> cat., Deutscher Fine Art, Melbourne, 1993

Susan Hiller b. New York 1942. Uses installations,
paintings, photography and video plus a range of
unlikely materials (wallpaper, shadows) to shake
settled perceptions of reality and to raise questions
of authorship and method. Studied anthropology.
Settled in London where she held her first exhibition
1973 (Gallery House, London). Influential as a teacher,
she has said that she is 'retrieving and reassembling
a collection of fragments' which require participation
from spectators to decode. (Tate cat., below, p. 10).
> *Susan Hiller*, L. Lippard essay 'Out of Bounds',
> exhib. cat., Institute of Contemporary Arts,
> London, 1986. *Susan Hiller*, exhib. cat.,
> Tate Gallery, Liverpool, 1996.

Sigrid Hjertén b. Sundsvall 1885 d. Stockholm 1948.
Specialized in weaving at the Konstindustriellaskola,
Stockholm, 1905–8. Attended Matisse's Academy
in Paris 1909–11. Married Swedish painter Isaac
Grünewald in 1911. She was influenced by Futurism
and German Expressionism and was one of a group
of artists who introduced modern French art to
Sweden. She lived in Paris 1920–30. She died in
the psychiatric hospital she had entered in 1937.
> E. Haglund, *Sigrid Hjertén*, Stockholm, 1985

Frances Hodgkins b. Dunedin 1869 d. Herrison
1947. Landscape and still-life painter in oil and
watercolour. Her father encouraged her to paint.
Studied with Girolamo Neri in 1893, receiving local
recognition by 1896. She came to London in 1901,
travelling widely and exhibiting a painting of Morocco
at the 1903 Royal Academy. In Paris 1908–14, exhibited
at the Salon and became the first female instructor
at the Académie Colarossi. From 1914, she lived in
England, linked with the 7 & 5 Society. In 1940
she represented Britain at the Venice Biennale.
> M. Evans, *Frances Hodgkins*, London, 1948.
> J. Rothenstein, *Modern English Painters*,
> London, 1952. E. H. McCormick, *Portrait*
> *of Frances Hodgkins*, Auckland, 1981.
> A. McKinnon, *Frances Hodgkins 1869–1947*,
> London, 1990. A. Kirker, *New Zealand Woman*
> *Artists: A Survey of 150 Years*, Auckland, 1986

Rebeccca Horn b. Michelstadt 1944. Sculptor
and filmmaker. Hochschule für Bildende Künste,
Hamburg, 1964–70; lectureship at the California Art
Institute, Los Angeles, 1974. Much of her art explores
contact – sometimes frustrated – between objects,
between people or between objects and people, and
can be sensual and exciting. She uses film to document
her own performances and to explore her interest
in communication.
> *Rebecca Horn*, exhib. cat., Kunsthaus, Zurich;
> Serpentine Gallery, London; Museum of
> Contemporary Art, Chicago, 1983–84. *Driving*
> *Through Buster's Bedroom*, exhib. cat., Museum
> of Contemporary Art, Los Angeles, 1990.
> *Rebecca Horn*, exhib. cat., Guggenheim
> Museum, New York; Stedel Van Abbemus,
> Eindhoven; Tate Gallery, London, 1993–95

Esther Inglis b. France 1571 d. 1624. Calligrapher.
Taught by her mother Parie Prisott Langlois
(C. Petteys, *Dictionary of Women Artists*, Boston,

1985). Married Bartholomew Kello c. 1596. Patronized
by English and Scottish aristocracy. Manuscripts in
British Library, London; Christ Church College,
Oxford; Folger Library, Washington.

Gwen John b Haverfordwest 1876 d. Dieppe 1939.
Painter of portraits, particularly of women. She
joined her brother, Augustus John, at the Slade
School of Fine Art, 1895–98; in 1898 she attended
the Académie Carmen, Paris, under James McNeill
Whistler. Settled in Paris in 1904 where she earned
money by modelling for women artists and for the
sculptor August Rodin with whom she fell deeply in
love. She became increasingly reclusive, exhibiting less
and less. The American John Quinn was her principal
patron 1910–24, prising from her all she would release.
Though represented in national collections (Tate
Gallery, London; National Museum of Wales,
Cardiff), her recognition and status is due to
several decades of research by feminist critics.
> *Gwen John: An Interior Life*, exhib. cat., essay
> C. Langdale, Barbican Art Gallery, London,
> 1985. C. Langdale, *Gwen John*, London and New
> Haven, 1987. A. Thomas, *Portraits of Women:*
> *Gwen John and Her Forgotten Contemporaries*,
> Cambridge, 1994. C. Lloyd-Morgan, *Gwen*
> *John Papers at the National Library of*
> *Wales*, Aberystwyth, 1988, rev. edn, 1995

Frances Benjamin Johnston b. Grafton 1864
d. 1952. Documentary, architectural and portrait
photographer. Studied painting at the Académie
Julian, Paris, 1883–85, then Art Students' League,
New York, and Corcoran Gallery School, Washington
DC. Through George Eastman, a family friend, she
obtained a Kodak camera and began an apprenticeship
at the photographic laboratory of the Smithsonian
Institution, Washington DC. She worked as a
photo-journalist, had her first studio in 1890, and
photographed presidential families. By 1892, she
was a US government photographer. Her 1899
commission to photograph the Hampton Institute
as part of a pictorial essay on the Washington school
system for the Paris Exposition is today famous for
its record of the training of non-white Americans. She
and Gertrude Käsebier (q.v.) encouraged women to
become photographers. In 1897 wrote 'What a Woman
can do with a Camera' for *Ladies Home Journal*.
> *The Hampton Album*, Museum of Modern Art,
> New York, 1966. A. Tucker, *The Woman's Eye*,
> New York, 1973

Frida Kahlo b. Mexico City 1907 d. Mexico City
1954. Painter of autobiography. Began to paint while
recovering from a bus accident in 1925 which left her
crippled and constantly in pain. Influenced by Italian
Renaissance artists, Surrealism and Mexican popular
art. Married the painter Diego Rivera in 1929, divorced
him in 1939 and remarried him in 1940. In 1938, André
Breton wrote the introduction for the first exhibition
of her work, in which he called her a self-invented
Surrealist, a label Kahlo disliked, claiming that
she painted reality not dreams.
> L. Mulvey et al., *Frida Kahlo and Tina Modotti*,
> exhib. cat., Whitechapel Art Gallery, London,
> 1982. H. Herrera, *Frida: A Biography of Frida*
> *Kahlo*, New York, 1983. M. Drucker, *Frida*
> *Kahlo: Torment and Triumph in Her Life and*
> *Art*, New York, 1991. H. Herrera, *Frida Kahlo:*
> *The Paintings*, London, 1991. C. Fuentes,
> *The Diary of Frida Kahlo: An Intimate*
> *Self-Portrait*, London, 1995

Getrude Käsebier b. Des Moines 1852 d. 1934. Portrait and Pictorialist photographer. After marriage and three children, studied painting at the Pratt Institute, New York, then photography. Had a portrait studio in New York 1897–1929. In 1897, 150 portraits were exhibited at the Boston Camera Club and the Pratt Institute, New York. In 1899, *The Manger* was sold for an unprecedented $100. In 1902, she was a founding member of the Photo-Secession with Alfred Stieglitz and Clarence H. White. In 1916, after Stieglitz and his 291 group advocated unmanipulated photography, she and White founded the rival Pictorial Photographers of America.

A. Tucker, *The Woman's Eye*, New York, 1973. W.J. Naef, *The Collection of Alfred Stieglitz: Fifty Pioneers of Modern Photography*, New York, 1978. A. Kennedy and D. Travis, *Photography Rediscovered: American Photographers 1900–1930*, Whitney Museum of Art, New York, 1979

Angelica Kauffman b. Chur 1741 d. Rome 1807. Painted portraits and scenes from classical history. Taught by her father who took her to Italy (1762–66) where she studied classical sculpture, learned perspective and met artists involved in the Neoclassical movement. The wife of Joseph Smith, the English consul, brought her to England (1766) where she undertook decorative schemes as well as easel paintings and was a founder member of the Royal Academy in 1768. She survived a marriage to a counterfeit aristocrat in 1767, marrying after his death in 1780 the artist Antonio Zucchi. They settled in Rome, where between 1782 and 1797 she produced Neoclassical paintings for royal patrons. In 1782 she declined the position of court painter to King Ferdinand and Queen Caroline of Naples. The sculptor Canova organized her funeral at which two of her works were carried in emulation of Raphael's funeral.

A.M. Clark, 'Roma me è sempre in pensiero', in *Studies in Roman Eighteenth-Century Paintings*, ed. E.P. Bowron, Washington, 1981, pp. 125–38. W.W. Roworth, ed., *Angelica Kauffman: A Continental Artist in Georgian England*, London, 1992

Mary Kelly b. Albert Lea 1941. Conceptual artist influenced by psychoanalytic theories. Studied fine art and aesthetics at the Pius Xll Institute, Florence, 1963–65, and painting at the St Martin's School of Art, London, 1968–70. First solo exhibition (Institute of Contemporary Arts, London, 1976) showed three of the six documents from *Post Partum Document*, 1973–77, in which she analysed the relationship with her son over four years through drawings, charts, objects and recordings. *Interim*, 1984–89, discusses the issues of middle age and the more recent *Gloria Patri* looks at the social consequences of the masculine ideal.

Mary Kelly, *Post Partum Document*, London, 1983. *Interim*, exhib. cat., Fruitmarket Gallery, Edinburgh; Kettle's Yard, Cambridge; Riverside Studios, London, 1985–86. H. Foster et al., *Mary Kelly: Interim*, New Museum of Contemporary Art, New York, 1990

Anne Killigrew b. London 1660 d. London 1685. Painter of subject pictures, landscapes and portraits (few survive) and poet. Daughter of Henry Killigrew, chaplain and almoner to the Duke of York (later James II) and maid of honour to the Duchess of York. It is not known how she trained and proximity to royalty does not explain the ambition which led her to do a small, full-length portrait

of James II (1685, Royal Collection).

H. Walpole, ed. R.N. Wornum, *Anecdotes of Painting in England* (1762–71), 1849, vol. ii, pp. 106–7. O. Miller, *The Tudor, Stuart and Early Georgian Pictures in the Collection of HM the Queen*, London, 1963, p. 141. J. Kinsley, ed., *The Poems of John Dryden*, 4 vols, Oxford, 1958, vol. 1, pp. 459–65, vol. 4, pp. 1965–67

Nancy Kitchel, now Nancy Wilson Pajic b. Peru, Indiana, 1941. Photographic artist. Graduated Cooper Union, New York 1963. As Nancy Kitchel, active in the feminist and avant-garde New York scene and co-founder of the A.I.R. Gallery. In 1978 moved to France and as Nancy Wilson Pajic her work has become increasingly formal, drawing on nineteenth-century photographic processes.

L. Lippard, *From the Center: Feminist Essays on Women's Art*, New York, 1976. *Nancy Wilson Pajic: Photographies*, exhib. cat., Institut Franco-Américain, Rennes, 1985

Laura Knight b. Long Eaton 1877 d. London 1970. Painter of the ballet, the circus, portraits. In 1889 she entered the Nottingham College of Art. Dependent on her own earnings, she taught art from 1894. In 1903, she married the painter Harold Knight and until 1914 the couple lived in various artists' communities, concluding with Newlyn. She exhibited at the Royal Academy from 1903 and achieved recognition early. She received official commissions during the Second World War (Imperial War Museum, London) and was the official artist at the Nuremberg war crime trials.

L. Knight, *Oil Paint and Grease Paint*, London, 1936. L. Knight, *The Magic of a Line*, London, 1965. D. Phillips, *Dame Laura Knight*, exhib. cat., Castle Museum, Nottingham, 1970. J. Dunbar, *Laura Knight*, London, 1975. C. Fox, *Dame Laura Knight*, Oxford, 1988

Käthe Kollwitz b. Königsberg 1867 d. Moritzburg 1945. Printmaker and sculptor. Trained as a painter in Berlin 1885 under Karl Stauffer-Bern and in Munich 1888 under Ludwig Herterich, devoting herself to printmaking after 1890. In 1904, she studied sculpture at the Académie Julian in Paris. Her first printmaking success was *A Weaver's Revolt*, 1895–98. After her son's death in the First World War, suffering joined revolution as a theme. She received much recognition after 1919, but in 1933, because of her anti-Nazi stance, was asked to leave the Prussian Academy of the Arts (its first woman member) and lost her studio. She remained in Germany during the Second World War.

O. Nagel, *Die Selbstbildnisse der Käthe Kollwitz*, Dresden, 1965. C. Zigrosser, ed., *Prints and Drawings of Käthe Kollwitz*, New York, 1969. M. Kearns, *Käthe Kollwitz: Woman and Artist*, New York, 1976. F. Whitford et al., *Käthe Kollwitz 1867–1945: The Graphic Works*, Cambridge, 1981. J. Bohnke-Kollwitz, ed., *Käthe Kollwitz: Die Tagebücher*, Berlin, 1989

Germaine Krull b. Wilda 1897. d. 1985 Architectural, fashion and industrial photographer. Studied photography at Bayerische Staatslehranstalt für Lichtbildwesen, Munich. Married Dutch filmmaker Joris Ivens 1937 (divorced 1943). Important member of the European artistic world of the 1920s, although all her work prior to 1945 was lost in the Second World War. Jean Cocteau wrote: 'You are a mirror which recreates things. With the help of your darkroom you allow a new world to spring into being,

a world which encompasses both technical and intellectual dimensions.' Lived in India after 1945.

Germaine Krull: Photographien 1922–1967, exhib. cat., Rheinisches Landesmuseum, Bonn, 1977 (80th birthday restrospective)

Adélaïde Labille-Guiard b. Paris 1749 d. Paris 1803. Portraits, miniatures and history paintings. About 1763 studied with the miniature painter François-Elie Vincent; 1769–74 learned pastel technique from Maurice-Quentin de La Tour; 1776 studied oil painting with François-André Vincent. In 1769 she became a member of the Académie de St Luc and in 1783 the Académie Royale (French Academy). In 1787 she was appointed Peintre des Mesdames, official painter to Louis XVI's aunts. Though she attempted to balance her royal with revolutionary patrons after the Revolution, this tumultuous period resulted in a decline in her output. From 1785, she fought for equal privileges for women academicians.

A.-M. Passez, *Adélaïde Labille-Guiard 1749–1830: Biographie et catalogue raisonné de son oeuvre*, Paris, 1973. Harris and Nochlin, *Women Artists*, pp. 185–87. Chadwick, *Women Art and Society*, pp. 164–74

Lotte Laserstein b. Prussia 1898 d. Kalmar 1993. Studied at the Berlin Academy where she was the star pupil of Erich Wollsfeld. Won the gold medal in 1925. To earn money at a time of inflation, she drew cadavers for anatomical textbooks. Set up her own studio in Berlin 1925–35; first solo show 1930 at Fritz Gurlitt Gallery, Berlin. Her Jewish antecedents made living in Germany difficult, and she settled in Sweden after an exhibition in 1937 at the Galleri Modern, Stockholm, becoming a respected teacher and portraitist. She had London exhibitions in 1987 (Belgrave Gallery) and 1990 (Agnew's).

Gen Doy, *Seeing and Consciousness*

Marie Laurencin b. Paris 1883 d. Paris 1956. Painter of portraits and flower pieces. Studied porcelain painting at the Sèvres factory (1901), drawing with the flower painter Madelaine Lemaire and attended the Académie Humbert 1903–4. As the partner of the poet Guillaume Apollinaire 1907–12, she was part of the Bateau-Lavoir group (Picasso, Gris, Braque etc.). Exhibited at the Salon des Independants from 1907; first solo show 1912 at the Galerie Barbazanges, Paris; showed seven works in the Armory Show in New York in 1913. After spending the First World War in Spain (1914–20), her return to Paris was marked by a book of poems in her honour (*L'Eventail*, Paris, 1922). She painted portraits of society women in the 1920s and '30s. From 1919 she illustrated books and received her first theatrical commission in 1923 (*Les Biches* for Diaghilev).

J. Pierre, *Marie Laurencin*, Paris, 1988. *Marie Laurencin. Artist and Muse*, exhib. cat., Birmingham Museum of Art, Alabama, 1989. *Marie Laurencin: Cent Oeuvres des Collections du Musée Marie Laurencin au Japon*, Martigny, Fondation Pierre Gianadda, 1993–94

Marie-Victoire Lemoine b. Paris 1754 d. Paris 1820. Portraits, genre, miniatures. Taught by F.G. Menageot, but earlier beliefs that she was a pupil of Elisabeth Vigée-Lebrun are now disproved (see below). Exhibited at the Salon de la Correspondance before the Revolution and afterwards at the Paris Salon.

Harris and Nochlin, *Women Artists*, pp. 188–89

Sabine Lepsius, née Graef b. Berlin 1864 d. Wurzburg 1942. Portraitist. Pupil of Gussow in Berlin and of Lefèvre and Benjamin Constant in Paris. Married artist Reinhold Lepsius. Her daughter Sabine Simons was a porcelain modeller, and painter.

Rachel Lewis b. London 1966 d. Exeter 1994. Painter, sculptor and mural artist. Studied at Polytechnic South West, Exeter. Stated that 'My art comes from talking, listening and being with people; life.'
A Degree of Emotion, exhib. cat., Nicholas Treadwell Gallery, Bradford, 1990

Judith Leyster b. Haarlem 1609 d. Heemstede 1660. Painter of genre scenes by artificial light, portraits and still-life. May have studied or worked with Frans Hals and Frans Pietersz. de Grebber and was influenced by the Utrecht Caravaggisti. By 1633 she was a member of the Guild of St Luke, Haarlem. In 1634, one of three students in her shop was taken on by Hals without Guild permission and a dispute was recorded. Married the artist Jan Miense Molenaer in 1636 and moved to Amsterdam. Five children were born 1637–50. Though little is known of her work after her marriage, many of her paintings were listed in Molenaer's inventory after his death in 1668.
Harris and Nochlin, *Women Artists*, pp. 137–40. *Masters of Seventeenth-Century Dutch Genre Painting*, exhib. cat., Philadelphia Musem of Art; West Berlin Gemäldegalerie; Royal Academy, London, 1987. J.A. Wehr et al., *Judith Leyster: A Dutch Master and Her World*, exhib. cat., Frans Halsmuseum, Haarlem; Massachusetts Art Museum, Worcester, 1993.

Barbara Longhi b. Ravenna 1552 d. *c.* 1638. Biblical subjects. Worked with her father, Luca Longhi. Her *St Catherine of Alexandria*, 1589, is thought to be a self-portrait.
L.D. Cheney, 'Barbara Longhi of Ravenna', *Woman's Art Journal*, ix, 1988

Yolanda M. Lopez b. San Diego. Began as a painter and expanded into installation, video and slide. Studied fine art at the University of California, San Diego. Lives in San Francisco with her son. Since working as a community artist she sees her art as a tool for political and social change. Much of her work centres on the Mexican immigration experience, e.g. the installation, *Things I Never Told My Son About Being a Mexican*.
Broude and Garrard, *The Power of Feminist Art*

Sarah Lucas b. London 1962. Uses photography, installation, objects, collage to upend gender stereotypes. Studied at Goldsmiths' College, London, 1984–87. Her manner of commenting on contemporary attitudes brought her early success and ties her in with a brilliant generation of Goldsmiths' graduates who exhibited in 'Freeze', (exhib. cat., Surrey Docks, London, 1988). Ran an art multiples shop with Tracey Emin (q.v.) in 1993.
Minky Manky, exhib. cat., South London Gallery, 1995. *Brilliant! New Art from London*, Walker Art Center, Minneapolis, 1995. *Sarah Lucas*, exhib. cat., Museum Boijmans Van Beuningen, Rotterdam, 1996

Helen J. Maguire b. 1860 d. 1909. Irish watercolourist. She and her sister, Adelaide Agnes Maguire (1852–76) were influenced by watercolourists William Henry Hunt and Myles Birket Foster.

Cynthia Mailman b. New York 1942. Painter of the urban landscape. Educated at Pratt Institute, New York (fine art and education) and Rutgers University, New Brunswick (painting). She has exhibited in group shows since 1975 and in solo shows since 1976. Her mural (1979) for the World Trade Center has been destroyed. Has taught and worked as an artist-in-residence across the USA.
S. Swenson, *Lives and Works, Talks with Women Artists*, Metuchen, NJ, 1981. J. Perrault, *The Staten Island Invitational*, exhib. cat., The Newhouse Center, Staten Island, 1989. Broude and Garrard, *The Power of Feminist Art*

Melanie Manchot b. Witten 1966. Photographer. One strand of her work has always involved self-portraiture. Royal College of Art, London, 1990–92. Her work investigates notions of pregnancy, maternity, femininity and female sexuality.
Twin Sets, exhib. cat., The Cut Gallery, London 1994. *John Kobal Photographic Portrait Award*, exhib. cat, Zelda Cheatle Press, 1995

Marisol (Escobar) b. Paris 1930. Sculptor. Trained as a painter at the École des Beaux-Arts, Paris, she studied painting at the Art Students League and Hans Hofmann School, New York. Self-trained as a sculptor. Dropped her surname when she began to exhibit in the 1950s. Earliest works were erotic terracotta sculptures inspired by primitive and folk art. By the late 1950s, she was combining constructions of wood and found objects with carved or moulded pieces cast from her own features. Part of the New York Pop Art scene, she starred in Andy Warhol's film *The Kiss*, a world she parodied in *The Party*, 1966. In the late 1960s, she became interested in the link of humans and nature, giving her features to fish carvings.
Marisol: New Drawings and Wall Sculptures by Marisol, exhib. cat., Sidney Janis Gallery, New York, 1975. C.S. Rubenstein, *American Women Artists*, New York, 1982, pp.347–50

Rosy Martin b. 1946. British photographer. In her phototherapy work, originally in collaboration with Jo Spence (q.v.), she explored the psychic and social construction of identities within the drama of the everyday. Currently working autobiographically on still-life and self-portraiture.
'Don't Say Cheese, Say Lesbian' in *Stolen Glances*, J. Fraser and T. Boffin eds.,London, 1991. 'Looking and Reflecting: Returning the Gaze, Re-enacting Memories and Imagining the Future Through Phototherapy' in *Feminist Approaches to Art Therapy*, ed. S. Hogan, London, 1997

Kate Matthews b. Louisville d. Louisville 1956. Photographer. The Kate Matthews Collection is at the University of Louisville, Kentucky.

Constance Mayer b. Paris 1775 d. Paris 1821. Painted portraits, genre and allegorical subjects. She was a pupil of Joseph-Benoît Suvée, Jean-Baptiste Greuze and Jacques-Louis David. From 1802, she was influenced by Pierre-Paul Prud'hon, forming a personal and professional relationship with him, collaborating on many works catalogued under his name. When she realized that Prud'hon would never marry her, even if his mentally unstable wife were to die, she cut her throat with his razor. Prud'hon organized a posthumous exhibition as a tribute to her.

C. Clement, *Prud'hon, sa vie, ses oeuvres, sa correspondance*, Paris, 1872. E. Pilon, *Constance Mayer*, Paris, 1927. H. Weston, 'The Case for Constance Mayer', *Oxford Art Journal*, iii/1 1980, pp. 14–19

Gillian Melling b. England 1956. Figurative painter. 1977–81 Hornsey College of Art. Taught 1986–89 Portsmouth College of Art and Design. Paints out of her own experiences. A single parent, she found that giving birth to three children ended her earlier anorexia. Says that she absolutely refutes Cyril Connolly's remark about the pram in the hall ending women's creativity.

Ana Mendieta b. Havana 1948 d. New York 1985. Performance artist whose work addressed female experience. 1969–77 University of Iowa. 1973–80 she produced about two hundred works in her Silueta series, based on her dialogue between the landscape and the female body. Moved to Rome in 1983 and began to make permanent studio objects. Her husband, Carl Andre, (m. 1975) was charged with her murder but acquitted.
'Ana Mendieta 1948–1985', *Heresies* 5, no. 2, issue 18, issue dedicated to Mendieta's memory. L. Lippard, *Overlay: Contemporary Art and the Art of Pre-History*, New York, 1983. *Ana Mendieta: A Retrospective*, exhib. cat., New Museum of Contemporary Art, New York, 1987

Paula Modersohn-Becker b. Dresden 1876 d. Worpswede 1907. Trained in Bremen 1892 then London; teacher training course 1894–96; Berlin Malerinnenschule 1896–98; in 1898 she was taught by Fritz Mackensen at the Worpswede artists' colony; in 1899 she attended the Académie Colarossi in Paris. In 1900, she returned to Worpswede, marrying the artist Otto Modersohn in 1901. She visited Paris in 1903, '05 and '06, where she was influenced by ancient art and Cézanne, Gauguin and Van Gogh. She died of an embolism three weeks after her daughter's birth.
Gill Perry, *Paula Modersohn-Becker*, London, 1979. C. Murken-Altrogge, *Paula Modersohn-Becker: Leben und Werk*, Cologne, 1980. G. Busch, *Paula Modersohn-Becker: Malerin, Zeichnerin*, Frankfurt am Main, 1981. L. von Reinken, *Paula Modersohn-Becker*, Hamburg, 1983. G. Busch and L. von Reinken eds., *Paula Modersohn-Becker in Briefen und Tagebüchern*, Frankfurt am Main, 1979; Eng. trans. New York, 1983

Berthe Morisot b. Bourges 1841 d. Paris 1895. Impressionist painter. Her training reflects her journey from well-born amateur to serious professional. She went from drawing lessons with Geoffroy Alphonse Chocarne (1857) to Joseph-Benoît Guichard (1858); from 1861, she was advised by Corot and his pupil Oudinot, who introduced her to modern ideas about painting out of doors; around 1867, she began a fruitful and reciprocal artistic relationship with Edouard Manet. She exhibited at the Salon from 1864 but, after showing nine works in the first Impressionist exhibition of 1874, never showed at the Salon again. In 1874, she married Manet's brother Eugène. Their home was a meeting place for artists, enabling Morisot to keep up with contemporary artistic developments.
D. Rouart, *Correspondance de Berthe Morisot*, Paris, 1950; trans. K. Adler and T. Garb, London, 1986. M.L. Bataille and G. Wildenstein, *Berthe Morisot: Catalogue*

des peintres, pastels et aquarelles, Paris, 1961; rev. edn, 2 vols, 1988. K. Adler and T. Garb, *Berthe Morisot,* Oxford, 1987. C. Stuckey, *Berthe Morisot,* exhib. cat., National Gallery of Art, Washington DC; Kimbell Art Museum, Fort Worth, Texas; Mount Holyoake College Art Museum, South Hadley, Mass., 1987–88. A. Higgonet, *Berthe Morisot's Images of Women,* Cambridge, Mass., 1993. M. Shennan, *Berthe Morisot: The First Lady of Impressionism,* Stroud, 1996

Marie Louise von Motesiczky b. Vienna 1906. Figurative painter. Paris 1924–26, then Max Beckmann's master class, Frankfurt am Main, 1927. Unmarried. Moved to England in 1939. First London solo show 1960, Beaux Arts Gallery. *Marie-Louise von Motesiczky: Paintings Vienna 1925– London 1985,* exhib. cat., Gombrich et al., Goethe Institute, London, 1985

Gabriele Münter b. Berlin 1877 d. Murnau 1962. Painter of landscape, still-life and portraits. Malschule für Damen, Munich 1897; Künstlerinnen-Verein, Düsseldorf 1901; Phalanxschule in Munich, 1902, where she was taught by the Director Wasily Kandinsky, with whom she had a relationship until 1916. From 1909 her home in Murnau was a centre for Kandinsky, Alexei Jawlenski and Marianne von Werefkin (q.v.). In 1911, she arranged Blaue Reiter exhibitions with Franz Marc and Kandinsky. She had solo shows from 1913. A relationship after the First World War with art historian Johannes Eichner encouraged a second flowering in her art. Although her work was not admired during the Nazi period, she received post-war recognition.
 A. Mochon, *Gabriele Münter: Between Munich and Murnau,* Harvard, 1980. V. Evers, *Deutsche Künstlerinnen des 20. Jahrhunderts,* Hamburg, 1983. S. Behr, *Women Expressionists,* Oxford, 1988. G. Kleine, *Gabriele Münter und Wassily Kandinsky,* Frankfurt am Main, 1990. Hoberg and Friedel, *Gabriele Münter, 1877–1962: Retrospektive*

Alice Neel b. Merion Square 1900 d. New York 1984. Figurative painter of people, landscapes, still-life and genre. After graduating from the Philadelphia School of Design for Women in 1925, she settled in New York with her husband, Cuban artist Carlos Enriquez. Her career began in the 1930s after the death of her daughter, the end of her marriage and a breakdown. Worked for the Public Works of Art project and the Works Progress Administration but critical recognition had to wait for a small retrospective in 1974 (Whitney Museum, New York). She painted intellectuals, artists and unknowns who caught her eye. She did not remarry and had two sons by different fathers.
 E. Solomon, *Alice Neel,* exhib. cat., Whitney Museum, New York, 1974. *Alice Neel: The Woman and her Work,* C. Nemser essay, exhib. cat., University of Georgia Museum of Art, Athens, 1975. H. Hope, *Alice Neel,* exhib. cat., Fort Lauderdale, Florida Museum of Art, 1978. E. Munro, *Originals: American Women Artists,* New York, 1979. P. Hills, ed., *Alice Neel,* New York, 1983. A. Sutherland Harris, *Alice Neel,* exhib. cat., Loyola Marymount University Art Gallery, Los Angeles, 1983

Anne Noggle b. USA 1922. Portrait photographer. After her career as a pilot ended in retirement

in 1959, she studied art history and photography with photography historian Van Deren Coke at the University of New Mexico where she subsequently taught. Photography curator at the Fine Arts Museum of New Mexico at Santa Fe, 1970–76. Often does self-portraits, for example, images of her facelift, and has produced work on ageing, using her mother, sister and a friend as models.
 A. Noggle and M. Mann, *Women of Photography: An Historical Survey,* exhib. cat., San Francisco Museum of Modern Art, 1975. A. Noggle, *Silver Lining,* Albuquerque, 1983. A. Noggle, *For God, Country and the Thrill of It: Women Airforce Service Pilots in WWII,* Texas A & M University Press, 1990

Maria van Oosterwijck b. Nootdorp 1630 d. Uitdam 1693. Flower pieces and still-life. Her work shows the influence of Jan Davidsz. de Heem with whom she is believed to have studied. The daughter of a clergyman, she never married. Recorded in 1676 as having a studio in Amsterdam and a female assistant, Geertje Pieters. Patronized by European royalty. As with many Dutch still-life painters, *vanitas* references abound in her work.
 Harris and Nochlin, *Women Artists,* pp. 145–46. P. Mitchell, *European Flower Painters,* Schiedam 1981, pp. 190–92. B. Haak, *The Golden Age: Dutch Painters of the Seventeenth Century,* New York, 1984

Catherine Opie b. USA 1961. Photographic artist concerned with the urban scene and gender. Studied at San Francisco Art Institute and California Instutute of the Arts in the 1980s.
 Feminimasculin, exhib. cat., Centre Georges Pompidou, Paris, 1995. *Sunshine & Noir: Art in Los Angeles 1960–1977,* exhib. cat., Louisiana Museum, Humlebaek, 1997. *Rrose is a Rrose is a Rrose: Gender Performance in Photography,* exhib. cat., Guggenheim Museum, New York, 1997

Meret Oppenheim b. Berlin 1913 d. Berne 1985. Painter and sculptor. Basle Kunstgewerbeschule 1929–30. Moved to Paris in 1932 where she participated in Surrealist exhibitions. To the Surrealists, she was the classic *femme-enfant* and she posed nude for Man Ray in a celebrated set of photographs. *Objet,* her fur-lined cup and saucer, was chosen as the quintessential Surrealist object by visitors to *Fantastic Art, Dada, Surrealism,* Museum of Modern Art, New York, 1936–37. After a 15-year fallow period, she worked until just before her death. For the opening of the last Surrealist exhibition in Paris, 1959, she placed a naked woman covered with food on a table.
 B. Curiger, *Meret Oppenheim,* catalogue raisonné, Zurich, 1982. Chadwick, *Women Artists and the Surrealist Movement*

Orlan b. France 1947. Performance artist using film and photography whose work offers increasing violence to viewers' susceptibilities. Adopted her name in 1971 in allusion to a mythical character embodying images of madonnas, virgins and saints. In the 1990s, she has become the site of an ongoing project of self-transformation through plastic surgery using mythical female figures as inspiration. Far from creating an ideal woman, an effect of her work is to question the search for such perfection. She herself is a work-in-progress.
 R. Millard 'Pain in the Art', *Art Review,* May, 1996. L. Anson, 'Orlan', *Art Monthly,* no.197,

June, 1996. *This is My Body… This is My Software,* book with CD-ROM, London, Black Dog Publishing, 1996

Maria Ormani Nun living in the fifteenth century, based in Florence. Manuscript artist in the Augustinian Order.
 Chadwick, *Women, Art and Society,* p. 68

Louisa Paris b. London 1811 d. nr. Salisbury 1875. Amateur watercolour painter. One of nine children of Dr John Paris, she remained unmarried and close to her family. The Towner Art Gallery in Eastbourne has a collection of her landscapes and portraits.
 Sketched for the Sake of Remembrance: A Visual Diary of Lousia Paris's English Travels 1852–54, exhib. cat., Towner Art Gallery and Local Museum, Eastbourne, 1995

Sarah Miriam Peale b. Philadelphia 1800 d. Philadelphia 1885. Portraits and still-life. Studied with father James, cousin Rembrandt and uncle Charles Willson Peale. First exhibited aged 17 at Pennsylvania Academy of the Fine Arts; elected to the Pennsylvania Academy 1824. Worked from her own studio in Baltimore 1831–46 and St Louis 1847. She returned to Philadelphia in 1878 to live with her artist sisters, Anna Claypoole Peale and Margaretta Angelica Peale.
 Miss Sarah Miriam Peale, exhib. cat., Peale Museum, Baltimore, 1967

Clara Peeters b. Antwerp 1589 d. after 1657. Still-life painter practising in Holland. Although about thirty paintings are known, there are few facts to flesh out her biography. It is not known how she trained or what brought her to Holland, although Decoteau (see below) provides a convincing contextualization of her work.
 P. Mitchell, *European Flower Painting,* London, 1973, pp. 196–99. Pamela Hibbs Decoteau, *Clara Peeters,* Lingen, 1992

Adrian Piper b. New York 1948 . Peformance and photographic artist concerned with race and gender. School of Visual Arts, New York 1966–69; 1969 assistant to the conceptual artist Sol Lewitt; 1981 PhD, Harvard University. She has worked simultaneously as an artist and a philosophy lecturer. The experience of winning a scholarship which carried her, a light-skinned black woman, to a wealthy white school, informs *Political Self-Portrait #2 (Race)* (1978) in which she describes her experience as grey not black. *Catalysis* was a series of performances in which she looked or acted offensively in public in order to raise the issue of 'otherness'; *Vanilla Nightmares,* a photo-text series based on advertising images confronts racism, gender and class.
 L. Lippard, *Get the Message? A Decade of Art for Social Change,* New York, 1984. A. Piper, 'Two Conceptions of the Self' in *Philosophical Studies,* 48, Sept. 1985. *Adrian Piper,* exhib. cat., Birmingham, Ikon Gallery, 1991

Suor Plautilla b. Florence 1523 d. Florence 1588. Religious subjects including altarpieces. Daughter of painter Luca Nelli and a student of Fra Paolini. After 1537, she was a nun in the convent of St Catherine of Siena in Florence. She is said to have trained the nuns Agata Traballesi and Maria Ruggieri.

Renata Rampazzi b. Turin 1948. Lives and works in Rome. Graduated from the Accademia delle Belle Arti in Turin with a degree in architecture and went on to work with Emilio Vedova and Zao Wou Ki in Salzburg and Venice. Significant exhibitions include solo shows in 1973 and 1979 at the Galleria dello Scudo in Verona, in 1975 at the Centro Olivetti in Paris and in 1984 at the Palazzo dei Diamanti in Ferrara. In the same year she took part in Arte Fiera Bologna and she was twice nominated for the Bolaffi prize. Subsequently exhibited in Geneva, Paris and Rome.

Tommaso Trini, *Renata Rampazzi*, exhib. cat., Galleria Civica d'Arte Moderna, Palazzo Lomellini, Campagnola, 1992. Dacia Maraini, *Renata Rampazzi*, exhib. cat., Le Immagini, Turin, 1996

Antonietta Raphaël b. Kowna 1900 d. Italy 1975. Painter and sculptor. She was a pupil of Jacob Epstein in London, where she had settled with her mother after the death of her rabbi father. At the Academy of Fine Arts in Rome she met and married (1926) Mario Mafai. Her Jewish background forced her to hide from the authorities in the Second World War.

Vergine, *L'Altra Meta dell'Avanguardia, 1910–1940*

Paula Rego b. Lisbon 1935. London-based painter of imaginative scenarios with animals and humans in which women often have a sinister power. Left aged two with her grandparents, whom she loved, and an aunt, whom she did not, a disruptive experience she considers contributed to the subversive content of her art. Trained at the Slade School of Fine Art, London, 1952–56, where she shared first prize. Married the artist Victor Willing in 1959 (d. 1989) and has three children. Represented Portugal at the XI Biennale, São Paulo, 1976, and Britain, with three others, at the XVIII Biennale in 1985. Her 1988 retrospective was seen in Lisbon, Oporto and London. Taught at the Slade School of Fine Art, London from 1983; senior fellow of the Royal College of Art, London, 1989; first associate artist of the National Gallery London, 1990.

Paula Rego, exhib. cat., Serpentine Gallery, London, 1988. John McEwen, *Paula Rego*, London, 1992. *Paula Rego: Nursery Rhymes*, intro. M. Warner, London, 1994. *Paula Rego: Dancing Ostriches*, London, 1996

Marietta Robusti known as La Tintoretta b. Venice c. 1554 d. Venice c. 1590. Painter of portraits and small religious pictures. Trained by her father Jacopo Tintoretto and assisted him in his workshop. More stories than facts attach to her life. Said to have been his favourite daughter and that he had her dress as a boy, follow him everywhere and marry a local jeweller to keep her close. Said to have caught the attention of Philip II of Spain (see Sofonisba Anguissola above).

P. Rossi, *Jacopo Tintoretto: I Ritratti*, Venice, 1974, pp. 138–39. C. Ridolfi, *Vita di Giacopo Robusti detto il Tintoretto*, Venice, 1642; Eng. trans. C. Enggass and R. Enggass, University Park, PA, 1984

Properzia de' Rossi b. Bologna c. 1490 d. Bologna 1530. Sculptor in marble who also worked in miniature on cherry and peach stones.

F.H. Jacobs, 'The Construction of a Life: Madonna Properzia de' Rossi "Schultrice" Bolognese,' *Word and Image*, ix, 1993, pp.122–32

Rachel Ruysch b. Amsterdam 1664 d. Amsterdam 1750. Still-life painter of fruit and flowers. Father was a professor of anatomy and botany and an amateur painter; mother was a daughter of architect Pieter Post. Studied with flower painter Willem van Aelst. Married portrait painter Juriaen Pool, continuing to paint to great acclaim despite ten children. In 1709 they moved to the Hague where both joined the Guild of St Luke. From 1708–13 they were court painters to the Elector Palatine at Dusseldorf. In 1716, they returned to Amsterdam.

M.H. Grant, *Rachel Ruysch*, Leigh-on-Sea, 1956. P. Mitchell, *European Flower Painters*, Schiedam, 1981, pp. 222–24. Harris and Nochlin, *Women Artists*, pp. 41–44. S. Segal, *Flowers and Nature: Netherlandish Flower Painting of Four Centuries*, exhib. cat., Nabio Museum of Art, Osaka; Station Gallery, Tokyo, 1990. P. Taylor, *Dutch Flower Painting 1600–1720*, London and New Haven, 1995

Kay Sage b. Albany 1898 d. Woodbury 1963. Self-taught Surrealist painter and poet. Lived abroad with her mother after her parents separated. Married Prince Ranieri di San Faustino in 1925 (divorced) and the artist Yves Tanguy in 1940. Exhibited in Italy during her first marriage and in America where she returned at the outbreak of the Second World War. Suicide followed Tanguy's death in 1955 and failing eyesight.

Kay Sage, exhib. cat., The Herbert F. Johnson Museum of Art, Cornell University, Ithaca, 1976–77. Chadwick, *Women Artists and the Surrealist Movement*

Jenny Saville b. Cambridge 1970. Portrait and figurative painter. Glasgow School of Art 1988–92. Work shown at National Portrait Gallery, London, 1990; Burrell Collection, Van Gogh Self-Portrait Competition, Glasgow, 1990; The Cooling Gallery, Clare Henry's Critic's Choice, London, 1992; 'Young British Artists III', Saatchi Gallery, 1994.

S. Kent, *Young British Artists III*, exhib. cat., Saatchi Gallery, London, 1994

Helene Schjerfbeck b. Helsinki 1862 d. Saltsjobaden 1946. Painter of still-life, landscape, figures. Attended the Finnish Art Society Drawing School, Helsinki, 1873; Adolf von Becker Academy, Helsinki, 1877; Académie Trelat de Vigne, Paris, under Léon Bonnat and Jean-Louis Gérome, 1880; Académie Colarossi, 1881. Pont-Aven 1883–4. Began exhibiting 1879. In 1884, she began the long series of self-portraits which punctuated her life. Taught at the Finnish Art Society Drawing School 1893–1902 in order to support her mother. From 1902 to 1917, she lived outside Helsinki, her reclusiveness encouraging her originality. Following a successful solo show in 1917, she became a member of Valpaat (the Free Ones).

L. Ahtola-Moorhouse, 'Helene Schjerfbeck', *Dreams of a Summer Night: Scandinavian Painting at the Turn of the Century*, exhib. cat., Arts Council of Great Britain, 1986; German trans. 1986; French trans. 1987; *Helene Schjerfbeck*, exhib. cat., Athenaeum Art Museum, Helsinki, 1992, English, Finnish and Swedish text

Carolee Schneemann b. Fox Chase 1939. Painter, filmmaker and performance artist who expresses a female sensibility and sexuality through her body. *More than Meat Joy*, 1964, a group performance with sausages, chickens and raw fish was seen in Paris,

New York and, in the nude, in London. Self-portraiture has been a continuing concern, from *Eye Body*, 1963 in which the nude female artist raised the issue of being both image and image-maker, to her photographic self-portrait series, *Infinity Kisses*, 1886–1990.

C. Schneemann, *More than Meat Joy*, (Documentext, 1979), 1997. T. Castle, 'Carolee Schneemann: The Woman Who Uses Her Body as Her Art', *Artforum 19*, November 1980, pp.64–70. C. Schneemann, *Carolee Schneemann: Early and Recent Work*, Documentext, 1983. *Carolee Schneemann: Up to and Including her Limits*, exhib. cat., The New Museum of Contemporary Art, New York, 1996

Eva Schulze-Knabe b. Pirna 1907 d. 1976. Painter and printmaker. Studied in Leipzig and with Otto Dix in Dresden. Married the artist Fritz Schulze in 1931. Arrested by the Gestapo in 1941 and freed in 1945. Fiftieth birthday retrospective held at the Albertina, Dresden, in 1957.

Eva Schulze-Knabe: 1906–1976, exhib. cat., Gemäldegalerie Neue Meister, Dresden, 1977

Anna Maria Schurman b. Cologne 1607 d. Leeuwarden 1678. Multi-talented amateur who worked in oil and pastel and carved, modelled and engraved. She argued for educational opportunities for women and later devoted herself to religion.

Chadwick, *Women, Art and Society*, ch. 4

Thérèse Schwartze b. Amsterdam 1851 d. Amsterdam 1918. Portrait painter. Taught by her father J.G. Schwartze, then after his death in 1874 by Gabriel Max, Franz von Lenbach and Karl von Piloty in Munich, Jean-Jacques Henner in Paris and the Rijksacademie van Beeldende Kunsten, Amsterdam (1875–83). In 1880 invited to teach Princess Hendrika. Her portrait of Queen Emma with Princess Wilhelmina, 1881, brought many commissions. Her participation in exhibitions in Munich, Barcelona and Chicago led to her international reputation. Solo exhibition Amsterdam, 1890.

J. de Klein 'Thérèse Schwartze', *Antiek*, ii, Feb. 1968, pp. 303–11. C. Hollema and P. Kouwenhoven, *Thérèse Schwartze, 1851–1918: Portret van een gevierd schilder*, Zeister Stichting voor Kunst en Cultuur, Zeist, 1989. R. Bionda et al. eds, *The Age of Van Gogh: Dutch Painting 1880–1895*, exhib. cat., Burrell Collection, Glasgow, 1990

Joan Semmel b. New York 1932. Painter. Studied in New York at Cooper Union, Art Students League and Pratt Institute. Two children from an early marriage. Since 1970, her paintings have dealt with the body, sexuality and the construction of a female gaze.

'Joan Semmel's Nudes: The Erotic Self and the Masquerade' *Woman's Art Journal*, vol. 16, Fall 1995/Winter 1996

Zinaida Serebryakova b. Neskuchnoye 1884 d. Paris 1967. Painted figures, landscape, still-life. Daughter of sculptor Evgeni Lansere and niece of Alexandre Benois. She attended the Tenisheva School under Repin, 1901; visited Italy, 1902–3; studio of Osip Braz in St Petersburg, 1903–5; Académie de la Grande Chaumière in Paris, 1905–6. In 1910 she showed her self-portrait (bought by the Tretyakov Gallery) at the Union of Russian Artists and from

1911 she was linked to The World of Art Society. In 1924 she settled in France where she was not appreciated.

> N.A. Senkovskaya and T.B. Serebryakova, *Z. Serebryakova*, exhib. cat., Tretyakov Gallery, Moscow, 1986. M.N. Yablonskaya, *Women Artists of Russia's New Age*, London, 1990. Gen Doy, *Seeing and Consciousness*

Rolinda Sharples b. New York 1793 or 1794 d. Bristol 1838. Portraits, genre, contemporary history. Daughter of artists James (who taught her) and Ellen (who encouraged her, particularly after the death of James). Exhibited at the Royal Academy and the Society of British Artists.

> K. McCook Knox, *The Sharples*, Newhaven, 1930. *The Bristol School of Artists. Francis Danby and Painting in Bristol 1810–40*, Bristol City Museum and Art Gallery, 1973

Cindy Sherman b. Glen Ridge 1954. Uses photography as her medium to explore issues of gender, pornography, etc. After studying painting and photography at State University College, Buffalo, she moved to New York in 1977. Her *Untitled Film Stills*, 1977–80, in which she was both photographer and model, were an immediate success. Subsequent series include *Disgust Pictures* (1986–89). a reworking of famous female portraits (1989). and *Sex Pictures* (from 1992) in which she replaces herself with anatomical dolls.

> P. Schjeldahl, *Cindy Sherman*, New York, 1984. R. Krauss, *Cindy Sherman 1978–1993*, with an essay by Norman Bryson, New York, 1993. *Cindy Sherman*, exhib. cat., Museum Boijmans Van Beuningen, Rotterdam, 1996, with bibliography in English and Dutch

Nina Simonovich-Efimova b. St Petersburg 1877 d. Moscow 1948. Painter, sculptor, puppeteer, graphic artist. Studied with her cousin, Valentin Serov; in Paris under Eugène Carrière 1901, and under Matisse 1908–10. Exhibited in Paris 1909–11. In 1918, she and Efimov opened the innovatory Theatre of Marionettes, Petrushkas and Shadows.

> M.N. Yablonskaya, *Women Artists of Russia's New Age*, London, 1990

Renée Sintenis b. Glatz 1888 d. Berlin 1965. Sculptor. Studied with Leo von König and W. Haverkamp at the Kunstgewerbeschule, Berlin. Married printmaker Emil Rudolf Weiss. Early sculptures of animals were succeeded by athletes in the 1920s. First female sculptor elected to the Prussian Academy of the Arts, Berlin. Taught from 1948 at the Hochschule für Bildende Künste, Berlin.

> B.E. Buhlmann, *Renée Sintenis: Werkmonographie der Skulpturen*, Darmstadt 1987

Elisabetta Sirani b. Bologna 1638 d. Bologna 1665. Religious and historical painter. Probably trained by her father, Giovanni Andrea Sirani, and encouraged by Carlo Malvasia who later wrote her biography. Her sisters Anna Maria (1645–1715) and Barbara were also artists. She took female students. She worked for private patrons, including aristocrats, and her subjects were often female heroines. A mythology has attached to her concerning her beauty and early death.

> O. Kurz, *Bolognese Drawings at Windsor Castle*, London, 1955, pp. 133–36. F. Frisoni, 'La Vera Sirani', *Paragone*, xxix/335, 1978, pp. 3–18.

The Age of Correggio and the Carracci: Emilian Painting of the Sixteenth and Seventeenth Centuries, exhib. cat., National Gallery of Art, Washington DC; Metropolitan Museum of Art, New York; Pinacoteca Nazionale, Bologna, 1986–87, pp. 534–37

Sylvia Sleigh b. Llandudno *c.* 1935. Figurative artist who also painted landscape and still-life. Studied at Brighton School of Art. Married art critic Lawrence Alloway and moved to the USA in 1961. The paintings she produced in the 1970s were informed by feminist theories about art: portraits of Paul Rosano investigated ways of suggesting the eroticism of the male body, and the goddess series depicted friends and colleagues.

> L. Tickner, 'The Body Politic: Female Sexuality and Women Artists Since 1970', *Art History* 1, no. 2, 1978, pp. 240–44. *Sylvia Sleigh: Invitation to a Voyage and Other Works*, exhib. cat., Wisconsin Art Museum, Milwaukee; Ball State University Art Gallery, Muncie, Indiana; Butler Institute of American Art, Youngstown, Ohio, 1990

Jo Spence b. South Woodford 1934 d. London 1992. Used her photographs to explore issues raised by feminism. After a conventional start working as a secretary for a commercial photographer and a printer's assistant (1951–66) she established a portrait studio in 1967. Radicalized by her origins as a working-class woman, she worked with Terry Dennett founding Photography Workshop, 1974, starting *Camerawork* magazine, and producing work on social deprivation. The diagnosis in 1982 of breast cancer led to a focused outpouring of work on health and the family.

> J. Spence, *Putting Myself in the Picture: A Political, Personal and Photographic Autobiography*, London, 1986

Alice Barber Stephens b. Salem 1858 d. Moylan 1932. Portrait and landscape painter and illustrator. Studied at the Philadelphia School of Design for Women; Philadelphia Academy of Fine Arts with Thomas Eakins; Académies Julian and Colarossi, Paris. Married artist Charles H. Stephens. Taught from 1902 at the Philadelphia School of Design for Women where she set up its first life-drawing class.

Dorothea Tanning b. Galesburg 1910. Painter, sculptor, theatrical designer. Studied at the Art Institute of Chicago school in 1932 and was influenced by the New York exhibition, 'Fantastic Art, Dada, Surrealism', 1936–37. From 1942–46 she was part of the group of exiled European Surrealists in New York. First exhibition 1944 at the Julien Levy Gallery, New York. In 1946 she married the Surrealist artist Max Ernst (d. 1976). Her work has become increasingly abstract while retaining a disturbing element typical of Surrealism.

> Chadwick, *Women Artists and the Surrealist Movement*. D. Tanning, *Birthday*, Santa Monica, *c.* 1986

Nadine Tasseel b. Sint Niklaas 1953. Portraits and staged pictorialism (artist's description). Studied painting at the Academy of Fine Arts, Antwerp, 1973–77, and photography at the Industrial School, Antwerp, 1979–82. Her first major show was 'Tableau Vivant/Nature Morte', 1994.

> *Tableau Vivant/Nature Morte*, exhib. cat.,

Museum voor Hedendaagse Kunst, Antwerp, 1994. M.C. de Zegher, *Inside the Visible: an elliptical traverse of twentieth-century art*, Cambridge, Mass., and London, 1996

Levina Teerlinc b. Bruges 1510–20 d. London 1576. Portrait painter and miniaturist. Eldest daughter of Simon Benninck, leading illuminator of the Ghent-Bruges school. Came to England with her husband *c.* 1545, and in 1546 was appointed 'paintrix' to Henry VIII at an annuity of £40.

> Harris and Nochlin, *Women Artists*, pp. 102–4. R. Strong, *Artists of the Tudor Court: The Portrait Miniature Rediscovered 1520–1620*, exhib. cat, Victoria and Albert Museum, London, 1983

Anna Dorothea Therbusch b. Berlin 1721 d. Berlin 1782. Painter of portraits, religious and mythological subjects. Taught by her father, Georg Lisiewski followed by Antoine Pesne in Paris. Worked for the Count of Württemberg in Stuttgart, 1761–62, and for the Elector Palatine of the Rhine in Mannheim, 1763–64. In Paris, 1765–69, she became a member of the Académie Royale in 1767, but was unable to establish herself professionally. Settled in Berlin 1769, where she received commissions from Empress Catherine II of Russia, and King Frederick II of Prussia.

> E. Berckenhagen, *Die Malerei in Berlin*, Berlin, 1964. G Bartoschek, *Anna Dorothea Therbusch*, exhib. cat., Schloss Sansouci, Potsdam, 1971. E. Berckenhagen, 'Anna Dorothea Therbusch', *Z. Kstwiss.*, xli, 1987, pp. 118–60

Charley Toorop b. Katwijk 1891 d. Bergen 1955. Painter of portraits, landscapes, city themes. Daughter of the artist Jan Toorop, but self-taught, beginning to paint in 1909. After living in Norway, Holland and Paris, she settled in Bergen in 1932. She was a figurative artist with strong links to the modern movement through the artist Piet Mondrian, the architect P.L. Kramer and the filmmaker Joris Ivens. Her self-portraits chronicle the phases of her life and art.

> *Charley Toorop 1891–1955*, exhib. cat., Centraal Museum, Utrecht, 1982. *Modern Dutch Painting*, exhib. cat., Athens National Gallery, 1983. J. Bremer, *Works in the Kroller-Muller Museum Collection*, Otterlo, 1995

Helen Mabel Trevor b. Lisnagead 1831 d. Paris 1900. Genre, landscape, portraits. Studied in London, Royal Academy Schools; in Paris with Carolus-Duran and Henner. In Italy 1883–89. Exhibited in Paris at the Salon de la Société des Artistes Français, and in Britain at the Royal Academy, London, the Royal Hibernian Academy and Manchester City Art Gallery.

> W.G. Strickland, *A Dictionary of Irish Artists*, 2 vols, Dublin, 1913, vol. 2, pp. 457–58

Mierle Laderman Ukeles b. Denver 1939. Sculptor, performance and environmental artist. Educated Pratt Institute, New York, and New York University. Lectures on public art issues. In 1982, she created sculptures and lighting for the Strawberry Mansion Bridge, Philadelphia. In 1992, she was the artist member of a design team for an Oregon rail system extension. In 1983–92, worked on *Flow City*, an interactive environment project to focus attention on the maintenance and waste disposal precesses in New York City's Marine Transfer Facility.

> L. Lippard, *From the Center: Feminist Essays on*

Women's Art, New York, 1976. E. Heartney, 'Skeptics in Utopia', *Art in America*, 80:7, July 1992, pp. 76–81. *Dispossessed installations: Adrian Piper, Mierle Laderman Ukeles, Bill Viola*, exhib. cat., Florida State University Gallery and Museum, Tallahassee, 1992

Suzanne Valadon b. Bessines-sur-Gartempe 1865 d. Paris 1938. Painter of nudes, portraits, allegory. Worked as an artist's model from 1880–87. Her first signed and dated work was a self-portrait pastel (1883, Georges Pompidou Centre, Paris). Degas bought three drawings in 1894, introduced her to collectors and taught her to print. Her marriage in 1896 to Paul Mousis enabled her to paint full time. She married the painter André Utter in 1914 after divorcing Mousis. Her son, the painter Maurice Utrillo, was born in 1883. In 1915, she had a solo show at the Galerie Berthe Weil and a retrospective at the Georges Petit Gallery in 1932. Ill health and a failing relationship with Utter halted her productivity in the 1930s.

P. Petrides, *Catalogue raisonné de l'oeuvre de Suzanne Valadon*, Paris, 1971. J. Warnod, *Suzanne Valadon*, Paris, 1981. Perry, *Women Artists and the Parisian Avant-garde. Suzanne Valadon 1865–1938*, exhib. cat., Fondation Pierre Gianadda, Martigny, 1996

Elisabeth-Louise Vigée-Lebrun b. Paris 1755 d. Paris 1842. Portrait painter of the European rich, famous, noble and royal. Daughter of a portrait painter, she studied with P. Devesne and Gabriel Briard and was advised by Joseph Vernet. In 1776 she married the art dealer Jean-Baptiste Lebrun. She was granted patronage by Queen Marie Antoinette, of whom she painted about thirty portraits. She left Paris with her 9-year-old daughter on the eve of the French Revolution for Italy (1789–93), Vienna (1793–4), St Petersburg (1795–1801) and London (1803–5), returning to France in 1805. Membership of academies followed her travels.

Elisabeth Louise Vigée-Lebrun 1755–1842, exhib. cat., by J. Baillio, Kimbell Art Museum, Fort Worth, Texas, 1982. *Souvenirs de Madame Louise-Elisabeth Vigée-Lebrun*, 3 vols, Paris, 1835–37; 1869; Eng trans. Sian Evans, *The Memoirs of Elisabeth Vigée-Lebrun*, London, 1989. M.D. Sheriff, *The Exceptional Woman: Elisabeth Vigée-Lebrun and the Cultural Politics of Art*, Chicago, 1996

Caterina dei Vigri b. Bologna 1413 d. Bologna 1463. Painter and writer. Nobly born and educated at the court of Ferrara, she became Abbess of the Convent of the Poor Clares in Bologna. Canonized in the eighteenth century.

G. Greer, *The Obstacle Race*, London, 1979, pp. 174–76

Cecile Walton b. Glasgow 1891 d. Edinburgh 1956. Painter, sculptor, illustrator. Daughter of painter E.A. Walton, she studied in Edinburgh, London, Paris, Florence. Member of the Edinburgh Group. After her 1923 separation from the artist Eric Robertson (m. 1914), she worked with Tyrone Guthrie on theatre designs.

D. Macmillan, *Scottish Art 1460–1990*, Edinburgh, 1990

Anna Waser b. Zurich 1678 d. Zurich 1714. Painted allegorical subjects (now lost) and miniature portraits. Taught as a young girl by Johannes Sulzer. After studying from 1692–95/6 with Joseph Werner II in Berne, she settled in Zurich as a miniature painter, her reputation bringing her commissions from Germany, England and the Netherlands. Her sister Elisabetha Waser was a graphic artist.

R. Fussli, *Geschichte der besten Künstler in der Schweiz*, Zurich, 1763

Alison Watt b. Greenock 1965. Painter of portraits and the human figure. Trained at the Glasgow School of Art, 1983–86. Awarded first prize for painting, British Institution Fund, Royal Academy, London, 1986. Winner of the John Player award, National Portrait Gallery, London, 1987. Recipient of the Elizabeth Greenshields Foundation Award, Montreal, Canada, 1989. Awarded the City of Glasgow Lord Provost Prize in 1993. Solo shows: The Scottish Gallery, London, 1990; London, Flowers East, 1993 and 95.

John Calcut, *Alison Watt: Paintings*, exhib. cat., Flowers East, London, 1995.

Carrie Mae Weems b. Portland 1953. Photographer who deals with black culture through women, reportage and self-portraiture. Educated California Institute of Arts, San Diego, and University of California, Berkeley. University tutor 1983–91. A retrospective exhibition on gender, race and class in America, toured the USA 1993–95. Her works can be posed *(Kitchen Table Series*, 1990) or documentary *(Sea Island Series*, 1992).

C.M. Weems, *Black Photographers 1940–1988*, Gardner Press, 1988. *Carrie Mae Weems*, exhib. cat., National Museum of Women in the Arts, Washington, 1993. *Carrie Mae Weems: The Kitchen Table Series*, exhib. cat., Contemporary Arts Museum, Houston, 1996

Marianne von Werefkin b. Tula 1860 d. Ascona 1938. Painter of landscapes and works tinged with social realism. Her mother, an artist, encouraged her. After Moscow Art School she studied ten years with Ilya Repin in St Petersburg. In his studio in 1901, she met Alexei Jawlensky, her companion until 1920. In 1908, the couple worked alongside Gabriele Münter and Wasily Kandinsky in Murnau. Active in a series of prewar avant-garde art movements. Her art theories, *Briefe an Einen Unbekannten*, concerning Symbolism and Expressionism, were published 1901–5.

S. Behr, *Women Expressionists*, Oxford, 1988. B. Fathke, *Marianne Werefkin*, Munich, 1988. M. Witzling, *Voicing Our Visions: Writings by Women Artists*, London, 1992

Hannah Wilke b. New York 1940 d. 1993. Performance and mixed media artist, much of it autobiographical. Attended Tyler School of Fine Arts, Philadelphia. Many works of the 1970s employed vaginal imagery (*Starification Object Series* and *176 Single-Fold Gestural Sculptures*). *In Memoriam: Selma Butter (Mommy)*, 1979–83, looked at women, illness and ageing. The *B.C.* series, 1986–88, is a diary of watercolour self-portraits.

M. Rother, *The Amazing Decade: Women and Performance Art in America 1970–1980*, Santa Monica, 1983. T. Kochheiser, ed., *Hannah Wilke: A Retrospective*, Columbia, 1989

Francesca Woodman b. Denver 1958 d. New York 1981. Photographer. Rhode Island School of Design 1975–79. In Rome 1977–78. Moved to New York 1979. Committed suicide 1981.

F. Woodman, *Some Disordered Interior Geometrics*, Philadelphia, 1981. *Francesca Woodman: Photographic Works*, exhib. cat., Shedhalle, Zurich, 1992–93. C. de Zegher, *Inside the Visible*, Cambridge, Mass., and London, 1996

Wanda Wulz b. Trieste 1903 d. 1984. Photographer. Member of a family of photographers with a studio in Trieste, she was the daughter of photographer Carlo Wulz.

La Trieste dei Wulz: Volti d'una Storia Fotografie 1860–1980, exhib. cat, Palazzo Costanzi, Trieste, 1989

SELECT BIBLIOGRAPHY

GENERAL BOOKS ON WOMEN ARTISTS

Betterton, R., ed., *Looking On: Images of Femininity in the Visual Arts and Media*, London and New York, 1987

Brawer, C., R. Rosen et al., *Making Their Mark: Women Artists Move into the Mainstream, 1979–85*, exhib. cat. (touring: Cincinnati Art Museum, New Orleans Museum of Art, Denver Art Museum, Pennsylvania Academy of the Fine Arts), New York, 1989

Broude, N., and M.D. Garrard, eds, *Feminism and Art History: Questioning the Litany*, New York, 1982

Broude, N., and M.D. Garrard, *The Power of Feminist Art*, London and New York, 1994

Chadwick, W., *Women, Art and Society*, rev. edn, London and New York, 1996

—, *Women Artists and the Surrealist Movement*, Boston and London, 1985

Cherry, D., *Painting Women: Victorian Women Artists*, London and New York, 1993

Dewhurst, C.K., B. Macdowell, M. Macdowell, *Artists in Aprons: Folk Art by American Women*, New York, 1979

Doy, G., *Seeing and Consciousness: Women, Class and Representation*, Oxford, 1995

Fine, E. Honig, *Women and Art: A History of Women Painters and Sculptors from the Renaissance to the Twentieth Century*, Montclair, NJ, 1978

Greer, G., *The Obstacle Race: The Fortunes of Women Painters and Their Work*, London, 1979

Harris, A.S., and L. Nochlin, *Women Artists: 1550–1950*, exhib. cat., Los Angeles County Museum of Art, 1976–77

Munro, E., *Originals: American Women Artists*, New York, 1979

Nochlin, L., 'Why Have There Been No Great Women Artists?' in *Art and Sexual Politics*, T. Hess and E. Baker, eds, London and New York, 1971

Nochlin, L., *Women, Art and Power and Other Essays*, New York, 1988. London, 1989

Orr, C.C., ed., *Women in the Victorian Art World*, Manchester, 1995

Parker, R., and G. Pollock, *Old Mistresses: Women, Art and Ideology*, London and New York, 1981

Perry, G., *Women Artists and the Parisian Avant-Garde*, Manchester and New York, 1995

Petersen, K., and J.J. Wilson, *Women Artists: Recognition and Reappraisal, from the Early Middle Ages to the Twentieth Century*, New York, 1976

Pollock, G., *Vision and Difference: Femininity, Feminism and the Histories of Art*, London and New York, 1988

Robinson, H., ed., *Visibly Female: Feminism and Art Today*, London, 1987

Vergine, L., *L'Altra Meta dell'Avanguardia, 1910–1940*, Milan, 1980

PUBLICATIONS ON SELF-PORTRAITURE

Attie, D., *Russian Self-Portraits*, London, 1978

L'Autoportrait du XVII siècle à nos jours, exhib. cat., Musée des Beaux-Arts, Pau, 1973

Behr, S., 'Das Selbstporträt bei Gabriele Münter' in *Gabriele Münter 1877–1962: Retrospective*, A. Hoberg and H. Friedel, eds, Munich, 1992

Benkard, E., *Das Selbstbildnis*, Berlin, 1927

Billeter, E., ed., *The Self-Portrait in the Age of Photography: Photographers Reflecting Their Own Image*, exhib. cat., Musée Cantonal des Beaux-Arts, Lausanne, 1985; Eng. trans. Sarah Campbell Blaffer Gallery, Houston, 1986

Brooke, X., *Face to Face: Three Centuries of Artists' Self-portraiture*, exhib. cat., Walker Art Gallery, Liverpool, 1994

Cohen, J.T., ed., *Insights, Self-Portraits by Women*, Boston, Mass., 1978; London, 1979

Exploring the Unknown Self: Self Portraits of Contemporary Women, Metropolitan Museum of Photography, Tokyo, 1991

Facos, M., 'Helene Schjerfbeck's Self Portraits: revelation and dissimulation', *Woman's Art Journal*, vol. 16, Spring/Summer, 1995

Gasser, M., *Self-Portraits from the Fifteenth Century to the Present Day*, London, 1963. (Argues that women do not perform well in this branch of art.)

Goldscheider, L., *Five Hundred Self-Portraits*, London, 1937

Identity Crisis: Self Portraiture at the End of the Century, Milwaukee Art Museum, 1997

Jenkins, D. Fraser, and S. Fox-Pitt, eds, *Portrait of the Artist*, Tate Gallery, London, 1989

Kelly, S., and E. Lucie-Smith, *The Self Portrait: A Modern View*, London, 1987

Kinneir, J., ed., *The Artist by Himself: Self-Portrait Drawings from Youth to Old Age*, London, 1980

Koortbojian, *Self-Portraits*, London 1992

Langedijk, K., *Die Selfstbildnisse der Hollandischen und Flämischen Künstler in den Uffizien*, Florence, 1992

Lubell, E., 'Women Artists: Self-Images' from *Views by Women Artists: Sixteen Independently Curated Theme Shows Sponsored by the New York Chapter of the Women's Caucus for Art*, New York, 1982

Masciotta, M., *Autoritratti dal XIV al XX Secolo*, Milan, 1955

Meloni, S., 'The Collection of Painters' Self Portraits' in M. Gregori, *Paintings in the Uffizi and Pitti Galleries*, Boston, 1994

Mercer, K., 'Home from Home', in *Self-Evident*, exhib. cat., Ikon Gallery, Birmingham, 1995

Meskimmon, M., *The Art of Reflection: Women Artists' Self-Portraiture in the Twentieth Century*, London, 1996

Ried, F., *Das Selbstbildnis*, Berlin, 1931

Selbstbildnisse und Künstlerporträts von Lucas van Leyden bis Anton Raphael Mengs, exhib. cat., Herzog Anton Ulrich-museum, Brunswick, 1980

Sobieszek, R.A., *The Camera i : Photographic Self-Portraits from the Audrey and Sydney Irmas collection*, exhib. cat., Los Angeles County Museum of Art, 1994

Staging the Self: Self-Portrait Photography 1840s–1980s, exhib. cat., National Portrait Gallery, London, 1986

Uffizi Collection, 'La Collezione degli Autoritratti e dei ritratti di artisti', *Gli Uffizi, Catalogo Generale*, Florence, 1979, pp. 763–1044

LIST OF ILLUSTRATIONS

Measurements are given in centimetres, followed by inches, height before width before depth

2 Adélaïde Labille-Guiard, *Self-Portrait with Two Pupils, Mademoiselle Marie Gabrielle Capet (1761–1818) and Mademoiselle Carreaux de Rosemond (died 1788)* (detail), 1785. Oil on canvas, 210.8 x 151.1 (83 x 59 1/2). The Metropolitan Museum of Art, New York. Gift of Julia A. Berwind, 1953. (53.225.5). Photograph © 1980 The Metropolitan Museum of Art

6 Cindy Sherman, *Untitled, #122*, 1983. Colour photograph, 220.9 x 147.3 framed (87 x 58). Saatchi Collection, London. Courtesy of the artist and Metro Pictures, New York

9 Sofonisba Anguissola, *Self-Portrait* (detail), 1554. Oil on poplar wood, 19.5 x 12.5 (7 5/8 x 4 7/8). Kunsthistorisches Museum, Vienna

10 Artemisia Gentileschi, *Self-Portrait as 'La Pittura'*, c. 1630–37. Oil on canvas, 96.5 x 73.7 (38 x 29). The Royal Collection, Windsor. © Her Majesty Queen Elizabeth II

11 Rosalba Carriera, *Self-Portrait*, after 1746. Pastel, 78.8 x 63.5 (31 x 25). Accademia, Venice. Photo Scala, Florence

12 Elisabeth-Louise Vigée-Lebrun, *Portrait of the Artist with Her Daughter Jeanne Marie-Louise (1780–1819)* (detail), 1785. Oil on wood, 105 x 85 (41 3/8 x 33 1/2). Musée du Louvre, Paris. © Photo RMN – Arnaudet. J. Schormans

13 Sabine Lepsius, *Self-Portrait* (detail), 1885. Oil on canvas, 84 x 63.5 (33 1/8 x 25). Alte Nationalgalerie, Berlin. Photo AKG London

14 Louise Hahn, née Fraenkel, *Self-Portrait* (detail), c. 1910. Photo AKG London

15 Frida Kahlo, *Self-Portrait with Monkeys* (detail), 1943. Oil on canvas, 81.5 x 63 (32 1/8 x 24 3/4). Collection Jacques and Natasha Gelman, Mexico City. © Banco de México, Av. Cinco de Mayo No. 2, Col. Centro, 06059, México, D.F. 1998. Reproduced by permission of the Instituto Nacional de Bellas Artes y Literatura, Mexico City. Photo AKG London

16 Paula Rego, *The Artist In Her Studio* (detail), 1993. Acrylic on paper laid on canvas, 180 x 130 (70 7/8 x 51 1/4). Leeds City Art Gallery. Photo Marlborough Fine Art, London

17 Luis Eugenio Meléndez, *Self-Portrait with Académie*, 1746. Oil on canvas, 100 x 82 (39 1/2 x 32 1/4). Musée du Louvre, Paris. Photo Witt Library, Courtauld Institute of Art, London

18 Bartolomé Esteban Murillo, *Self-Portrait*, c. 1670–73. Oil on canvas, 122 x 106.7 (48 x 42). Reproduced by courtesy of the Trustees, The National Gallery, London

18 Salvator Rosa, *Self-Portrait*, c. 1640–45. Oil on canvas, 116.3 x 94 (45 3/4 x 37). Reproduced by courtesy of the Trustees, The National Gallery, London

19 Rosalba Carriera, *Self-Portrait as Winter*, 1731. Pastel on paper, 46.5 x 34 (18 1/4 x 13 3/8). Staatliche Kunstsammlungen Dresden Gemäldegalerie Alte Meister. Photo Klut/Dresden

19 Charley Toorop, *Self-Portrait*, 1955. Oil on canvas, 62 x 42 (24 3/8 x 16 1/2). Gemeente Alkmaar. Photo Berend Ulrich, copyright Stedelijk Museum Alkmaar. © DACS 1998

20 Miniature showing Marcia painting a self-portrait from her reflection in a mirror in a French translation of Boccaccio's *De Claris Mulieribus*, c. 1402. Bibliothèque Nationale, Paris. Ms. Fr. 12420, *fol. 101 v.*

20 Miniature showing Marcia in Boccaccio's *Livre des femmes nobles et renommées*, presented to the Duc de Berry in 1404. Bibliothèque Nationale, Paris. Ms. Fr. 598, *fol. 100 v.*

21 German psalter from Augsburg, c. 1200. Walters Art Gallery, Baltimore

21 Gwen John, *Self-Portrait Nude, Sketching*, 1908–09. Pencil on paper, 23.5 x 16.5 (9 1/4 x 6 1/2). National Museum and Galleries of Wales, Cardiff. © Estate of Gwen John 1998. All rights reserved DACS

22 Lavinia Fontana, *Self-Portrait with Small Statues*, 1579. Oil on copper, tondo, D 15.7 (6 1/8). Galleria degli Uffizi, Florence. Photo Archivi Alinari, Florence

23 Elisabeth Vigée-Lebrun, *Self-Portrait*, 1791. Oil on canvas, 99.1 x 81.3 (39 x 32). Ickworth, Suffolk. © The National Trust Photographic Library/Angelo Hornak

24 Sofonisba Anguissola, *Self-Portrait*, c. 1555. Oval miniature; oil on copper, 8 x 6.5 (3 1/4 x 2 1/2). Museum of Fine Arts, Boston. Emma F. Munroe Fund. Courtesy, Museum of Fine Arts, Boston

25 Sofonisba Anguissola, *Self-Portrait*, c. 1610. Oil on canvas, 94 x 75 (37 x 29 1/2). Gottfried Keller Collection, Bern

27 Ambrogio Lorenzetti, *Vanagloria* (detail), from *The Allegory of Bad Government*, 1338–40. Palazzo Pubblico, Siena. Photo Studio Fotografico Quattrone, Florence

31 Anonymous, *The Damerian Apollo*, 1789. Engraving. Copyright British Museum, London

LIST OF ILLUSTRATIONS

LIST OF ILLUSTRATIONS

190 Orlan, *Le Visage du 21 siècle*, 1990. Photo Rex Features, London
191 Sarah Lucas, *Self-Portrait with Fish*, 1996. Courtesy Sadie Coles HQ Ltd, London
192 Wanda Wulz, *Myself + Cat (Io + gatto)*, 1932. Museo di Storia della Fotografia Fratelli Alinari. Photo Archivi Alinari, Florence
194 Mary Beth Edelson, *Some Living American Women Artists/Last Supper*, 1972. Offset poster, 66 x 96.5 (26 x 38). Courtesy of the artist
195 Rose Garrard, *Madonna Cascade* from *Models Triptych*, 1982–83. New Hall College, Cambridge. Panel approximately 107 x 76 (42 x 30). Photo Edward Woodman. Courtesy of the artist

196 Alice Neel, *Self-Portrait, Skull*, 1958. Ink on paper, 29.2 x 21.6 (11 1/2 x 8 1/2). © The Estate of Alice Neel. Courtesy Robert Miller Gallery, New York
197 Audrey Flack, *Wheel of Fortune (Vanitas)*, 1977–78. Oil over acrylic on canvas, 243.8 x 243.8 (96 x 96). Courtesy Louis K. Meisel Gallery, New York
198 Melanie Manchot, *Double Portrait – Mum and I*, 1997. Silver gelatin on canvas, 150 x 120 (59 x 47 1/4). Courtesy of the artist and Zelda Cheatle Gallery, London
199 Nadine Tasseel, *Untitled*, 1992. Silver print on barite. Photo Kanaal Art Foundation, Kortrijk. Courtesy of the artist
200 Francesca Woodman, *Providence*, 1975–76. Black-and-white photograph, 20.3 x 25.4 (8 x 10).

From the estate of Francesca Woodman, courtesy Betty and George Woodman, New York
201 Nathalie Hervieux, *Untitled*, 1986. © Nathalie H. 1986. Photo Kanaal Art Foundation, Kortrijk
202 Meret Oppenheim, *X-ray of My Skull*, 1964. Black-and-white photograph, 25.5 x 20.5 (10 x 8). Kunstmuseum Bern. Hermann-und-Margrit-Rupf-Stiftung. © DACS 1998
203 Hannah Wilke, *S.O.S – Starification Object Series* (detail), 1974. 1 of 35 black-and-white photographs from *Mastication Box*, 1974. 17.8 x 12.7 (7 x 5). Performalist Self-Portrait with Les Wollam. Courtesy Ronald Feldman Fine Arts, New York. © The Estate of Hannah Wilke

INDEX